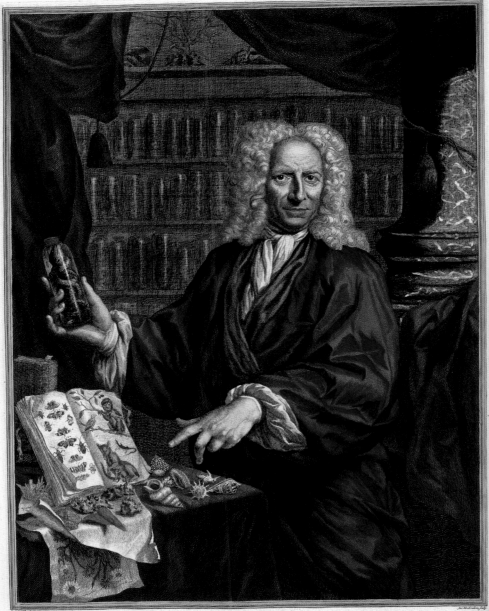

# ALBERTVS SEBA, ETZELA OOSTFRISIVS

Pharmacopoeus Amſtelaedamenſis

ACAD: CAESAR: LEOPOLDINO CAROLINAE NAT: CVRIOS: COLLEGA XENOCRATES DICTVS,
SOCIET: REG: ANGLICANAE, et ACAD: SCIENTIAR: BONONIENSIS INSTITVTVS SODALIS.
AETATIS LXVI. ANNO CIƆIƆCCXXXI.

ALBERTUS SEBA

# Cabinet of
# Natural Curiosities
## Das Naturalienkabinett
## Le Cabinet des curiosités naturelles

*Locupletissimi rerum naturalium thesauri*

### 1734–1765

Based on the copy in the Koninklijke Bibliotheek,
The Hague

## TASCHEN
*Bibliotheca Universalis*

# LOCUPLETISSIMI
# RERUM
# NATURALIUM
# THESAURI

## ACCURATA DESCRIPTIO,
### ET
## ICONIBUS ARTIFICIOSISSIMIS
# EXPRESSIO,
### PER
## UNIVERSAM PHYSICES HISTORIAM.

### OPUS,

*CUI, IN HOC RERUM GENERE, NULLUM PAR EXSTITIT.*
*EX TOTO TERRARUM ORBE COLLEGIT,*
*DIGESSIT, DESCRIPSIT, ET DEPINGENDUM CURAVIT*

# ALBERTUS SEBA,

*ETZELA OOSTFRISIUS,*

ACADEMIÆ CÆSAREÆ LEOPOLDINO CAROLINÆ NATURÆ CURIOSORUM
COLLEGA XENOCRATES DICTUS; SOCIETATIS REGIÆ ANGLICANÆ,
ET INSTITUTI BONONIENSIS, SODALIS.

## TOMUS I.

I. F. D. R. del.                P. Tanié sculp.

## AMSTELAEDAMI,
Apud JANSSONIO-WAESBERGIOS,
& J. WETSTENIUM, & GUL. SMITH.

### MDCCXXXIV.

**6**

ALBERTUS SEBA'S
COLLECTION OF NATURAL SPECIMENS
AND ITS PICTORIAL INVENTORY

**28**

ALBERTUS SEBAS NATURALIENSAMMLUNG
UND IHR BILDINVENTAR

**52**

LA COLLECTION D'HISTOIRE NATURELLE
D'ALBERTUS SEBA ET SON INVENTAIRE ILLUSTRÉ

IRMGARD MÜSCH

**77**

# THE COMPLETE
# PLATES IN COLOUR

## VOLLSTÄNDIGE AUSGABE
## DER KOLORIERTEN TAFELN

### LES TABLEAUX
### COLORIÉS COMPLETS

### 1734–1765

# ALBERTUS SEBA'S
# COLLECTION OF NATURAL SPECIMENS
# AND ITS PICTORIAL INVENTORY
### IRMGARD MÜSCH

Albertus Seba (1665–1736) in Amsterdam was proud indeed of his collection of natural specimens, the work of many decades. Having emphasized its uniqueness in a letter to a potential buyer, composed in c. 1725, he expanded further on its scope, writing that it included *all sorts of exquisite pieces from the East and West Indies,* among these no less than *700 jars containing the rarest exotic animals* and *many particularly rare snakes.* Also *brought together thus are every exceptional sort of beautiful and rare conch, the finest and most complete butterflies from the 4 corners of the Earth.* Completing this list are samples *of all the plants, some familiar pieces, but unfamiliar ones too.* Seba commissioned artists to make meticulous drawings of these diverse objects from his collection. He went on to publish these drawings, supplemented by commentary, in a four-volumed set entitled *Loccupletissimi Rerum Thesauri Accurata Descriptio* (abbreviated in the following as *Thesaurus*). The large and magnificent work, incorporating an impressive total of 446 copperplates, was published between 1734 and 1765, hence also posthumously. This pictorial record of Seba's unique collection is now available in reprint. For a better appreciation of this major publishing enterprise, it is necessary to take a closer look at the life and historical context of the man behind it.

## AN APOTHECARY AND
## COLLECTOR IN AMSTERDAM

By becoming an apothecary, Albertus Seba, who was born in 1665 in the East Frisian town of Etzel, chose a profession with close ties to natural history. Doctors and apothecaries were pioneers of the empirical sciences, which had been growing significantly in importance since the Renaissance. Unlike today, medications were not synthetically made but mixed together from natural constituents. A whole range of traditional recipes were available to those versed in the art of creating remedies from animal, vegetable and mineral ingredients. But many did not stop there. They continued the search for new methods, collecting natural specimens from distant lands, studying them, and testing their potential uses. Their passion for collecting and researching often extended beyond immediate pharmaceutical applications. In many instances apothecaries started major natural history collections and contributed personally to the growing knowledge of nature.

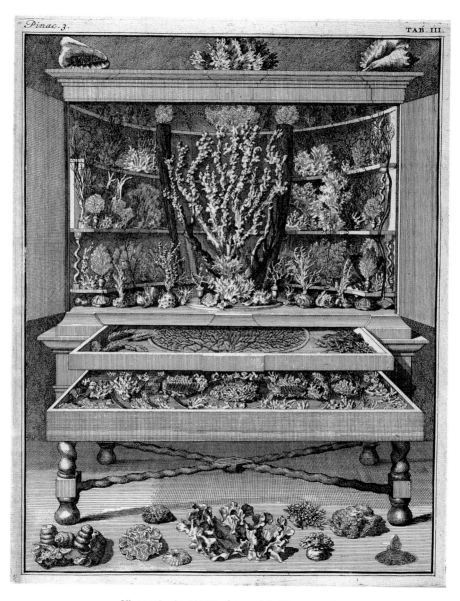

Vincent Levin: *Het Wondertooneel der Natuure*, 1706
Plate · Tafel · Planche III
Göttingen, Niedersächsische Staats- und Universitätsbibliothek

Seba's collection of natural specimens also went far beyond what was required for the normal exercise of his profession. His portrait, programmatically placed at the front of the *Thesaurus*, depicts him amidst his collection (ill. p. 2). The wall behind him is completely lined with shelves of glass jars in which he stored his large collection of preserved snakes. Seba is holding one of these jars, probably filled with alcohol, in his right hand as well. He is pointing with his left hand at shells, loose sheets of drawings and an open book before him. This still-life arrangement illustrates the evolutionary course of the publication – from collected specimen to drawing to printed work. Indeed, the animals depicted on the right-hand page of the book can be found in two of the plates in the actual *Thesaurus* (I, 33 and 38). The portrait of Seba himself, executed by the copper engraver Jakob Houbraken (1698–1780) after a painting by Jan Maurits Quinkhard (1688–1772), shows Seba in the pose of a scholar of his day. The characteristic workroom, the periwig appropriate to his rank, the dignified drapery complete with pillar, signal that, even without a university education, it was possible to regard oneself as a member of the republic of letters in the 18th century.

In his day, Seba's profession, pharmaceutical science, was not a subject of academic study but of vocational training. Manuals already existed on the topic, of course, but they only contained excerpts of the empirical knowledge that continued to be transmitted mainly orally and in professional day-to-day practice. Apprenticeships and years as journeymen, entailing frequent changes of workplace, were thus essential for a good command of the profession. Seba started his training in 1684 in Neustadt-Gödens, not far from his home town, completing it in Groningen, Amsterdam, Nuremberg and Strasbourg. Each different location enabled him not

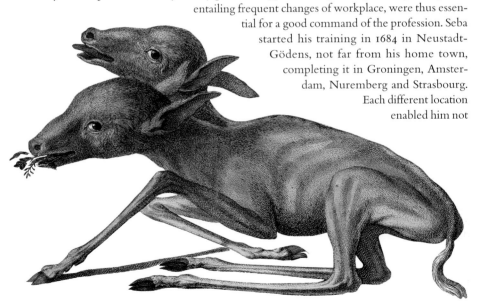

**I, Tabula 45, Fig. 2** African deer, double-headed monster · Hirsch aus Afrika, monströs, mit zwei Köpfen · Cerf d'Afrique, monstrueux, à deux têtes

only to deepen his pharmaceutical knowledge but also to acquaint himself with and study some natural history collections. His employer in Nuremberg, for example, the apothecary Johann Leonhard Stöberlein (1636–1696), maintained an extensive collection of art and natural specimens. Each of the many such collections, large and small, were one little mosaic piece in the incomplete picture that naturalists around 1700 were able to form of the rich diversity of nature. Each collection, bearing the peculiar stamp of its owner's interests and astuteness, could make its own contribution to the advancing knowledge about nature, and hence each was a valuable instrument of research.

After his time of travel as a journeyman, Seba returned to Amsterdam, becoming a citizen there in 1697. In the same year, he passed his apothecary examinations, for which he was required to prepare various medicaments. Marrying Anna Loopes, the daughter of one of his colleagues, Seba bought a house and settled down as an independent apothecary in Amsterdam.

With his "Die Deutsche Apotheke" (German Apothecary's Shop), as he called his business, Seba rapidly earned an excellent reputation for himself. Even the Russian tsar Peter the Great trusted his pharmaceutical expertise, purchasing medicines from him for many years. Financially, too, he was successful – something which would enable him to establish his comprehensive collection of natural specimens. Not relying solely on casual customers who happened to pass by his apothecary, Seba actively sought them out. He traded in drugs from overseas, advertising his prices in an Amsterdam newspaper. He supplied departing ships with cases of medicines and treated their crews. It is related how, whenever a ship arrived in port, Seba would hasten down to the harbour without delay and administer his medicines to the exhausted sailors. Any natural specimens that they had brought with them he would then be able to purchase at a good price or accept in exchange for his medications.

In Amsterdam, Seba was ideally situated for starting such a collection of natural curios. The city on the Amstel river was still the flourishing centre of international maritime trade that it had first become in the 17th century. The Low Countries had, after 1580, liberated themselves in a series of stages from domination by Catholic Spain and had united as a Protestant republic. The succeeding century was a Golden Age, an extraordinary blossoming of the arts, sciences and commerce. The influx of Protestant refugees from the Spanish-occupied southern regions (now Belgium) enriched intellectual and economic life, and capital and know-how poured into the city. Amsterdam replaced Antwerp – still firmly in the grip of the Spanish – as the most important port, and trade with the colonies was expanded. Enjoying special political privileges, the Dutch East India Company imported spices, textiles, gems and other colonial goods on a grand scale, reselling them all over Europe at an enormous profit.

The sciences benefited directly from this flourishing trade. The Hortus Botanicus of Amsterdam, established in 1638 as a garden for medicinal herbs, was substantially enlarged with exotic plants brought home by representatives of the East India Company. These rare

plants in Europe transformed the botanical garden, which still exists today, into an important focal point for naturalists. The research that the Swede Carl Linnaeus (1707–1778) conducted there led to his groundbreaking book *Systema Naturae* (1735), which continues to form the methodological basis of the classification of plants and animals. Numerous private collections of natural specimens likewise profited from the foreign trade and developed into important natural history collections offering indispensable visual material for domestic and foreign naturalists.

Dutch researchers were respected members of the republic of letters, that international network in which information was exchanged and open questions debated without regard for social class or national boundary. Seba, too, fostered relations with important researchers throughout Europe, such as Sir Hans Sloane (1660–1753), the influential president of the scientific Royal Society in London, Johann Jakob Scheuchzer (1672–1733), the Zurich-based naturalist and physician, Johann Jacob Baier (1677–1735), president of the Leopoldina Academy of Science, and Count Luigi Ferdinando de Marsigli (1658–1730) in Bologna. These were just a few of Europe's many collectors of natural specimens. The long letters between these scholars shed light on details about their collections. They sent each other unusual pieces, discussed observations of natural phenomena and established contacts amongst themselves. They founded academies and societies which, partly assisted by public funds, collated their research and published their findings in periodicals. Seba's achievements, helped along by his good contacts, were rewarded with membership of the Royal Society, the Bologna Academy and the Leopoldina.

The so-called republic of letters rose not only above issues of nationality or class; it tended to leave religious quarrels behind it, as well. During the turbulent first half of the 17th century, bloody wars raged between Catholics and Protestants, yet the sciences offered a generally neutral sphere in which a new, more or less objective understanding of the world could be developed beyond theological controversy. It was a sphere in which natural history collections could play an important part.

## FROM CABINETS OF CURIOSITIES
## TO COLLECTIONS OF NATURAL SPECIMENS

Under the influence of humanist scholarship, around 1500 there began to appear – initially at the courts of Italian princes – collections of a special type, known as *Kunstkammern* or cabinets of curiosities.

Very different things found their way into these collections: antique objects such as figurines and coins, artistically crafted artefacts, scientific instruments, books, pictures, items from faraway lands, and for the first time on a larger scale, natural specimens. One particularly large cabinet – built upon older precursors – was established by Francesco I de' Medici, Grand Duke of Tuscany, around 1570 in Florence. Early examples north of the Alps are the collections of Duke Albrecht V of Bavaria in Munich (from 1563) and the Tyrolean

Joseph Arnold: *The curiosity cabinet of the Dimpfel family of wholesale ironmongers and miners from Regensburg*, 1668(?), Opaque pigment with embellishments in gold on parchment · *Die Kunstkammer der Regensburger Großeisenhändler- und Gewerkenfamilie Dimpfel*, 1668(?), Deckfarben mit Goldhöhung auf Pergament · *La chambre des merveilles de la famille Dimpfel, commerçants de fer en gros et membres d'une société minière*, 1668(?), Couleurs couvrantes et rehauts d'or sur parchemin. Ulm, Ulmer Museum

archduke Ferdinand at Ambras castle (from 1573). The cabinet of curiosities that Emperor Rudolph II established around 1600 in Prague, which filled many rooms, gained legendary fame. In emulation of their princes, members of the middle classes also began compiling private collections in the second half of the 16th century. Famous examples include the collections by Abraham Ortelius (1527–1598), a geographer and cartographer in Antwerp, and Herman Boerhaave (1668–1738), professor of medicine at Leiden, who, incidentally, wrote a glowing preface to Seba's *Thesaurus*.

A small gouache by the Ulm artist Joseph Arnold (?–1671), executed in 1668(?), portrays the *Kunstkammer* owned by the 17th-century Regensburg ironmonger Dimpfel (ill. above). We see a room amply stocked with an assortment of very different objects. Paintings, weaponry, celestial and terrestrial globes, clocks, books, shells, small sculptures, and much more stand in decorative arrangements on the floor, on tables, shelves, and little cabinets.

Although Arnold's depiction seems somewhat idealized, it is documented that splendid displays aimed at pleasing aesthetic tastes were quite commonplace. In order to be able to display a collection artistically while protecting it from dirt and damage, in the 16th and 17th century a new piece of furniture was specially developed: the collector's cabinet. In the description of his collection which he published in 1706, the Dutch cloth merchant Vincent Levin (1658–1727) illustrated individual areas of his collection just as they had been arranged in their cabinets (ill. p. 7). The selected plate shows an artistic display of corals and other sea creatures in an open cabinet. It is easy to imagine the effect on the visitors when Levin threw open the cabinet doors and drew out the drawers to reveal the secretly hidden treasures. A drawer that was once a part of a seashell cabinet dating from about 1725 also gives us a sense of the charm of such beautifully arranged collections (ill. p. 34). Equally impressive is the illustration of a collector's room which precedes a description by the Danish naturalist Ole Worm (1588–1654) of his cabinet (ill. p. 20). Worm's collection includes domestic utensils and natural specimens, so-called exotica, from overseas: musical instruments, a canoe, preserved animals, shells and much more besides.

The multifarious and disparate objects united in early encyclopaedic collections appeared to later generations as confused cabinets of curiosities. For all its variety, however, Worm's collection is far from a random hotchpotch. Besides its clear focus on natural specimens, its pieces are sorted and clearly arranged on shelves and inside drawers, all neatly identified. The labels reveal that Worm ordered his objects according to different criteria, for example, by material: thus there are labels for metal and *Ligna* (wood).

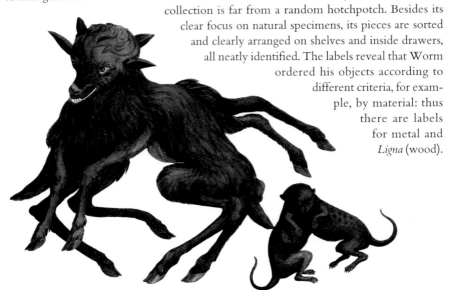

**I, Tabula 46, Fig. 1 & 2**
Goat from Curaçao, conjoined with a little kid / Monstrous cat from America, which is one of the young ones · Ziegenbock aus Curaçao, der mit einer kleinen Ziege verwachsen ist / Monströse Katze aus Amerika, die eines der Jungen ist · Bouc de Curaçao, uni et accru à une petite chèvre / Chat monstrueux d'Amérique qui est un des petits

Advice on arranging and ordering such collections was provided by theoretical guides, the first of which was written by Samuel van Quiccheberg (1529–1567) in 1565. In his *Inscriptiones vel tituli theatri amplissimi*, this Flemish doctor and administrator of the ducal art collection in Munich outlines an ideal cabinet of curiosities. In his system of five departments, the first was devoted to noble lineage, i.e. genealogy. The second department was dedicated to handicrafts from Antiquity to his own day, the third department to natural specimens, and the fourth to technical and cultural objects. Quiccheberg's fifth department was a picture gallery comprising paintings, drawings and engravings. In addition to these departments he also saw as necessary not only a library and workshops, but also an apothecary's shop. It is precisely these last which make it clear that the *Kunstkammer* was intended not merely as a collection, but as a place of learning.

In a world becoming ever more complex with each new geographic and scientific discovery, the ideal cabinet of curiosities constituted an attempt to produce an overall picture of this world, the cosmos. Within its limited space, the cabinet of curiosities presented a microcosm, reproducing the general picture, the macrocosm, on a reduced scale. The early cabinets of curiosities thereby spotlighted areas on the fringes of the known world. These included medical "curiosities" such as so-called freaks of nature, as well as handicrafts and natural specimens from foreign lands, and many other rarities which in Europe provoked astonishment and raised questions. The aim was to bring together – at least in representative form – the most complete collection possible of all things knowable and worth knowing, to record them and thus to make them easier to grasp. The arrangement of the various objects in a room – some laid out on tabletops – gave the viewer the opportunity to relate the individual objects to one another visually and to draw connections between them. A given natural specimen, a piece of coral for instance, which was represented in the collections of Levin, Dimpfel and Seba (ill. pp. 2, 7 & 11), thereby acquired quite different meanings. Initially it was regarded as a remedy for illnesses such as anaemia, but was subsequently also imputed magical powers, such as protection against lightning bolts or the evil eye. Its brilliant colour made it an aesthetic ornament, intricately set in gold by fine metalsmiths. But coral excited scientific interest as well, because it was not easily assigned either to the kingdom of animals or plants, while the fact that it hardened to stone once out of the water meant it might even belong to the mineral kingdom. Thus objects like coral could suggest a variety of links to different fields. What today seems the very heterogeneous organization of cabinets of curiosities was grounded in this network of meanings, and arose out of correlations with religion and alchemy as well as out of the classification of objects by their specific material properties.

The cosmological view of the world that governed the encyclopaedic pretensions of early collections began to lose importance after 1600. In the 17th and 18th century, cabinets of curiosities were replaced by more specialized collections. The new aim was less to reflect, in representative samples, the whole cosmos than to cover comprehensively a chosen area of speciality. Natural history collections became tools of empirical research. Through description, comparison and ordering of their pieces, collectors strove to reach a scientific under-

standing of nature. An illustration from 1727 (ill. p. 15) shows a collector working with his objects in such an ideal "research laboratory". Caspar Friedrich Neickel placed it at the front of his *Museographia*, published by the Breslau physician Johann Kanold (1679–1729). This manual on early museum science combined a guide to collecting with descriptions of existing collections, including Seba's own.

There were motivations enough for collecting – whether to act as an intellectual stimulus, to satisfy an investigative spirit, or to display wealth and erudition. And of course, collections raised the social prestige of their owners. Large collections, or ones containing rare pieces, attracted foreign visitors, and even royalty. And it was not unheard of for complete collections to be resold at a handsome profit.

Collecting was naturally subject to fashion. Shells, for example, were a popular item and from the Renaissance onwards were collected and studied in ever-growing numbers. As an employee of the Dutch East India Company on the island of Amboina (in modern Indonesia), Georg E. Rumphius (1627–1702) was well placed to build up an exquisite collection that became the subject of *D'Amboinsche Rariteitkamer*, an influential volume of 1705 with which Seba was also familiar (ill. p. 26). Around 1700 the Netherlands were seized by a veritable conch mania; market prices soared to almost absurd levels for these fascinatingly pretty natural specimens. Alongside the countless little shell collections which formed as a consequence, there were a few larger ones – with Seba's collection being among the most comprehensive.

## THE COLLECTION OF ALBERTUS SEBA

In assembling his collection, Seba was thus following a trend of his time. As an apothecary, however, he was already per se a collector and researcher of natural specimens. Contemporary reports testify to his being a well-versed member of this species. His tactic of buying the souvenirs from sailors just returned from the distant seas, sometimes even before they had disembarked from their vessels, has already been mentioned. He may well have made arrangements with the odd seafarer to bring back specific natural samples that rarely reached Europe and were scarcely known at home. Many remarks in the *Thesaurus* indicate that Seba exchanged correspondence with contacts in Sri Lanka, Greenland, Virginia, Batavia (now Jakarta, Indonesia) and elsewhere, from whom he obtained specimens. With other collectors he swapped duplicates from his collection, or sold them – with his usual business acumen – at a profit.

Seba succeeded in assembling a wealth of natural specimens whose fame spread beyond the bounds of Amsterdam. The full extent of his collection has come down to posterity as a consequence of an exceptionally fortunate transaction that Seba made in 1717. He had heard about the impending visit of the Russian tsar, Peter the Great, who wanted to see the Netherlands and at the same time shop for acquisitions for his own cabinet of wonders. The adroit Seba sent him a written itemization of his collection in advance and thus prepared

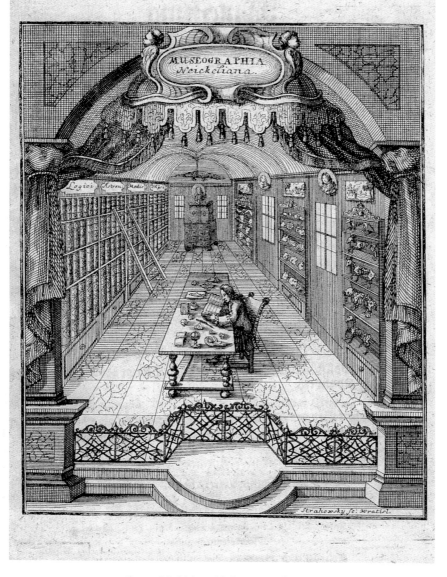

Caspar Friedrich Neickel: *Museographia*, 1727
Frontispiece · Frontispiz · Frontispice
Göttingen, Niedersächsische Staats- und Universitätsbibliothek

the way for its sale. This sale actually took place after Peter had paid a visit to his home. The full scope of Seba's first collection is revealed in an inventory drawn up by an administrator from St Petersburg upon the arrival of the newly purchased pieces. Among other things, it comprised no less than 72 drawers full of shells, 32 drawers displaying 1,000 European insects, and 400 jars of animal specimens preserved in alcohol.

After selling his first collection, Seba immediately set about establishing a second one that eventually became even larger. As the *Thesaurus* shows, the main emphases of this collection were marine animals, insects and reptiles. With this approach Seba was in good company. As already mentioned, naturalists around 1700 were generally tending to concentrate their collecting activities on a few specific aspects of the natural kingdom. Instead of amassing the broadest possible assortment of rarities, they strove to put together a detailed overview of selected fields. What made a collec- tion scientifically valuable was less the worth of some of its single

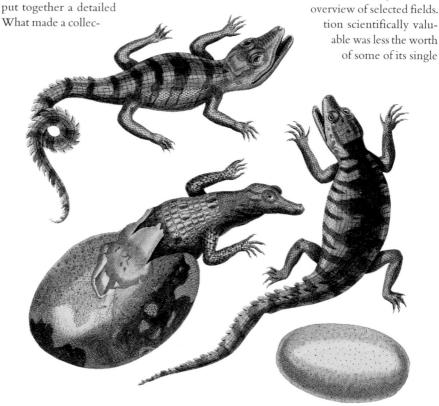

**I, Tabula 103**
Young crocodile from Ceylon, hatching from its egg · Junges von einem Krokodil aus Ceylon, aus dem Ei schlüpfend · Petit d'un crocodile de Ceylan, sortant de l'œuf

pieces than its completeness in covering a particular branch of the natural world, including native flora and fauna.

Leafing through the *Thesaurus*, one is struck by a certain ambivalence in the selection. The Amsterdam apothecary succeeded in assembling a collection of the greatest scientific importance in the areas of reptiles, insects and marine animals, and made a major contribution towards the identification of the various species. And yet his collection retains a clear link with the older cabinets of wonders and curiosities. It continues to make room for the peculiar, the rare and the strange. It is more out of curiosity than in the name of science, for instance, that a deformed baby from Curaçao, preserved in alcohol, is separately depicted. The *Thesaurus* also includes an illustration of a malformed goat with one head and two bodies (I, 46). What found its way into Seba's book was not necessarily the typical representative of a given species but the occasional anomaly, which was certain to excite much greater interest. Unlike earlier cabinets of curiosities, however, Seba's collection of natural specimens made no room for ancient coins, exotic weapons or the like. Untouched nature was the main interest of this professional apothecary. Only the nautilus shell is elaborately adorned by the work of a human hand (III, 84).

One general problem facing natural history collections was storage and conservation. While objects such as hard, calcareous seashells were not subject to major decay, other natural specimens required complex conservation measures. Procedures were borrowed from other disciplines, such as medicine, and developed further. At the end of the 17th century another Amsterdam apothecary, Frederik Ruysch (1638–1731), who was also a doctor, naturalist and friend of Seba's, adapted existing techniques for preserving human corpses. His conservation by means of coloured wax and oils was so effective that the bodies looked as if they were still alive. Although he kept his formula secret, it is possible that Seba had at least some understanding of the processes involved. Seba, for example, employed a method by which he could isolate the skeleton of a leaf. He submitted the leaf to an accelerated rotting process to expose its internal structure. In 1730 he published an article on this technique. Specimens prepared in this way are displayed on the first few pages of the *Thesaurus*.

Seba's large collection of preserved natural specimens, which he exhibited in a specially designated room of his house, was famous far afield. Naturalists from many countries came to view it. After Seba's death in 1736 the collection passed to his heirs. In order to assure continued publication of the still incomplete *Thesaurus*, they eventually found it necessary to sell the collection. The auction took place in 1752. Thanks to a printed auction catalogue containing handwritten notes, we know the considerable sums which were paid for some of the pieces. Some items have survived the centuries and form a part of the holdings of European natural history museums, including the Zoological Institute in St Petersburg, the Natural History Museum in Stockholm, the Zoological Museum in Amsterdam and the British Museum in London.

## FROM A COLLECTION TO A BOOK

Natural history collections and books about the natural world are inextricably linked to each other. While naturalists from the late Renaissance onwards increasingly emphasized the primacy of immediate, empirical studies of nature over knowledge from books, this did not, by any means, completely preclude reading. As with *Kunstkammern*, books formed a part of every natural history collection and also served as commentaries on them. They provided access to the subject matter and enabled identification and ordering. Books and their illustrations also served to supplement collections of natural specimens, closing any gaps and making up for any deficiences with pictures. As Seba's *Thesaurus* exemplifies, some collections were themselves made into books.

Works devoted to plant identification, to individual collections, and to natural history in general reveal the close tie between books and collections. Indeed, books themselves could constitute collections of natural specimens, as in the case of herbaria, which became increasingly popular from the 16th century onwards. Herbaria are blank volumes of highly absorbent, soft paper on which pressed and dried plants were glued. An example still extant today was compiled by Boëtius, court physician to Emperor Rudolph II in Prague (ill. p. 38). The two dried plants illustrated are members of the geranium family, as the handwritten label at the top of the page indicates. A small drawing in the lower margin, showing a stork, refers to the botanical name given to the plants in German – *Storchschnabelgewächse* (cranesbill). After 1700, compiling herbaria with personally collected plant samples was considered a useful pastime and even an important element of education. One went out to "botanize", exploring and recording one's natural surroundings. Everyone could participate in scientific inquiry, acquire a personal first-hand grasp of the current state of knowledge and possibly even contribute to it.

Assembling an extensive collection of natural specimens required considerable financial outlay, however. Since, moreover, many objects were not so easily obtained or were difficult to preserve, collections of drawings could act as a substitute or supplement. Like the plants in a herbarium, these pictures were glued in the desired order onto the blank pages of folio volumes. The results were veritable "museums on paper", such as the *Museo Cartaceo* by the Italian naturalist and classical scholar Cassiano dal Pozzo (1589–1627), which comprises over 7,000 drawings.

When a collector or naturalist commissioned an artist to draw specimens of interest to him, and in a second stage even to transfer them onto a plate for the press, the plant or animal in question underwent considerable abstraction and distillation on its way to becoming a scientific illustration (ill. p. 37). Just as a specimen was regarded as representative of its species, so its appearance was systematized. Individual traits not typical of its kind were minimized and the scientifically significant ones were accentuated. This process becomes clear upon comparison of a jar containing a snake preserved in alcohol, such as seen in Seba's portrait (ill. p. 2), with one of the numerous snake depictions in the *Thesaurus*. A convoluted, compressed, often faded and partly decomposed creature suspended in a murky

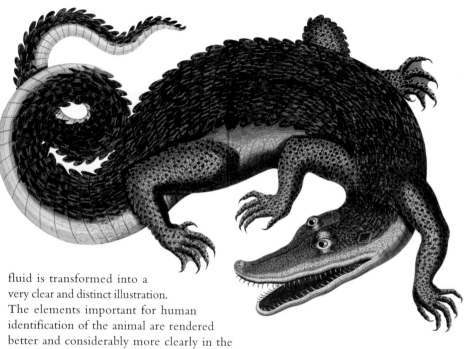

fluid is transformed into a
very clear and distinct illustration.
The elements important for human
identification of the animal are rendered
better and considerably more clearly in the
picture than in the actual specimen itself. This pictorial abstraction may also be understood
as one way of taming the multifariousness of nature. From the 16th century onwards, books
on the natural world contained detailed and realistic depictions permitting identification
of the specimens in question. First came large botanical works, since the identification of
plants played a crucial role in pharmaceutics. The epoch-making *Historia Stirpium* by the
botanist Leonhart Fuchs (1501–1566) is illustrated with a handsome 511 woodcuts. The
important contribution which the artists made to this work is also acknowledged pictorially:
they can be seen drawing and transferring a drawing onto the wooden block (ill. p. 37).

The example set by botany was soon followed by medicine, with its plate volumes on
anatomy, and zoology, with richly illustrated books on animals. The 17th century subse-
quently saw the appearance of ever more specialized books, such as the *Metamorphosis
Naturalis* by the Dutch painter and naturalist Jan Goedaert (?–c. 1668), a three-volume work
on insects which was published in various languages in the 1660s. Goedaert was the first to
present the developmental stages of these creatures systematically in a single picture; thus

**I, Tabula 106, Fig. 1**
Crocodile · Krokodil · Crocodile

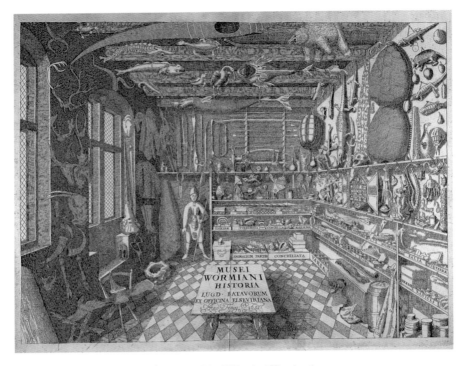

Ole Worm: *Musei Wormiani Historia*, 1655
Frontispiece · Frontispiz · Frontispice
Göttingen, Niedersächsische Staats- und Universitätsbibliothek

we see a larva, a caterpillar and a butterfly together on one sheet (ill. p. 42). The book on *Ornithologiae libri tres* by the Englishman Francis Willughby (1635–1672), which first appeared in 1676, presents 78 plates of native and "exotic" birds, arranged by specific category, such as birds of prey or waterfowl (ill. p. 29).

Scholars like Willughby were usually not acquainted at first hand with the animals and plants from distant parts of the world. Rather, they consulted illustrated travel accounts in which such unfamiliar fauna and flora were described and depicted. To obtain more accurate information, they provided ship's captains or other voyagers with detailed questionnaires to help them record what they saw. Towards the end of the 17th century, more naturalists began to travel abroad themselves. They documented what they saw in pictures or had artists accompany them on their travels to carry out this task. After their return, the sketches and descriptions made on site were subsequently turned into travel books which were simultaneously regular natural histories of the regions visited. Hans Sloane, a naturalist who

corresponded with Seba, published his travel account in 1707 and 1725 as a *Natural History of Jamaica*. It is very likely that Seba knew these two volumes, containing plates of a variety of reptiles and insects.

A particularly exceptional work was compiled by Maria Sibylla Merian (1647–1717), an artist from Frankfurt am Main who set out for Suriname at her own expense and on her own initiative on a voyage that lasted between 1699 and 1701. She was particularly interested in insects, but also studied other animals and plants in this South American country. In 1705 she published the work *Metamorphosis Insectorum Surinamensium*, which consisted of 60 large illustration plates and detailed descriptions (ill. p. 53). Her artistic still-life compositions are strikingly beautiful and influenced the design of the first volume of the *Thesaurus*.

Works of natural history from this era were illustrated in many very different ways. This is explained by their various purposes. Many books followed the tradition of earlier botanical works, whose illustrations were designed for unambiguous plant identification in herbal medicine. The specimens are depicted individually on a neutral background, so that they do not overlap and their characteristic traits are visible as clearly as possible (ill. pp. 29 & 38). A different emphasis, on the other hand, is offered by a book from 1681, the *Anatome Animalium* by the Amsterdam physician Gerard Blasius (ill. p. 50). Here the author attempts to reach a deeper understanding of nature by examining the internal organs and bone structure of animals. Each of his plates is devoted to a single species. Its skeleton and the results of anatomical analysis are presented next to a view of the animal in a natural setting. Maria Sibylla Merian placed particular importance on conveying an impression of the habitat in which the plants and animals lived and interacted. Her carefully designed scenes presented the individual elements distinctly and identifiably in an aesthetically pleasing manner (ill. p. 53). The Swiss naturalist Johann Jakob Scheuchzer (1672–1733) had another purpose in mind with his *Kupfer-Bibel*, which was also called the *Physica Sacra* (ill. p. 66). He discussed the animals, plants and natural phenomena mentioned in the Bible in the light of the latest scientific findings. This work, published between 1731 and 1735, was intended to help elucidate the Bible and to demonstrate its authenticity from the point of view of natural history. Depictions of biblical events are combined with illustrations from natural science. For example, the scene of Eve succumbing to the serpent's temptations and persuading Adam to taste the forbidden apple as well is accompanied by depictions of various kinds of snakes. While such representations of the natural world are clearly embedded within a specific worldview, Carl Linnaeus (1707–1778) sought to free his *Systema Naturae* from any such extraneous ballast (ill. p. 62). This book, which first appeared in 1735, developed the system of classification of plants and animals which still holds today. Linnaeus chose the reproductive organs as the main distinguishing factor between the genera and species of living organisms. The illustrations in his book are correspondingly reduced to simple diagrams of the relevant plant parts. It is easy to see how much Seba's *Thesaurus* diverges from this example of cutting-edge contemporary science.

# ALBERTUS SEBA'S THESAURUS

On 30 October 1731 a contract was signed in Amsterdam between three parties: Seba and the agents of two publishing houses agreed to produce a major work of 400 plates depicting Seba's collection. Ultimately, the *Thesaurus* incorporated a magnificent 446 plates, 175 of them double-page. The four volumes appeared over a span of 30 years, for after the appearance of the first two volumes in 1734 and 1735, Seba's death delayed the last two to 1758 and 1765. The commentary on the plates was published in a Latin-French and a Latin-Dutch edition, so as to reach a broad international readership of natural historians, collectors and book lovers. Seba wrote the text for the first two volumes largely himself, but also had other naturalists assist him. Frederik Ruysch, for example, helped him identify the snakes. Seba also entrusted the task of writing the commentary about fish in the third volume to an expert on the subject, the Swede Peter Artedi (1705–1735). When Albertus Seba died, his notes for the fourth volume were ready, but had to be revised a little and updated.

Volume I of the *Thesaurus* opens with a few pages devoted to illustrations of the plant skeletons that Seba had prepared and conserved using his own special technique. These are followed by depictions of plants and animals from South America and Asia. Alongside lizards, birds, frogs, spiders and other creatures, Seba includes a few fantastical creatures, such as dragons. Volume II is dedicated primarily to snakes, but a few plants and other animals are also depicted on the plates for decorative purposes and in order to illustrate the reptiles' environment. Volume III is devoted to marine life. The imposing variety of sea creatures includes scallops, starfish, squid, sea urchins and fish. Volume IV presents, in nearly 100 plates, a large collection of insects followed by a few pages of minerals and fossils from Seba's cabinet.

These natural-history plates are preceded not only by the author's portrait (ill. p. 2) but also by an allegorical frontispiece typical of books of the Baroque era (ill. p. 70). Figures embodying abstract concepts are here combined into a composition which yields a complex message and which represents a programmatic statement of the aims of the book. The original drawing was executed by the Dutch painter and draughtsman Louis Fabritius Dubourg (1693–1775) and then transferred onto a copperplate for printing by Pieter Tanjé (1706–1761), an engraver in Amsterdam. The Latin motto at the lower edge of the picture provides important clues for decoding its message. The female figure seated in the centre is thus to be understood as *Industria*, the personification of Industry and Diligence, who is motivated by her love of the sciences. She is busily carrying out her task, symbolized by the beehive beside her, under the protection of the enlightened personification of Truth, *Veritas*. Time, represented by the allegorical figure of *Chronos* with his scythe idle, is giving her the opportunity to pursue her work, namely, collecting. She is receiving from a winged messenger, who personifies Commerce, natural specimens from the different parts of the world. These last are personified in turn by allegorical figures standing behind Commerce.

A Native American represents the New World, followed by a dark-skinned inhabitant of the African continent, and a person from Asia. Europe is not represented, indicating that natural specimens from overseas – brought back on the large sailing ships visible in the background – are the focus of attention. Since Australia was still unknown to Europeans, its symbolical representative is missing. Many putti are scampering about at *Industria*'s feet, engaged in gathering specimens, examining and discussing them. As can be seen, pictures and books are also part of this study of nature. Two spirits are descending from the heavens to acknowledge *Industria*'s tireless collecting for the benefit of knowledge about the natural world. The one in front is carrying a circlet wrought in the shape of a snake biting its tail. This symbol of eternity, together with the laurel wreath in the hands of the second spirit, stands for lasting fame. The personification of diligent collecting thus outshines the idle reaper *Chronos* and is rewarded with symbols of enduring honour. The frontispiece of course reflects how Seba saw himself: its allegorical composition celebrates his own industriousness as an indefatigable collector and as the author of a comprehensive catalogue of his collection.

Publication of a work like the *Thesaurus* called for considerable sums of money. Hugely expensive to produce were above all the many illustration plates, whose engraving was a laborious and drawn-out task. The names of no less than 13 artists are recorded as being employed on the transferral of the drawings, frontispiece, and portrait to the copperplates. Besides Houbraken and Tanjé, who have already been mentioned, these included copper engravers from Amsterdam such as Frans de Bakker (active from 1736–1765), Adolf van der Laan (active from 1717–1740), and Jan Punt (1711–1779). But first Seba had to find a publisher willing to take on the financial risk associated with such an elaborate enterprise. It was

**II, Tabula 49, Fig. 4**
Jaguarondi, very young, from America · Wieselkatze, ganz jung,
aus Amerika · Jaguarondi, tout jeune, d'Amérique

customary in the Netherlands for several publishers to join forces in the case of such costly book projects. The contract drawn up between the two publishers of the *Thesaurus* reveals that the author was still obliged to put up one third of the money himself. Initial production costs were funded by means of a subscription: future customers placed their names on a list, paid at least a partial amount in advance and were granted in return a discount of 30 per cent.

The expensive work was initially published in black-and-white, in other words, without the vibrant colouring of the copy upon which this reprint is based. It is not known whether the publishers also offered a hand-painted edition, which would naturally have raised the price and profit margin considerably. Buyers probably had the work painted at their own extra expense by specialist colourists. One such was J. Fortuÿn, whose biographical dates are not known. Because he signed his work, several coloured copies of the *Thesaurus* can be traced back to him, including the present volumes, reprinted here from the copies in the Royal Library in The Hague. Since Fortuÿn followed his signature with the word "Hague", he must have lived and worked in The Hague as well. One of Fortuÿn's bills preserved in the archive in The Hague is dated 1767, which suggests that he carried out his colouring work only after all the volumes had been published.

The gorgeous colours add substantially to the attractiveness of the plates, but their purpose was not just aesthetic enhancement. They had a scientific use as well. Some specimens, such as those of butterflies, snakes and shellfish, are only distinguishable by their colouring, and the differences in patterning of many fauna can barely be discerned in black-and-white. The colourist's skill and knowledge of the

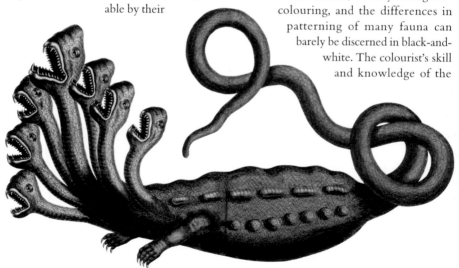

**I, Tabula 102, Fig. 1**
Hydra, or seven-headed serpent · Hydra, oder Schlange mit sieben Köpfen ·
Hydre, ou serpent à sept têtes

subject played an important part in enabling the illustrations to convey their message. Fortuÿn occasionally deviated from reality, however, and added colours for purely aesthetic effect. This happened in his interpretation of the pearly nautilus. The satin-white shell of this creature was highly valued and was often finely decorated with engraved motifs. Fortuÿn coloured one such ornamented nautilus in the *Thesaurus* in multiple hues, although the original shell would undoubtedly have been engraved simply in black (III, 84).

In his introduction Seba asserted that all the illustrations in his *Thesaurus* were based on specimens taken from his collection. The fabulous seven-headed creature in Volume I casts some doubt on this statement (I, 102). It is also known that, while writing the fourth volume, Seba drew upon a manuscript containing insect illustrations that he had purchased, and also incorporated into the *Thesaurus* drawings of animals from South Africa that a colleague had lent him. The Leipzig apothecary Johann Heinrich Linck (1674–1734) had also sent Seba drawings of his excellent snake collection, with the intention of using them in a joint publication on reptiles. When that project fell through, Seba had the drawings copied before he sent them back to Leipzig. Linck complained in a letter to Scheuchzer that Seba had then included the drawings in his *Thesaurus*. Seba also availed himself of the existing literature on natural history to fill in gaps in his collection and to obtain pictorial material. If we compare a plate from Blasius (ill. p. 50) with one in the *Thesaurus* (I, 82), and one from Merian (ill. p. 53) with another in the *Thesaurus* (I, 69), it becomes clear that a substantial portion of the plates in his first volume are based on older works. Such borrowings were made for the sake of completeness and were quite commonplace. They nevertheless carried a certain risk, especially when the original sources were drawings made or provided by sailors. Many of these were of mediocre quality and dubious authenticity (I, 101).

Whether or not originally in colour, whether or not based on existing illustrations, the *Thesaurus* remains an impressive example of a Baroque book. The artistic composition of every plate is particularly remarkable in the first volume, with all the pictorial elements combined into an overall composition. In emulation of Merian, the animals and plants are skilfully positioned and often arranged in little scenes, which adds considerably to their lifelike effect as well as to their informative value. A snake, for example, is depicted in the process of swallowing its prey (II, 17); another is in a threatening position in front of a lizard (II, 30). The illustrations in the second, third and fourth volumes, which rely much less on previously published sources, increasingly follow contemporary conventions in scientific literature. Thus the animals are arranged in neat rows, properly separated by genus. In the last two volumes, which were completed after Seba's death, there is no interaction between the depicted animals. For best possible visual clarity, the animals are portrayed without any overlapping and with their size ratios correct – albeit in mirror image, which in the case of snail shells spiralling counterclockwise became the source of some confusion. What was retained, though, was an ornamental arrangement of the objects on the plates, which is demonstrated by the symmetrically arranged snake plates (II, 37; II, 67) as well as by artistically arranged shells (III, 35; III, 56) and insects (IV, 25; IV, 77). That the display of

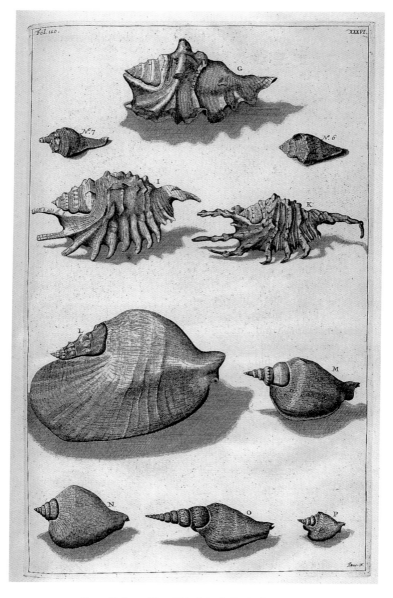

Georg E. Rumphius: *D'Amboinsche Rariteitkamer*, 1705
Plate · Tafel · Planche XXXVI
Göttingen, Niedersächsische Staats- und Universitätsbibliothek

a collection was aimed as much at satisfying the eye as the mind is illustrated by a surviving drawer full of shells from 1725 (ill. p. 34). The shells form a mosaic of diverse shapes and brilliant colours that is comparable to some of Seba's seashell plates (cf. III, 35–37). Seba presumably simply had the existing layouts in his storage boxes reproduced on the plates, just as Vincent Levin had done before him (ill. p. 7). Just as with the collection, there were thus always two aspects to the illustrations: they served both scientific instruction and aesthetic appreciation.

Most of the illustrations in the *Thesaurus* are limited to the external image of animals and plants. Besides the leaf skeletons, only a few anatomical dissections are represented. Nor does microscopy, which became very popular at the beginning of the 18th century, make any noticeable impact on the illustrations in the *Thesaurus*. Seba was a collector in the tradition of descriptive natural history, which was far removed from analytic approaches. Besides investigating and documenting the diversity of the earth's species, this descriptive method could also demonstrate developmental processes in nature, such as the metamorphosis of insects. Following Goedaert's example (ill. p. 42), the plates in the fourth volume depict, side by side, caterpillars, larvae and butterflies or moths (IV, 1).

The style of illustration adopted in the first two volumes elicited the particular criticism of some of its purchasers. The aesthetic and scenic arrangements of the natural specimens satisfied scientific purposes no better than did the mixing of animals and plants in one plate. There was criticism, too, of the sometimes bizarre differences in scale. The reproach that the snakes, marine animals, and insects were not arranged according to the latest classificatory system, however, ignored the fact that when Seba died in 1736, a good portion of the plates were already finished and did not yet reflect the findings of Linnaeus, only published a year earlier in 1735. The foreword to Volume IV of the *Thesaurus* was almost apologetic in emphasizing that its aim was not to serve as a comprehensive handbook of natural history but only as a description of an individual collection. That this was itself of great value was underlined by Herman Boerhaave (1668–1738) in his foreword to Volume I. He emphasized the richness and uniqueness of Seba's collection and praised the usefulness of the work. At a time when knowledge of the diversity of nature was still very incomplete and satisfactory pictorial material was a scarce commodity, Seba's *Thesaurus* provided an enormous fund of information. Although the scientific utility of Seba's collection had its clear limitations, the *Thesaurus* nevertheless served as a point of departure for further research. Linnaeus, for instance, used the illustrations of Seba's collection to improve and supplement later editions of his *Systema Naturae*. A new edition of Seba's work was published in the second half of the 18th century, and the illustrations were still considered valuable enough to be reprinted again in the following century. The *Thesaurus* treated an important collection of natural specimens of the early 18th century. As a book, the actual stationary collection became mobile and permanently accessible to many interested persons – even when the collection itself had long been scattered to the four winds.

# ALBERTUS SEBAS
# NATURALIENSAMMLUNG UND
# IHR BILDINVENTAR

### IRMGARD MÜSCH

Voller Stolz charakterisiert Albertus Seba (1665–1736) um 1725 seine Sammlung von Naturalien, die er über Jahrzehnte hinweg in Amsterdam angelegt hatte, als einzigartig. In einem Brief, den er an einen potenziellen Käufer sandte, führte er deren Umfang noch weiter aus. Demnach umfasste sie *allerhand auserlesene Stücke aus Ost- und Westindien*, darunter allein *700 Stück Gläser mit den raresten fremden Animalien* [Tieren] *besetzt* und *vielerhand extra-rare Schlangen*. Auch *alle besondere Sorten von schönen und raren Conchylien* [Muscheln]*, die allerschönsten und completesten Papilionen* [Schmetterlinge]*, so aus allen 4 Theilen der Welt gecolligiret seyn*, sowie Beispiele *von allen Gewächsen, theils bekandte, auch theils unbekannte Stücke* finden sich in der Auflistung. Die vielfältigen Objekte seiner Sammlung ließ Seba von Künstlern sorgfältig zeichnen. Mit einem erläuternden Kommentar versehen, veröffentlichte er diesen Fundus an Abbildungen als vierbändiges Buch mit dem Titel *Loccupletissimi Rerum Thesauri Accurata Descriptio*, im Folgenden abgekürzt als *Thesaurus*. Das großformatige Prachtwerk mit der beeindruckenden Zahl von 446 Kupfertafeln erschien im Zeitraum von 1734 bis 1765, also über Sebas Tod hinaus. Dieses bildliche Inventar von Sebas einzigartiger Sammlung liegt nun im Nachdruck vor. Für ein tieferes Verständnis dieses publizistischen Großunternehmens ist die Kenntnis der Biographie Sebas und seines historischen Umfeldes unerlässlich.

## EIN APOTHEKER UND SAMMLER
## IN AMSTERDAM

Albertus Seba, 1665 im ostfriesischen Etzel geboren, wählte mit dem Apothekerberuf eine Profession, die zu seiner Zeit eng mit naturhistorischen Studien verknüpft war. Ärzte und Apotheker waren Pioniere der empirischen Wissenschaften, die seit der Renaissance einen immensen Bedeutungszuwachs erfuhren. Medikamente wurden nicht wie heute synthetisch hergestellt, sondern aus natürlichen Bestandteilen gemischt. Um aus Tieren, Pflanzen und Mineralien Heilmittel zu gewinnen, stand Arzneikundigen eine ganze Reihe überlieferter Rezepte zur Verfügung. Viele suchten jedoch nach neuen Wegen, sammelten Naturalien aus allen Himmelsrichtungen, studierten sie und erprobten ihre mögliche Verwendbarkeit. Vielfach verselbstständigte sich die Sammel- und Forscherleidenschaft

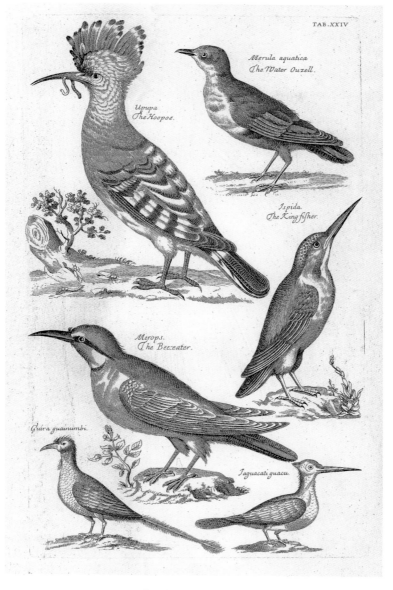

TAB.XXIV

Merula aquatica
The Water Ouzell.

Upupa
The Hoopoe.

Ispida
The Kingfisher.

Merops
The Bee-eater.

Guira guainumbi.

Jaguacati guacu.

Francis Willughby: *Ornithologiae libri tres*, 1676
Plate · Tafel · Planche XXVI
Göttingen, Niedersächsische Staats- und Universitätsbibliothek

über einen unmittelbaren pharmazeutischen Nutzen hinaus. Mehrfach legten Apotheker bedeutende naturhistorische Sammlungen an und trugen selbst zur wachsenden Kenntnis der Natur bei.

Auch Sebas Naturalienkabinett umfasste weit mehr, als zur Ausübung seines Berufes notwendig war. Das Porträt, das dem *Thesaurus* programmatisch vorangestellt ist, zeigt ihn inmitten seiner Sammlung (Abb. S. 2). Die Regalwand hinter ihm ist gänzlich mit Glasgefäßen gefüllt, in denen er seine große Kollektion präparierter Schlangen aufbewahrte. Ein solches, wohl mit Alkohol gefülltes Gefäß hält Seba auch in der rechten Hand. Mit der linken deutet er auf vor ihm liegende Muscheln, lose Blätter mit Zeichnungen und ein aufgeschlagenes Buch. In diesem stilllebenartigen Arrangement ist der Entstehungsprozess des *Thesaurus* von der Naturalie aus der Sammlung über die Zeichnung zum Druckwerk vorgeführt. Tatsächlich finden sich die auf der rechten Buchseite abgebildeten Tiere in zwei Tafeln des fertigen *Thesaurus* wieder (I, 33; I, 38). In dem Bildnis, das Jakob Houbraken (1698–1780) nach einem Gemälde von Jan Maurits Quinkhard (1688–1772) in Kupfer stach, ließ sich Seba im Habitus zeitgenössischer Gelehrter darstellen. Der als Arbeitszimmer gekennzeichnete Innenraum, die standesgemäße Allongeperücke, die würdevolle Vorhangdraperie einschließlich Säule machen deutlich, dass es im 18. Jahrhundert möglich war, sich auch ohne Universitätsstudium als Teil der Gelehrtenrepublik zu verstehen.

Sebas Profession, die Pharmazie, war zu seinen Lebzeiten kein Universitätsfach, sondern ein Lehrberuf. Natürlich existierten Handbücher, doch beinhalteten diese nur Ausschnitte des zum Großteil weiterhin nur mündlich überlieferten und in der täglichen individuellen Arbeitspraxis ermittelten Erfahrungswissens. Lehr- und Wanderjahre mit

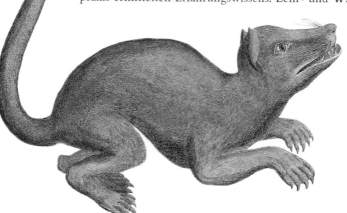

**I, Tabula 30, Fig. 1**
Wild dog from America with a very long tail · Wilder Hund aus Amerika mit sehr langem Schwanz · Chien sauvage d'Amérique, à la queue très longue

mehrfachem Wechsel des Arbeitsortes stellten deshalb einen notwendigen Bestandteil der Ausbildung dar. Seba begann in Neustadt-Gödens, nicht weit von seinem Heimatort entfernt, 1684 seine Ausbildung, die er dann in Groningen, Amsterdam, Nürnberg und Straßburg vervollständigte. An den verschiedenen Stationen konnte er nicht nur seine pharmazeutischen Kenntnisse vertiefen, sondern er hatte auch Gelegenheit, einige naturkundliche Sammlungen kennenzulernen und zu studieren. Beispielsweise verfügte sein Arbeitgeber in Nürnberg, der Apotheker Johann Leonhard Stöberlein (1636–1696), über ein umfangreiches Kunst- und Naturalienkabinett. Die größeren und kleineren Sammlungen bildeten in ihrer Vielzahl Mosaiksteinchen in dem noch unvollständigen Bild, das sich Naturforscher um 1700 vom Artenreichtum der Natur machen konnten. Jede Sammlung, geprägt von den individuellen Interessen und dem Sammelgeschick des Einzelnen, konnte einen Beitrag zur fortschreitenden Kenntnis der Natur bilden und war somit ein wertvolles Instrument der Forschung.

Seba kehrte nach seinen Wanderjahren nach Amsterdam zurück und ließ sich 1697 dort einbürgern. Noch im selben Jahr bestand er das Apothekerexamen, für das er verschiedene Arzneimittel anfertigen musste. Nach der Heirat mit Anna Loopes, der Tochter eines Berufskollegen, und dem Ankauf eines Hauses ließ sich Seba als selbstständiger Apotheker in Amsterdam nieder.

Mit seinem Geschäft, das er „Die deutsche Apotheke" nannte, erwarb sich Seba rasch einen guten Ruf. Sogar der russische Zar Peter der Große vertraute auf seine pharmazeutischen Fähigkeiten und bezog mehrere Jahre Arzneimittel von ihm. Zum großen finanziellen Erfolg seiner Apotheke, der ihm das Anlegen seiner umfangreichen Naturaliensammlung ermöglichte, trug ganz wesentlich bei, dass sich der geschäftstüchtige Seba nicht nur auf Laufkundschaft verließ. Vielmehr handelte er auch mit pharmazeutischen Rohstoffen (Drogen) aus Übersee, für die er unter Angabe der Preise in einer Amsterdamer Zeitung warb. Außerdem lieferte er den auslaufenden Schiffen Reiseapotheken und behandelte die Seeleute. Der Überlieferung zufolge eilte Seba unverzüglich auf die in den Hafen einlaufenden Schiffe und behandelte die Matrosen mit seinen Arzneien. Dabei gelang es ihm, den erschöpften Männern Naturalien, die sie mitgebracht hatten, günstig abzukaufen oder gegen Medikamente einzutauschen.

Mit Amsterdam hatte sich Seba einen Standort für den Aufbau einer Naturaliensammlung ausgesucht, wie er ihn besser kaum hätte finden können. Die Stadt an der Amstel war noch immer eine Metropole des Überseehandels, zu der sie sich im 17. Jahrhundert entwickelt hatte. Die heutigen Niederlande hatten sich nach 1580 in mehreren Schritten von der spanisch-katholischen Herrschaft losgesagt und als protestantische Republik zusammengeschlossen. Das folgende Jahrhundert erlebten sie als goldenes Zeitalter, als eine außerordentliche Blüte der Kunst, der Wissenschaften und des Handels. Protestantische Glaubensflüchtlinge aus den weiterhin spanisch okkupierten südlichen Gebieten (heute Belgien) bereicherten das intellektuelle und wirtschaftliche Leben, es flossen Kapital und Know-how in die Stadt. Amsterdam löste das besetzte Antwerpen als wichtigsten Seehafen

ab und baute vor allem den Handel mit den Kolonien aus. Mit politischen Vorrechten ausgestattet, importierte die Vereinigte Ostindische Kompanie (VOC) im großen Stil Gewürze, Stoffe, Edelsteine und andere Kolonialwaren, die mit enormem Gewinn nach ganz Europa weiterverkauft wurden.

Vom prosperierenden Handel profitierten die Naturwissenschaften ganz unmittelbar. Der noch heute existierende Hortus Botanicus Amsterdams, 1638 als Heilkräutergarten angelegt, erfuhr eine beträchtliche Erweiterung durch Arten, die Vertreter der VOC aus Übersee mitbrachten. Diese in Europa seltenen Pflanzen machten den botanischen Garten zu einer wichtigen und berühmten Forschungsstätte. Dort betrieb zum Beispiel auch der Schwede Carl von Linné (1707–1778) seine Studien, die ihn zur Publikation seines bahnbrechenden Buches *Systema Naturae* (1735) führten, der noch heute grundlegenden Methodik zur Klassifikation von Pflanzen und Tieren. Auch zahlreiche private Naturalienkabinette profitierten vom Überseehandel und entwickelten sich zu wichtigen Sammlungen, die einheimischen und auswärtigen Naturforschern unentbehrliches Anschauungsmaterial boten.

Niederländische Forscher waren angesehene Mitglieder der Gelehrtenrepublik, jenes internationalen Netzwerkes, in dem über Standes- und Landesgrenzen hinweg Informationen ausgetauscht und offene Fragen debattiert wurden. Auch Seba unterhielt Kontakte zu wichtigen Forschern in ganz Europa, wie zu Sir Hans Sloane (1660–1753), dem einflussreichen Präsidenten der Wissenschaftsorganisation Royal Society in London, zu Johann Jakob Scheuchzer (1672–1733), Naturforscher und Stadtarzt in Zürich, zu Johann Jacob Baier (1677–1735), Präsident der Akademie von Naturforschern Leopoldina, oder zu Graf Luigi Ferdinando de Marsigli (1658–1730) in Bologna. Die Genannten, beispielhaft für viele andere, besaßen ebenfalls Naturalienkabinette. In ausführlichen Briefen informierten die Gelehrten einander über den Inhalt ihrer Sammlungen, schickten sich besondere Stücke zu, diskutierten beobachtete Naturphänomene und stellten untereinander Kontakte her. Sie bildeten Akademien und Sozietäten, die, zum Teil von obrigkeitlicher Finanzierung unterstützt, Forschungen bündelten und die Ergebnisse in Zeitschriften publizierten. Sebas Leistungen und seine guten Kontakte bewirkten, dass er in der Royal Society, der Akademie in Bologna und in der Leopoldina Aufnahme fand. Die sogenannte Gelehrtenrepublik agierte nicht nur international und schichtenübergreifend, sondern ließ tendenziell auch Religionszwistigkeiten hinter sich. Tobten in der ersten Hälfte des 17. Jahrhunderts blutige Kriege zwischen Katholiken und Protestanten, so bot die Naturforschung eine weitgehend neutrale und als objektiv erachtete Sphäre, in der ein neues Verständnis der Welt jenseits theologischer Streitigkeiten entwickelt wurde. Hierbei konnten naturhistorische Sammlungen wesentliche Impulse geben.

# VON DER KUNSTKAMMER
# ZUM NATURALIENKABINETT

Unter dem Einfluss humanistischer Gelehrsamkeit entstand um 1500 zuerst an italienischen Fürstenhöfen ein besonderer Typ von Sammlungen, die sogenannten Kunst- und Wunderkammern. In diese Kunstkammern fanden ganz verschiedenartige Dinge Eingang: antike Objekte wie kleine Skulpturen und Münzen, kunsthandwerkliche Arbeiten, wissenschaftliche Instrumente, Bücher, Bilder, Objekte aus fernen Ländern und zum ersten Mal in einem größeren Maße auch Naturalien. Eine besonders umfassende Kunstkammer legte der toskanische Großherzog Francesco I. de'Medici – basierend auf älteren Vorläufern – um 1570 in Florenz an. Nördlich der Alpen sind als frühe Beispiele die Sammlungen von Herzog Albrecht V. von Bayern in München (ab 1563) und des Erzherzogs von Tirol, Ferdinand, auf Schloss Ambras (ab 1573) zu nennen. Legendären Ruf erwarb sich die mehrere Räume umfassende Kunstkammer, die Kaiser Rudolf II. um 1600 in Prag einrichten ließ. Neben diesen fürstlichen entstanden seit der zweiten Hälfte des 16. Jahrhunderts auch bürgerliche Privatsammlungen. Berühmt waren zum Beispiel die Sammlungen von Abraham Ortelius (1527–1598), Geograph und Kartograph in Antwerpen, oder von Herman Boerhaave (1668–1738), Professor für Medizin in Leiden, der im Übrigen für Sebas *Thesaurus* ein lobendes Vorwort schrieb. Eine kleine Gouache des Ulmer Malers und Zeichners Joseph Arnold (?–1671), angefertigt im Jahre 1668(?), zeigt die Aufstellung einer bürgerlichen Kunstkammer des 17. Jahrhunderts (Abb. S. 11). Der Blick fällt in den Sammlungsraum des Regensburger Eisenhändlers Dimpfel, in dem sich eine üppige Auswahl ganz unterschiedlicher Gegenstände befindet. Auf dem Boden, auf Tischen, Regalbrettern und Schränk-

**I, Tabula 30, Fig. 2**
Wild cat from America, resembling the tiger · Wilde Katze aus Amerika, ähnlich dem Tiger · Chat sauvage, d'Amérique, ressemblant au tigre

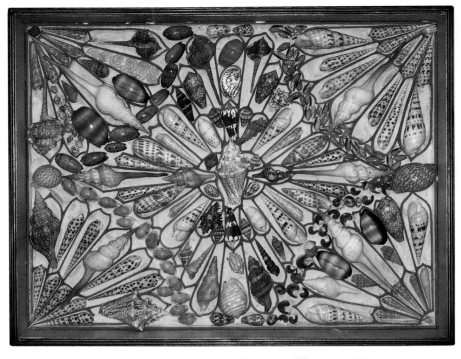

Drawer from a cabinet of seashells · Schublade aus einem Muschelkabinett ·
Tiroir d'un cabinet de coquillages, 1725
Amsterdam, Zoölogisch Museum, Universiteit van Amsterdam

chen stehen Gemälde, Waffen, Himmels- und Erdgloben, Uhren, Bücher, Muscheln, kleine
Skulpturen und vieles mehr in ansprechend dekorierter Anordnung. Mag Arnolds Darstellung
auch idealisierende Züge tragen, so ist aus schriftlichen Beschreibungen bekannt, dass eine
prächtige, auf ästhetisches Wohlgefallen abzielende Inszenierung durchaus nicht unüblich
war. Um eine Sammlung zu-gleich kunstvoll zu präsentieren und vor Schmutz und Zerstö-
rung zu schützen, wurde im 16. und 17. Jahrhundert eine ganz eigene Möbelgattung ent-
wickelt: der Sammlungsschrank. In der Beschreibung, die der niederländische Tuchhänd-
ler Vincent Levin (1658–1727) 1706 von seinem Kabinett veröffentlichte, ließ er einzelne
Sammlungsbereiche so abbilden, wie er sie in ihren Schränken zusammengestellt hatte
(Abb. S. 7). Die ausgewählte Tafel zeigt die malerische Anordnung von Korallen und
anderen Meerestieren in einem geöffneten Schrank. Leicht vorstellbar ist der Effekt, der
sich beim Besucher des Kabinetts einstellte, wenn Levin die Türen und Schubladen des
Schranks öffnete und seine zuvor geheimnisvoll verborgenen Schätze präsentierte. Eine

Vorstellung von der ästhetischen Wirkung einer kunstvoll arrangierten Kollektion vermittelt auch eine erhaltene Schublade aus einem Muschelkabinett um 1725 (Abb. S. 34). Ebenso eindrucksvoll wirkt ein Sammlungsraum, wie ihn der dänische Naturforscher Ole Worm (1588–1654) der Beschreibung seines Kabinetts als Abbildung voranstellte (Abb. S. 20). Bei Worm sind Gebrauchsgegenstände und Naturalien aus Übersee zu sehen, sogenannte Exotika, Musikinstrumente, ein Kanu, Tierpräparate, Muscheln und vieles mehr.

Wegen der Vielfalt und Verschiedenheit der Gegenstände, die in frühen enzyklopädischen Sammlungen vorhanden waren, galten sie späteren Generationen lange Zeit als konfuse Kuriositätenkabinette. Worms Sammlung, die schon einen deutlichen Schwerpunkt auf Naturalien erkennen lässt, ist bei aller Mannigfaltigkeit jedoch alles andere als ein wahlloses Sammelsurium. Die Gegenstände sind sortiert und übersichtlich platziert, die Regale und Fächer fein säuberlich beschriftet. Von den Schildern ist ablesbar, dass Worm seine Objekte nach verschiedenen Kriterien geordnet hatte, zum Beispiel nach Materialien: So finden sich Hinweise auf Metall und *Ligna* (Holz).

Hilfestellung beim Anlegen und Ordnen einer Sammlung gaben sammlungstheoretische Schriften, deren erste Samuel van Quiccheberg (1529–1567) im Jahre 1565 verfasste. In den *Inscriptiones vel tituli theatri amplissimi* skizzierte der flämische Arzt und Verwalter der herzoglichen Kunstschätze in München die idealtypische Kunstkammer. In einem Gefüge von fünf Abteilungen solle die erste der fürstlichen Genealogie, also der Abstammungsgeschichte, gewidmet sein. Die zweite Abteilung habe dem Kunsthandwerk von der Antike bis zur zeitgenössischen Produktion zu gelten, die dritte Abteilung den Naturalien. Als Viertes sah Quiccheberg technische sowie völkerkundliche Objekte vor und als letzte Abteilung eine Bildergalerie mit Gemälden, Zeichnungen und Stichen. Hinzu kam neben einer Bibliothek und Werkstätten auch eine Apotheke. Gerade an diesen Einrichtungen wird deutlich, dass Kunstkammern über das Sammeln hinaus auch als Lernorte gedacht waren.

In einer Welt, die durch geographische und naturkundliche Entdeckungen immer komplexer wurde, stellte die ideale Kunstkammer den Versuch dar, ein Gesamtbild dieser Welt, des Kosmos, zu erzeugen. Auf engen Raum begrenzt, zeigte die Kunstkammer einen Mikrokosmos, der das große Ganze, den Makrokosmos, im Kleinen abbildete. Dabei fanden gerade die Randbereiche des Bekannten ihren Platz in den frühen Kunst- und Wunderkammern. Hierzu gehörten medizinische „Merkwürdigkeiten" wie sogenannte Missgeburten, Kunsthandwerk und Naturalien aus fernen Ländern sowie viele andere Raritäten, die in Europa Erstaunen erregten und Fragen aufwarfen. Möglichst vollständig sollte hier alles Wissbare und Wissenswerte – zumindest exemplarisch – zusammengeführt, erfasst und damit auch begreifbar werden. Die Anordnung der unterschiedlichen Gegenstände in einem Raum – zum Teil offen auf den Tischen – bot dem Betrachter die Möglichkeit, visuelle Bezüge zwischen den einzelnen Objekten herzustellen und Zusammenhänge zu verstehen. Einer Naturalie, beispielsweise der Koralle, die gleichermaßen in den Samm-

lungen Levins, Dimpfels und Sebas vorkam (Abb. S. 2, 7 & 11), wuchsen hierbei ganz unterschiedliche Bedeutungen zu. Zunächst galt sie als Heilmittel gegen Krankheiten wie Blutarmut, darüber hinaus wurde ihr auch magische Schutzkraft zugeschrieben, zum Beispiel gegen Blitzschlag oder den bösen Blick. Mit ihrer leuchtenden Farbigkeit war sie ein ästhetisches Schmuckstück, das von Feinschmieden aufwendig in Gold gefasst wurde.

Wissenschaftliche Fragen warf die Koralle auf, weil sie nicht eindeutig dem Tier- oder Pflanzenreich zuzuweisen war und außerhalb des Wassers sogar zu Stein erstarrte, also auch dem dritten Naturreich angehören konnte. Ein Objekt wie die Koralle wies somit Bezüge zu mehreren Bereichen auf. Die aus heutiger Sicht sehr heterogene Ordnung der Kunstkammern beruhte auf diesem Bedeutungsgeflecht, das sich aus religiösen und alchemistischen Sinnzusammenhängen sowie der Zuordnung der Gegenstände zu Materialgruppen mit bestimmten Eigenschaften ergab.

Die kosmologische Sicht auf die Welt, die den enzyklopädischen Anspruch der frühen Sammlungen begründete, verlor nach 1600 zunehmend an Bedeutung. An die Stelle der Kunstkammern traten im 17. und 18. Jahrhundert spezialisiertere Sammlungen. Weniger die beispielhafte Widerspiegelung des gesamten Kosmos als die vollständige Erschließung eines Teilbereichs stand nunmehr im Mittelpunkt. Naturaliensammlungen wurden zum Instrument der empirischen Naturforschung. Durch Beschreiben, Vergleichen und Ordnen ihrer Stücke strebten die Sammler ein wissenschaftliches Erfassen der Natur an. Das Idealbild eines solchen „Forschungslabors", in dem der Sammler mit seinen Objekten arbeitet, zeigt eine Darstellung von 1727 (Abb. S. 15). Caspar Friedrich Neickel stellte sie seiner 1727 von dem Breslauer Arzt Johann Kanold (1679–1729) herausgegebenen *Museographia* voran. Auch Sebas Sammlung fand in diesem Handbuch zum frühen Museumswesen, bestehend aus einer Anleitung zum Sammeln und Beschreibungen existierender Kollektionen, Erwähnung.

Motive zum Sammeln gab es genug: sei es aus intellektuellem Antrieb und aus Forschergeist oder um Reichtum und Gelehrsamkeit zur Schau zu stellen. Natürlich erhöhte eine Sammlung das soziale Prestige des Besitzers. Große oder mit seltenen Stücken ausgestattete Kollektionen zogen auswärtige Besucher bis hin zu gekrönten Häuptern an. Auch gibt es Beispiele dafür, dass komplette Sammlungen mit finanziellem Gewinn weiterverkauft wurden.

Sammeln war selbstverständlich Modeströmungen unterworfen. Beliebt waren etwa Muscheln, die seit der Renaissance vermehrt gesammelt und wissenschaftlich bearbeitet wurden. Georg E. Rumphius (1627–1702) konnte als Angestellter der VOC auf der Insel Amboina (heute Ambon, Indonesien) eine vorzügliche Sammlung anlegen, die 1705 in dem einflussreichen und auch von Seba rezipierten Band *D'Amboinsche Rariteitkamer* publiziert wurde (Abb. S. 26). In den Niederlanden selbst kam es um 1700 zu einer regelrechten *Conchyliomanie*, also einer besonderen Leidenschaft für Muscheln. Diese ästhetisch reizvollen Naturalien erzielten im Handel hohe, fast absurde Preise. Es entstanden so unzählige kleine Muschelsammlungen und einige größere – Sebas gehörte zu den umfassendsten.

Leonhart Fuchs: *Historia Stirpium*, 1542
Ulm, Stadtbibliothek

## DIE SAMMLUNG VON ALBERTUS SEBA

Bei der Anlage seiner Sammlung folgte Seba also auch einer Zeitströmung. Vor allem aber war er als Apotheker per se Naturaliensammler und -forscher. Zeitzeugnisse weisen ihn als sehr versierten Vertreter dieser Spezies aus. Bereits erwähnt wurde sein Vorgehen, von langen Reisen zurückkehrenden Seeleuten noch auf dem Schiff ihre Mitbringsel abzukaufen. Vielleicht beauftragte er den einen oder anderen Seemann auch, von der nächsten Fahrt Naturalien mitzubringen, die erst selten nach Europa gelangt und hier kaum bekannt waren. Aus Sebas Kommentar im *Thesaurus* geht an mehreren Stellen hervor, dass er in Kontakt mit Korrespondenten unter anderem in Sri Lanka, Grönland, Virginia und Batavia (heute Jakarta, Indonesien) stand, von denen er Naturalien erhielt. Mit anderen Sammlern tauschte er doppelte Exemplare, allerdings verkaufte er als guter Geschäftsmann die Dubletten seiner Kollektion auch gewinnbringend.

Seba gelang es, eine bedeutende Sammlung aufzubauen, deren Ruf über die Grenzen Amsterdams hinausging. Die ganze Größe seines Naturalienreichtums ist auch deshalb überliefert, weil Seba 1717 ein besonderer Coup gelang. Er hatte von dem anstehenden

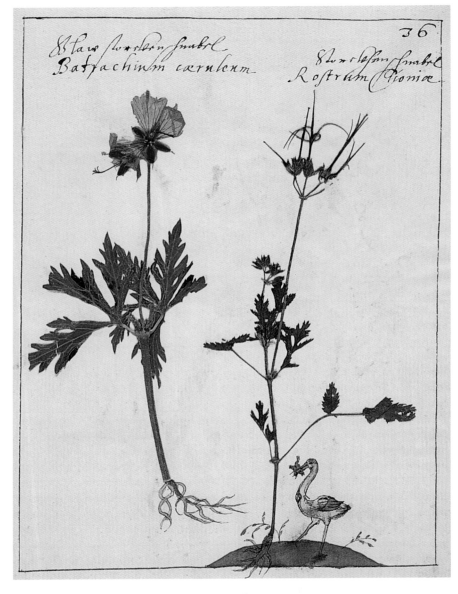

Blaw storchenschnabl
Batrachium cœruleum

Blawr leßen schnabl
Rostrum Ciconiae

36

Boëtius, Herbarium
Braunschweig, Technische Universität Carolo-Wilhelmina zu Braunschweig,
Universitätsbibliothek

Besuch des russischen Zaren Peter des Großen erfahren, der die Niederlande bereisen wollte – auch um Ankäufe für sein eigenes Kabinett zu tätigen. Der geschickte Seba sandte ihm vorab eine schriftliche Aufstellung seiner Sammlung und bereitete so deren Verkauf vor. Dieser wurde nach dem Besuch Peters in seinem Haus tatsächlich vollzogen. Aus der Bestandsaufnahme, die ein Petersburger Verwalter beim Eintreffen der neu erworbenen Stücke anfertigte, geht der Umfang von Sebas erster Sammlung hervor. Sie bestand unter anderem aus Schränken mit nicht weniger als 72 Schubladen voller Muscheln, 32 Schubladen mit 1 000 europäischen Insekten sowie 400 Flaschen mit in Alkohol konservierten Tierpräparaten.

Unmittelbar nach dem Verkauf seiner ersten Sammlung begann Seba mit dem Aufbau einer zweiten, die tatsächlich noch umfangreicher wurde. Wie der *Thesaurus* zeigt, machten Meerestiere, Insekten und Reptilien ihre besonderen Schwerpunkte aus. Mit diesem Vorgehen befand sich Seba in guter Gesellschaft. Generell tendierten, wie erwähnt, viele Naturforscher um 1700 dazu, ihre Sammlungstätigkeit auf einige Aspekte des Naturreichs zu konzentrieren. Anstatt eine möglichst große Bandbreite unterschiedlicher Raritäten anzuhäufen, strebten sie an, in ausgewählten Bereichen einen Überblick zu gewinnen. Weniger das wertvolle Einzelstück als die potenzielle Vollständigkeit eines Teilbereichs – auch unter Einbeziehung der heimischen Flora und Fauna – machte eine Sammlung wissenschaftlich wertvoll.

Beim Durchblättern des *Thesaurus* fällt eine gewisse Ambivalenz auf. Dem Amsterdamer Apotheker gelang es zwar, wissenschaftlich höchst bedeutende Kollektionen im Bereich der Reptilien, Insekten und Meerestiere zusammenzutragen und einen Beitrag zu Bestandsaufnahme der Natur zu leisten, aber dennoch weist seine Sammlung noch eine deutliche Verbindung zu den älteren Kunst- und Wunderkammern auf. Bei ihm hat das Kuriose, Seltene und Seltsame weiterhin seinen Platz. Weniger als Beitrag zum wissenschaftlichen Erkenntnisgewinn denn als Ausdruck einer alles umfassenden Neugierde muss beispielsweise die isoliert dastehende Abbildung eines in Alkohol konservierten tot geborenen Babys aus Curaçao gewertet werden. Auch findet sich im *Thesaurus* die Darstellung einer missgebildeten Ziege mit einem Kopf und zwei Körpern (I, 46). Nicht der typische Vertreter dieser Tiergattung fand somit Eingang in Sebas Buch, sondern die deformierte Ausnahme, die sehr viel mehr Aufsehen erregen konnte. Im Unterschied zu den früheren Kunstkammern spielten antike Münzen, exotische Waffen oder Ähnliches in Sebas Naturaliensammlung jedoch keine Rolle mehr. Bei dem hauptberuflichen Apotheker stand die unbearbeitete Natur im Zentrum des Interesses, lediglich die Schale des Nautilus ist kunstvoll von Menschenhand verziert (III, 84).

Ein Generalthema naturkundlicher Sammlungen stellten Probleme bei der Aufbewahrung und Konservierung dar. Unterlagen Objekte wie die harten, kalkhaltigen Schalen von Muscheln keinem größeren Verfallsprozess, bedurften andere Naturalien aufwendiger Konservierungsmaßnahmen. Hierfür wurden Verfahren anderer Disziplinen, wie zum Beispiel der Medizin, übernommen und weiterentwickelt. Frederik Ruysch (1638–1731),

Amsterdamer Apothekerkollege, Mediziner, Naturforscher und Freund Sebas, entwickelte Ende des 17. Jahrhunderts ältere Techniken zum Präparieren menschlicher Leichen fort. Sein Rezept, wie er mit gefärbtem Wachs und Ölen die Leichen konservierte und ihnen ein lebendiges Aussehen verlieh, hielt er zwar geheim, doch ist es möglich, dass Seba zumindest einen Einblick in die Materie erhielt. Seba wendete zum Beispiel ein Verfahren an, mit dem er das Skelett von Blättern isolieren konnte. Somit entzog er die Blätter einem raschen Fäulnisprozess und machte zudem ihre innere Struktur sichtbar. 1730 veröffentlichte er einen Artikel über diese Technik. Beispiele präparierter Exemplare sind auf den ersten Seiten des *Thesaurus* zu sehen.

Die große Sammlung konservierter Naturalien, die Seba in einem separaten Raum seines Hauses präsentierte, hatte einen weitreichenden Ruf. Naturforscher aus vielen Ländern kamen, um sie zu besuchen. Nach dem Tod Sebas im Jahre 1736 fiel sie an seine Erben. Um die weitere Publikation des noch nicht fertiggestellten *Thesaurus* zu gewährleisten, sahen diese sich gezwungen, die Sammlung zu verkaufen. 1752 nahm die Versteigerung des Kabinetts ihren Lauf. Dank eines gedruckten Auktionskatalogs mit handschriftlichen Anmerkungen sind die zum Teil stattlichen Preisen bekannt, die für manche Stücke gezahlt wurden. Einige haben die Wirren der Zeit überstanden und befinden sich heute in den naturkundlichen Museen Europas, zum Beispiel im Zoologischen Institut in St. Petersburg, im Naturhistorischen Museum in Stockholm, im Zoologischen Museum in Amsterdam und im British Museum in London.

## VON DER SAMMLUNG ZUM BUCH

Naturhistorische Sammlungen und naturkundliche Bücher sind durch ein unauflösliches Band miteinander verknüpft. Zwar betonten Naturforscher seit der Spätrenaissance zunehmend den Vorrang unmittelbarer, empirischer Naturstudien vor dem Bücherwissen, doch bedeutete dies keineswegs den kompletten Verzicht auf die Lektüre. Wie schon bei der Kunstkammer waren Bücher sowohl Bestandteil als auch Kommentar jeder naturkundlichen Kollektion. Sie ermöglichten die geistige Durchdringung des Materials, dessen Bestimmung und Ordnung. Zudem stellten Bücher und die darin enthaltenen Abbildungen auch eine Ergänzung der Realiensammlung dar, deren Lücken und Fehlstellen sie per Bild schlossen. Wie Sebas *Thesaurus* zeigt, wurde manch eine Sammlung auch selbst zum Buch.

Bestimmungs-, Überblicks- und Sammlungswerke zeigen den engen Zusammenhang von Buch und Kollektion. Tatsächlich konnten Bücher aber auch selbst Sammlungen von Naturalien sein, wie Herbarien, die sich seit dem 16. Jahrhundert zunehmender Beliebtheit erfreuten. Herbarien sind Bücher mit unbedruckten Seiten aus sehr saugfähigem, weichem Papier, auf das gepresste und getrocknete Pflanzen geklebt wurden. Ein heute noch erhaltenes Exemplar stammt von Boëtius, Hofarzt Kaiser Rudolfs II. in Prag (Abb. S. 38). Die beiden getrockneten Pflanzen gehören zur Familie der Storchschnabelgewächse, wie die handschriftliche Bezeichnung am oberen Blattrand angibt. Eine kleine Zeichnung unten bildet den

Namensgeber der Pflanzen ab. Nach 1700 galt das Anlegen von Herbarien mit selbst gesammelten Pflanzen nicht mehr nur als Angelegenheit von Spezialisten, sondern als sinnvolle Freizeitbeschäftigung, gar als wichtiger Bestandteil der Erziehung. Man ging „botanisieren", erschloss sich somit seine natürliche Umgebung. Jeder konnte an der Naturforschung teilhaben, den Stand des Wissens nachvollziehen oder sogar einen eigenen Beitrag leisten.

Das Anlegen umfangreicher naturhistorischer Sammlungen erforderte jedoch beträchtlichen finanziellen Einsatz. Da zudem viele Objekte nicht ohne Weiteres zu bekommen oder nur schwer zu konservieren waren, konnte an die Stelle einer Naturaliensammlung – oder zu deren Ergänzung – auch eine Kollektion von Zeichnungen treten. Dieses Anschauungsmaterial wurde, ähnlich den Pflanzen in einem Herbarium, in der jeweils gewünschten Ordnung auf die leeren Seiten großer Folianten geklebt. Hierbei entstanden regelrechte „Papiermuseen", wie das *Museo Cartaceo* des italienischen Antiken- und Naturforschers Cassiano dal Pozzo (1589–1627), das über 7 000 Zeichnungen umfasste.

Wenn ein solcher Sammler oder Naturforscher Künstler beauftragte, die ihn interessierenden Stücke zu zeichnen und in einem zweiten Schritt gar auf eine Druckplatte zu übertragen, durchlief die einzelne Pflanze, das einzelne Tier auf dem Weg zum wissenschaftlichen Bild einen erheblichen Abstraktions- und Klärungsprozess (Abb. S. 37). Die jeweilige Naturalie wurde als Stellvertreterin ihrer Art betrachtet, ihr Erscheinungsbild wurde systematisiert. Individuelle, für die Art nicht typische Eigenheiten wurden reduziert, die wissenschaftlich bedeutsamen Merkmale dagegen herausgearbeitet. Führt man sich ein Glas mit einer in Alkohol konservierten Schlange, wie sie auf dem Porträt Sebas zu sehen ist (Abb. S. 2), vor Augen und

**I, Tabula 32, Fig. 8**
Cheetah · Gepard · Guépard

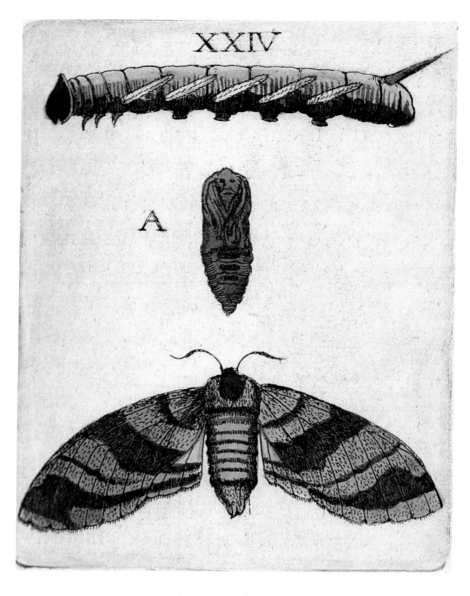

Jan Goedaert: *Metamorphosis Naturalis*, 1662
Plate · Tafel · Planche XXIV
Göttingen, Niedersächsische Staats- und Universitätsbibliothek

betrachtet dann eine der zahlreichen Schlangendarstellungen im *Thesaurus*, wird dieser Prozess nachvollziehbar. Aus einem in sich verschlungenen, zusammengepressten, oftmals verblichenen sowie teilweise zersetzten Tier, das in einer trüben Flüssigkeit schwimmt, wird eine sehr klare und differenzierte Darstellung. Das für die menschliche Wahrnehmung des Tieres Wichtige ist im Bild besser und eindeutiger sichtbar als im Präparat – diese bildliche Abstraktion lässt sich auch als ein Weg verstehen, die vielgestaltige Natur zu bändigen.

Seit dem 16. Jahrhundert finden sich in naturkundlichen Büchern detaillierte und realistische Darstellungen, die ein Identifizieren der jeweiligen Naturalien ermöglichen. Den Anfang machten große botanische Werke, denn das Bestimmen von Pflanzen spielte für die Pharmazie eine entscheidende Rolle. In sein epochales Werk *Historia Stirpium* ließ der Pflanzenkundler Leonhart Fuchs (1501–1566) nicht weniger als 511 Holzschnitte einfügen. Der bedeutende Beitrag, den die Künstler zu diesem Werk leisteten, fand hier auch einen bildlichen Niederschlag: Zu sehen sind sie beim Zeichnen und Übertragen der Zeichnung auf den hölzernen Druckstock (Abb. S. 37).

Dem Vorbild der Botanik folgten rasch auch die Medizin mit anatomischen Tafelwerken und die Zoologie mit reich bebilderten Tierbüchern. Im 17. Jahrhundert entstanden dann immer spezialisiertere Bücher, wie das dreibändige Insektenbuch *Metamorphosis Naturalis* von Jan Goedaert (?–um 1668), das in den 1660er-Jahren in mehreren Sprachen auf den Markt kam. Als Erster führte der niederländische Maler und Naturforscher systematisch die Entwicklungsstadien dieser Tiere im Bild vor; so sind auf einem Blatt Raupe, Larve und Falter zu sehen (Abb. links). Das 1676 in erster Auflage erschienene Vogelbuch *Ornithologiae libri tres* des Engländers Francis Willughby (1635–1672) zeigt auf 78 Tafeln Darstellungen heimischer und „exotischer" Tiere, die gezielt nach Gattungen, wie Greif- oder Wasservögel, geordnet sind (Abb. S. 29). Gelehrte wie Willughby kannten die aus fernen Ländern stammenden Tiere oder Pflanzen zumeist nicht aus eigener Anschauung. Vielmehr konsultierten sie illustrierte Reiseberichte, in denen sie die unbekannte Fauna und Flora der Überseeregionen beschrieben und abgebildet fanden. Um möglichst genaue Informationen zu erhalten, versahen die Gelehrten Schiffskapitäne oder andere Reisende mit umfangreichen Fragebögen, mit deren Hilfe diese das Gesehene festhalten sollten. Im fortgeschrittenen 17. Jahrhundert fuhren Naturforscher vermehrt selbst in ferne Länder. Sie dokumentierten das Gesehene bildlich oder ließen sich von bildenden Künstlern begleiten, die diese Aufgabe übernahmen. Die vor Ort angefertigten Zeichnungen und Beschreibungen verarbeiteten sie nach ihrer Rückkehr zu gedruckten Reiseberichten, die gleichzeitig regelrechte Naturgeschichten der bereisten Region waren. Hans Sloane, Naturforscher und Briefpartner Sebas, publizierte seinen Reisebericht 1707 und 1725 als *Natural History of Jamaica*. Die beiden Bände, deren Tafeln eine Vielzahl von Reptilien und Insekten zeigen, hat Seba mit großer Wahrscheinlichkeit gekannt.

Eine außergewöhnliche Leistung vollbrachte die aus Frankfurt am Main stammende Künstlerin Maria Sibylla Merian (1647–1717), die von 1699 bis 1701 auf eigene Kosten und

aus eigenem Antrieb nach Surinam reiste. Sie studierte vor allem die Insekten, aber auch Tiere und Pflanzen des südamerikanischen Landes und zeichnete sie. Nach ihrer Rückkehr publizierte Merian 1705 den Band *Metamorphosis Insectorum Surinamensium*, bestehend aus 60 großen Bildtafeln und ausführlichen Beschreibungen (Abb. S. 53). Die kunstvoll-stilllebenhaften Arrangements ihrer Darstellungen bestechen durch ihre Schönheit und beeinflussten die Gestaltung des ersten *Thesaurus*-Bandes.

Beim Vergleich naturkundlicher Werke aus dieser Zeit zeigt sich, dass ihre Darstellungen sehr unterschiedlich gestaltet sind. Dies erklärt sich aus den verschiedenen Zielsetzungen der Bücher. Viele Werke folgten der Tradition älterer botanischer Werke, deren Illustrationen das zweifelsfreie Identifizieren der in der Heilkunde verwendeten Pflanzen gewährleisten mussten. Die Abbildungen zeigen die Naturalien vor neutralem Hintergrund so, dass sie sich nicht überschneiden und ihre Merkmale möglichst deutlich sichtbar werden (Abb. S. 29 & 38). Einen anderen Schwerpunkt setzte zum Beispiel der Amsterdamer Mediziner Gerard Blasius in seinem Buch *Anatome Animalium* von 1681. Er versuchte ein tieferes Verständnis der Natur zu erlangen, indem er die Organe und den Knochenbau der Tiere untersuchte. Die Bildtafeln sind jeweils einem Tier gewidmet. Sie zeigen das Skelett sowie die Ergebnisse einer anatomischen Untersuchung, aber auch das unversehrte Tier in einer Landschaft (Abb. S. 50). Maria Sibylla Merian legte besonderen Wert darauf, dem Betrachter eine bildliche Vorstellung einer ganzen Lebenswelt in ihrem Zusammenwirken von Tieren und Pflanzen zu vermitteln. Durch geschickte Inszenierung gelang es ihr, die einzelnen Elemente dabei klar, identifizierbar und dennoch höchst ästhetisch abzubilden (Abb. S. 53). Der Schweizer Naturforscher Johann Jakob Scheuchzer (1672–1733) verfolgte mit seiner *Kupfer-Bibel*, auch *Physica Sacra* genannt, ein anderes Ziel (Abb. S. 66). Die in der Bibel erwähnten Tiere, Pflanzen und Naturphänomene kommentierte er vor dem Hintergrund neuester Naturforschungen. Mit seinem 1731 bis 1735 veröffentlichten Werk wollte Scheuchzer zum Verständnis der Bibel beitragen und ihre auch naturkundliche Zuverlässigkeit nachweisen. Er verband deshalb die Bilderzählungen zum Bibelgeschehen mit naturkundlichen Illustrationen. So begleiten die Szene, in der Eva sich von der Schlange zum Genuss des verbotenen Apfels verführen lässt und auch Adam die Frucht genießt, Abbildungen verschiedener Schlangenarten. Zeigen hier die naturkundlichen Darstellungen deutlich eine weltanschauliche Einbindung, suchte Carl von Linné (1707–1778) die Abbildungen seiner *Systema Naturae* von allem überflüssigen Ballast zu befreien (Abb. S. 62). Linné entwickelte in seinem 1735 in erster Auflage erschienenen Buch das noch heute gültige System zur Klassifikation von Tieren und Pflanzen. Als ausschlaggebendes Kriterium zur Unterscheidung der Gattungen und Arten wählte er die Fortpflanzungsorgane der Lebewesen. Dementsprechend sind die Illustrationen seines Buches auf schlichte Umrisszeichnungen der relevanten Pflanzenteile reduziert. Leicht ist im Vergleich zu erkennen, dass sich Sebas *Thesaurus* deutlich von diesem Beispiel zeitgenössischer Wissenschaftsavantgarde unterscheidet.

## DER THESAURUS
## VON ALBERTUS SEBA

Am 30. Oktober 1731 schlossen in Amsterdam drei Parteien einen Vertrag: Vertreter zweier Verlage und Seba vereinbarten darin, das Kabinett des Sammlers in einem großen Werk mit etwa 400 Tafeln zu publizieren. Tatsächlich umfasst der *Thesaurus* stolze 446 Tafeln, davon 175 als Doppelseite. Die vier Bände erschienen in einem Zeitraum von 30 Jahren, denn nach der Herausgabe der ersten beiden Bände in den Jahren 1734

und 1735 verzögerte Sebas Tod 1736 das Erscheinen der letzten beiden Bände bis 1758 bzw. 1765. Die begleitenden Erläuterungen zu den Tafeln wurden jeweils in einer lateinisch-französischen und einer lateinisch-niederländischen Fassung veröffentlicht, da sich Seba mit dem *Thesaurus* an ein internationales Publikum von Naturforschern, Sammlern und Buchliebhabern wandte. Den Text der ersten beiden Bände verfasste Seba weitgehend selbst, doch ließ er sich von anderen Naturforschern unterstützen. Beispielsweise half ihm Frederik Ruysch beim Bestimmen der Schlangen. Mit der Aufgabe, einen Kommentar zu den Fischen in Band III zu schreiben, betraute Seba den Schweden Peter Artedi (1705–1735), einen Kenner der Materie. Und als Albertus Seba starb, lagen seine Notizen zum vierten Band bereits vor, allerdings mussten sie ein wenig überarbeitet und aktualisiert wurden.

Am Anfang des ersten *Thesaurus*-Bandes stehen zunächst einige Seiten mit Abbildungen von Pflanzenskeletten, die Seba

**I, Tabula 39, Fig. 1**
Southern common opossum · Beutelratte · Opossum commun

mit seiner speziellen Präparationstechnik bearbeitet und konserviert hatte. Dann folgen Darstellungen von Tieren und Pflanzen aus dem südamerikanischen und asiatischen Raum. Neben Eidechsen, Vögeln, Fröschen, Spinnen und anderen Tieren finden sich auch einige Fabelwesen wie Drachen. Band II gilt vorrangig den Schlangen, zu dekorativen Zwecken und zur Veranschaulichung der Lebensweise der Reptilien sind allerdings auch einige Pflanzen und andere Tiere auf den Tafeln zu sehen. Dem maritimen Lebensraum ist der dritte Band gewidmet: Es erwartet den Betrachter eine überwältigende Vielzahl von Meerestieren wie Muscheln, Seesterne, Tintenfische, Seeigel und Fische. Der abschließende Band präsentiert auf knapp 100 Tafeln eine umfangreiche Sammlung von Insekten, gefolgt von einigen Seiten mit Darstellungen der Mineralien und Fossilien aus Sebas Kabinett.

Den naturkundlichen Tafeln stellte Seba neben seinem Porträt (Abb. S. 2) ein für die barocke Buchkultur typisches allegorisches Frontispiz voran (Abb. S. 70). In diesem Bild, das die Zielsetzung des Buches programmatisch zusammenfasst, verkörpern Personifikationen verschiedene abstrakte Begriffe, die sich zu einer komplexen Aussage verbinden. Der niederländische Maler und Zeichner Louis Fabritius Dubourg (1693–1775) entwarf eine Zeichnung, nach der Pieter Tanjé (1706–1761), ein Amsterdamer Kupferstecher, die Darstellung für den Druck auf eine Kupferplatte übertrug. Zum Entschlüsseln der Darstellung geben die lateinischen Verse am unteren Bildrand wichtige Hinweise. Die zentrale, sitzende Frauengestalt ist demnach als *Industria*, Personifikation des Fleißes und der Betriebsamkeit, anzusehen, die von der Liebe zu den Wissenschaften motiviert wird. Ihre emsige Tätigkeit, auf die der Bienenkorb neben ihr verweist, übt sie im Schutz der erleuchteten Personifikation der Wahrheit, *Veritas*, aus. Die Zeit, als *Chronos* mit ruhender Sense verbildlicht, gibt ihr die Möglichkeit, ihre Arbeit, nämlich das Sammeln, voranzutreiben. Von der Personifikation des Handels, einem geflügelten Boten, nimmt *Industria* Naturalien aus den verschiedenen Erdteilen entgegen. Diese stehen sinnbildlich hinter dem Handel. Den Anfang macht ein Indianer als Personifikation Amerikas, es folgen ein Schwarzer für Afrika und ein Orientale

**I, Tabula 57, Fig. 1**
Flying fox · Flughund · Roussette géante

für Asien. Europa ist nicht vertreten. Dies verdeutlicht, dass Naturalien aus Übersee – herbeigebracht von großen Segelschiffen, die im Hintergrund zu sehen sind – im Zentrum des Interesses standen. Den Europäern noch unbekannt war zu diesem Zeitpunkt Australien, das deshalb auch nicht mit einer Personifikation vertreten ist. Zu Füßen *Industrias* tummeln sich mehrere Putti, die eingehend mit den zusammengetragenen Naturalien beschäftigt sind, sie untersuchen und diskutieren. Auch bildliche Darstellungen und Bücher gehören, wie zu sehen ist, zu diesem Studium der Natur. Die Leistung der *Industria*, mit großer Beharrlichkeit eine Naturaliensammlung anzulegen und somit zur Kenntnis der Natur beizutragen, würdigen zwei vom Himmel herabschwebende Genien. Der vordere bringt einen Reif, der aus einer sich in den Schwanz beißenden Schlange gebildet ist. Dieses Ewigkeitssymbol, verbunden mit dem Lorbeerkranz in den Händen des zweiten Genius, steht für den Nachruhm, der die Zeit überdauert. So überragt die Personifikation des Sammelfleißes den untätigen Sensenmann *Chronos* und erhält die Zeichen bleibender Ehrung überreicht. Natürlich verdeutlicht dieses Frontispiz auch das Selbstverständnis Sebas, der hier seine Tätigkeit als unermüdlicher Sammler und Initiator einer umfangreichen Sammlungsbeschreibung bildlich überhöhen lässt.

Das Unterfangen, ein Werk wie den *Thesaurus* herauszugeben, erforderte beträchtlichen Einsatz von Geldmitteln. Vor allem die vielen Bildtafeln, deren Anfertigung mit hohem Zeitaufwand verbunden war, verursachten immense Kosten. Allein 13 Künstler, die Tafeln, Frontispiz und Porträt auf Druckplatten übertrugen, sind namentlich bekannt. Neben den bereits genannten Houbraken und Tanjé waren es Amsterdamer Kupferstecher wie Frans de Bakker (tätig 1736–1765), Adolf van der Laan (tätig 1717–1740) und Jan Punt (1711–1779). Zunächst musste Seba allerdings einen Verleger finden, der das finanzielle Risiko für ein so aufwendiges Werk übernahm. In den Niederlanden war es üblich, dass sich bei sehr kostenintensiven Buchprojekten mehrere Verlage zu einer Kompanie zusammenschlossen. Aus dem Vertrag der beiden für den *Thesaurus* zusammengekommenen Verlage mit Seba geht hervor, dass dieser dennoch ein Drittel der Geldmittel selbst aufbringen musste. Zur Vorfinanzierung der Produktionskosten fand eine Subskription statt: Zukünftige Abnehmer schrieben sich in Listen ein, entrichteten zumindest einen Teilbetrag vorweg und erhielten dafür einen Preisnachlass von 30 Prozent.

Das teure Werk erschien zunächst in schwarz-weißer Ausführung, also ohne die farbenprächtige Kolorierung des dem vorliegenden Reprint zugrunde liegenden Exemplars. Es ist nicht bekannt, ob auch die Verlage selbst eine kolorierte Ausgabe anboten, die den Preis und die Gewinnspanne natürlich erheblich gesteigert hätte. Vermutlich ließen die Käufer das Werk auf eigene Rechnung farblich fassen und wandten sich dazu an spezialisierte Koloristen. Ein solcher Fachmann war J. Fortuÿn, dessen Lebensdaten nicht bekannt sind. Er signierte seine Arbeiten, sodass mehrere kolorierte Exemplare des *Thesaurus* auf ihn zurückgeführt werden können. Dazu zählen die hier abgedruckten Bände aus der Königlichen Bibliothek Den Haag. Da Fortuÿn seine Signatur mit dem Zusatz „Hague" versah, wird er in dieser Stadt auch gelebt und gearbeitet haben. Aus einer im Haager

Archiv erhaltenen und 1767 datierten Rechnung Fortuÿns geht hervor, dass er das Kolorieren erst nach Fertigstellung aller Bände durchführte.

Die Farbenpracht der Tafeln ist ein besonderer Genuss, doch erhöhte die Kolorierung nicht nur den ästhetischen Reiz, sondern auch den wissenschaftlichen Nutzen. Beispielsweise lassen sich manche Exemplare von Schmetterlingen, Schlangen oder Muscheln nur mit Hilfe der Farbe unterscheiden, während in Schwarz-Weiß die Unterschiede in der Musterung mancher Tiere kaum auszumachen sind. Wesentlich für die Aussagekraft der farbigen Abbildungen waren natürlich die Fähigkeiten des Koloristen und dessen Kenntnis der Materie. Gelegentlich fügte Fortuÿn um der ästhetischen Wirkung willen Farben hinzu, die vom realen Vorbild abwichen. So geschah es bei der Darstellung des Nautilus, auch Perlboot genannt. Das seidenweiß schimmernde Gehäuse dieses Tieres wurde hoch geschätzt und häufig mit gravierten Darstellungen versehen. Die Abbildung eines so verzierten Nautilus im *Thesaurus* kolorierte Fortuÿn vielfarbig, obwohl das Gehäuse im Original sicherlich nicht farbig gefasst, sondern nur schwarz graviert war (III, 84).

In seiner Einleitung gibt Seba an, sämtliche Abbildungen beruhten auf den Naturalien seiner Sammlung. Nicht nur das siebenköpfige Phantasiewesen im ersten Band lässt Zweifel an dieser Aussage aufkommen (I, 102). Es ist überliefert, dass Seba ein von ihm gekauftes Manuskript mit Insektendarstellungen für den vierten Teil nutzte und in den *Thesaurus* auch Zeichnungen mit Tieren aus Südafrika einbrachte, die ihm ein Kollege geliehen hatte. Von dem Leipziger Apotheker Johann Heinrich Linck (1674–1734) erhielt Seba Zeichnungen, die dessen vorzügliche Schlangensammlung zeigten. Die Abbildungen waren für eine gemeinsame Publikation über Reptilien gedacht. Als dieses Unternehmen scheiterte, ließ Seba die Zeichnungen kopieren, bevor er sie nach Leipzig zurücksandte. Wie Linck sich in einem Brief an Scheuchzer beschwerte, verwendete Seba die Darstellungen dann für den *Thesaurus*. Neben solchen Transaktionen wertete Seba naturkundliche Literatur aus, um Lücken seiner Sammlung zu schließen und an Bildmaterial zu gelangen. Der Vergleich einer Tafel aus Blasius (Abb. S. 50) mit einer *Thesaurus*-Tafel (I, 82) sowie einer Tafel aus Merian (Abb. S. 53) mit einer zweiten Tafel aus Sebas Werk (I, 69) verdeutlicht exemplarisch, dass wesentliche Teile der *Thesaurus*-Tafeln des ersten Bandes auf älteren Büchern beruhen. Um der Vollständigkeit willen war ein solches Zitieren vorhandener Abbildungen durchaus üblich. Allerdings bargen solche Übernahmen, insbesondere wenn es sich um von Seeleuten angefertigte oder mitgebrachte Zeichnungen handelte, ein gewisses Risiko, waren manche von ihnen doch von bescheidener Qualität oder fraglicher Authentizität (I, 101).

Mit oder ohne Kolorierung, auf bildlichen Vorlagen aufbauend oder nicht, überzeugt der *Thesaurus* in jedem Fall als ein beeindruckendes Beispiel barocker Buchkunst. Besonders im ersten Band fällt die malerische Gestaltung jeder Tafel auf, in der alle Bildelemente zu einem geschlossenen Gesamtbild zusammengefügt sind. Nach Merians Vorbild sind die Tiere und Pflanzen kunstvoll angeordnet. Häufig sind sie in kleinen Szenen arrangiert, was erheblich zur lebendigen Wirkung beiträgt. Zudem erhöhte dies den Informationswert. Beispiels-

weise ist eine Schlange beim Verzehren ihrer Beute (II, 17), eine andere in drohender Haltung vor einer Echse (II, 30) zu sehen. Die Tafeln des zweiten bis vierten Bandes, die sehr viel weniger auf älteren Buchvorlagen beruhen, entsprechen zunehmend einer zeitüblichen wissenschaftlichen Präsentation. Die Tiere sind – fein säuberlich nach Gattungen getrennt – aufgereiht. In den beiden letzten Bänden, die nach Sebas Tod fertiggestellt wurden, findet in den Darstellungen keine Interaktion zwischen den Tieren statt. Für eine größtmögliche Lesbarkeit der Abbildungen sind die Tiere ohne Überschneidungen und mit einheitlichem Größenmaßstab abgebildet – allerdings seitenverkehrt, was bei Schnecken mit linksdrehendem Gehäuse zu Missverständnissen führte. Erhalten blieb jedoch eine ornamentale Anordnung der Objekte auf den Tafeln, die sich bei symmetrisch ausgerichteten Schlangentafeln (II, 37; II, 67) ebenso zeigt wie bei kunstvoll arrangierten Muscheln (III, 56) oder Insekten (IV, 25; IV, 77). Dass auch bei der Sammlungspräsentation das Auge zu seinem Recht kommen sollte, zeigt eine erhaltene Muschelschublade von 1725 (Abb. S. 34). Die Muscheln bilden ein formenreiches und farbenprächtiges Mosaik, das manchen Muscheltafeln bei Seba vergleichbar ist (vgl. III, 36–37). Vermutlich ließ Seba die Anordnung in seinen Aufbewahrungskästen einfach auf die Tafeln übertragen, wie es vor ihm bereits Vincent Levin getan hatte (Abb. S. 7). Somit enthalten die Illustrationen wie die Sammlung immer zwei Aspekte: Sie dienen gleichzeitig der wissenschaftlichen Belehrung und dem ästhetischen Vergnügen. Die meisten Darstellungen im *Thesaurus* zeigen das äußere Erscheinungsbild von Tieren und Pflanzen. Neben den Blattskeletten finden sich nur wenige anatomische Sektionen unter den Abbildungen. Auch die Anfang des 18. Jahrhunderts sehr populäre Mikroskopie findet keinen nennenswerten Niederschlag in den *Thesaurus*-Tafeln.

**I, Tabula 49, Fig. 5**
Hedgehog · Igel · Hérisson

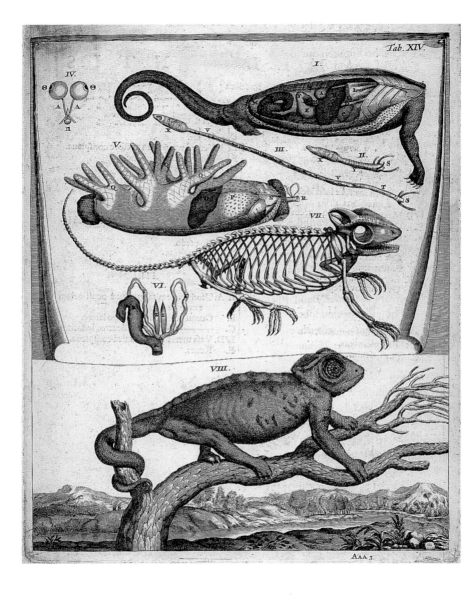

Gerard Blasius: *Anatome Animalium*, 1681
Plate · Tafel · Planche XIV
Göttingen, Niedersächsische Staats- und Universitätsbibliothek

Seba stand als Sammler eher in der Tradition einer beschreibenden Naturkunde, die sich von analytischen Ansätzen unterschied. Über die Erkenntnis und Dokumentation der Artenvielfalt hinaus konnten mit dieser deskriptiven Methode auch Entwicklungsvorgänge in der Natur vorgeführt werden, beispielsweise die Metamorphose der Insekten. Nach dem Vorbild Goedaerts (Abb. S. 42) zeigen die Tafeln des vierten Bandes nebeneinander Raupe, Larve und Schmetterling oder Falter.

Vor allem die Präsentationsform der ersten beiden Bände rief unter den Käufern des Buches kritische Stellungnahmen hervor. Die szenische und auf ästhetische Wirkung angelegte Anordnung der Naturalien genügte wissenschaftlichen Anforderungen ebensowenig wie das Zusammenwürfeln von Tieren und Pflanzen auf einer Tafel; auch die mitunter bizarren Größenverhältnisse wurden bemängelt. Der Vorwurf, die Schlangen, Meerestiere und Insekten seien nicht nach dem neuesten Klassifikationssystem angeordnet, ließ jedoch außer Acht, dass zum Zeitpunkt von Sebas Tod, also 1736, die Tafeln weitgehend fertiggestellt waren und somit Linnés 1735 publizierte Erkenntnisse noch nicht in den allgemeinen Kenntnisstand eingegangen waren. Im Vorwort zum vierten Band des *Thesaurus* wird fast entschuldigend hervorgehoben, dass es nicht Ziel war, ein komplettes Handbuch der Naturgeschichte zu schreiben, sondern lediglich die Beschreibung einer einzelnen Sammlung vorzulegen. Dass hierin ein großes Verdienst lag, betont Herman Boerhaave (1668–1738) in seinem Vorwort zum ersten Band des *Thesaurus*. Er hebt die Fülle und Einzigartigkeit von Sebas Sammlung hervor und lobt den Nutzen des Werkes. In einer Zeit, in der die Kenntnis der Artenvielfalt noch sehr unvollkommen und ausreichendes Bildmaterial Mangelware war, stellte Seba mit dem *Thesaurus* einen ungeheuren Fundus zur Verfügung. Hatte die wissenschaftliche Durchdringung des Gesammelten bei Seba deutliche Grenzen, so diente der *Thesaurus* jedoch als Ausgangspunkt für weitere Forschungen. Beispielsweise nutzte Linné die Abbildungen von Sebas Sammlung, um in späteren Auflagen seine *Systema Naturae* zu verfeinern und zu erweitern. Sebas Werk erhielt noch in der zweiten Hälfte des 18. Jahrhunderts eine Neuauflage, und selbst im 19. Jahrhundert galt das Bildmaterial noch als so beachtlich, dass die Tafeln erneut abgedruckt wurden. Der *Thesaurus* erschloss ein bedeutendes Naturalienkabinett des frühen 18. Jahrhunderts. Die eigentlich stationäre Sammlung wurde als Buch beweglich und für viele Interessenten dauerhaft verfügbar – auch dann noch, als die Sammlung selbst schon Jahrzehnte in alle Winde zerstreut war.

# LA COLLECTION D'HISTOIRE NATURELLE D'ALBERTUS SEBA ET SON INVENTAIRE ILLUSTRÉ

### IRMGARD MÜSCH

Ce fut avec un sentiment de grande fierté que, vers 1725, en la ville d'Amsterdam, Albertus Seba (1665–1736) qualifia d'unique sa collection d'objets d'histoire naturelle qu'il avait mis des décennies à réunir. Dans une lettre adressée à un acheteur potentiel, il en décrivit plus en détail l'envergure. Elle comprenait *toutes sortes de pièces choisies des Indes orientales et occidentales*, dont notamment *700 pièces de verre, décorées des animaux exotiques les plus rares* et *de nombreux serpents d'une extrême rareté*. Dans son énumération, il mentionne en outre *toutes sortes particulières de beaux et rares coquillages*, les *papillons les plus beaux et les plus complets, collectés des quatre parties du monde* ainsi que des exemples *de plantes anciennes, pour certaines connues, pour d'autres inconnues*. A la demande de Seba, des artistes avaient dessiné avec soin les divers objets de sa collection. Puis il publia ce fonds d'illustrations, accompagné d'un commentaire explicatif, dans un ouvrage en quatre volumes intitulé *Loccupletissimi Rerum Thesauri Accurata Descriptio*, que nous appellerons plus brièvement *Thesaurus* dans la suite de ce texte. La publication de cette œuvre somptueuse, de grand format, totalisant un nombre impressionnant de 446 planches sur cuivre, s'étendit de 1734 à 1765, donc bien au-delà de la mort de Seba. Aujourd'hui, l'inventaire illustré de cette collection unique est en cours de réimpression. Pour mieux comprendre la signification d'une telle entreprise de publication, une connaissance de la biographie de Seba et du contexte historique est indispensable.

## APOTHICAIRE-COLLECTIONNEUR À AMSTERDAM

En devenant apothicaire, Albertus Seba, né en 1665 à Etzel, dans la partie orientale de la Frise, avait choisi une profession qui, à son époque, était étroitement liée à l'étude de l'histoire naturelle. Médecins et apothicaires étaient les pionniers des sciences empiriques, qui avaient connu un grand essor depuis la Renaissance. Les médicaments ne s'obtenaient pas par synthèse comme aujourd'hui, mais à partir de composants naturels. Pour tirer leurs remèdes des règnes animal, végétal et minéral, les connaisseurs disposaient de toute une série de recettes transmises par la tradition. Mais beaucoup cherchaient des manières nouvelles d'opérer, et collectionnaient à cet effet des objets de la nature en provenance des quatre coins du monde, dont ils étudiaient et testaient les usages possibles. Bien souvent,

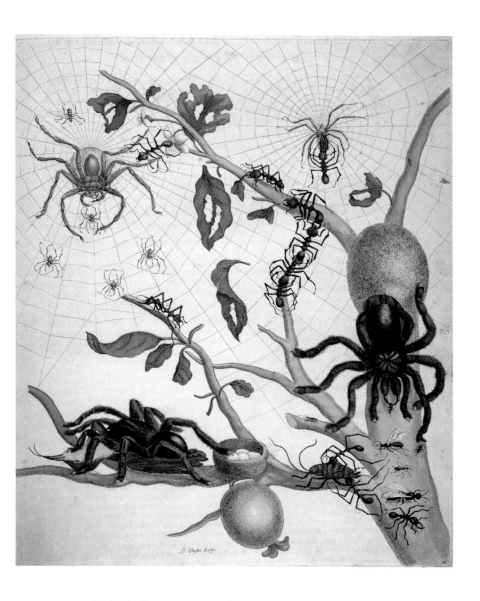

Maria Sibylla Merian: *Metamorphosis Insectorum Surinamensium*, 1705
Plate · Tafel · Planche XVIII
Göttingen, Niedersächsische Staats- und Universitätsbibliothek

cette passion de collectionneur et de chercheur dépassait son utilité pharmaceutique immédiate. Il n'était pas rare de voir des apothicaires constituer d'importantes collections d'histoire naturelle et contribuer ainsi à une connaissance toujours plus grande de la nature.

Le cabinet d'objets naturels de Seba contenait lui aussi bien plus que le strict nécessaire pour l'exercice de sa profession. Son portrait, placé en exergue du *Thesaurus*, le montre au milieu de sa collection (ill. p. 2). Les rayonnages recouvrant le mur derrière lui sont entièrement remplis de récipients en verre, dans lesquels Seba conservait sa collection de serpents naturalisés. L'apothicaire tient d'ailleurs l'un de ces récipients, sans doute rempli d'alcool, dans sa main droite. De la main gauche, il montre des coquillages, des feuilles détachées couvertes de dessins et un livre ouvert, disposés devant lui. Cet arrangement conçu à la façon d'une nature morte décrit le processus de création du *Thesaurus*, depuis les objets de la nature jusqu'à l'ouvrage imprimé en passant par l'étape intermédiaire des dessins. D'ailleurs, les animaux reproduits sur la page de droite du livre ouvert figurent effectivement sur deux planches du *Thesaurus* imprimé (I, 33 et 38). Dans son portrait, réalisé par le graveur sur cuivre Jakob Houbraken (1698–1780) d'après une peinture de Jan Maurits Quinkhard (1688–1772), Seba s'est fait représenter dans la pose et le décor des savants de l'époque. La pièce aménagée en cabinet de travail, la perruque carrée conforme à son rang, le majestueux drapé du rideau et la colonne montrent qu'il était possible, au XVIIIe siècle, de se sentir inclus dans la communauté des savants même sans avoir fait des études universitaires.

En effet, la profession de pharmacien, qui n'était pas à l'époque de Seba une discipline universitaire, s'apprenait par un apprentissage. Il existait évidemment des manuels, mais

**I, Tabula III, Fig. I**
Asiatic elephant (foetus) · Indischer Elefant (Fötus) · Eléphant d'Asie (fœtus)

ceux-ci ne contenaient que des bribes de ce qui, pour l'essentiel, était encore transmis oralement ou à travers la pratique d'un travail individuel quotidien. Les années d'apprentissage et de voyage ainsi que le changement répété du lieu de travail étaient un aspect important de la formation. Seba commença son apprentissage en 1684 à Neustadt-Gödens, non loin de sa ville natale, et le compléta dans les villes de Groningen, Amsterdam, Nuremberg et Strasbourg. Ces différentes étapes lui permirent d'approfondir ses connaissances pharmaceutiques et lui donnèrent l'occasion de découvrir et d'étudier un certain nombre de collections d'histoire naturelle. Son employeur de Nuremberg, par exemple, l'apothicaire Johann Leonhard Stöberlein (1636–1696), disposait d'un vaste cabinet d'art et d'objets naturels. Ces collections, grandes et petites, formaient autant de pièces d'un puzzle encore incomplet – celui de l'immense variété d'espèces naturelles, que les naturalistes s'efforçaient de reconstituer dans les années autour de 1700. Chaque collection, caractérisée par l'intérêt que lui consacrait son auteur et l'habileté de celui-ci, pouvait aider à faire progresser la connaissance de la nature et constituait de ce fait un précieux outil de recherche.

Après ses voyages d'étude et d'apprentissage, Seba retourna à Amsterdam où il se fit naturaliser en 1697. La même année, il obtint son diplôme d'apothicaire pour lequel il lui avait fallu confectionner plusieurs remèdes. Après s'être marié avec Anna Loopes, fille d'un collègue pharmacien, et avoir acheté une maison, Seba ouvrit sa propre officine à Amsterdam.

Son entreprise, qu'il appela « La pharmacie allemande », lui valut rapidement une bonne réputation. Même le tsar Pierre de Russie faisait confiance à ses capacités pharmaceutiques et se procura pendant plusieurs années des remèdes chez lui. Son habileté en affaires valut à Seba l'énorme succès financier grâce auquel il a pu payer son importante collection d'objets naturels. Evidemment, il ne se contentait pas seulement de la clientèle de passage. Il s'était aussi lancé dans le commerce des matières premières pharmaceutiques (drogues) d'outre-mer, dont il faisait la publicité dans une revue d'Amsterdam, en y indiquant les prix. Par ailleurs, il fournissait des pharmacies de voyage aux bateaux en partance et soignait les marins. Certaines sources racontent qu'il se précipitait au port à l'arrivée des bateaux, pour traiter les matelots avec ses remèdes. Il parvenait ainsi à acheter à bon prix à ces hommes épuisés des objets de la nature qu'ils avaient rapportés de leur voyage, ou à les échanger contre des médicaments.

En s'installant à Amsterdam, Seba n'aurait guère pu trouver un lieu plus propice à la constitution d'une collection d'histoire naturelle. Cette ville sur l'Amstel était encore la métropole du commerce d'outre-mer qu'elle était devenue au cours du XVII^e siècle. Historiquement, les Pays-Bas d'aujourd'hui s'étaient détachés par étapes, après 1580, de la souveraineté catholique espagnole, pour se constituer en une république protestante. Le siècle suivant fut pour eux un *Age d'or*, une période extraordinairement florissante pour les arts, les sciences et le négoce. Les réfugiés protestants des régions plus méridionales encore occupées par l'Espagne (Belgique actuelle) enrichirent la vie intellectuelle et économique. Capitaux

et savoir-faire affluèrent vers la ville. Relayant la ville d'Anvers encore sous occupation, Amsterdam devint le port maritime le plus important et développa surtout le commerce avec les colonies. Forte de ses privilèges politiques, la Compagnie hollandaise des Indes importait massivement épices, étoffes, pierres précieuses et autres denrées coloniales qui étaient revendues avec des bénéfices fabuleux dans toute l'Europe.

Les sciences de la nature profitèrent directement de ce commerce florissant. Le jardin botanique d'Amsterdam (Hortus Botanicus), qui existe encore aujourd'hui, fut initialement, en 1638, planté d'herbes médicinales et connut un développement considérable avec les plantes que les membres du Compagnie hollandaise des Indes rapportaient d'outre-mer. Ces plantes rares en Europe firent du jardin botanique un lieu de recherche renommé. Par exemple, le naturaliste suédois Carl von Linné (1707–1778) y mena les études qui le conduisirent à la publication de son ouvrage révolutionnaire *Systema Naturae* (1735), encore considéré aujourd'hui comme la base méthodique de la classification des plantes et des animaux. De nombreux cabinets d'histoire naturelle profitèrent également du commerce d'outre-mer et devinrent d'importantes collections, offrant aux naturalistes nationaux et étrangers un matériel d'observation indispensable.

Les chercheurs néerlandais jouissaient d'une grande considération dans la République des savants, ce réseau international à travers lequel s'échangeaient des informations et se débattaient les questions irrésolues, par-delà les frontières des pays et des appartenances sociales. Seba était lui aussi en lien avec d'importants chercheurs dans toute l'Europe, tels que Sir Hans Sloane (1660–1753), président influent de la Royal Society à Londres, Johann Jakob Scheuchzer (1672–1733), naturaliste et médecin de ville à Zurich, Johann Jacob Baier (1677–1735), président de la Leopoldina, une académie de naturalistes, ou le comte Luigi Ferdinando de Marsigli (1658–1730) à Bologne. Ces personnalités, comme beaucoup d'autres, possédaient également des cabinets d'histoire naturelle. Dans des courriers très détaillés, les savants s'informaient mutuellement du contenu de leurs collections, échangeaient des pièces particulières, discutaient des phénomènes de la nature observés et établissaient des contacts entre eux. Ils formaient des académies et des sociétés qui, parfois aidées par des fonds publics, menaient des recherches et publiaient leurs résultats dans des revues. Grâce à ses travaux et à ses bons contacts, Seba avait été admis à la Royal Society, à l'Académie de Bologne et à la Leopoldina.

Cette République des savants se tenait à l'écart des querelles religieuses. Alors que des guerres sanglantes faisaient rage au XVIIᵉ siècle entre catholiques et protestants, la recherche naturaliste offrait un terrain considéré comme relativement neutre et objectif, sur lequel se développait une nouvelle conception du monde au-delà des disputes théologiques. Les collections d'histoire naturelle pouvaient apporter sur ce point des impulsions non négligeables.

## DU CABINET D'ART
## AU CABINET D'HISTOIRE NATURELLE

Sous l'influence des érudits humanistes, un type particulier de collections vit le jour autour de 1500. Les cours princières italiennes furent les premières à créer ce qu'on appelait alors les cabinets d'art et de merveilles. Les pièces les plus diverses y étaient rassemblées : objets antiques tels que petites sculptures et monnaies, produits de l'artisanat d'art, instruments scientifiques, livres, images, objets de pays lointains et pour la première fois aussi, en plus grandes quantités, des objets d'histoire naturelle. A partir de collections plus anciennes, le grand-duc de Toscane, François I<sup>er</sup> de Médicis, s'était constitué vers 1570 à Florence un cabinet d'art particulièrement riche. Parmi les premiers exemples connus au nord des Alpes, on peut citer les collections du duc Albert V de Bavière à Munich (à partir de 1563) et de l'archiduc du Tyrol Ferdinand, au château Ambras (à partir de 1573). Vers 1600, l'empereur Rodolphe II de Prague se fit installer un cabinet d'art devenu légendaire, qui occupait plusieurs pièces. La deuxième moitié du XVI<sup>e</sup> siècle vit aussi apparaître des collections privées bourgeoises. Certaines furent célèbres, comme celles d'Abraham Ortelius (1527–1598), géographe et cartographe à Anvers, ou de Herman Boerhaave (1668–1738), professeur de médecine à Leyde, qui écrivit d'ailleurs une préface élogieuse pour le *Thesaurus* de Seba.

Une petite gouache du peintre et dessinateur d'Ulm, Joseph Arnold (?–1671), réalisée en 1668(?), montre la disposition d'un cabinet d'art bourgeois du XVII<sup>e</sup> siècle (ill. p. 11). Nous y voyons la salle que le ferronnier Dimpfel consacrait, dans sa ville de Ratisbonne, à sa collection

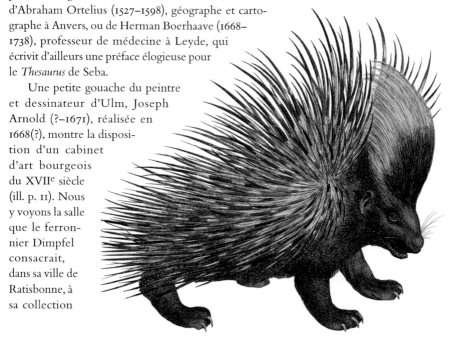

**I, Tabula 50, Fig. I**
Porcupine · Stachelschwein · Porc-épic à crête

composée d'une riche sélection d'objets les plus divers. Par terre, sur les tables, sur les rayons des étagères et dans les petites armoires sont disposés de manière décorative des tableaux, des armes, des globes célestes et terrestres, des horloges, des livres, des coquillages, des petites sculptures et beaucoup d'autres objets. Même si la représentation d'Arnold peut paraître idéalisée par certains aspects, des descriptions écrites montrent que les mises en scène étudiées, visant le plaisir esthétique, étaient tout à fait courantes. Un mobilier spécifique – l'armoire à collection – fut créé aux XVI$^e$ et XVII$^e$ siècles pour présenter une collection avec art, tout en la protégeant de la poussière et de la destruction. Dans la description que le drapier néerlandais Vincent Levin (1658–1727) publia en 1706 de son cabinet, il avait introduit des illustrations qui présentaient certaines parties de sa collection, telles qu'elles étaient disposées dans ses armoires (ill. p. 7). La planche choisie ici montre une présentation pittoresque de coraux et autres animaux marins dans une armoire ouverte. Il n'est pas difficile de se représenter l'effet produit sur le visiteur du cabinet lorsque Levin ouvrait les portes et les tiroirs de son armoire pour présenter ses trésors qui, le reste du temps, étaient tenus mystérieusement cachés. L'effet esthétique d'une collection présentée avec art nous est encore suggéré par un tiroir provenant d'un cabinet de coquillages de 1725 (ill. p. 34). La reproduction de la salle de collection que le naturaliste danois, Ole Worm (1588–1654), a placée en exergue de la description de son cabinet est tout aussi impressionnante (ill. p. 20). On y voit des objets usuels et d'histoire naturelle d'outre-mer – dits exotiques – tels que des instruments de musique, un canoë, des animaux naturalisés, des coquillages et bien d'autres choses. Du fait de la multiplicité et de la diversité des objets réunis dans les premières collections encyclopédiques, celles-ci parurent confuses aux générations

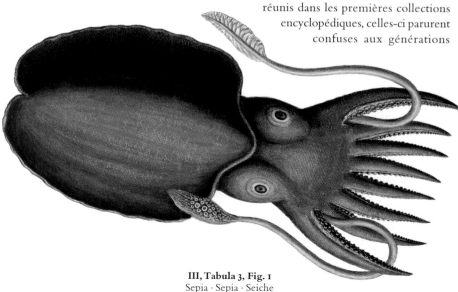

**III, Tabula 3, Fig. 1**
Sepia · Sepia · Seiche

ultérieures, qui n'y virent longtemps que des cabinets de curiosités. La collection de Worm, cependant, où les pièces d'histoire naturelle sont fortement représentées, n'a rien d'un ramassis d'objets disparates. Tout y est trié et disposé avantageusement, des inscriptions claires figurent sur les rayons et les casiers. A leur lecture, on comprend que Worm avait classé ses objets d'après différents critères, par exemple d'après les matériaux. On trouve ainsi des indications relatives au métal et au bois (*ligna*).

Des écrits théoriques, dont le premier a été rédigé par Samuel van Quiccheberg (1529–1567) en 1565, conseillent sur la manière de disposer et d'ordonner les collections. Dans ses *Inscriptiones vel tituli theatri amplissimi*, ce médecin flamand, administrateur de la précieuse collection d'art ducale de Munich, esquisse une description du cabinet d'art idéal. Son ouvrage est divisé en cinq sections. La première est consacrée à la généalogie du prince. La seconde regroupe l'artisanat d'art de l'Antiquité à l'époque contemporaine, la troisième les objets d'histoire naturelle. Dans la quatrième section, Quiccheberg prévoyait des objets techniques et ethnologiques et dans la dernière une galerie de tableaux, de dessins et de gravures. A cela il ajouta une bibliothèque, des ateliers et une pharmacie. Cette conception montre clairement que les cabinets d'art ne correspondaient pas seulement à une passion de collectionner, mais étaient aussi considérés comme des lieux d'apprentissage.

Dans un monde que les découvertes de géographie et d'histoire naturelle rendaient toujours plus complexe, le cabinet d'art idéal était une tentative de donner une vue d'ensemble de ce monde, de ce cosmos. Limité à un espace restreint, le cabinet d'art représentait ainsi un microcosme qui concentrait en lui une image du grand tout, ou macrocosme. Ce qui était en marge du connu y trouvait naturellement sa place. Il s'agissait, par exemple, de « curiosités » médicales comme ce qu'on appelait les monstres, d'objets d'artisanat d'art ou d'histoire naturelle provenant de pays lointains, ainsi que de beaucoup d'autres objets rares qui, en Europe, suscitaient l'étonnement ou soulevaient des questions. L'objectif était de constituer un ensemble aussi représentatif et complet que possible de tout ce qui pouvait faire l'objet d'un savoir, afin de tout enregistrer et rendre compréhensible. La disposition des différents objets dans une même pièce – en partie posés tels quels sur des tables – permettait au visiteur d'établir des liens visuels entre eux et de les comprendre dans leur contexte. Les coraux, par exemple, qui existaient aussi bien dans les collections de Levin, de Dimpfel et de Seba (ill. p. 2, 7 & 11), y faisaient chaque fois l'objet d'une interprétation différente. Considérés en premier lieu comme un remède contre des maladies telle que l'anémie, il leur était également attribué des pouvoirs magiques de protection, par exemple contre la foudre ou le mauvais œil. Leurs teintes lumineuses en faisaient des bijoux de choix, que les joailliers sertissaient dans de l'or.

Mais le corail soulevait aussi des questions scientifiques parce qu'il n'était pas possible de l'attribuer clairement au règne animal ou végétal et qu'il avait même la propriété de se pétrifier hors de l'eau, de sorte qu'il pouvait aussi appartenir au troisième règne. Un objet tel que le corail avait donc des liens avec différents règnes. L'ordre des cabinets d'art, qui, d'un point de vue moderne, paraît très hétérogène, reposait sur cet entrecroisement de sens

basé sur des interprétations religieuses et alchimiques, ainsi que sur la classification des objets dans des catégories matérielles aux caractéristiques bien définies.

La vision cosmologique du monde, à la base de la visée encyclopédique des premières collections, perdit de plus en plus de son sens après 1600. Aux XVII$^e$ et XVIII$^e$ siècles, les cabinets d'art furent progressivement remplacés par des collections. On cherchait moins à donner une image représentative de l'ensemble du cosmos qu'à découvrir et à connaître un domaine particulier dans ses moindres détails. Les collections d'objets naturels devinrent un instrument de l'exploration empirique de la nature. En décrivant, comparant et ordonnant leurs pièces, les collectionneurs espéraient parvenir à une compréhension scientifique de la nature. L'image idéale d'un tel « laboratoire de recherche », dans lequel le collectionneur travaille avec ses objets, est donnée par une illustration de 1727 (ill. p. 15). Caspar Friedrich Neickel la plaça tout au début de sa *Museographia*, publiée en 1727 par le médecin de Wroclaw (Breslau), Johann Kanold (1679–1729). La collection de Seba était également mentionnée dans ce manuel sur les débuts du musée, qui se composait d'instructions sur la manière de collectionner et de descriptions de collections existantes.

Les motivations pour collectionner étaient nombreuses : la curiosité intellectuelle, l'esprit explorateur, le désir d'étaler sa richesse et son érudition. Il va sans dire que la possession d'une collection ajoutait au prestige social de son propriétaire. Les grandes collections ou les pièces rares attiraient des visiteurs extérieurs, et même des princes et des rois. Il existe aussi des exemples de collections complètes revendues avec d'importants gains financiers.

La manière de collectionner était évidemment tributaire des fluctuations de la mode. Par exemple, les coquillages, très appréciés, se collectionnaient de plus en plus depuis la Renaissance. Employé de la Compagnie hollandaise des Indes sur l'île d'Amboine (Indonésie), Georg E. Rumphius (1627–1702) put constituer une collection de grande qualité, publiée en 1705 dans l'ouvrage *D'Amboinsche Rariteitkamer* dont Seba avait lui aussi pris connaissance (ill. p. 26). Les Pays-Bas connurent vers 1700 une véritable *conchyliomanie*, c'est-à-dire une passion prononcée pour les coquillages. Ces objets esthétiquement très attrayants se vendaient à des prix élevés, parfois à la limite de l'absurde. A côté d'innombrables petites collections de coquillages, quelques-unes étaient plus importantes. Celle de Seba comptait parmi les plus grandes.

## LA COLLECTION D'ALBERTUS SEBA

En constituant sa collection, Seba s'inscrivait donc dans un courant de son époque. Mais surtout, il était collectionneur et chercheur d'histoire naturelle de par sa profession de pharmacien. Les témoignages de son époque le présentent comme très versé dans ce domaine. Nous avons déjà évoqué comment il s'y prenait pour acheter aux marins, avant même qu'ils aient pu descendre du bateau, les souvenirs qu'ils rapportaient des contrées lointaines. Peut-être chargeait-il aussi l'un ou l'autre d'entre eux de lui trouver lors de son prochain voyage des objets naturels rares ou peu connus en Europe. Il ressort de plusieurs passages des com-

mentaires du *Thesaurus* qu'il était en contact avec des correspondants, notamment au Sri Lanka, au Groenland, en Virginie et à Batavia (aujourd'hui Djakarta, Indonésie), dont il recevait des objets. Avec d'autres collectionneurs, il échangeait les exemplaires qu'il avait en double, mais en bon commerçant, il lui arrivait aussi de les vendre en s'assurant un bénéfice.

Seba réussit à constituer une collection imposante dont la renommée dépassa les frontières d'Amsterdam. L'ensemble de ce trésor nous reste connu aujourd'hui notamment grâce au beau coup qu'il réussit en 1717. Il avait appris la visite prochaine du tsar de Russie, Pierre le Grand, qui venait aux Pays-Bas entre autres pour développer son propre cabinet. Habilement, il lui envoya à l'avance une description précise de sa collection et en prépara ainsi la vente. Celle-ci fut effectivement conclue, après la visite du tsar dans sa maison. L'inventaire que l'intendant de Saint-Pétersbourg dressa des pièces nouvellement acquises montre l'ampleur de cette première collection de Seba. Elle comportait un certain nombre d'armoires contenant pas moins de 72 tiroirs remplis de coquillages, 32 tiroirs remplis de 1000 insectes européens ainsi que 400 bocaux d'animaux conservés dans de l'alcool.

Aussitôt après la vente de sa première collection, Seba commença à en constituer une seconde, qui devint encore plus importante. Comme le montre le *Thesaurus*, les animaux marins, les insectes et les reptiles en constituaient une partie essentielle. En procédant de la sorte, Seba se trouvait en bonne compagnie. Comme il a déjà été dit, les naturalistes avaient souvent tendance, vers 1700, à concentrer leur activité de collectionneur sur quelques aspects de la nature. Au lieu de chercher à réunir un éventail aussi large que possible d'objets rares, ils s'efforçaient de se donner une vue d'ensemble dans des domaines précis. La valeur scientifique d'une collection dépendait moins de la possession d'une pièce précieuse isolée que de la capacité à reconstituer complè-

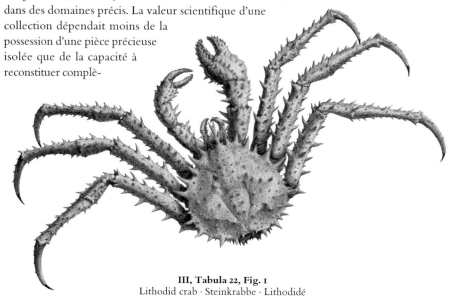

**III, Tabula 22, Fig. 1**
Lithodid crab · Steinkrabbe · Lithodidé

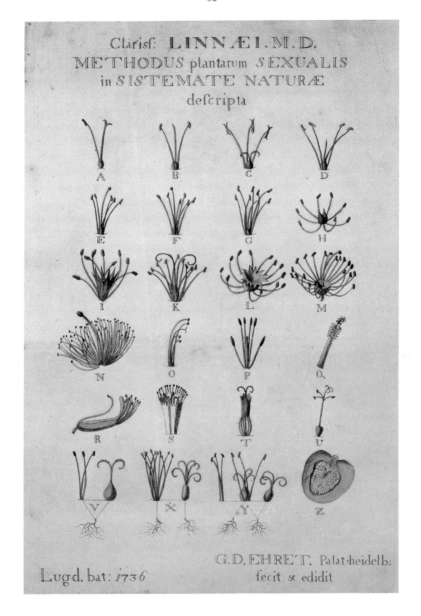

Clariſſ: **LINNÆI.M.D.**
METHODUS plantarum *SEXUALIS*
in *SISTEMATE NATURÆ*
deſcripta

Lugd. bat: *1736*

G.D.EHRET. Palat-heidelb:
fecit & edidit

Carolus Linnaeus: *Systema Naturae*, 1735
Vienna, Österreichische Nationalbibliothek

tement un domaine particulier – y compris en y intégrant la flore et la faune locales. En feuilletant le *Thesaurus*, une certaine ambivalence se fait jour. Notre apothicaire d'Amsterdam a certes su se constituer une collection très importante dans le domaine des reptiles, des insectes et des animaux marins, et contribué ainsi à l'inventaire de la nature, mais sa collection témoigne néanmoins d'un lien très clair avec les cabinets d'art et de merveilles d'autrefois. Les objets curieux, rares ou bizarres continuent à avoir une place chez lui. Ainsi l'illustration isolée d'un bébé mort-né de Curaçao, conservé dans l'alcool, répond sans doute moins ici à un intérêt scientifique qu'il n'est l'expression d'une curiosité universelle. Le *Thesaurus* contient aussi l'illustration d'une chèvre anormalement conformée, à une tête et deux corps (I, 46). Seba ne fit donc pas figurer dans son livre le représentant type de cette espèce animale mais l'exception déformée, beaucoup plus spectaculaire. Cependant, à la différence des cabinets d'art anciens, les pièces de monnaie antiques, les armes exotiques et autres objets de cette espèce n'avaient plus leur place dans la collection d'histoire naturelle de Seba. Chez cet homme dont le premier métier restait celui d'apothicaire, la nature non transformée par l'homme demeurait le principal centre d'intérêt. Seule la coque du nautile était décorée de main d'homme (III, 84).

Un problème se posait généralement pour toutes les collections d'histoire naturelle : celui de leur conservation. Si les durs coquillages de calcaire ne risquaient guère de se décomposer, d'autres objets du règne naturel exigeaient, en revanche, des mesures de conservation délicates. On recourait à cet effet aux procédés employés dans d'autres disciplines, comme la médecine, en les faisant évoluer au besoin. Frederik Ruysch (1638–1731), un ami de Seba, également apothicaire à Amsterdam, mais aussi médecin et naturaliste, développa à la fin du XVII$^e$ siècle des techniques plus anciennes pour naturaliser des cadavres humains. Certes, il ne livra pas son secret sur la manière dont il utilisait la cire colorée et les huiles pour conserver les cadavres et leur donner une apparence vivante, mais il est possible que Seba en ait eu au moins un aperçu. Par exemple, il utilisait un procédé pour isoler les nervures d'une feuille. Il soustrayait ainsi les feuilles à un processus de pourrissement rapide et rendait en outre visible leur structure intérieure. En 1730, il publia un article sur cette technique. Des exemples de feuilles ainsi préparées sont visibles dans les premières pages du *Thesaurus*.

La vaste collection d'objets naturels conservés, que Seba présentait dans une pièce de sa maison, jouissait d'une large renommée qui attirait les naturalistes de nombreux pays. Après sa mort, en 1736, la collection passa à ses héritiers. Ceux-ci se virent toutefois obligés de la vendre pour continuer la publication du *Thesaurus* encore inachevé. La vente aux enchères du cabinet se déroula en 1752. Les prix, parfois considérables, qui étaient demandés pour certaines pièces nous sont connus grâce à l'impression d'un catalogue d'enchères, complété par des annotations manuscrites. Certaines de ces pièces ont survécu aux aléas du temps et se trouvent aujourd'hui dans les musées d'histoire naturelle d'Europe, par exemple à l'Institut zoologique de Saint-Pétersbourg, au Museum d'histoire naturelle de Stockholm, au Musée zoologique d'Amsterdam et au British Museum de Londres.

## DE LA COLLECTION AU LIVRE

Les collections d'histoire naturelle et les livres scientifiques sur le sujet sont indissociablement liés. Même si les chercheurs dans ce domaine voulaient, depuis la fin de la Renaissance, donner toujours davantage la priorité à l'étude empirique et directe de la nature, ils n'avaient jamais totalement négligé la lecture des ouvrages spécialisés. Comme déjà dans les cabinets d'art, les livres faisaient partie des collections d'histoire naturelle, mais servaient aussi à les commenter. Ils aidaient l'homme à pénétrer de son esprit ce matériau naturel, et ainsi à le définir et à l'ordonner. Par leur contenu textuel et leurs reproductions, les livres comblaient aussi les lacunes et les imperfections des collections d'objets réels. D'ailleurs, comme le montre le *Thesaurus* de Seba, certaines collections firent aussi l'objet d'un livre.

Les ouvrages généraux, les livres de détermination et les catalogues de collections témoignent du lien étroit entre livre et collection. Certains livres pouvaient eux-mêmes constituer une collection d'objets naturels, comme les herbiers qui jouirent d'un succès grandissant à partir du XVIe siècle. Les herbiers sont des livres dont les pages, non imprimées, sont constituées d'un papier tendre, très absorbant, sur lequel on colle des plantes préalablement pressées et séchées. Celui de Boëtius, médecin de cour de l'empereur Rodolphe II de Prague, a été conservé jusqu'à ce jour (ill. p. 38). Les deux plantes séchées appartiennent à la famille des géraniacées, comme l'indique l'inscription à la main, au bord supérieur de la feuille. Un petit dessin au bord inférieur représente celui qui a donné son nom à la plante. Après 1700, la constitution d'herbiers fut considérée comme un passe-temps utile et même un aspect important de l'éducation. On allait « herboriser », et on découvrait ainsi son environnement naturel. Tout le monde pouvait participer à cette exploration de la nature, apporter éventuellement une contribution ou au moins corroborer par soi-même l'état des connaissances.

Cependant, la constitution de collections importantes nécessitait de gros investissements financiers. Comme, en outre, beaucoup d'objets étaient difficiles à obtenir ou à conserver, il arrivait au collectionneur de les remplacer par des représentations dessinées. Ce matériel visuel était collé dans l'ordre souhaité, comme les plantes dans l'herbier, sur les pages vides de grands in-folios. On constituait ainsi de véritables « musées en papier », comme le *Museo Cartaceo* du naturaliste italien, spécialiste d'antiquités, Cassiano dal Pozzo (1589–1627), qui comprenait plus de 7 000 dessins.

Lorsqu'un tel collectionneur ou naturaliste chargeait des artistes de dessiner les objets qui l'intéressaient, et même, dans une deuxième étape, de les transférer sur une plaque d'impression, la plante ou l'animal considéré étaient soumis à un important processus d'abstraction et d'élucidation tout au long de son traitement jusqu'à l'obtention de l'image scientifique (ill. p. 37). L'objet en question était considéré comme un représentant de son espèce, et son phénotype systématisé. L'artiste devait minimiser les caractères individuels, non typiques de l'espèce, mais faire ressortir les caractéristiques scientifiques importantes. Ce processus nous est révélé en considérant par exemple l'un des bocaux à serpents conser-

vés dans de l'alcool, comme on en aperçoit dans le portrait de Seba (ill. p. 2), et en contemplant ensuite l'une des nombreuses représentations de serpents dans le *Thesaurus*. A partir d'un animal comprimé, entortillé sur lui-même, souvent décoloré et en partie décomposé, nageant dans un liquide trouble, l'artiste a réalisé une représentation très claire et différenciée. L'illustration montre plus nettement que l'original dans le bocal ce qu'il est important d'en percevoir. On peut voir aussi dans cette abstraction par l'image une manière de maîtriser une nature multiforme.

Depuis le XVIᵉ siècle, les ouvrages de sciences naturelles contiennent des représentations réalistes et détaillées qui permettent d'identifier les divers objets de la nature. Les premiers d'entre eux étaient de gros livres de botanique, car la définition des plantes jouait un rôle décisif en pharmacie. Dans son *Historia Stirpium*, un ouvrage qui a fait date, le botaniste Leonhart Fuchs (1501–1566) a inséré pas moins de 511 gravures sur bois. La contribution importante que les artistes ont apportée à cet ouvrage a même été représentée : on les voit en train de dessiner puis de reporter leurs dessins sur les plaques d'impression en bois (ill. p. 37). L'exemple de la botanique a vite été suivi par la médecine, avec ses planches d'anatomie, et par la zoologie aux ouvrages richement illustrés de représentations d'animaux. Puis au XVIIᵉ siècle, les livres sont devenus de plus en plus spécialisés, comme le *Metamorphosis Naturalis*, un ouvrage en trois volumes sur les insectes, réalisé par Jan Goedaert (?–vers 1668) et mis sur le marché en plusieurs langues dans les années 1660. Ce peintre et naturaliste néerlandais fut le premier à

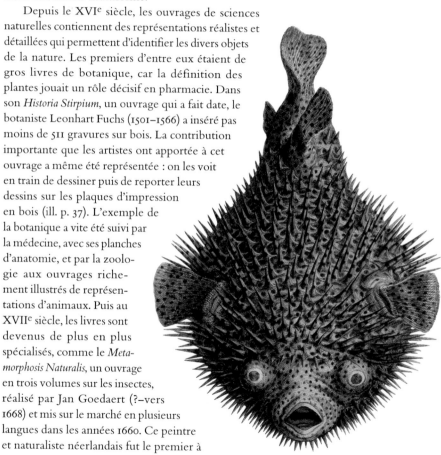

**III, Tabula 23, Fig. 1**
Poisonous puffer fish from tropical waters, which inflates itself when threatened ·
Giftiger Kugelfisch aus tropischen Gewässern, der sich bei Bedrohung aufbläst ·
Poisson-globe venimeux des eaux tropicales, qui se gonfle lorsqu'il est menacé

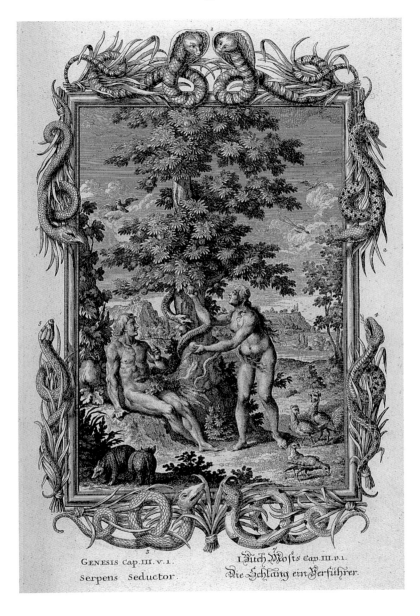

GENESIS Cap.III.v.1.

Serpens Seductor.

I Buch Mosis Cap.III.v.1.

Die Schlang ein Verführer.

Johann Jakob Scheuchzer: *Kupfer-Bibel*, 1731–1735
Göttingen, Niedersächsische Staats- und Universitätsbibliothek

représenter systématiquement les phases de développement de ces animaux . Ainsi voit-on sur une même feuille la chenille, la larve et le papillon. *Ornithologiae libri tres*, un ouvrage sur les oiseaux paru pour la première fois en 1676, est le travail d'un Anglais, Francis Willughby (1635–1672), présentant en 78 planches des illustrations d'animaux indigènes et « exotiques », ordonnés selon leur espèce, par exemple oiseaux de proie ou oiseaux aquatiques (ill. p. 29).

Des savants tels que Willughby n'avaient pas, en général, une connaissance de première main des animaux et des plantes des pays lointains. Ils consultaient des récits de voyage illustrés, dans lesquels ils trouvaient des descriptions et des représentations de la faune et de la flore des régions d'outre-mer. Pour obtenir des renseignements aussi précis que possible, les savants remettaient aux capitaines des bateaux ou à d'autres voyageurs des longs questionnaires qui devaient les aider à consigner ce qu'ils voyaient. Mais de plus en plus, au cours du XVIIᵉ siècle, les naturalistes entreprirent eux-mêmes le voyage vers les pays lointains. Ils rendaient compte de ce qu'ils voyaient par des images, ou se faisaient accompagner par des artistes qui se chargeaient de ce travail. A leur retour, ils incluaient les dessins et les descriptions ainsi obtenus dans leurs récits de voyage imprimés, qui étaient de véritables histoires naturelles des régions visitées. Hans Sloane, un naturaliste et correspondant de Seba, publia son récit de voyage en 1707 et en 1725 sous le titre *Natural History of Jamaica*. Seba avait très vraisemblablement connu ces deux ouvrages, qui étaient illustrés d'un grand nombre de planches de reptiles et d'insectes.

Maria Sibylla Merian (1647–1717), une artiste originaire de Francfort-sur-le-Main, qui avait voyagé à Surinam de sa propre initiative et à ses propres frais entre 1699 et 1701, avait réalisé un travail remarquable. Son étude et ses dessins avaient surtout porté sur les insectes, mais aussi sur les animaux et les plantes de ce pays d'Amérique du Sud. Après son retour, Merian publia en 1705 l'ouvrage *Metamorphosis Insectorum Surinamensium*, qui se composait de 60 grosses planches assorties de descriptions détaillées (ill. p. 53). Ses représentations disposées avec art, à la manière de natures mortes, touchent par leur beauté et ont influencé la présentation du premier volume du *Thesaurus*.

La comparaison entre différents ouvrages de sciences naturelles de cette époque révèle des conceptions très différentes. Cela s'explique par des différences d'objectifs. Beaucoup suivent la tradition des premiers livres de botanique dont les illustrations devaient servir à identifier sans erreur les plantes médicinales. Les illustrations présentent les objets de la nature sur un fond neutre, de sorte qu'ils ne se recouvrent pas et que leurs caractéristiques apparaissent aussi clairement que possible (ill. p. 29 & 38). Le livre d'anatomie de Gerard Blasius, intitulé *Anatome Animalium* et publié en 1681, témoigne d'une autre approche. Ce médecin d'Amsterdam avait essayé d'acquérir une compréhension plus profonde de la nature en examinant les organes et la constitution osseuse des animaux. Chaque planche est consacrée à un animal précis et montre son squelette. Elle est le fruit d'une étude anatomique. L'animal entier est également présenté dans un paysage (ill. p. 50). Maria Sibylla Merian tenait beaucoup à donner au lecteur une représentation de la vie environnante et

de ses interactions avec les animaux et les plantes. Par d'habiles mises en scène, elle réussit ainsi à rendre les différents éléments clairement identifiables, tout en les présentant d'une manière extrêmement esthétique (ill. p. 53). Avec sa *Kupfer-Bibel* (Bible de cuivre), encore appelée *Physica Sacra*, le naturaliste suisse Johann Jakob Scheuchzer (1672–1733) poursuivait un autre but (ill. p. 66). Il commentait les animaux, les plantes et les phénomènes de la nature mentionnés dans la Bible à la lumière des recherches les plus récentes en sciences naturelles. Avec cet ouvrage publié de 1731 à 1735, Scheuchzer voulut contribuer à une meilleure compréhension de la Bible et démontrer sa validité scientifique. Il accompagnait ainsi des images racontant les événements de la Bible d'illustrations d'histoire naturelle. Par exemple, la scène dans laquelle Eve est séduite par le serpent pour goûter le fruit interdit et où Adam goûte à son tour la pomme est associée à des représentations de diverses espèces de serpents. Les images des sciences naturelles sont ici clairement intégrées à une conception du monde. Carl von Linné (1707–1778), en revanche, chercha à libérer les illustrations de son *Systema Naturae* de toute surcharge inutile (ill. p. 62). Il développa dans son livre, paru pour la première fois en 1735, le système de classification des animaux et des plantes encore en vigueur aujourd'hui. Le critère déterminant qu'il choisit pour distinguer les genres et les espèces était celui des organes de reproduction des êtres vivants. Aussi les illustrations de son livre se limitent-elles à de simples croquis des parties de plantes concernées. Il n'est pas difficile de constater que le *Thesaurus* de Seba est très différent de ce spécimen de l'avant-garde scientifique de l'époque.

## LE THESAURUS D'ALBERTUS SEBA

Le 30 octobre 1731, un contrat tripartite fut conclu à Amsterdam : les représentants de deux éditeurs et Seba convinrent de publier le contenu du cabinet de l'apothicaire dans un grand ouvrage d'environ 400 planches. Effectivement, le *Thesaurus* arbore 446 planches, dont 175 sous forme de double page. Les quatre volumes sont parus en l'espace de 30 ans, car après la parution des deux premiers, en 1734 et en 1735, la mort de Seba en 1736 recula celle des deux derniers jusqu'en 1758 et 1765. Les explications qui accompagnaient les planches étaient chaque fois publiées en deux versions : l'une latino-française, l'autre latino-néerlandaise. En effet, Seba s'adressait avec son *Thesaurus* à un public international de naturalistes, de collectionneurs et de bibliophiles. Le texte des deux premiers volumes fut, dans une grande mesure, écrit par Seba lui-même, mais il se fit aider par d'autres naturalistes, comme Frederik Ruysch pour la définition des serpents. Il chargea aussi le Suédois Peter Artedi (1705–1735), dont c'était le domaine, de rédiger un commentaire sur les poissons dans le troisième volume. Lorsqu'il mourut, ses notes pour le quatrième volume étaient déjà disponibles. Il fallut seulement les retravailler et réactualiser un peu.

Les quelques pages au début du premier volume du *Thesaurus* présentent des reproductions de squelettes de plantes, que Seba avait préparés et conservés à l'aide d'une technique spéciale. Les images suivantes étaient des représentations d'animaux et de plantes d'Amérique

du Sud et d'Asie. Outre des lézards, des oiseaux, des grenouilles, des araignées et d'autres espèces, il représenta aussi des animaux légendaires, tels que les dragons. Le deuxième volume est avant tout consacré aux serpents, mais quelques plantes et animaux figurent également sur ses planches, à des fins décoratives et pour représenter la façon de vivre des reptiles. Le milieu marin fait l'objet du troisième volume où un nombre impressionnant d'animaux tels que coquillages, étoiles de mer, pieuvres, oursins et poissons attendent le lecteur. Le dernier volume présente en à peine une centaine de planches une vaste collection d'insectes, suivie sur quelques pages de représentations des minéraux et fossiles du cabinet de Seba.

En tête de toutes ces planches d'histoire naturelle, Seba plaça son portrait (ill. p. 2) ainsi qu'un frontispice allégorique, typique de la tradition baroque (ill. p. 70). Cette image, qui résume les objectifs du livre, comporte les personnifications de différents concepts réunis en un message complet. Le peintre et dessinateur néerlandais Louis Fabritius Dubourg (1693–1775) avait réalisé un dessin que le graveur d'Amsterdam, Pieter Tanjé (1706–1761), avait ensuite transféré sur une plaque d'impression en cuivre. Les vers en latin au bord inférieur de l'image donnent des indications précieuses pour en décrypter le sens. La figure féminine au centre serait, d'après ces vers, une personnification de l'Industrie, c'est-à-dire d'une activité exécutée avec zèle et motivée par l'amour de la science. Elle exerce cette activité intense, évoquée par l'image de la ruche à côté d'elle, sous la protection éclairante de la Vérité, Veritas. Le Temps, personnifié par Chronos, dont la faucille est au repos, lui donne la possibilité de progresser dans son travail, qui est de collectionner. Un messager ailé, représentant le Commerce, remet à Industrie des objets de la nature en provenance des différents continents. Ceux-ci sont placés symboliquement derrière le Commerce. Au

**I, Tabula 38, Fig. 2**
Three-banded armadillo · Kugelgürteltier · Tatou à trois bandes

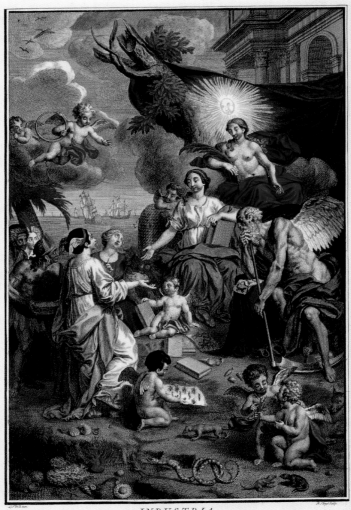

INDUSTRIA

*Præsidio VERITATIS munita, SCIENTIARUM incitata AMORE, adjuta TEMPORE, suam Sibi undequaque, instar APUM, colligens Supellectilem, cum PHYSICA disserit de variis Naturæ operibus, admiratione dignis, quæ in triplicis Animantium, Vegetantium, Fossiliumque Regni divitiis, ex omni ORBIS TERRARUM plaga Mercaturæ ac Navigationis adminiculo, comparatis, detexit; nonnullis interim GENIIS adsidentibus, qui, admirandorum intenti Spectaculo, de his inter se conferunt; dum alii duo, ex alto delapsi, indefessos INDUSTRIAE labores Laureo Serto, et immortali Gloria, remunerari gestiunt.*

Albertus Seba: *Loccupletissimi Rerum Thesauri Accurata Descriptio*, 1734–1765
Volume I, frontispiece · Band I, Frontispiz · Tome I, frontispice : Industria

début, nous voyons un Indien, personnification de l'Amérique, suivi d'un Noir pour l'Afrique et d'un Oriental pour l'Asie. L'Europe n'est pas représentée. Cela montre que l'on s'intéressait surtout aux objets naturels d'outre-mer, apportés par les gros voiliers que l'on voit dans le fond. Encore inconnue à l'époque des Européens, l'Australie n'y figure pas non plus. Aux pieds d'Industrie s'ébattent plusieurs putti, très occupés à étudier et à commenter les objets ainsi réunis. Les illustrations et les livres contribuent également à cette étude de la nature. Deux génies descendant du ciel apprécient le travail d'Industrie qui, avec persévérance, a réuni une collection de sciences naturelles et contribue ainsi à la connaissance de la nature. Le premier, plus en avant, apporte un anneau, constitué d'un serpent qui se mord la queue. Ce symbole d'éternité, associé à la couronne de lauriers tenue par le deuxième, représente la gloire posthume, qui résiste à l'usure du temps. Ainsi, la figure symbolisant le collectionneur assidu dépasse par sa taille l'homme à la faucille, Chronos, et reçoit les insignes d'une vénération durable. Naturellement, ce frontispice illustre le rôle que Seba entend se donner, et sert à mettre en valeur par l'image son activité de collectionneur infatigable et d'initiateur d'une vaste entreprise de description de sa collection.

La publication d'une œuvre telle que le *Thesaurus* nécessita d'importants moyens financiers. Surtout, les nombreuses planches, dont la réalisation demanda beaucoup de temps, générèrent des coûts immenses. Ainsi connaît-on les noms de pas moins de 13 artistes, qui transférèrent sur plaques les planches, le frontispice et le portrait. Outre Houbraken et Tanjé déjà cités, il y avait des graveurs sur cuivre d'Amsterdam tels que Frans de Bakker (actif de 1736 à 1765), Adolf van der Laan (actif de 1717 à 1740) et Jan Punt (1711–1779). Mais avant tout, Seba avait dû trouver un éditeur acceptant de prendre le risque financier lié à un ouvrage aussi cher. Aux Pays-Bas, il était courant que des éditeurs se regroupent en une société pour des projets très coûteux. Le contrat signé entre Seba et les deux éditeurs réunis pour la publication du *Thesaurus* précise que Seba devait apporter un tiers du financement. Une souscription fut organisée pour préfinancer les coûts de production. Les futurs acquéreurs pouvaient s'inscrire sur une liste et payer une avance sur le prix d'achat. En échange, une réduction de 30 pour cent leur était accordée.

Cet ouvrage luxueux parut d'abord en noir et blanc, c'est-à-dire sans les teintes somptueuses de l'exemplaire initial qui a servi à reproduire le présent ouvrage. Nous ignorons si les éditeurs eux-mêmes ont proposé une version colorée, ce qui aurait évidemment considérablement augmenté le prix et la marge bénéficiaire. Il est probable que les acheteurs faisaient colorier leur livre à leurs propres frais, et qu'ils s'adressaient à cet effet à des coloristes spécialisés. J. Fortuÿn, dont les dates ne sont pas connues, était un tel spécialiste. Il signa ses travaux, de sorte que plusieurs exemplaires coloriés du *Thesaurus* ont pu lui être attribués. Il en est ainsi des volumes de la bibliothèque royale de La Haye reproduits ici. Comme Fortuÿn ajoutait à sa signature le mot « Hague » (Haye), il a sans doute vécu et travaillé dans cette ville. Il ressort d'une facture conservée dans les archives de La Haye et datée de 1767 qu'il ne coloria les différents livres qu'une fois tous les volumes parus. La beauté des couleurs offre un plaisir particulier. Mais outre l'attrait esthétique, ce coloriage

revêtait aussi une utilité scientifique. Par exemple, certains spécimens de papillons, de serpents ou de coquillages ne se distinguent que par leurs couleurs, et les différences de motifs ne sont guère visibles en noir et blanc. La force d'expression des illustrations coloriées dépendait évidemment du savoir-faire du coloriste et de sa connaissance du domaine. Il arrivait à Fortuÿn d'ajouter des couleurs pour leur effet esthétique, alors qu'elles ne correspondaient pas au modèle réel. C'est ce qu'il fit pour le nautile. La coquille blanche et soyeuse de cet animal était très prisée et souvent ornée de multiples dessins gravés. Dans le *Thesaurus*, Fortuÿn coloria en de multiples couleurs les gravures d'un nautile ainsi décoré, bien que, dans l'édition originale, la coquille fût certainement gravée en noir et blanc et non en couleur (III, 84).

Dans son introduction, Seba prétend que toutes les illustrations correspondent à des objets de sa collection. L'être imaginaire à sept têtes du premier volume n'est pas le seul à jeter le doute sur ce propos (I, 102). D'après certaines sources, Seba aurait utilisé un manuscrit acheté contenant des représentations d'insectes pour illustrer sa quatrième partie et aurait également inséré dans le *Thesaurus* des dessins d'animaux d'Afrique du Sud, prêtés par un collègue. En effet, l'apothicaire de Leipzig, Johann Heinrich Linck (1674–1734), avait transmis à Seba des dessins représentant son exceptionnelle collection de serpents. Ces illustrations étaient destinées à une publication commune sur les reptiles. Lorsque cette entreprise échoua, Seba fit copier les dessins avant de les renvoyer à Leipzig. Comme Linck s'en était plaint dans un courrier à Scheuchzer, Seba avait effectivement utilisé les représentations pour son *Thesaurus*. Outre de telles transactions, Seba exploita aussi la littérature en sciences naturelles qui lui apportait un matériel d'illustration pour combler des lacunes de sa collection. La comparaison entre deux planches, l'une de Blasius (ill. p. 50) et l'autre du *Thesaurus* (I, 82), ou entre une planche de Merian (ill. p. 53) et une autre de l'ouvrage de Seba (I, 69) montre à l'évidence que des parties essentielles des planches du premier volume du *Thesaurus* sont inspirées d'ouvrages plus anciens. Par souci d'exhaustivité, de telles reprises étaient tout à fait courantes. Toutefois, elles comportaient un certain risque, en particulier lorsqu'il s'agissait de dessins réalisés ou rapportés par des marins, qui pouvaient parfois être d'humble qualité ou d'une authenticité douteuse (I, 101).

Avec ou sans couleur, reprenant des images existantes ou non, le *Thesaurus* est en tout cas un exemple impressionnant et convaincant de l'art baroque du livre. Surtout dans son premier volume, on est frappé par la conception picturale de chaque planche, où toutes les parties de l'image sont réunies en un ensemble cohérent. Conformément au modèle de Merian, les animaux et les plantes sont ordonnés avec art. Ils sont souvent disposés en petites scènes, ce qui contribue sensiblement à produire un effet vivant et en renforce également la valeur informative. Par exemple, un serpent est représenté en train de dévorer sa proie (II, 17), un autre est figuré dans une attitude menaçante devant un lézard (II, 30). Les planches des volumes deux à quatre, qui empruntent beaucoup moins à des ouvrages antérieurs, correspondent de plus en plus à une présentation scientifique caractéristique de l'époque. Les animaux sont présentés les uns après les autres – soigneusement séparés par genre. Dans

les deux derniers volumes, réalisés après la mort de Seba, il n'y a plus d'interactions entre les animaux représentés. Pour rendre les illustrations aussi lisibles que possible, les animaux ne se recouvrent jamais et leurs grandeurs respectives sont respectées – avec toutefois une inversion latérale, ce qui conduisit à des méprises dans le cas des coquilles d'escargot spiralées vers la gauche. Il reste toutefois le principe de l'arrangement ornemental des objets sur les planches, que l'on observe aussi bien sur les illustrations de serpents à structure symétrique (II, 37 ; II, 67) qu'avec les coquillages (III, 56) ou les insectes (IV, 25 ; IV, 77) disposés avec art. Dans la présentation de la collection, l'œil aussi pouvait revendiquer ses droits, comme le montre un tiroir à coquillages encore conservé, datant de 1725 (ill. p. 34). Dans leur disposition, les coquillages forment une mosaïque riche en formes et en couleurs somptueuses, comparable à certaines planches de coquillages de Seba (voir III, 36–37). Sans doute les planches ont-elles recopié tel quel l'ordonnancement des casiers de rangement, comme Vincent Levin l'avait déjà fait avant Seba (ill. p. 7). Ainsi, les illustrations et les collections présentent toujours un double intérêt : l'instruction scientifique et le plaisir esthétique. La plupart des illustrations du *Thesaurus* donnent à voir l'aspect extérieur des animaux et des plantes. A part les systèmes de nervures dans le cas des feuilles, les représentations anatomiques sont rares. La microscopie, très en vogue au début du XVIIIe siècle,

**I, Tabula 38, Fig. 1**
Brown four-eyed opossum · Braune Vieraugenbeutelratte · Sarigue à quatre yeux

ne trouve pas non plus d'application véritable dans les planches du *Thesaurus*. En tant que collectionneur, Seba s'inscrivait plutôt dans la tradition d'une science naturelle descriptive, qui se distinguait de l'approche analytique. Cette méthode descriptive enrichissait la connaissance de la multiplicité des espèces. Elle créait aussi une documentation sur le sujet et permettait en outre de rendre compte de certains processus de développement dans la nature, tels que la métamorphose des insectes. Sur le modèle de Goedaert (ill. p. 42), les planches du quatrième volume présentent côté à côte des chenilles, des chrysalides et des papillons.

Surtout, la forme de la présentation des deux premiers volumes suscita des réactions critiques parmi les acheteurs du livre. Cette mise en scène des objets de la nature, la recherche d'un effet esthétique et l'assemblage d'animaux et de plantes disparates sur une même planche ne suffisaient pas à contenter les scientifiques. Le reproche selon lequel les serpents, les animaux marins et les insectes n'étaient pas ordonnés d'après le système de classification le plus moderne ne tenait pas compte du fait qu'à la mort de Seba, en 1736, la plupart des planches étaient déjà dans un état de réalisation très avancé et que les découvertes de Linné n'avaient pas encore pu imprégner l'état général des connaissances. L'introduction du quatrième volume du *Thesaurus* précise, comme pour s'excuser, que le but n'avait pas été de réaliser un manuel complet d'histoire naturelle, mais seulement de décrire une seule collection. Dans son avant-propos au premier volume du *Thesaurus*, Herman Boerhaave (1668–1738) souligne le grand mérite de cette entreprise. Il rappelle le caractère unique et complet de la collection de Seba et se répand en éloges sur l'utilité de l'ouvrage. A une époque où le nombre d'espèces connues restait encore très

**I, Tabula 40, Fig. 2**
Tamandua from Mexico, called Yzquiepatl, which means little fox ·
Tamandua aus Mexiko, genannt Yzquiepatl, das bedeutet: kleiner Fuchs ·
Tamandua, du Mexique, nommé Yzquiepatl, c'est-à-dire petit renard

limité, et où l'on manquait encore beaucoup de supports visuels, Seba avait, avec cet ouvrage, mis à disposition un fonds inestimable. Même si, d'un point de vue scientifique, le traitement des objets collectionnés est clairement limité, il n'en reste pas moins vrai que le *Thesaurus* de Seba était un point de départ pour des recherches plus avancées. Par exemple, Linné se servit des illustrations de la collection de Seba pour affiner et compléter les versions ultérieures de son *Systema Naturae*. L'ouvrage de Seba connut une réédition dans la seconde moitié du XVIIIe siècle et, même au XIXe siècle, le fonds d'images parut si remarquable que les planches furent imprimées une nouvelle fois. Le *Thesaurus* a fait découvrir au public un important cabinet d'histoire naturelle du début du XVIIIe siècle. Grâce au livre, la collection, qui était stationnaire à l'origine, est devenue mobile et accessible à un large public d'intéressés pendant encore des décennies, après avoir été dispersée à tous vents.

# PLATES

## TAFELN
## PLANCHES

SCIENTIFIC IDENTIFICATION OF SPECIES
WISSENSCHAFTLICHE BESTIMMUNG DER ARTEN
DÉTERMINATION SCIENTIFIQUE DES ESPÈCES

## RAINER WILLMANN,
## JES RUST & VOLKER WISSEMANN

GEORG-AUGUST UNIVERSITY
OF GÖTTINGEN

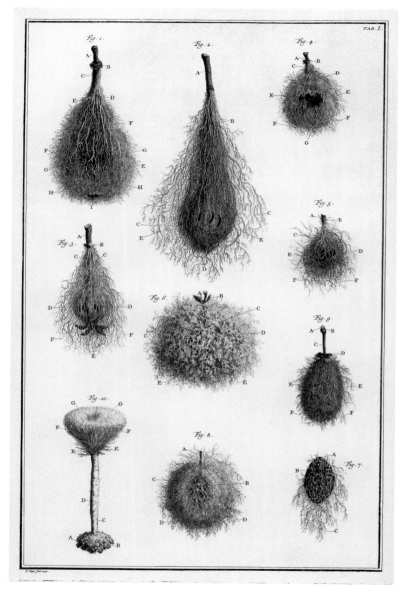

TAB. I.

1-2 *Pyrus* 3 *Cydonia* 4-5 *Malus* 6-7 *Prunus persica* 8 *Prunus armeniaca* 9 *Prunus domestica* 10 *Agaricus bisporus*
Fruit skeletons · Fruchtskelette · Squelettes de fruits: 1-2 Pear · Birne · Poire 3 Quince · Quitte · Coing
4-5 Apple · Apfel · Pomme 6-7 Peach · Pfirsich · Pêche 8 Apricot · Aprikose · Abricot
9 Plum · Pflaume · Prune 10 Mushroom · Champignon · Champignon

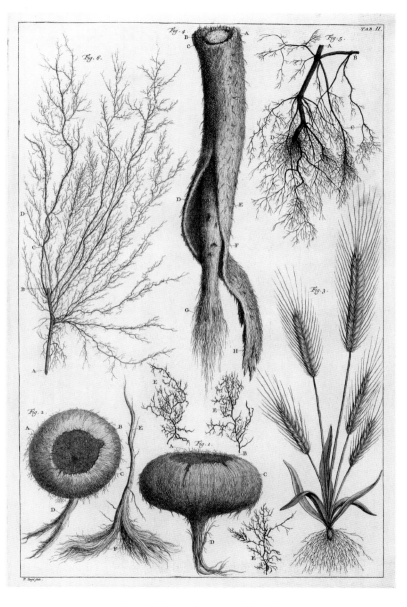

*1-2* Beta **3** *Hordeum* **4** *Scorzonera* **5** *Sium* **6** *Pyrus*
**1-2** Beet · Rübe · Bette **3** Barley · Gerste · Orge
**4** Viper's grass · Schwarzwurzel · Scorsonère
**5** Greater water-parsnip · Merk · Berle **6** Pear · Birne · Poirier

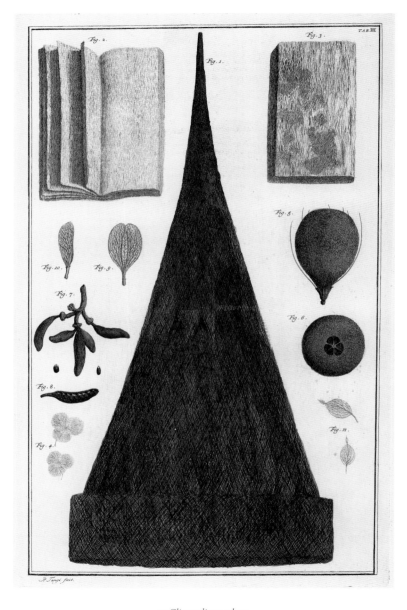

11 *Clinopodium vulgare*
Plant parts and craft products made from plants · Pflanzenteile und handwerkliche
Produkte aus Pflanzen · Parties de plantes et divers produits dérivés de plantes
11 Wild basil · Wirbeldost · Calament vulgaire

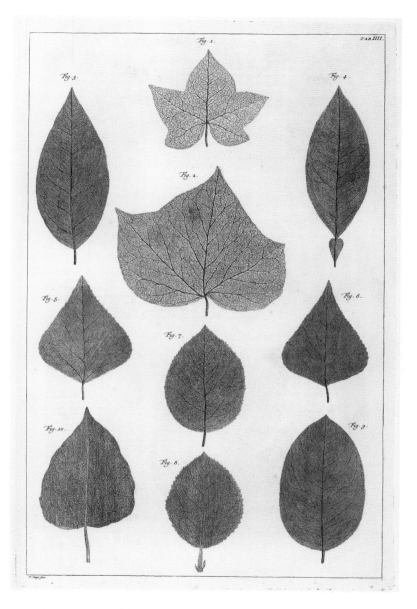

1-2, 10 *Hedera* 3 *Citrus aurantifolia* 4 *Citrus limonia* 5 *Populus nigra* 6 *Prunus armeniaca* 7 *Malus* 9 *Pyrus*
Skeletons of leaves · Blattskelette · Squelettes de feuilles 1-2, 10 Ivy · Efeu · Lierre 3 Lime fruit tree ·
Limette · Limettier 4 Rangpur lime · Zitrone · Limonier 5 Black popular · Schwarzpappel · Peuplier noir
6 Apricot · Aprikose · Abricotier 7 Apple · Apfel · Pommier 9 Pear · Birne · Poirier

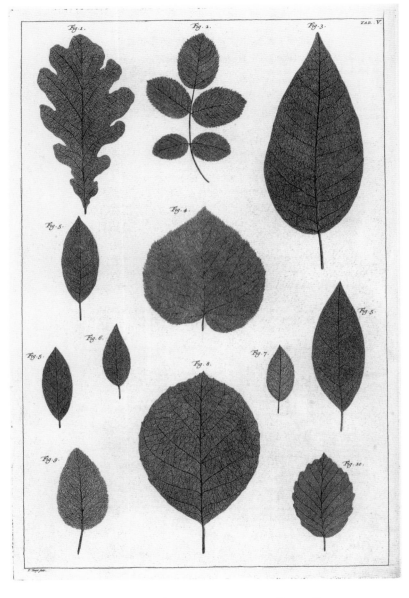

1 *Quercus* 2 *Rosa* 4 *Tilia* 5 *Laurus* **6-7** *Jasminium* **9** *Pyrus* **10** *Fagus*
**1** Oak · Eiche · Chêne **2** Rose · Rose · Rosier **4** Line · Linde · Tilleul
**5** Laurel · Lorbeer · Laurier **6-7** Jasmine · Jasmin · Jasmin
**9** Pear · Birne · Poirier **10** Beech · Buche · Hêtre

**2** *Apios americana*
Deciduous leaves from various plants · Laubblätter verschiedener Pflanzen ·
Feuilles de différentes plantes
**2** American potato bean · Erdbirne · Apios d'Amérique

1 Araceae 2 Inga 3 Liliaceae

TAB. VIII.

Fig. 1.

Fig. 2.

Fig. 4.

Fig. 3.

Fig. 5.

**1** *Pancratium illyricum* **2-4** *Iris* **5** *Cypripedium calceolus*
**1** Corsican lily · Pankrazlilie · Pancrais d'Illyrie
**2-4** Iris · Schwertlilie · Iris
**5** Lady's slipper orchid · Frauenschuh · Sabot de Vénus

1-2 *Euphorbia sp.* 3 *Dorotheantus* 4 Caesalpiniaceae 5 Helianthemum
1-2 Spurge · Wolfsmilch · Euphorbe
5 Sun-rose · Sonnenröschen · Hélianthème

Lepidoptera, *Acmella* et *Serpentes* **1** *Bungarus fasciatus*
Butterflies, plant and snakes · Tagfalter, Pflanze und Schlangen · Papillons diurnes, plante et serpents
**1** Banded krait · Gelber Bungar · Bongare annelé **2** Snake, according
to Seba from Ceylon · Schlange, nach Seba aus Ceylon · Serpent, de Ceylan selon Seba

*TAB. XI.*

*Fig. 1.*

*Fig. 2.*

Papilionidae et *Acmella* **1** Serpentes **2** *Oligodon?*
Tropical butterflies and plant · Tropische Tagfalter und Pflanze · Papillons diurnes tropicaux
et plante **1** Snake, according to Seba from Ceylon · Schlange, nach Seba
aus Ceylon · Serpent, de Ceylan selon Seba **2** Kukuri snake · Oligodon · Oligodon

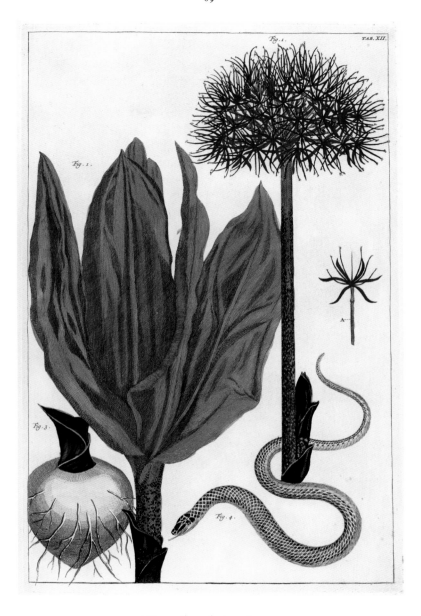

1-3 *Haemanthus catharinae* 4 Serpentes
**1-3** Katherine blood-lily · Katharinas Blutblume · Hémanthe de Catherine Saunders
**4** Snake, according to Seba from Africa · Schlange, nach Seba aus Afrika ·
Serpent, d'Afrique selon Seba

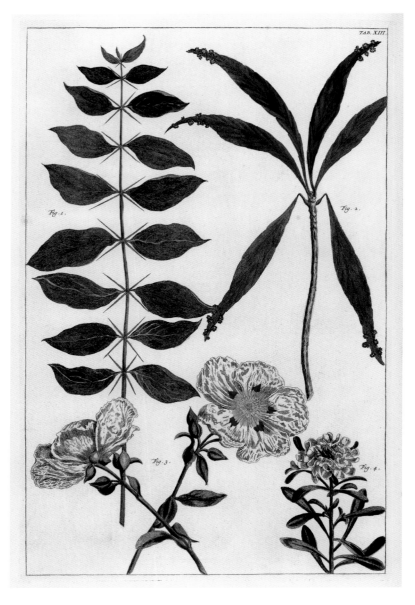

TAB. XIII.

Fig. 1.

Fig. 2.

Fig. 3.

Fig. 4.

2 *Phyllanthus* 3 *Cistus* 4 *Iberis*
2 Laurel seaside · Blattblume · Phyllanthe
3 Rockrose · Zistrose · Ciste
4 Candytuft · Schleifenblume · Ibéris

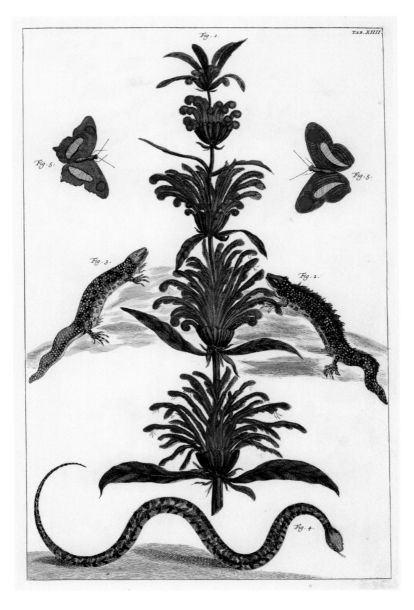

1 *Leonotis leonurus* **2-3** *Salamandridae* **4** Serpentes **5** Lepidoptera
**1** Lion's ear · Löwenohr · Queue-de-lion **2-3** Newts · Molche · Urodèles
**4** Snake, according to Seba from Africa · Schlange, nach Seba aus Afrika · Serpent,
d'Afrique selon Seba **5** Tropical butterflies · Tagfalter · Papillons diurnes

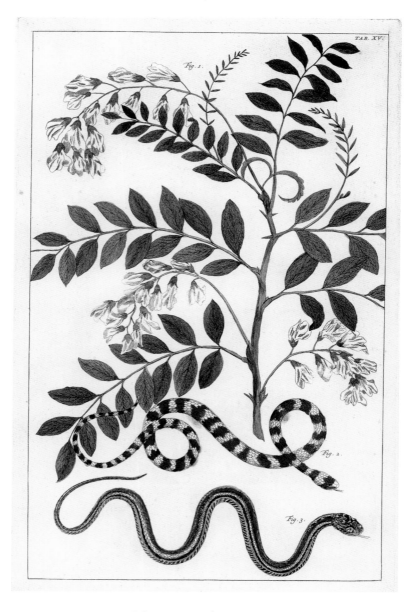

TAB. XV.

Fig. 1.

Fig. 2.

Fig. 3.

1 *Robinia* 2 *Lampropeltis sp.* 3 Serpentes
1 False acacia · Robinie · Robinier faux-acacia 2 King snake · Königsnatter · Serpent roi
3 Snake, according to Seba from Africa · Schlange, nach Seba aus Afrika ·
Serpent, d'Afrique selon Seba

*TAB. XVI.*

*Fig. 1.*

*Fig. 2.*

*Fig. 3*

*Fig. 4.*

*Fig. 5.*

**1, 3-4** Compositae **2** *Anacyclus* **5** *Campanulaceae*
**1, 3-4** Sunflower family · Korbblütler · Composées
**2** Mount Atlas daisy · Ringblume · Pyrèthre d'Afrique
**5** Bluebell family · Glockenblumengewächse · Campanulacées

TAB. XVII

1-2 *Crinum zeylanicum* 3 *Nerine sarniensis* 4 *Colutea* 5 *Heliophila elongata*
1-2 Crinum · Hakenlilie · Crinole 3 Guernsey lily · Guernseylilie · Nérine
4 Bladder senna · Blasenstrauch · Baguenaudier 5 Sun cress · Sonnenliebchen · Héliophile

TAB. XVIII.

1 *Carpobrotus edulis* 2 *Hypathelis sp.* 3 *Abelmoschus moschatus* 4 *Pelargonium sp.*
1 Sour fig · Pferdefeige · Ficoïde 3 Musk-mallow · Sumpfeibisch · Ketmie musquée
4 Stork's-bill · Pelargonie · Pélargonium

Fig. 1.

Fig. 3.

Fig. 3.

Fig. 7.

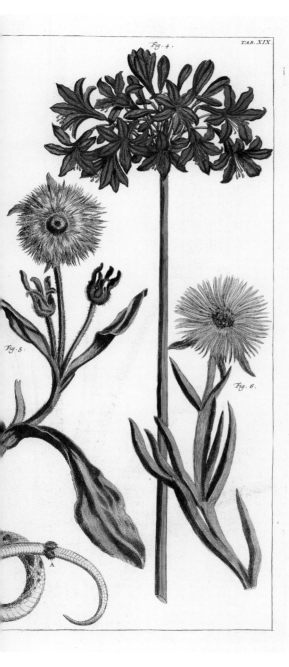

*Fig. 4.*

*TAB. XIX.*

*Fig. 5.*

*Fig. 6.*

**1** *Opuntia ficus-indica*
**2** *Euphorbia sp.* **3** *Kniphovia uvaria*
**4** *Agapanthus africanus*
**5** Mesembryanthemaceae
**6** *Carpobrotus edulis* **7** Serpentes
**1** Prickly pear · Echter
Feigenkaktus · Figuier d'Inde
**2** Spurge · Wolfsmilch · Euphorbe
**3** Red-hot poker · Fackellilie ·
Tritorne **4** African lily ·
Schmucklilie · Agapanthe
**5** Ice plant · Eiskrautgewächse ·
Mésembryanthémacée
**6** Sour fig · Pferdefeige · Ficoïde
**7** Snake, according to Seba
from Africa · Schlange, nach Seba
aus Afrika · Serpent, d'Afrique
selon Seba

*Fig. 1.*

*Fig. 2.*

*Fig. 3.*

*Fig. 4.*

*Fig. 1.*

*Fig. 2.*

*Fig. 3.*

*Fig. 4.*

TAB. XXII.

*Fig. 4.*

*Fig. 5.*

*Fig. 10.*

*Fig. 11.*

*Fig. 12.*

**1-5** *Senecio sp.* **2** *Senecio arenarius* **7** *Sebaea exacoides* **8** *Helichrysum sp.* **9** *Rhamnus sp.* **10-11** *Oxalis sp.* **12** *Legousia sp.*
**1-5** Ragwort · Greiskraut · Séneçon **8** Everlasting flower · Strohblume · Hélichryse **9** Buckthorn · Kreuzdorn · Nerprun **10-11** Wood-sorrel · Sauerklee · Surelle **12** Venus's looking-glass · Frauenspiegel · Miroir-de-Vénus

2 Compositae **3** *Helichrysum*
**4-5** Proteaceae **6** *Genista*
**2** Sunflower family ·
Korbblütler · Composées
**3** Everlasting flower ·
Strohblume · Hélichryse
**4-5** Protea family ·
Silberbaumgewächse ·
Protéacées **6** Greenweed ·
Ginster · Genêt

TAB. XXIII.

Fig. 2.

Fig. 3.

Fig. 5.

Fig. 6.

Fig. 1.

Fig. 2.

Fig. 3.

Fig. 4.

TAB. *XXIIII.*

Fig. 5.

Fig. 6.

**3** *Aspalathus* **4-6** Leguminosae
**3** Tea rooibos · Rotbusch ·
Thé rooibos **4-6** Pea family ·
Hülsenfruchtgewächse ·
Légumineuses

1-2 *Palmae*
**1-2** Palm family · Palmengewächse · Palmacées

TAB. XXV.

Fig. 1.

Fig. 2.

A

B

1 *Asclepias sp.* 2 *Pelargonium sp.*
3 *Ludvigia sp.* **4-5** *Ophrys sp.*
**1** Milk-weed · Seidenpflanze ·
Asclépiade **2** Stork's-bill ·
Pelargonie · Pélargonium
**3** Hampshire purslane ·
Heusenkraut · Ludwigie
**4-5** Spider orchids · Ragwurz ·
Ophrys

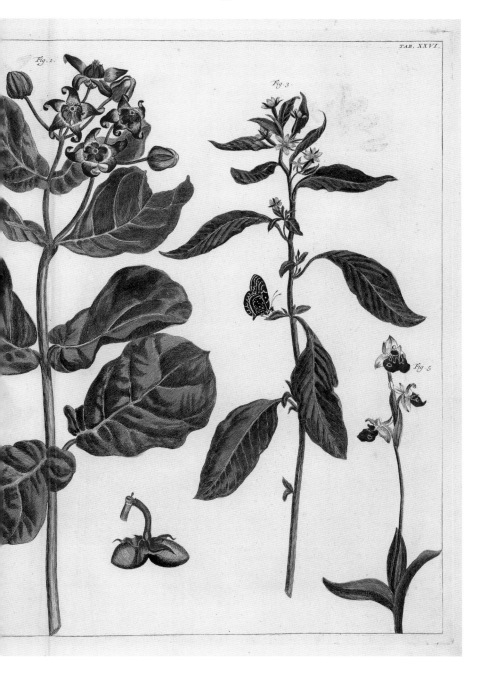

TAB. XXVI.

Fig. 1.

Fig. 3.

Fig. 5.

2 *Corylus sp.* 3 *Paliurus sp.*
2 Hazel · Hasel · Noisetier
3 Christ's thorn · Christdorn · Paliure

TAB. XXVII.

Fig. 1.

Fig. 2.

Fig. 3.

TAB. XXVIII.

1 *Broussonecia papyrifera*
2 *Homalopsis buccata*
1 Paper mulberry ·
Papiermaulbeerenbaum ·
Mûrier à papier
2 Masked water snake ·
Boa-Wassertrugnatter ·
Homalopside joufflu

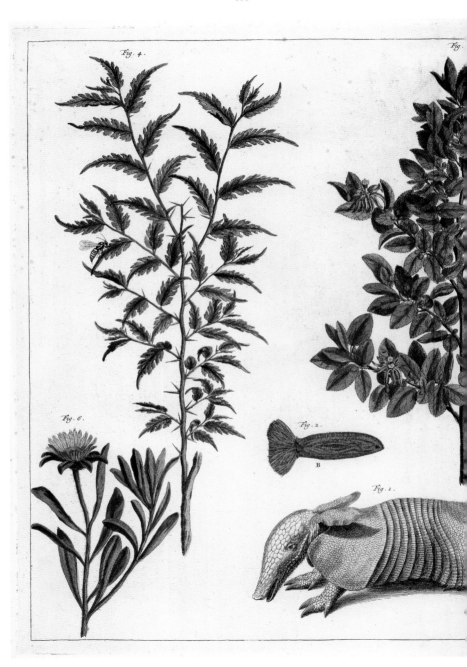

Fig. 5.

TAB. XXIX.

1 *Dasypus novemcinctus*
3 *Grewia occidentalis*
6 Mesembryanthemaceae
7 *Asteriscus sp.*
1 Nine-banded armadillo ·
Neunbinden-Gürteltier ·
Tatou à neuf bandes
3 Crossberry · Grewie ·
Greuvier 6 Ice plant ·
Eiskrautgewächse ·
Mésembryanthémacée
7 Asteriscus · Asteriskus ·
Astérolide

Fig. 7.

Fig. 1.

Fig. 4.

TAB. XXX.

*Fig. 5.*

*Fig. 2.*

1 Herpestidae? 2 Felidae
3 *Cabassous unicinctus*
4 *Dasypodidae*
5 *Terpsiphone paradisi*
1 Mongoose · Mungo ·
Mangouste 2 Felines ·
Katzenartige · Félidés
3 Northern naked-tailed
armadillo · Nacktschwanz-
Gürteltier · Tatou à onze
bandes 4 Armadillo ·
Gürteltier · Tatou
5 Asian paradise-flycatcher
(dark variety) · Fahlbauch-
paradiesschnäpper
(dunkle Form) · Tchitrec
de Paradis (espèce sombre)

1-8 *Marmosa sp.* 9 *Rattus rattus* 10 *Merops nubicus*
**1-8** Mouse opossums ·
Mauszwergbeutelratten ·
Sarigues **9** House rat · Skelett
der Hausratte · Rat noir
**10** Carmine bee-eater ·
Scharlachspint · Guêpier
superbe

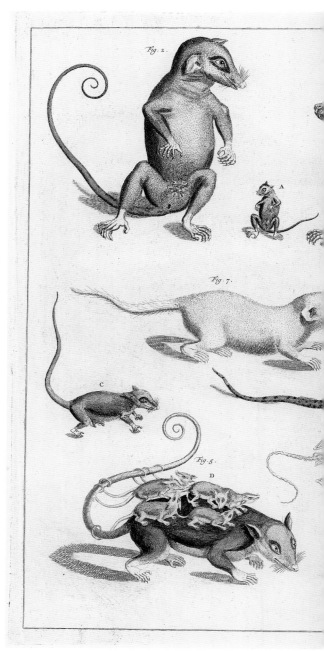

TAB. XXXI.

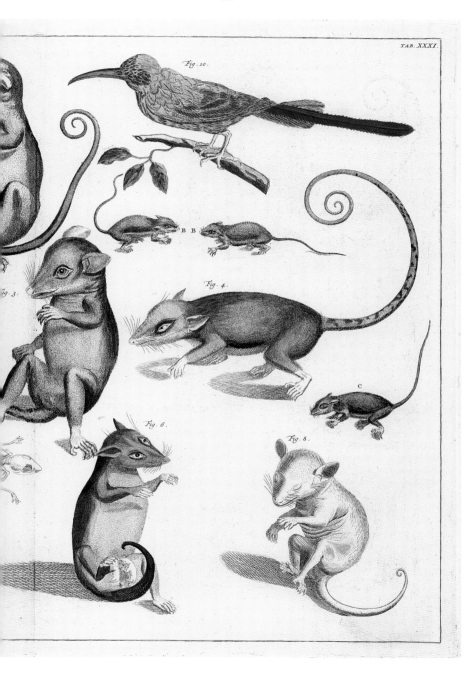

1 *Choloepus didactylus*
1 Two-toed tree sloth · Zweizehen-Faultier · Paresseux à deux doigts

TAB. XXXIV.

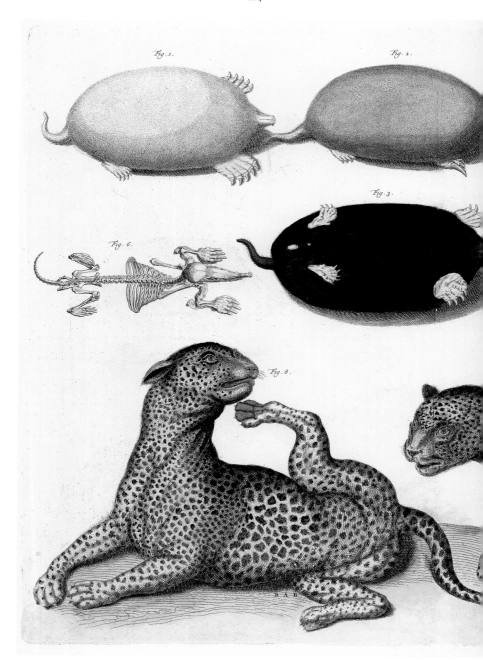

Fig. 1.

Fig. 2.

Fig. 3.

Fig. 6.

Fig. 8.

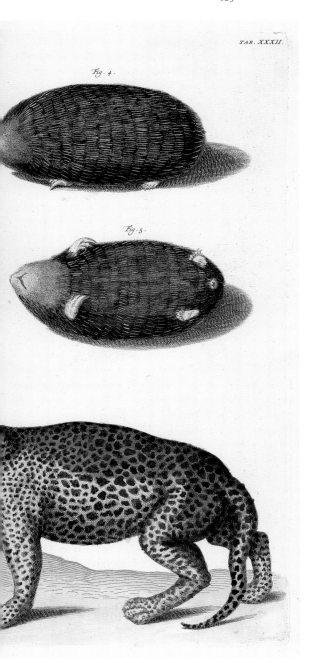

TAB. XXXII.

Fig. 4.

Fig. 5.

**1, 6** *Talpa europaea* **2** *Talpa sp.*
**3** *Scalopus aquaticus*
**4-5** *Chrysochloris sp.*
**7-8** *Acinonyx jubatus*
**1, 6** Eurasian common mole ·
Maulwurf · Taupe commune
**2** Mole · Maulwurf · Taupe
**3** Eastern American mole ·
Ostamerikanischer Maulwurf ·
Taupe à queue glabre
**4-5** Golden mole · Goldmull ·
Chrysochloridé **7-8** Cheetahs ·
Geparde · Guépards

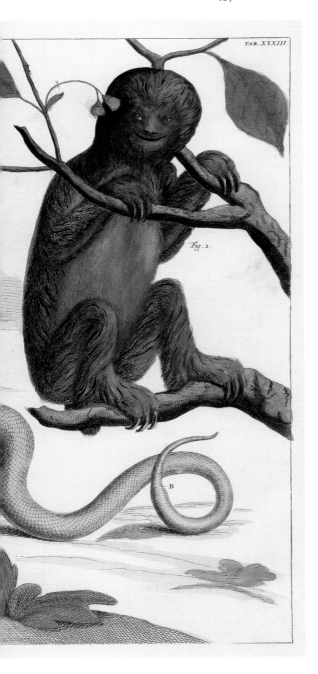

*TAB. XXXIII.*

*Fig. 2.*

1 *Saimiri sciureus*
2 *Bradypus tridactylus* 3 *Camphora*
4 *Choloepus didactylus*
5 *Vipera berus* 6 Serpentes
1 Squirrel monkey ·
Totenkopfäffchen · Sapajou
jaune 2 Three-toed tree sloth ·
Dreizehen-Faultier · Paresseux
à trois doigts 3 Camphor tree ·
Kampferbaum · Cannelier
camphrier 4 Two-toed tree
sloth · Zweizehen-Faultier ·
Paresseux à deux doigts
5 Common viper ·
Kreuzotter · Vipère péliade
6 Snake, according to Seba from
Ceylon · Schlange, nach Seba
aus Ceylon · Serpent, de Ceylan
selon Seba

**1-2** *Loris tardigradus* **3** Menispermaceae **4** Serpentes
**1-2** Slender loris · Schlankloris · Loris grêle **3** Moonseed Family · Mondsamengewächse ·
Ménispermacées **4** Snake, according to Seba from Ceylon · Schlange,
nach Seba aus Ceylon · Serpent, de Ceylan selon Seba

TAB. XXXV

Fig. 3.

Fig. 1.

Fig. 2.

A

B

**1-3** *Philander opossum* **4** *Caluromys philander* **5** *Boa constrictor* **7** *Cotinus*
**1-3** Gray four-eyed opossum ·
Graue Vieraugenbeutelratte ·
Sarigue à quatre yeux
**4** Woolly opossum · Wollhaar-
beutelratte · Opossum jaune
**5** Common boa · Abgott-
schlange · Boa constricteur
**7** Smoke-tree · Perückenstrauch ·
Arbre à perruque

TAB. XXXVI.

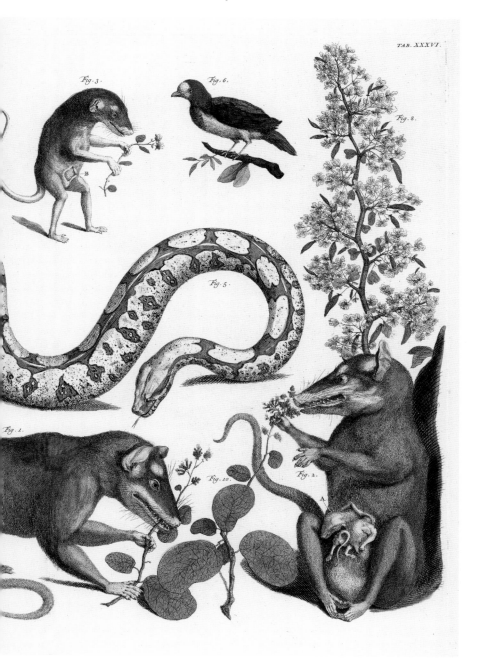

Fig. 3.

Fig. 6.

Fig. 8.

Fig. 5.

Fig. 1.

Fig. 10.

Fig. 2.

B

A

1 Pythonidae 2 *Tamandua
tetradactyla* 3 *Cyclopes didactylus*
4 *Chrysolampis mosquitus* 5 *Erica sp.*
1 Python · Python · Python
2 Lesser anteater · Kleiner
Ameisenbär · Tamandua à quatre
doigts 3 Silky anteater ·
Zwergameisenbär · Fourmilier
didactyle 4 Ruby-topaz
hummingbird · Moskitokolibri ·
Colibri rubis-topaze
5 Heath · Heide · Bruyère

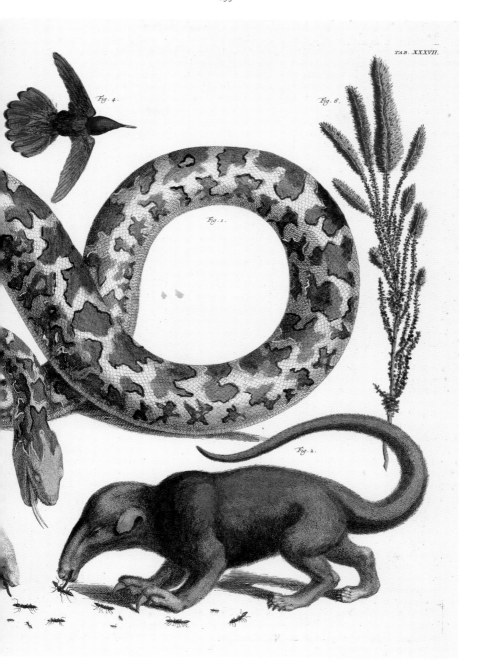

TAB. XXXVII.

Fig. 4.

Fig. 6.

Fig. 1.

Fig. 2.

1 *Didelphis marsupialis*
1 Southern common opossum · Beutelratte · Opossum commun

TAB. XXXIX.

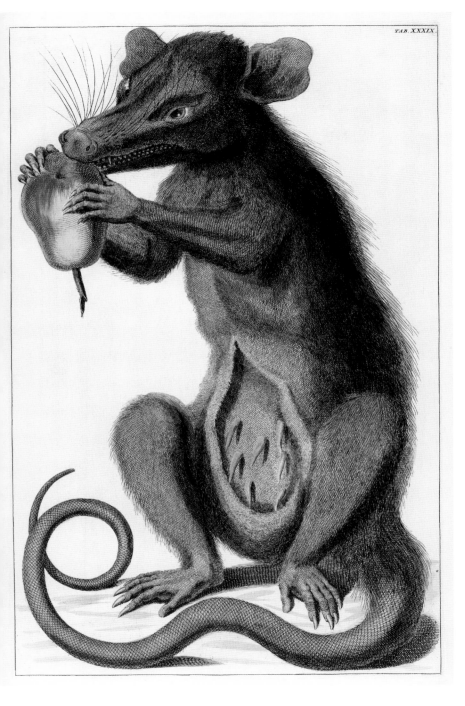

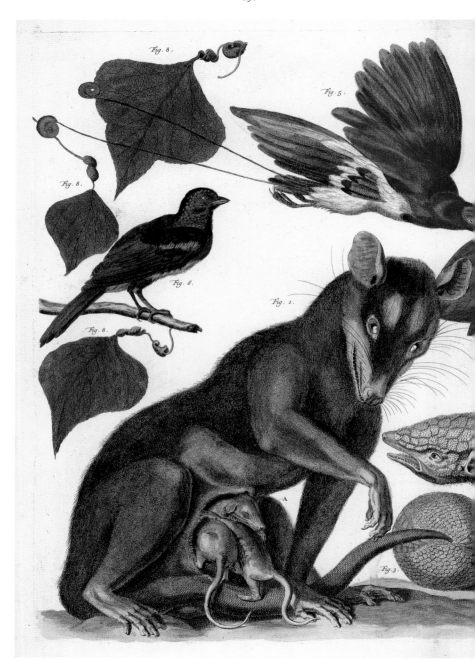

Fig. 8.

Fig. 5.

Fig. 8.

Fig. 8.

Fig. 6.

Fig. 1.

Fig. 8.

A.

Fig. 3.

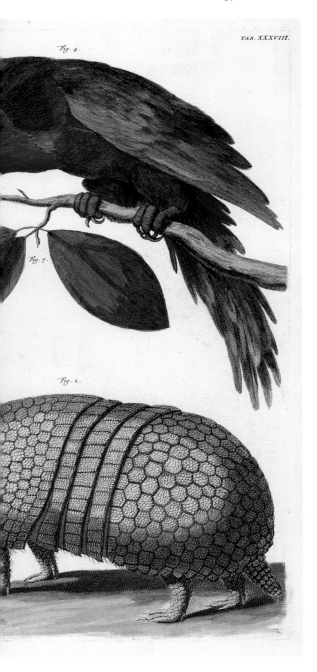

TAB. XXXVIII.

*Fig. 4.*

*Fig. 7.*

*Fig. 2.*

1 *Metachirus nudicaudatus*
2-3 *Tolypeutes tricinctus* 4 *Lorius
lory* 5 *Cicinnurus regius*
1 Brown four-eyed opossum ·
Braune Vieraugenbeutelratte ·
Sarigue à quatre yeux
2-3 Three-banded armadillo ·
Kugelgürteltier · Tatou à trois
bandes 4 Black-capped Lory ·
Frauenlori · Lori tricolore
5 King bird of paradise ·
Königsparadisvogel ·
Paradisier royal

Fig. 2.

TAB. XI.

Fig. 1.

**1** *Tamandua tetradactyla*
**2** Herpestidae/Viveridae?
**1** Lesser anteater · Kleiner
Ameisenbär · Tamandua à
quatre doigts **2** Mongoose:
Slender-tailed meerkat ·
Schleichkatze: Erdmännchen ·
Viverridé: Suricate

1 Herpestidae 2 *Myoprocta
exilis* 3 *Glaucomys volans*
4 *Talpa europaea*
1 Mongoose · Mungo ·
Mangouste 2 Red acouchi ·
Acouchi · Acouchi
3 Southern flying squirrel ·
Gleithörnchen · Ecureuil
volant du Sud 4 Eurasian
common mole · Maulwurf ·
Taupe commune

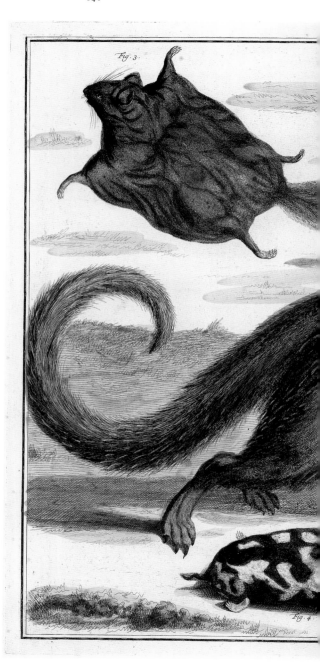

TAB. XLI.

*Fig. 2.*

*Fig. 1.*

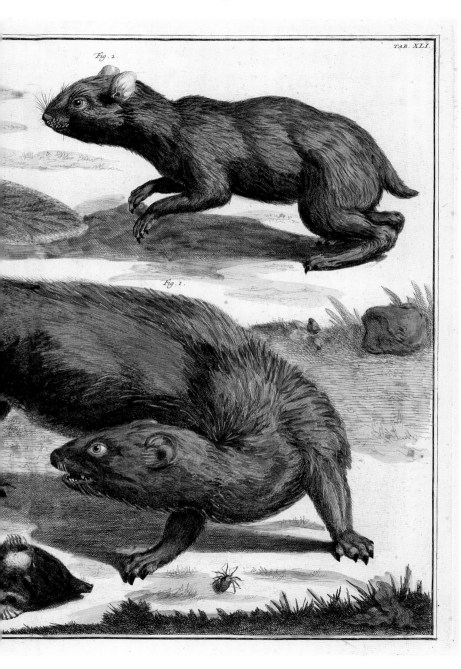

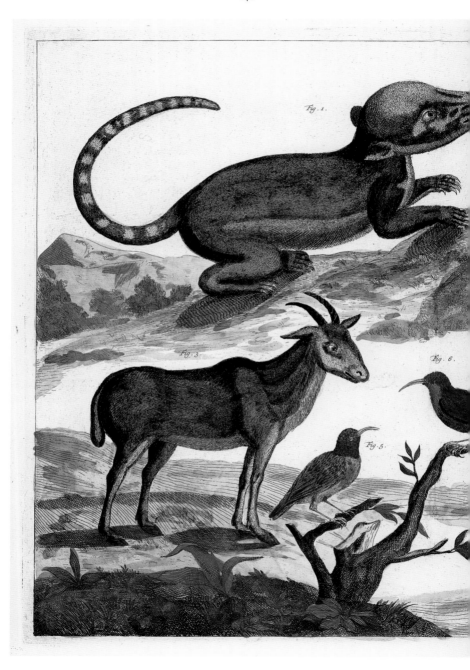

*Fig. 1.*

*Fig. 3.*

*Fig. 6.*

*Fig. 5.*

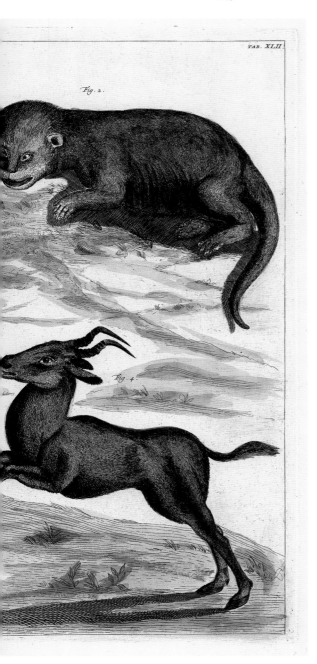

TAB. XLII.

*Fig. 2.*

*Fig. 4.*

1 *Nasua nasua* 2 Pteronura
brasiliensis 3 Bovidae
4 Antilopinae?
1 Coati · Nasenbär ·
Coati roux 2 Giant otter ·
Riesenotter · Loutre géante
du Brésil 3 Bovides · Bovide ·
Boviné 4 Antilopine ·
Antilope · Antilopiné

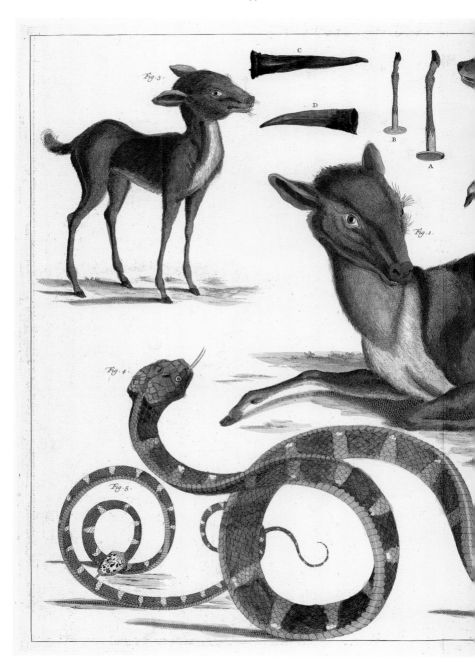

TAB. XLIII.

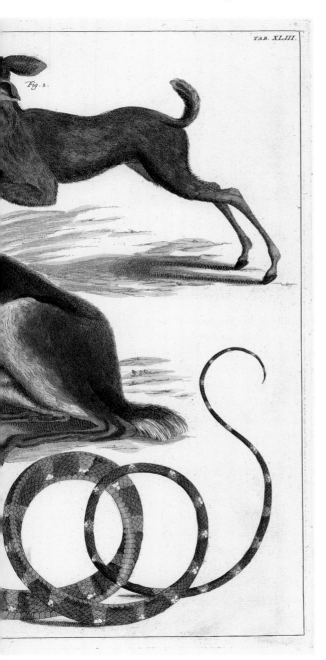

*Fig. 2.*

**1, 3** Cervidae **2** Bovidae
(Caprinae? Antelopinae?)
**4-5** *Dipsas indica*
**1, 3** Deers · Hirsche · Cerfs
**2** Bovide (Caprine?
Antelopinae?) · Rinderartiges
Säugetier (Caprinae?
Antelopinae?) · Bovidé
(Capriné? Antilopiné?)
**4-5** Snail-eating snakes ·
Dipsas-Schlangen · Dipsas,
serpents mangeurs
d'escargots

**1** *Naja naja* **2** Cervidae
**3** *Hylopetes* **4-5** *Urginea maritima*
**1** Indian cobra · Brillen-
schlange · Cobra des Indes
**2** Deer · Hirsch · Cerf
**3** Arrow-tailed flying squirrel ·
Gleithörnchen · Ecureuil
volant **4-5** Squill ·
Meerzwiebel · Scille

TAB. XLIIII.

Fig. 3.

Fig. 6.

C

B

A

Fig. 5.

Fig. 4.

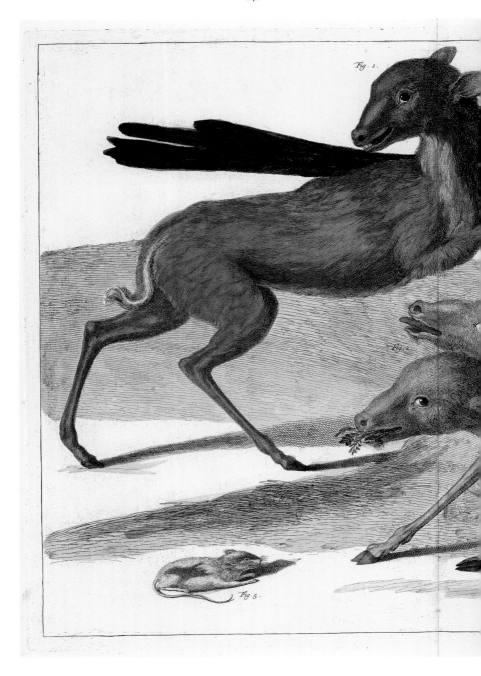

Fig. 1.

Fig. 2.

Fig. 5.

TAB. XLV.

Fig. 3.

1-2 Cervidae 3 Cuculiformes
4 Lepidoptera 5 *Mus sp.*
1 Deer · Hirsch · Cerf 2 Siamese
deer twins · Siamesische
Zwillinge von Hirschen · Frères
siamois de cerfs 3 Cuculiform
bird · Kuckucksvogel · Oiseau
cuculiforme 4 Lepidopteran
caterpillar · Schmetterlingsraupe ·
Larve de papillon
5 Mouse · Maus · Souris

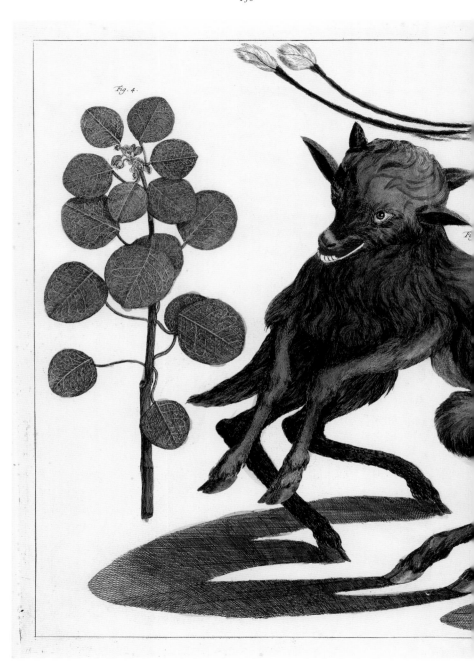

Fig. 4.

TAB. XLVI.

Fig. 3.

Fig. 2.

1 *Capra* 2 *Felis* 3 *Tanysiptera galatea* 4 Euphorbiaceae
1 Siamese goat twins · Siamesische Zwillinge von Ziegen · Frères siamois de chèvres 2 Siamese twins of young small cats · Siamesische Zwillinge von jungen Katzenartigen · Frères siamois de chats 3 Common paradise-kingfisher · Spatelliest · Martin-chasseur à longs brins 4 Spurge family · Wolfsmilchgewächs · Euphorbiacées

1 *Loris tardigradus* 2 Sciuridae 3 *Funambulus tristriatus* 4 *Mus sp.*
1 Slender loris · Schlanklori · Loris grêle 2 Tree squirrel · Hörnchen · Ecureuil
3 Asiatic striped palm squirrel · Palmenhörnchen · Ecureuil palmiste
4 Mouse · Maus · Souris

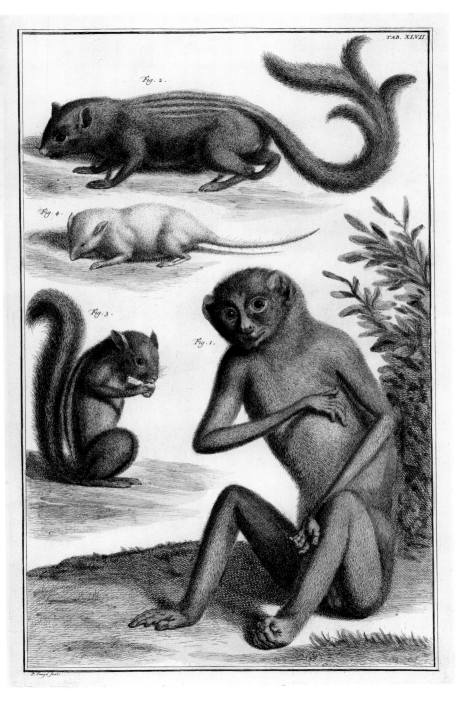

TAB. XLVII.

Fig. 2.

Fig. 4.

Fig. 3.

Fig. 1.

P. Tanjé Sculp.

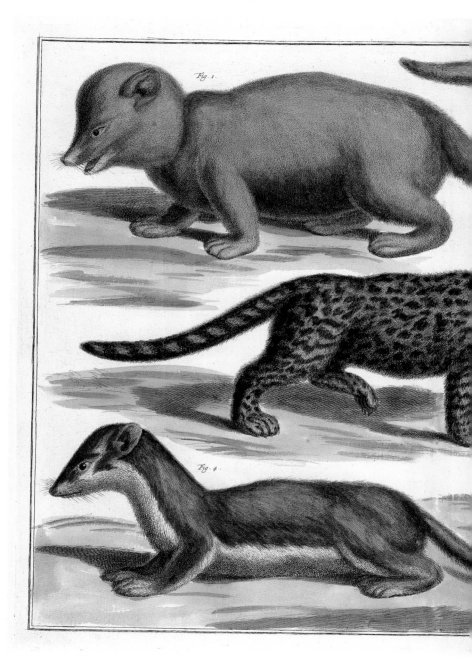

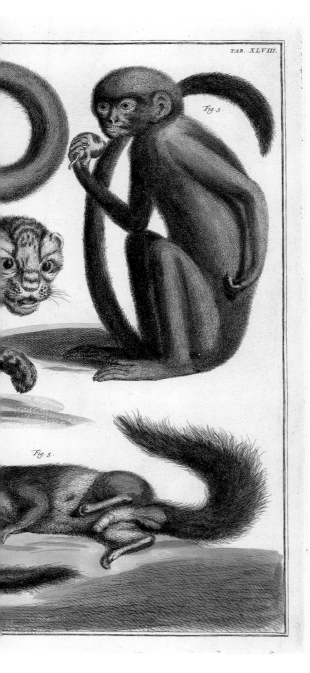

TAB. XLVIII.

*Fig. 3.*

*Fig. 5.*

1 Viverridae 2 *Felis*
3 *Cercopithecus mitis* 4 *Mustela
erminea* 5 *Sciurus*
1 Civet · Zibetkatze · Civette
2 Small cat · Katzenartige ·
Chat 3 Blue monkey ·
Diademmeerkatze ·
Cercopithèque diadème
4 Ermine · Hermelin ·
Hermine 5 Tree squirrel ·
Hörnchen · Ecureuil

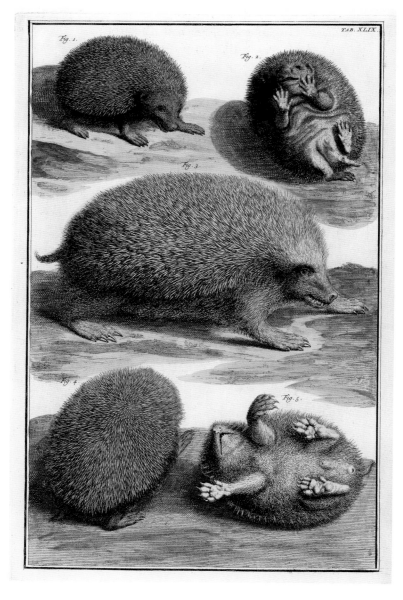

*1-2* Erinaceus europaeus *3-5* Erinaceus sp.
**1-2** Hedgehogs · Igel · Hérissons communs
**3-5** Hedgehogs · Igel · Hérissons

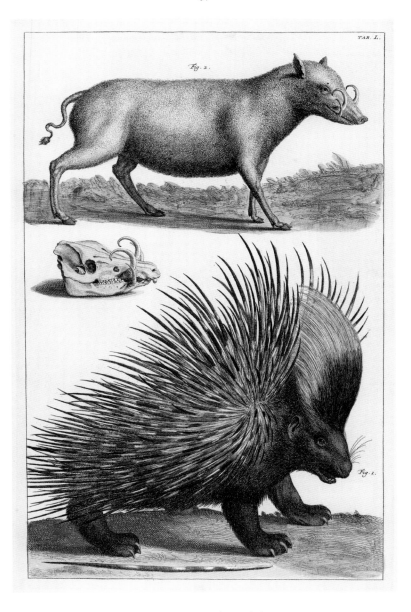

1 *Hystrix cristata* 2-3 *Babyrousa babyrussa*
1 Porcupine · Stachelschwein · Porc-épic à crête
2-3 Babirussa · Hirscheber · Babiroussa

1-2 *Hystrix brachyura*
6 *Struthio camelus*
1-2 Malayan porcupines ·
Stachelschweine · Porcs-épics
6 Ostrich · Strauß · Autruche
d'Afrique

TAB. LI.

Fig. 7.

Fig. 6.

Fig. 1.

A

A

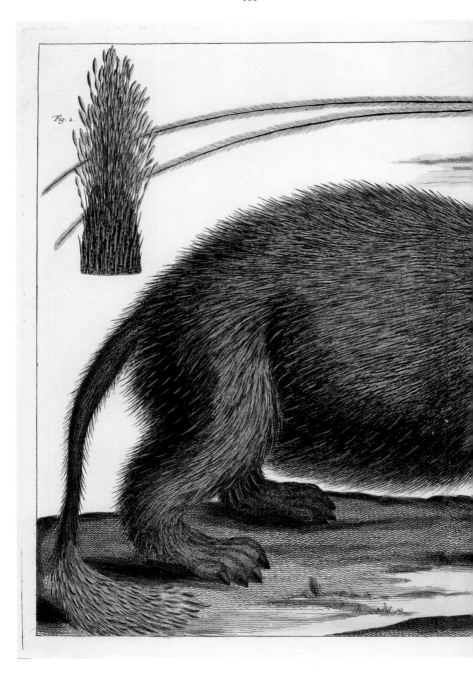

Fig. 2.

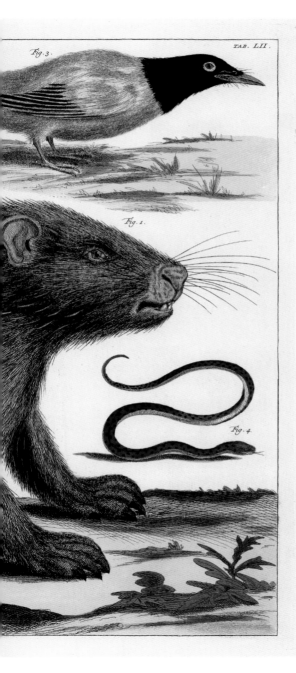

*TAB. LII.*

*Fig. 3.*

*Fig. 1.*

*Fig. 4.*

1-2 *Trichys fasciculata* 3 *Terpsiphone paradisi* 4 Crotalus
**1-2** Long-tailed porcupine ·
Malayischer Pinselstachler ·
Porc-épic à longue queue
**3** Asian paradise-flycatcher
(dark version) · Fahlbauch-
paradiesschnäpper
(dunkle Form) · Tchitrec de
Paradis (plumage sombre)
**4** Red diamond rattlesnake ·
Rote Diamantklapperschlange ·
Crotale rouge

1 *Boa constrictor* 2 *Guaiacum sp.*
3 Alcedinidae 5 *Manis sp.*
6 *Dasypus novemcinctus*
7 Amphisbaenia sp.?
8 Serpentes 9 Lacertidae
10 Saltatoria: Caelifera
1 Common boa ·
Abgottschlange ·
Boa constricteur
2 Lignum vitae ·
Guajakbaum · Bois de gaïac
2 Kingfisher · Eisvogel ·
Martin-pêcheur 5 Pangolin ·
Schuppentier · Pangolin
6 Nine-banded armadillo ·
Neunbinden-Gürteltier ·
Tatou à neuf bandes
7 Worm lizard · Doppel-
schleiche · Amphisbène
8 Snake, according to Seba
from the Orient · Schlange,
nach Seba aus dem Orient ·
Serpent, d'Orient selon Seba
9 Lizard · Eidechse · Lézard
10 Saltatorian · Kurz-
fühlerschrecke · Sauterelle à
antennes courtes

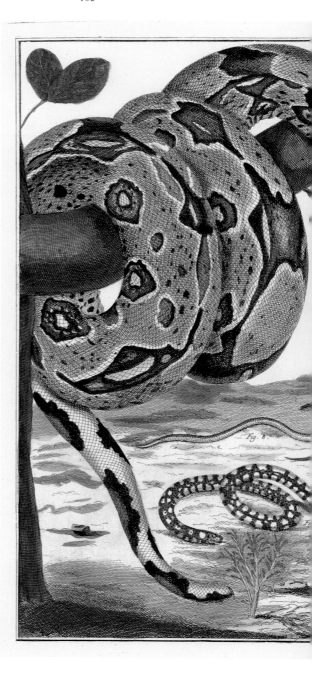

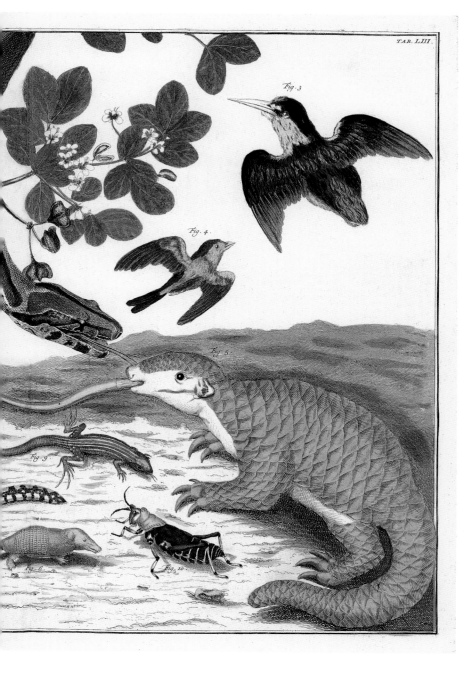

TAB. LIII.

Fig. 3.

Fig. 4.

Fig. 5.

Fig. 9.

Fig. 6.

Fig. 10.

1 *Manis sp.* 2 *Corallus hortulanus*
3 *Psammophis schokari?*
4 Serpentes
1 Pangolin · Schuppentier ·
Pangolin 2 Amazon tree boa ·
Gewöhnliche Hundskopfboa ·
Boa canin 3 Forskål's sand-
snake · Schlanke
Sandrennnatter · Couleuvre des
sables 4 Snake, according to
Seba from Africa · Schlange,
nach Seba aus Afrika ·
Serpent, d'Afrique selon Seba

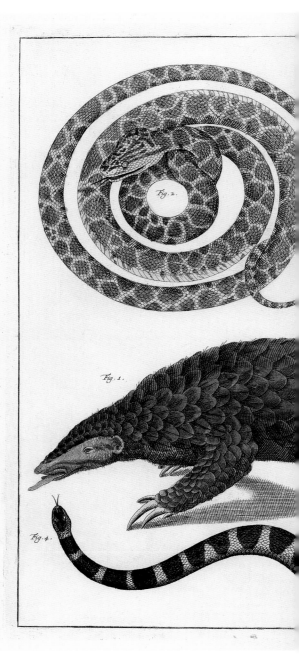

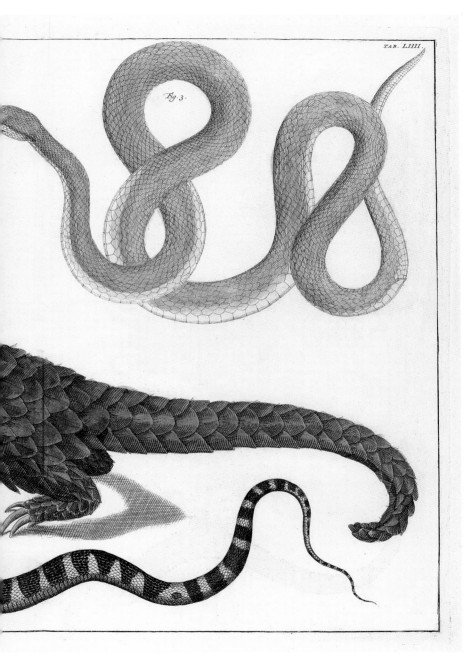

TAB. LIIII.

Fig. 3.

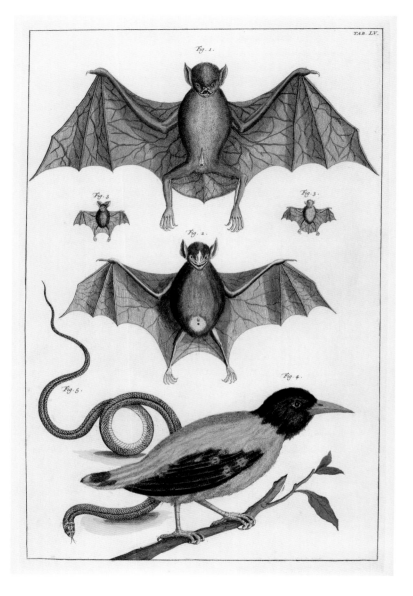

1 *Noctilio sp.* 2 *Carollia perspicillata* 3 Chiroptera 4 *Icterus granduacauda* 5 Serpentes
1 Bulldog bat · Bulldoggen-Fledermaus · Noctilion pêcheuse 2 Seba's short-tailed bat · Blattnase ·
Vespertilion à nez plat 3 Bats · Fledermäuse · Chauve-souris 4 Black-headed oriole (Audubon's Oriole) ·
Schwarzkopftrupial · Oriole d'Audubon 5 Snake, according to Seba from America ·
Schlange, nach Seba aus Amerika · Serpent, d'Amérique selon Seba

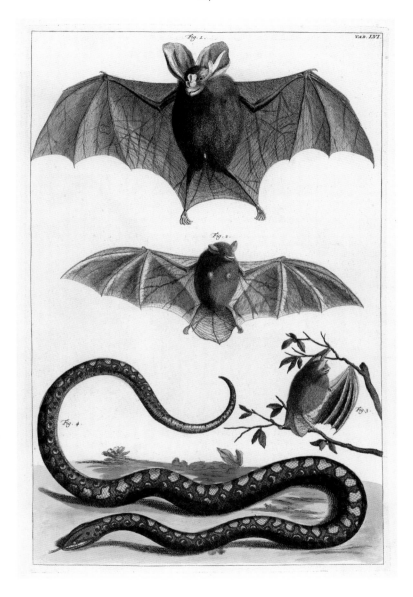

1 Megadermatidae 2-3 *Kerivoula picta* 4 Serpentes
1 False vampire bats · Falscher Vampir · Mégaderme
2-3 Long-winged bats · Langflügel-Fledermäuse · Kerivoules 4 Snake, according to Seba
from Ternate · Schlange, nach Seba aus Ternate · Serpent, de Ternate selon Seba

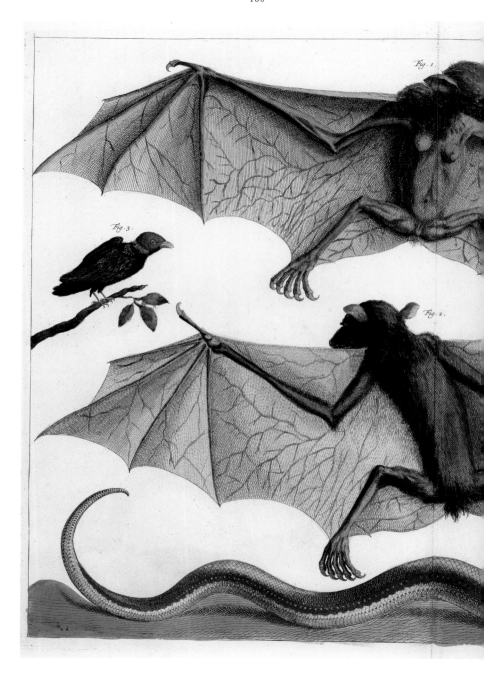

Fig. 1.

Fig. 3.

Fig. 2.

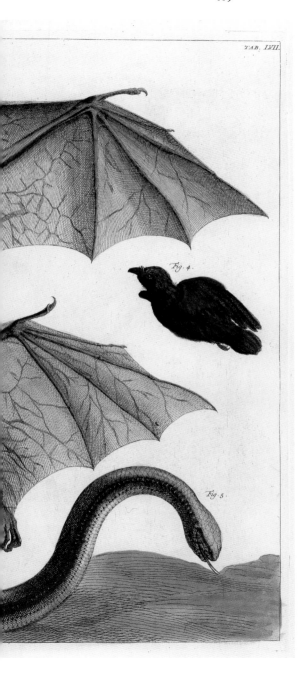

*TAB. LVII.*

*Fig. 4.*

*Fig. 5.*

**1-2** *Pteropus sp.*
**3** *Pipra rubrocapilla*
**5** Homalopsinae
**1-2** Flying foxes · Flughunde ·
Roussettes géantes
**3** Red-headed Manakin ·
Rotkopfpipra ·
Manakin à tête rouge
**5** Homalopsine colubrid snake ·
Wassertrugnatter ·
Homalopsiné

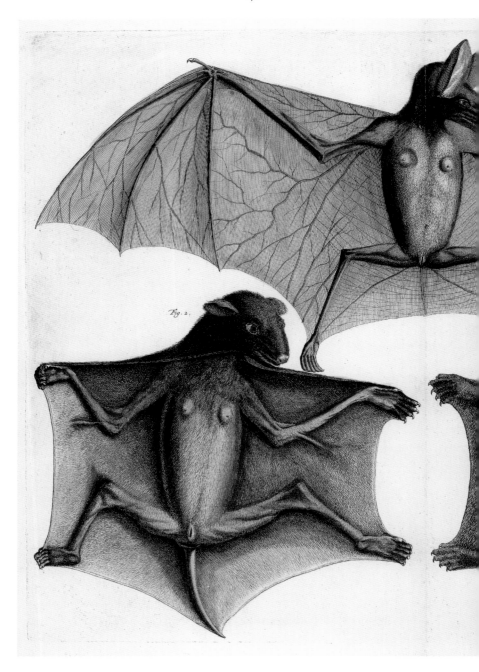

Fig. 2.

TAB. LVIII.

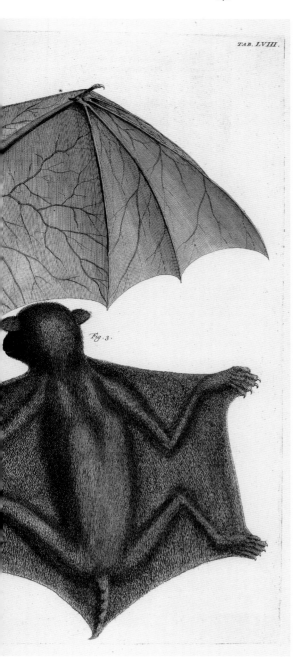

*Fig. 3.*

1 *Vampyrum spectrum*
2-3 *Cynocephalus volans*
1 Spectral bat · Vampir-
Fledermaus · Vampire commun
2-3 Philippine flying lemur ·
Philippinen-Gleitflieger ·
Galéopithèque volant

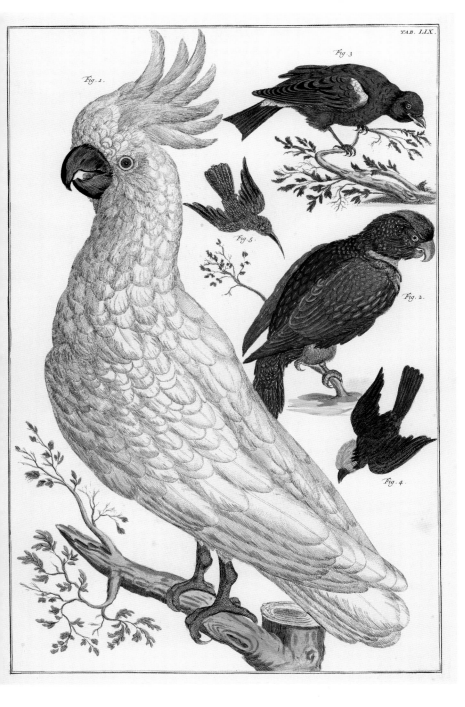

TAB. LIX.

Fig. 1.

Fig. 3

Fig. 5.

Fig. 2.

Fig. 4.

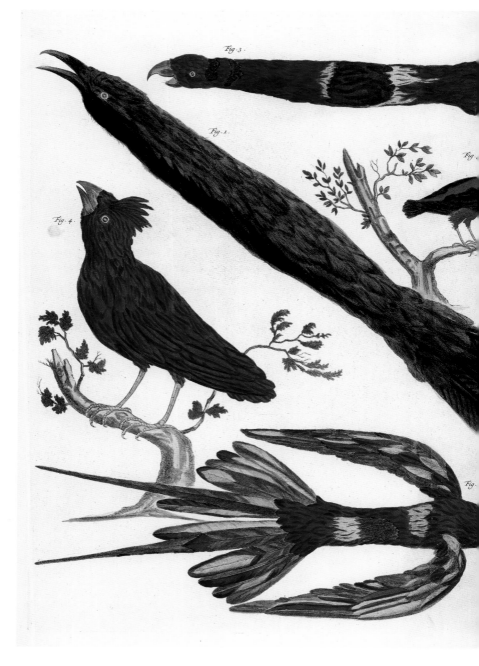

Fig. 3.

Fig. 1.

Fig.

Fig. 4.

Fig.

*TAB. LX.*

*Fig. 6.*

*Fig. 8.*

1 *Quiscalus sp.* **2-3** Psittaculidae
**4** *Cardinalis cardinalis*
**5** *Cyanerpes cyaneus* **6** *Tangara
guttata* **7** *Pipra erythrocephala*
**8** *Pipra rubrocapilla*
**1** Grackle · Grackel · Quiscale
bronzé **2-3** Parrots ·
Edelpapageien · Perroquets
**4** Common cardinal ·
Rotkardinal · Cardinal rouge
**5** Red-legged honeycreeper ·
Türkisnaschvogel · Guit-guit sai
**6** Speckled Tanger · Tropfen-
tangare · Calliste tiqueté
**7** Golden-headed manakin ·
Goldkopfpipra · Manakin
à tête d'or **8** Red-headed
manakin · Rotkopfpipra ·
Manakin à tête rouge

Aves **3** Oriolidae **5** Trochilidae
Various birds · Verschiedene
Vögel · Oiseaux divers
**3** Oriol · Pirol · Merle doré
**5** Hummingbird · Kolibri ·
Colibri

*Fig. 1.*

TAB. LXI.

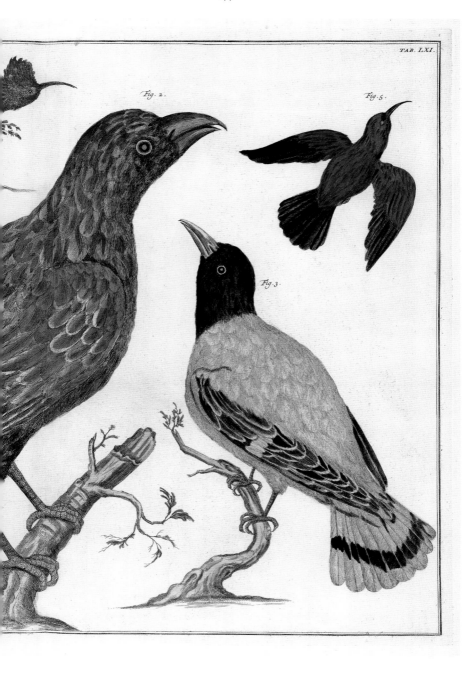

Fig. 2.

Fig. 5.

Fig. 3.

1 *Python regius* 2 *Python reticulatus*
3 *Eudocimus ruber* 4 *Trichixos
pyrrhopyga*
1 Royal python · Königspython ·
Python royal  2 Reticulated
python (pale specimen) ·
Netzpython (helles Exemplar) ·
Python réticulé (exemplaire clair)
3 Scarlet ibis · Scharlachsichler ·
Ibis rouge 4 Rufous-tailed shama ·
Feuerschwanzschama · Shama
à queue rousse

TAB. LXII.

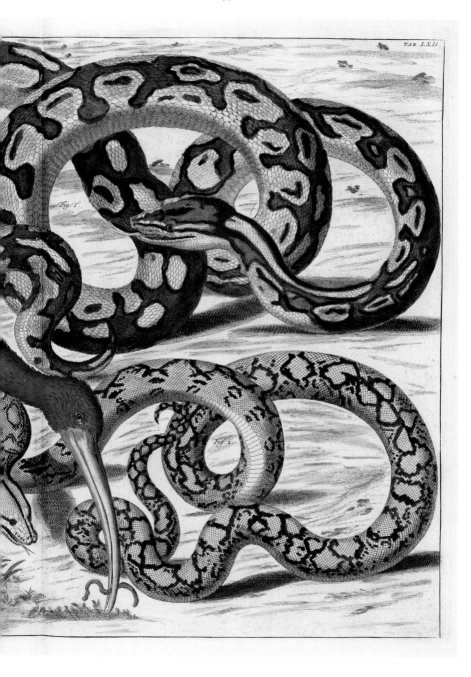

Fig. 1.

Fig. 2.

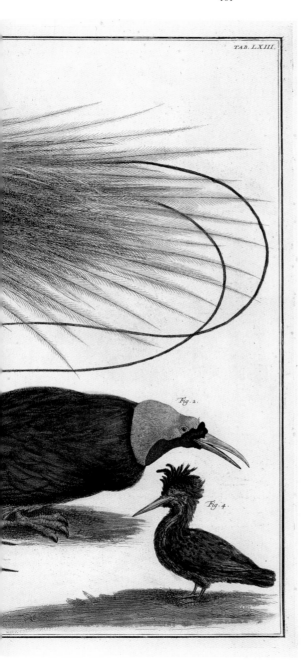

TAB. LXIII.

*Fig. 2.*

*Fig. 4.*

1-2 *Paradisea apoda* 3 Dicaeinae
4 Alcedinidae
1-2 Greater bird of paradise ·
Großer Paradiesvogel · Paradisier
grand-émeraude 4 Kingfisher ·
Eisvogel · Martin-pêcheur

1, 5 *Aves* 2 Rallidae 3 *Picus viridis*
4 *Eupsittula pertinax* 6 Picidae sp.
1, 4-5 Birds · Vögel · Oiseaux
2 Rail · Ralle · Rallidé 3 European
green woodpecker · Grünspecht ·
Pic vert 6 Woodpecker · Specht ·
Pic vert

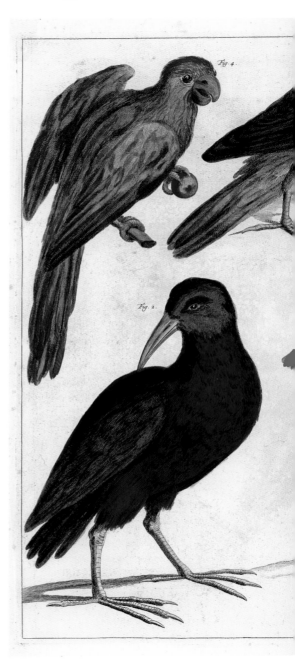

TAB. LXIV.

Fig. 5.

Fig. 6.

Fig. 3.

Fig. 1.

1 *Cyanocompsa brissonii* 2 Picidae 3 Trochilidae
1 Ultramarine grosbeak · Ultramarinbischof · Evêque de Brisson
2 Woodpecker · Specht · Pic vert 3 Hummingbird · Kolibri · Colibri

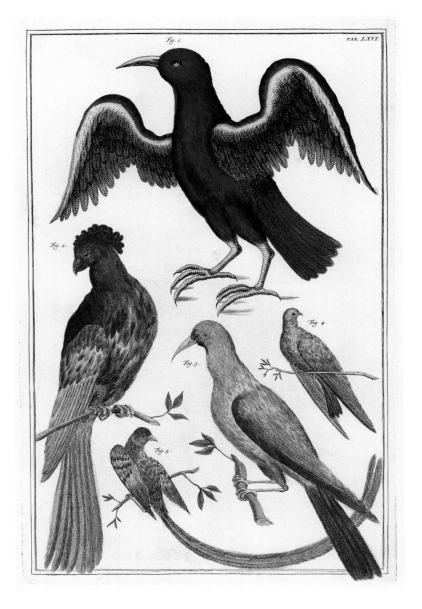

Aves **4** Hirundinidae
Various Birds · Verschiedene Vögel · Oiseaux divers
**4** Swallow · Schwalbe · Hirondelle

1 *Phoenicopterus ruber* 2 Columbidae 4 Alcedinidae
1 Greater flamingo · Flamingo · Flamant rose 2 Pigeons & doves · Taube · Pigeon
4 Kingfisher · Eisvogel · Martin-pêcheur

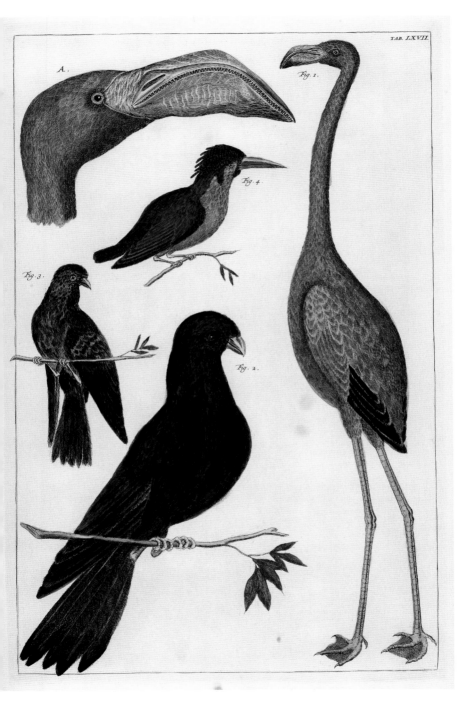

TAB. LXVII.

A.

Fig. 1.

Fig. 4.

Fig. 3.

Fig. 2.

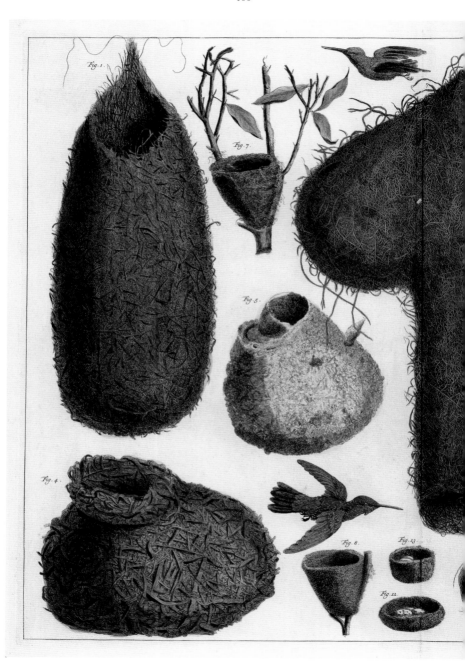

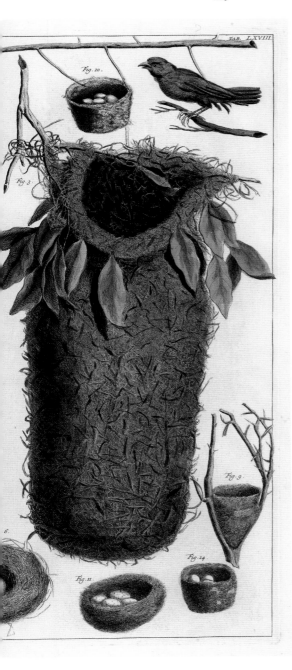

TAB. LXVIII.

Aves
Bird nests · Nester verschiedener
Vogelarten · Nids d'oiseaux

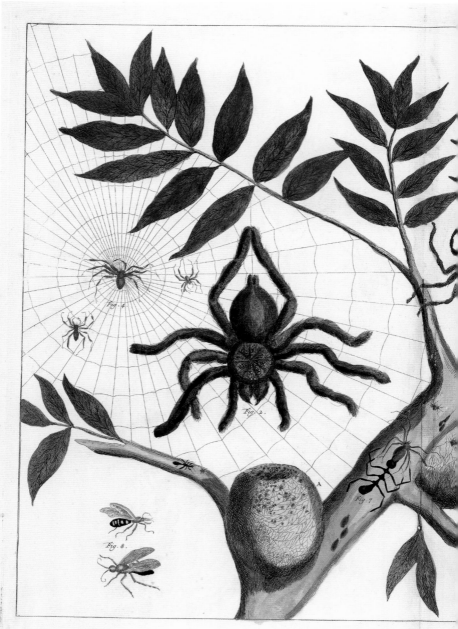

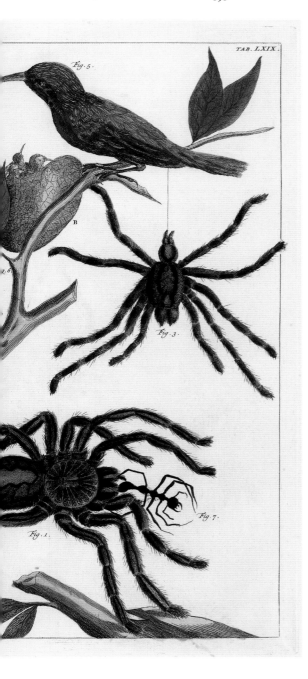

TAB. LXIX.

**1-4** Chelicerata **8** Aculeata
**1-4** Chelicerates · Spinnen-
tiere · Chélicérates **8** Aculeate
hymenopterans · Stechimmen ·
Guêpes piqueuses

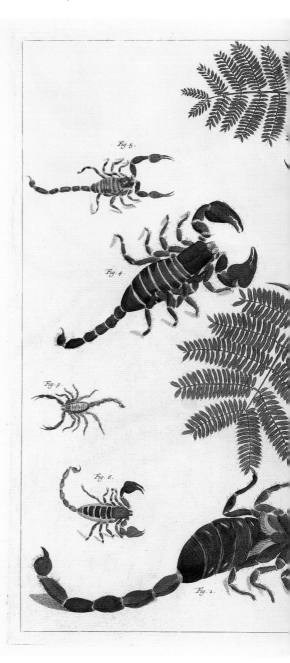

TAB. LXX.

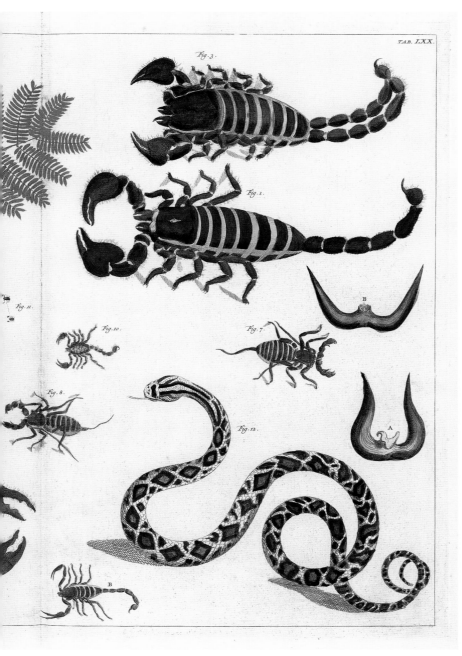

**1-9** Anura
**1-9** Frogs from Africa · Froschlurche aus Afrika ·
Grenouilles d'Afrique

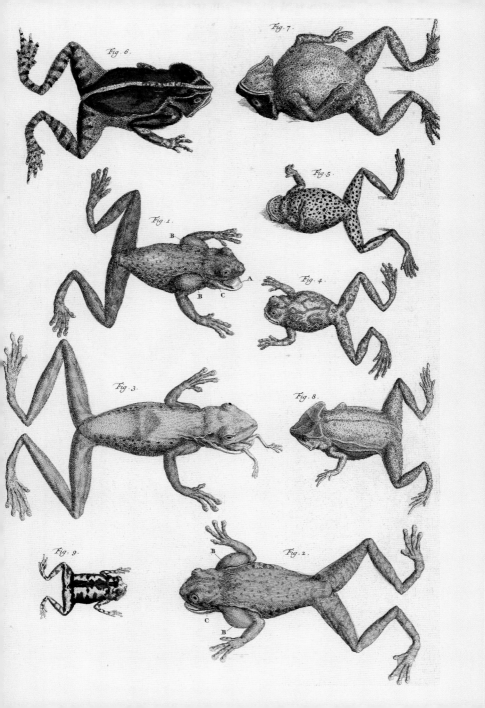

1 *Bufo marinus* 2 Lacertidae
1 Giant toad · Aga-Kröte ·
Crapaud géant 2 Lizard ·
Eidechse · Lézard

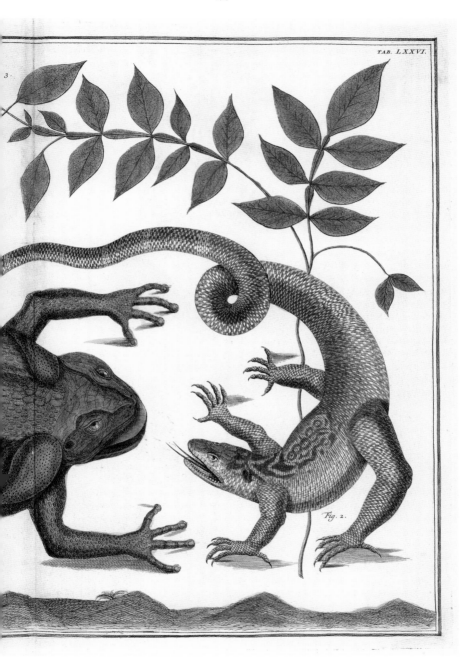

TAB. LXXVI.

3.

Fig. 2.

**1-4** Anura **5** Lacertidae
**6** Serpentes
**1-4** Frogs · Froschlurche ·
Grenouilles **5** Lizard ·
Eidechse · Lézard **6** Snake,
according to Seba from
Virginia · Schlange, nach Seba
aus Virginia · Serpent, de
Virginie selon Seba

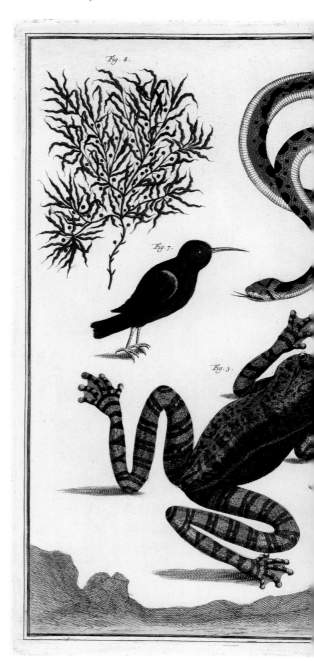

TAB. LXXII.

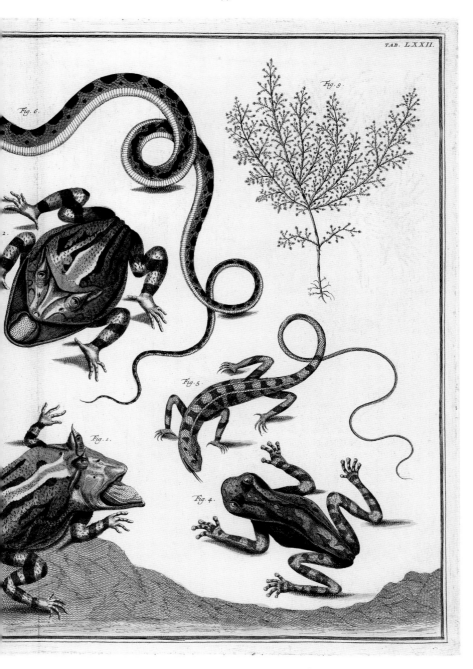

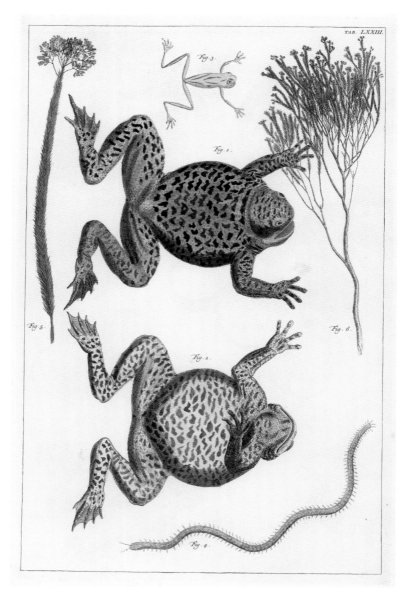

TAB. LXXIII.

**1-2** *Bufo marinus* **3** *Epipedobates tricolor* **4** Chilopoda
**1-2** Giant toad · Aga-Kröte · Crapaud géant
**3** Tree frog · Baumfrosch · Grenouille arboricole
**4** Centipede · Hundertfüßer · Centipède

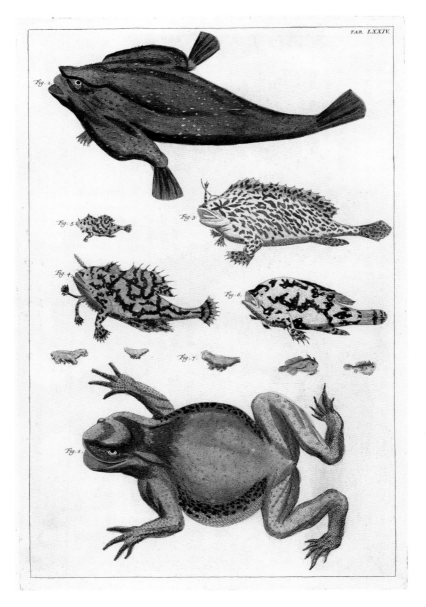

TAB. LXXIV.

1 Anura 2 *Ogcocephalus vespertilio* 3-6 *Histrio histrio* 7 Partem Mollusca?
1 Toad · Froschlurch · Crapaud 2 Longsnout batfish · Langnasen-Seefledermaus · Chauve-souris de mer
3-6 Sargassumfishes · Sargasso-Fische · Pêcheurs des Sargasses 7 Marine snails (partly) ·
Meeres-Nacktschnecken (zum Teil) · Gastéropodes de mer sans coquille (partiellement)

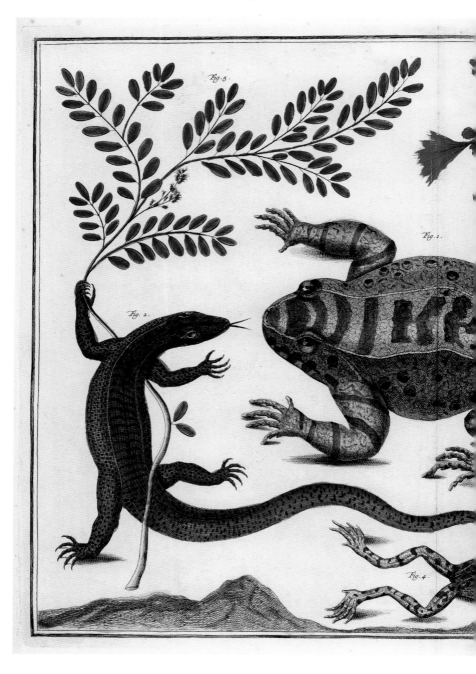

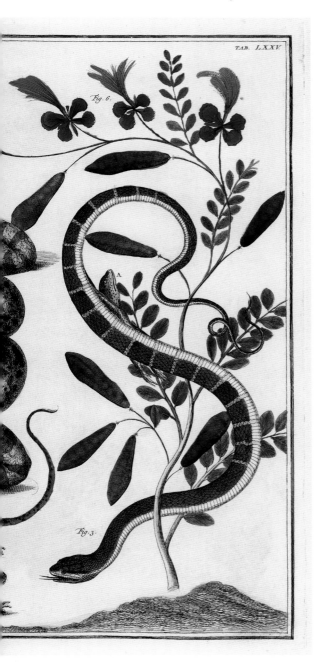

TAB. LXXV.

Fig. 6.

A

Fig. 3.

**1, 4** Anura **2** Lacertidae
**3** Serpentes **5** Plantae
**6** Capparaceae
**1** Toad · Kröte · Crapaud
**2** Lizard · Eidechse · Lézard
**3** Snake, according to Seba
from Virginia · Schlange, nach
Seba aus Virginia · Serpent,
de Virginie selon Seba
**6** Caper family · Kapern-
gewächse · Capparidacées

**1-4** *Pipa pipa*
**1-4** Surinam toad ·
Wabenkröte · Pipa
américain du Surinam

TAB. LXXVII.

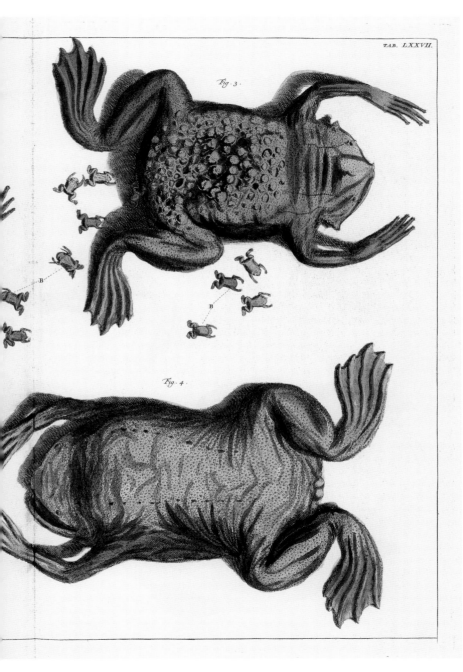

Fig. 3.

Fig. 4.

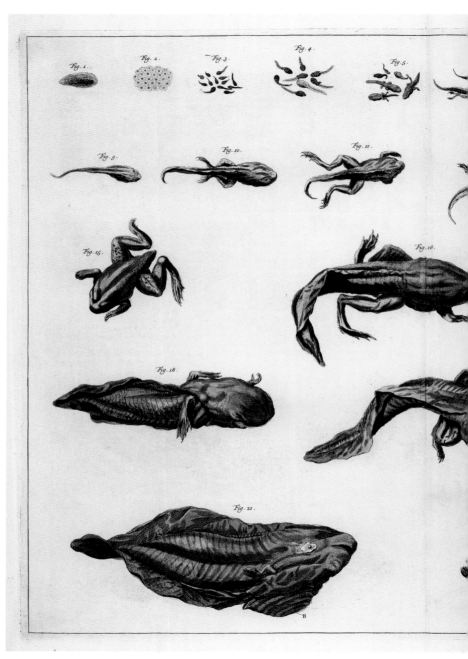

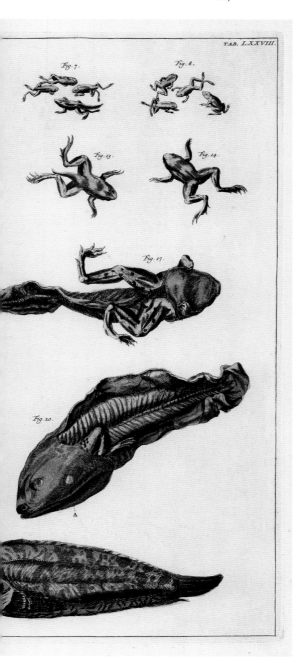

TAB. LXXVIII.

Fig. 7. Fig. 8.

Fig. 13. Fig. 14.

Fig. 17.

Fig. 20.

A

**1-15** Anura **16-21** Anura et pisces
**1-15** Metamorphosis of frogs ·
Metamorphose von Fröschen ·
Métamorphose des grenouilles
**16-21** Fictive metamorphosis
of American frogs into fishes ·
Fiktive Umwandlung
amerikanischer Frösche in
Fische · La métamorphose fictive
des grenouilles en poissons

1-2 *Melanochelys tricarinata* 3 *Geochelone elegans* 4-7 *Chelonia mydas* 8 Ovum
1-2 Three-keeled land tortoise · Landschildkröte · Tortue carinée
3 Star tortoise · Sternschildkröte · Tortue carinée
4-7 Green turtles · Suppenschildkröten · Tortues vertes 8 Egg · Ei · Œuf

TAB. LXXIX.

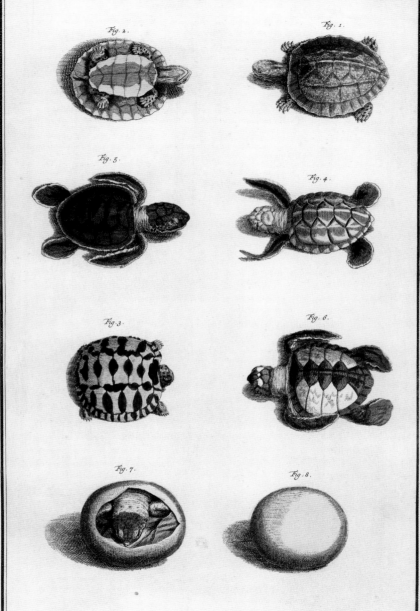

Fig. 2.

Fig. 1.

Fig. 5.

Fig. 4.

Fig. 3.

Fig. 6.

Fig. 7.

Fig. 8.

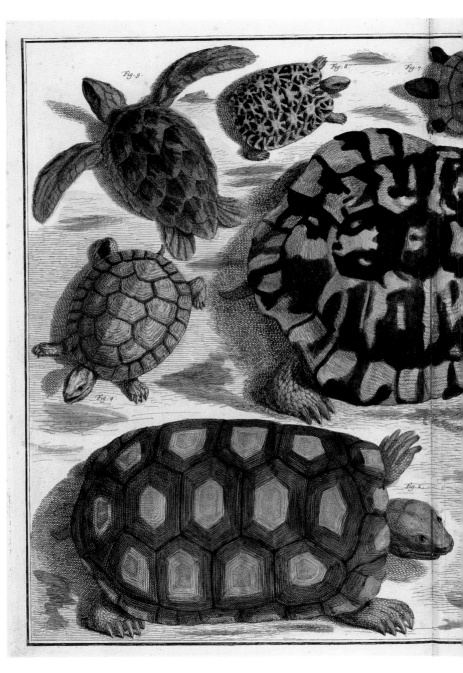

TAB. LXXX.

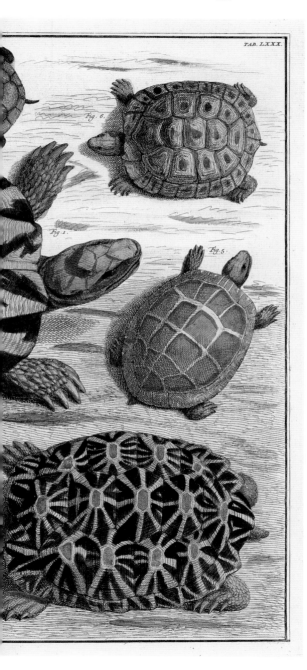

1 *Testudo hermanni* 2 *Geochelone carbonaria* 3 *Geochelone elegans* 4 Chelonia 5 *Chrysemys picta* 6 *Homopus areolatus* 7 *Clemmys guttata* 8 *Homopus sp.* 9 *Eretmochelys imbricata* 1 Greek tortoise · Griechische Landschildkröte · Tortue d'Hermann 2 Red-footed tortoise · Köhlerschildkröte · Tortue charbonnière 3 Star tortoise · Sternschildkröte · Tortue étoilée de l'Inde 4 Tortoise · Schildkröte · Tortue 5 Painted turtle · Zierschildkröte · Tortue peinte 6 Beaked cape tortoise · Papageischnabel-Flachschildkröte · Homopode aérolé 7 Spotted turtle · Tropfenschildkröte · Clemmyde à gouttelettes 8 Cope turtle · Flach-schildkröte · Homopode 9 Hawksbill turtle · Karettschildkröte · Tortue imbriquée

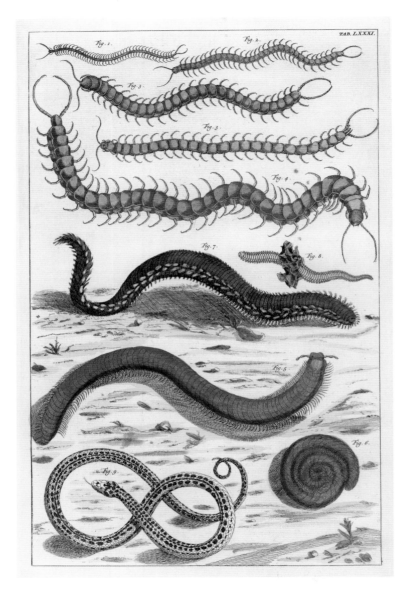

TAB. LXXXI.

1-2 Geophilomorpha 3-4 *Scolopendra* 5-6 Julidae 7-8 Polychaeta 9 Serpentes
1-2 Luminous centipedes · Erdläufer · Centipèdes 3-4 Giant centipedes · Skolopender/Riesenläufer ·
Scolopendres 5-6 Snake millipedes · Schnurfüßer · Mille-pattes 7-8 Bristle worms/Polychaetes ·
Vielborster · Vers marins/Polychètes 9 Snake, according to Seba from America · Schlange, nach
Seba aus Amerika · Serpent, d'Amérique selon Seba

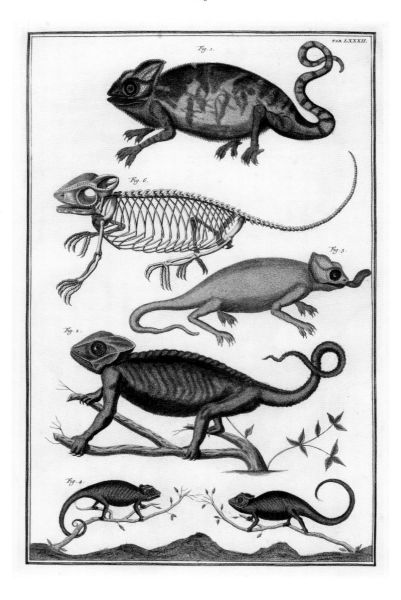

*TAB. LXXXII.*

*Fig. 1.*

*Fig. 6.*

*Fig. 3.*

*Fig. 2.*

*Fig. 4.*

1-3 *Chamaeleo chamaeleon* 4-6 Chamaeleonidae
1-3 Common chameleons · Gewöhnliche Chamäleons · Caméléons communs
4-5 Chameleons · Chamäleons · Caméléons 6 Skeleton of a chameleon ·
Skelett eines Chamäleons · Squelette d'un caméléon

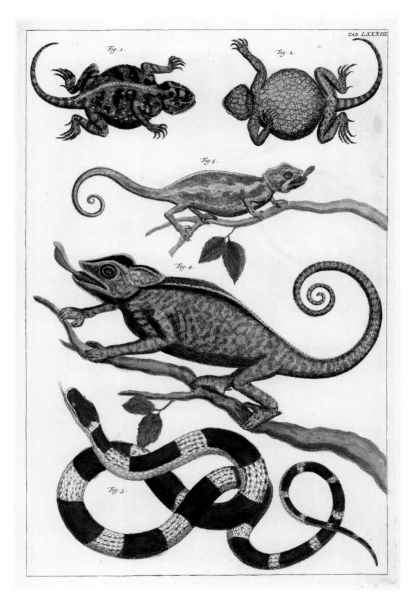

TAB. LXXXIII.

**1-2** Lacertidae **3** Serpentes **4-5** Chamaeleodinae
**1-2** Lizards · Eidechsen · Lézards **3** Snake, according to Seba from Guinea ·
Schlange, nach Seba von Guinea · Serpent, de Guinée selon Seba
**4-5** Chameleons · Chamäleons · Caméléons

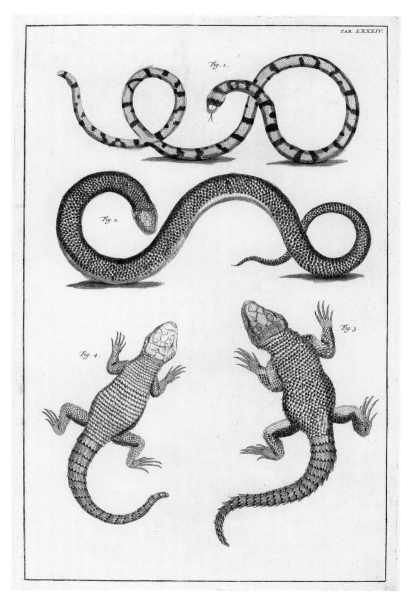

TAB. LXXXIV.

*Fig. 1.*

*Fig. 2.*

*Fig. 3.*

*Fig. 4.*

1 Serpentes 2 Amphisbaenia 3-4 *Agama sp.*
1 Snake, according to Seba from America · Schlange, nach Seba aus Amerika ·
Serpent, d'Amérique selon Seba 2 Burrowing lizard · Doppelschleiche · Amphisbènes
3-4 Agamas (Chisel-teeth lizards) · Agamen · Agamidés

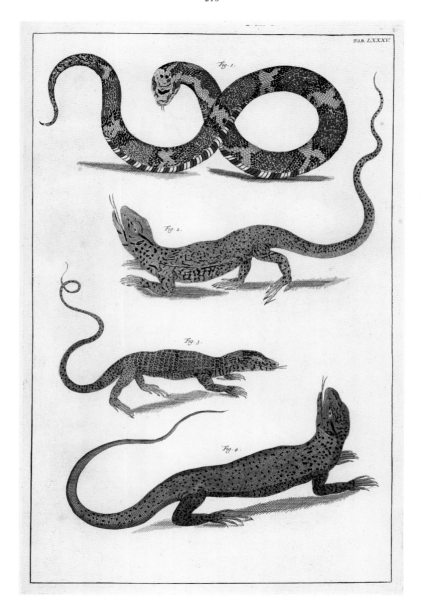

TAB. LXXXV.

*Fig. 1.*

*Fig. 2.*

*Fig. 3.*

*Fig. 4.*

1 Xenodontinae 2-4 Squamata
1 Snake from South America · Südamerikanische Schlange · Serpent d'Amérique du Sud
2-4 Lizards or iguanas · Echsen · Sauriens

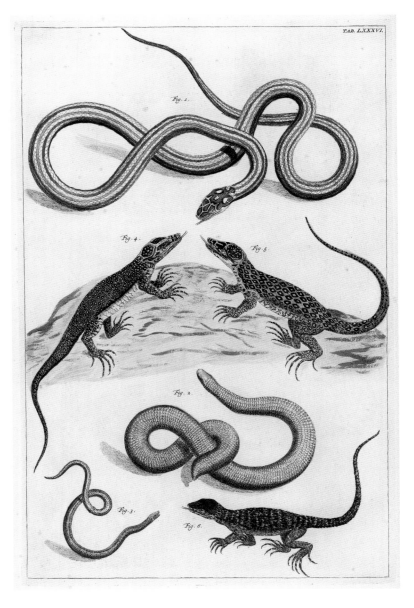

TAB. LXXXVI.

1 Serpentes 2 Typhlopidae 4-6 Squamata
1 Snake, according to Seba from Mauritania · Schlange, nach Seba aus Mauretanien ·
Serpent, de Mauritanie selon Seba 2 Blind snake · Blindschlange · Typhlopidé
4-6 Squamata · Echsen · Squamates

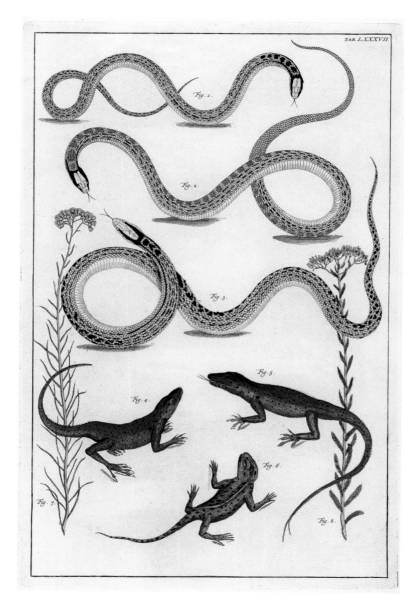

**1-3** Serpentes **4-6** Lacertidae **7** Compositae
**1-3** Snakes, according to Seba from Brazil · Schlangen, nach Seba aus Brasilien ·
Serpents, du Brésil selon Seba **4-6** Lizards · Eidechsen · Sauriens
**7** Sunflower family · Korbblütler · Composées

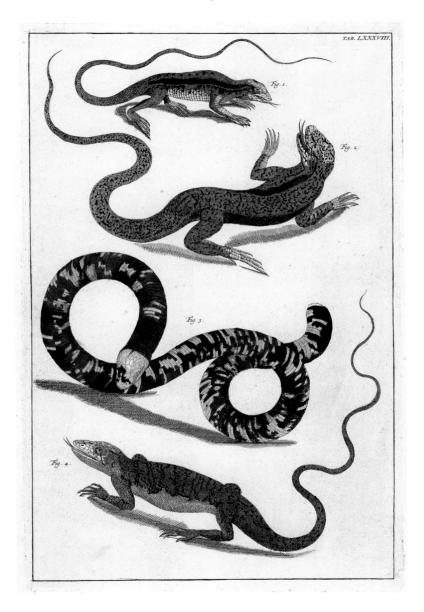

*TAB. LXXXVIII.*

*Fig. 1.*

*Fig. 2.*

*Fig. 3.*

*Fig. 4.*

**1-2, 4** Sauria **3** Amphisbaenia
**1-2, 4** Lizards, iguanas or anoles · Eidechsen, Iguanas oder Anolis · Sauriens, iguanes ou anolis
**3** Worm lizard · Doppelschleiche · Amphisbène

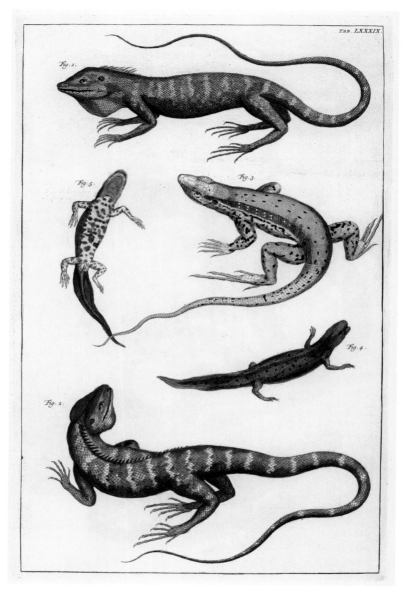

TAB. LXXXIX.

1-2 Iguanidae 3 Sauria 4-5 Salamandridae
1-2 Iguanas or anoles · Leguane oder Anolis · Iguanes ou anolis
3 Lizard · Eidechse · Saurien
4-5 Newts · Molche · Tritons

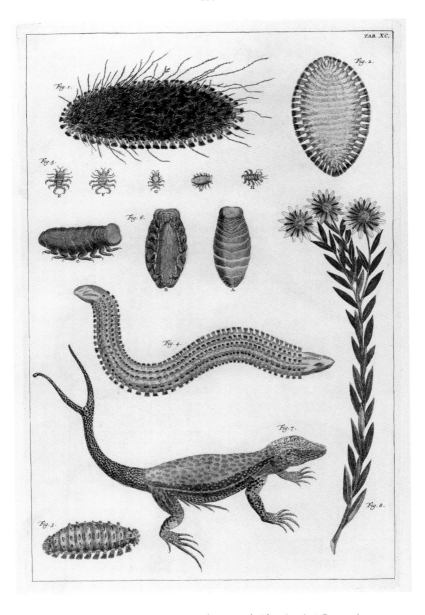

TAB. XC.

1-4 Polychaeta 5 Cyamidae 6 Isopoda: Cymothoida 7 Sauria 8 Compositae
1-4 Sea mice · Seemäuse · Aphrodites épineuses 5 Whale-lice · Wal-Läuse · Crustacéens
6 Isopod · Marine Assel · Crustacéens 7 Lizard · Eidechse · Saurien
8 Sunflower family · Korbblütler · Composées

TAB. XCI.

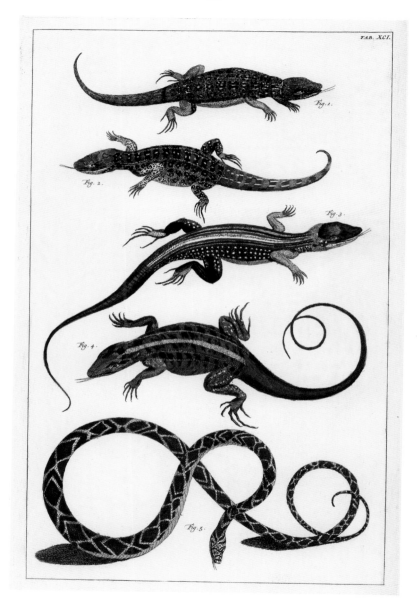

*Fig. 1.*

*Fig. 2.*

*Fig. 3.*

*Fig. 4.*

*Fig. 5.*

1-4 Sauria 5 Serpentes
1-4 Lizards · Eidechsen · Lézards
5 Snake, according to Seba from Brazil · Schlange, nach
Seba aus Brasilien · Serpent, du Brésil selon Seba

TAB. XCII.

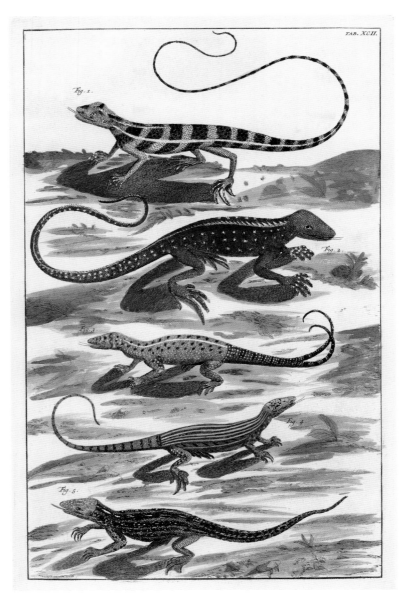

**1-5** Sauria
**1-5** Lizards and anoles · Eidechsen und Anolis · Lézards et anolis

1-4 Sauria
1-4 Lizards · Eidechsen · Lézards

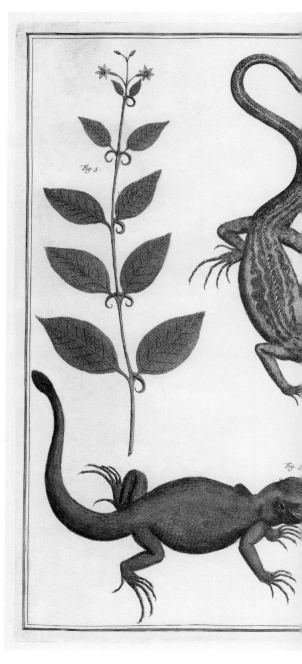

TAB. XCIII.

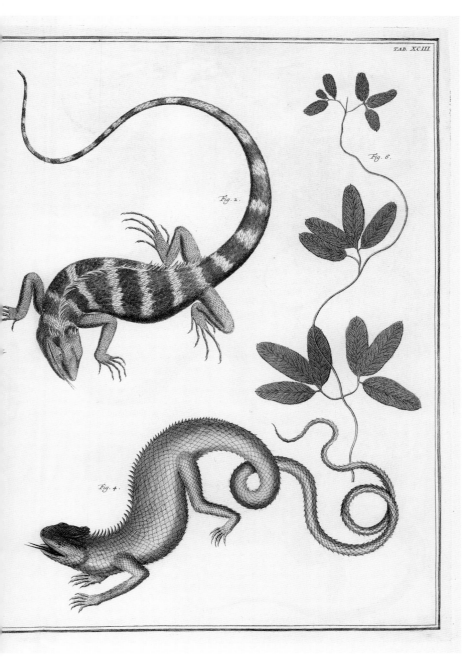

Fig. 6.

Fig. 2.

Fig. 4.

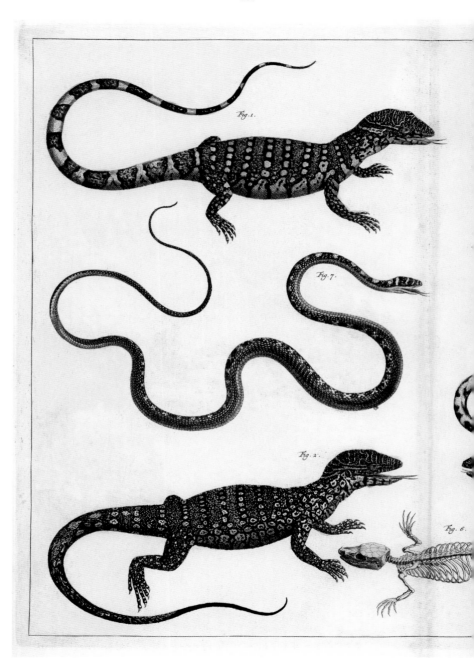

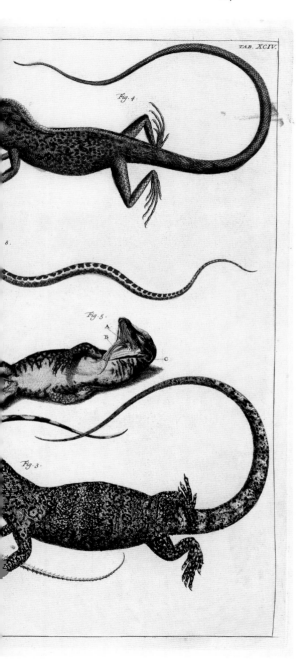

*TAB. XCIV.*

1-3 *Varanus* 4 Agamidae
5-6 Sauria 7-8 Serpentes
1-3 Monitors · Warane ·
Varanidés 4 Agama · Agame ·
Agamidé 5-6 Lizards and anoles ·
Eidechsen und Anolis · Lézards
et anolis 7 Snake, according to
Seba from Ceylon · Schlange,
nach Seba aus Ceylon · Serpent,
de Ceylan selon Seba

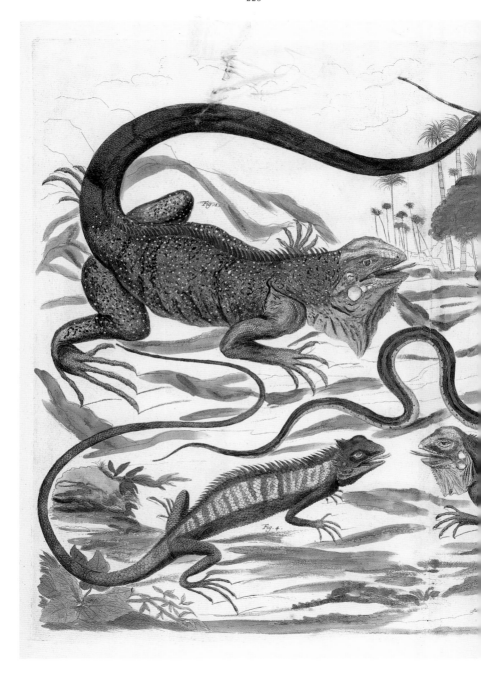

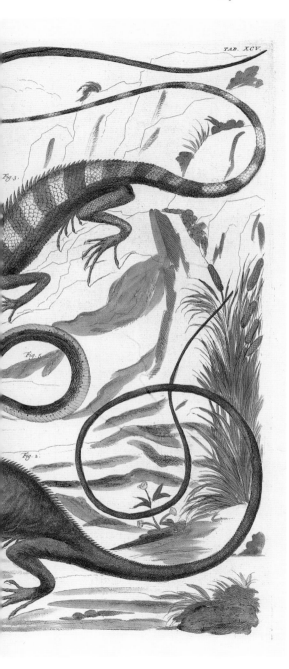

TAB. XCV.

*Fig. 3.*

*Fig. 5.*

*Fig. 2.*

**1-2** *Iguana iguana* **3-4** Agamidae
**5** Serpentes
**1-2** Green iguanas · Grüne
Leguane · Iguanes communs
**3-4** Agamas · Agamen · Agamidés

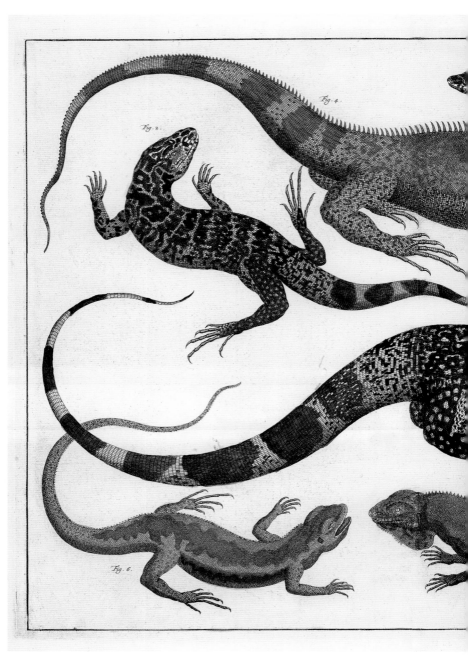

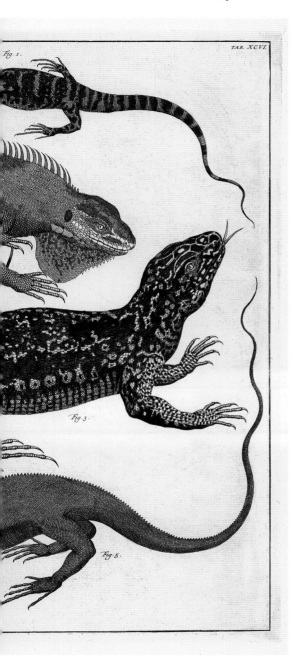

TAB. XCVI.

Fig. 1.

Fig. 3.

Fig. 5.

**1-3** *Tupinambis teguixin*
**4-6** Sauria
**1-3** Common tegus · Tejus ·
Tégus communs **4-6** Lizards ·
Eidechsen · Sauriens

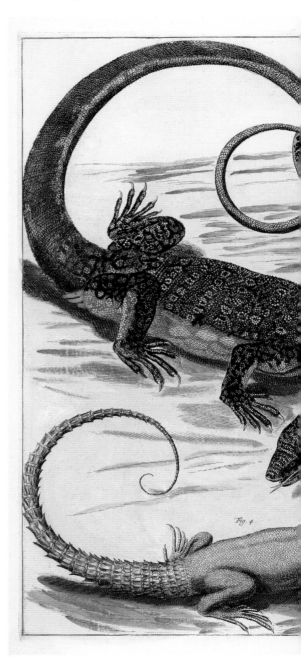

1-5 Squamata 3 *Iguana iguana*
1-5 Squamata from South
America · Echsen aus
Südamerika · Squamates
d'Amérique du Sud
3 Green iguana · Grüner Leguan ·
Iguane vert

TAB. XCVII.

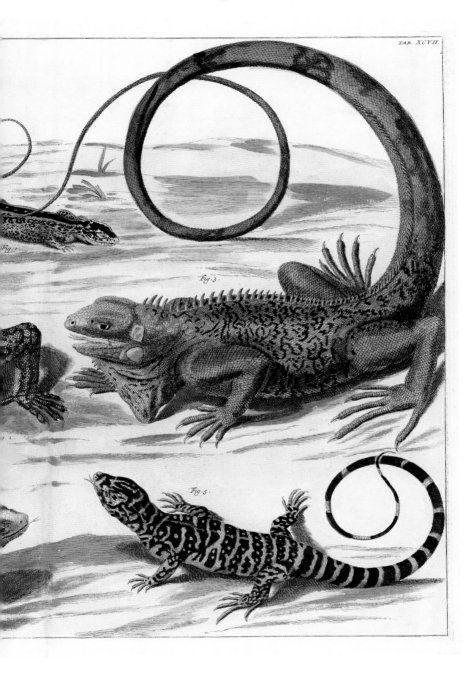

Fig.1

Fig.3

Fig.5

1 *Iguana iguana* 2 Polychrotidae
3 *Tupinambis teguixin*
1 Green iguana · Grüner
Leguan · Iguane vert 3 Common
tegu · Teju · Tégu commun

*Fig. 3.*

TAB. XCVIII.

Fig. 1.

Fig. 2.

1 *Tupinambis teguixin* 2 Varanus
3 Serpentes 4 Trochilidae
1 Common tegu · Teju · Tégu
commun 2 Monitor from South
East Asia · Waran aus
Südostasien · Varanidé de l'Asie
du Sud-Est 3 Snake, according
to Seba from Madeira ·
Schlange, nach Seba von
Madeira · Serpent, de Madère
selon Seba 4 Hummingbird ·
Kolibri · Colibri

TAB. XCIX.

Fig. 2.

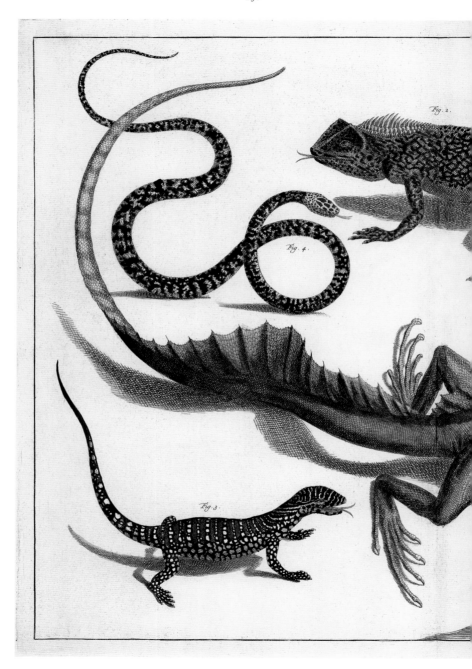

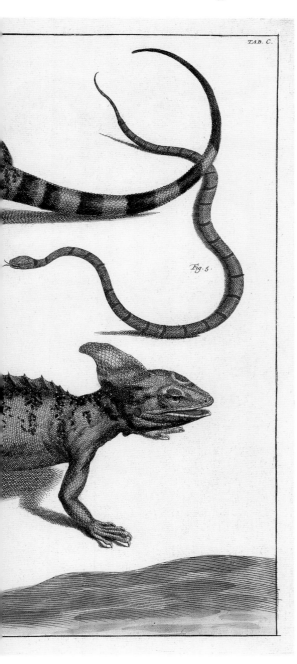

*TAB. C.*

*Fig. 5.*

1 *Basiliscus basiliscus*
2-3 Squamata 4-5 Serpentes
1 Common basilisk · Basilisk ·
Basilic 2-3 Squamata · Schuppen-
kriechtiere · Squamates
4-5 Snakes, according to
Seba from Ceylon · Schlangen,
nach Seba aus Ceylon ·
Serpents, de Ceylan selon
Seba

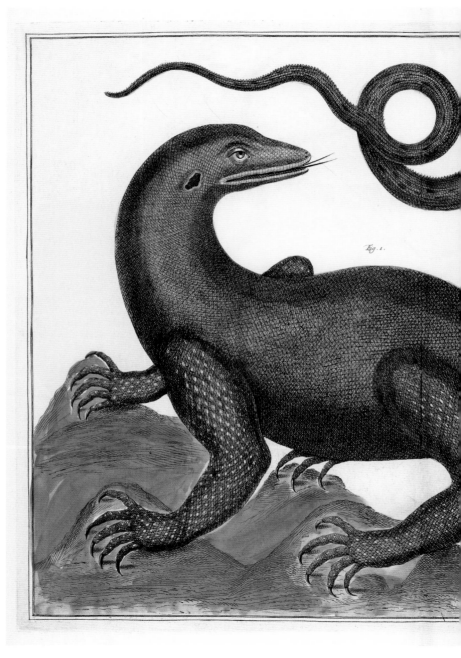

*Fig. 1.*

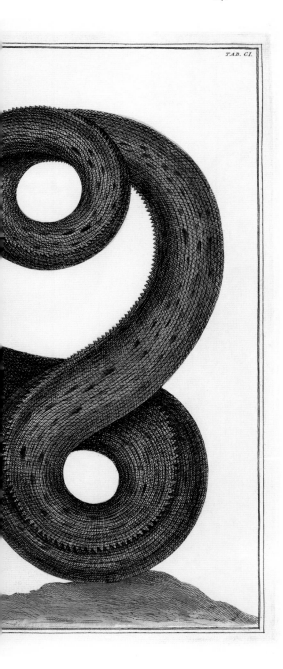

TAB. CI.

Squamata
Squamata · Echse · Squamate

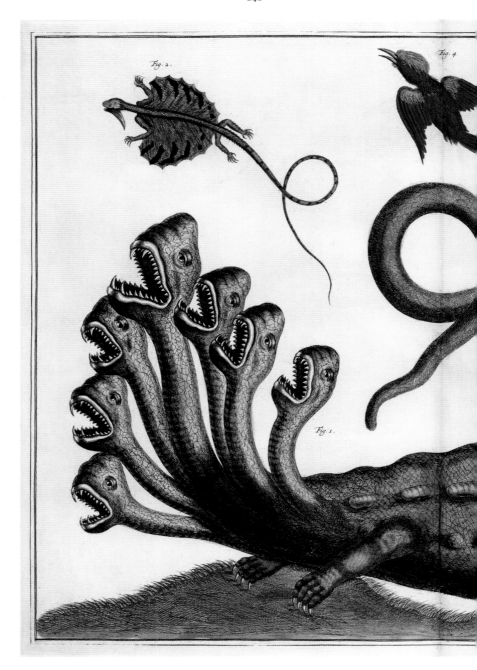

Fig. 2.

Fig. 4.

Fig. 1.

TAB. CII.

Fig. 3.

1 "Hydra" 2 Draco sp.
1 Fantasy animal · Fantasietier ·
Animal fabuleux
2 Flying dragon · Flugdrachen ·
Dragon volant

1-5 Crocodilia
**1-5** Crocodiles · Krokodile · Crocodiliens

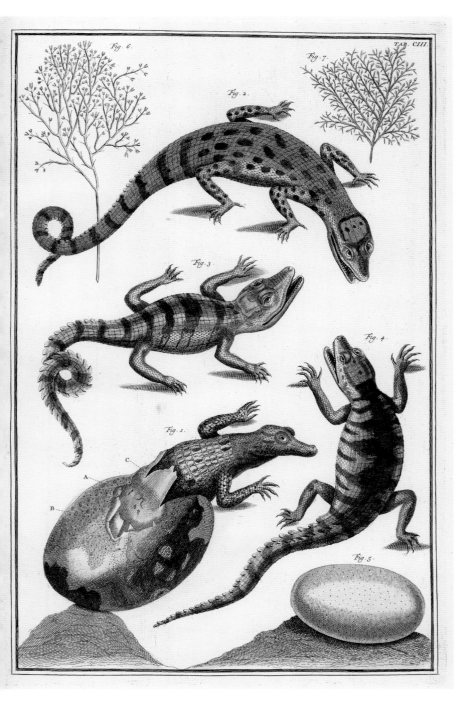

TAB. CIII.

Fig. 6.

Fig. 7.

Fig. 2.

Fig. 3.

Fig. 4.

Fig. 1.

C

A

B

Fig. 5.

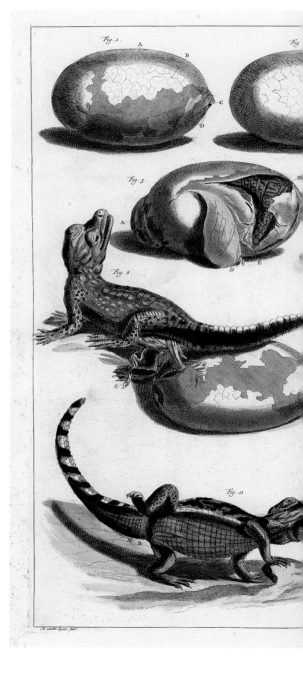

**I-12** Crocodilia
**I-12** Crocodiles · Krokodile ·
Crocodiliens

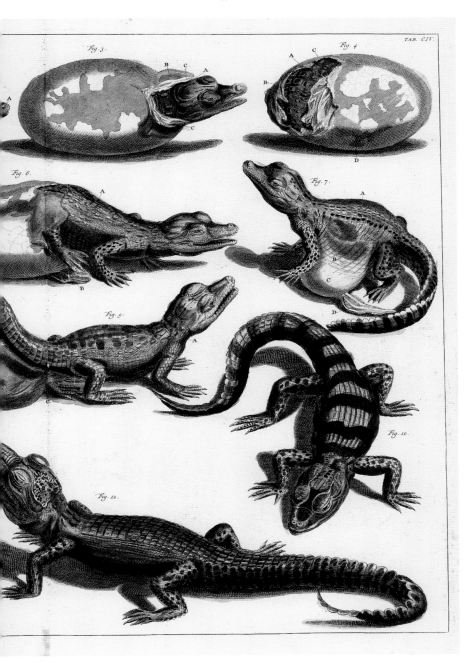

1-2 *Varanus sp.* 3-4 *Paleosuchus sp.*
1-2 Monitors from South East
Asia · Warane aus Südostasien ·
Varanidés de l'Asie du Sud-Est
3-4 Dwarf caimans ·
Glattstirnkaimane · Paléosuches

*Fig. 4.*

TAB. CV.

*Fig. 2.*

A
B
C
E D

*Fig. 3.*

1 Squamata 2 Squamata
1 Crocodile · Krokodil ·
Crocodilien 2 Lizard · Kleine
Echse · Petit lézard

*Fig. 2.*

TAB. CVI.

Fig. 1.

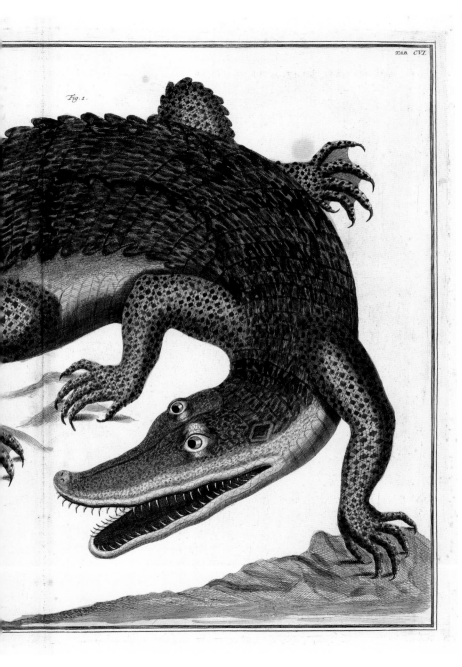

TAB. CVII.

Fig. 1.

Fig. 2.

Fig. 3.

TAB. CIX.

Fig. 6.

**1, 7-8** Serpentes **2-6** Squamata
**1** Snake, according to Seba
from Ceylon · Schlange, nach Seba
aus Ceylon · Serpent, de Ceylan
selon Seba **2-3** Squamata ·
Schuppenkriechtiere · Squamates
**7** Snake, according to Seba from
America · Schlange, nach Seba aus
Amerika · Serpent, d'Amérique
selon Seba **8** Snake, according to
Seba from Africa · Schlange, nach
Seba aus Afrika · Serpent,
d'Afrique selon Seba

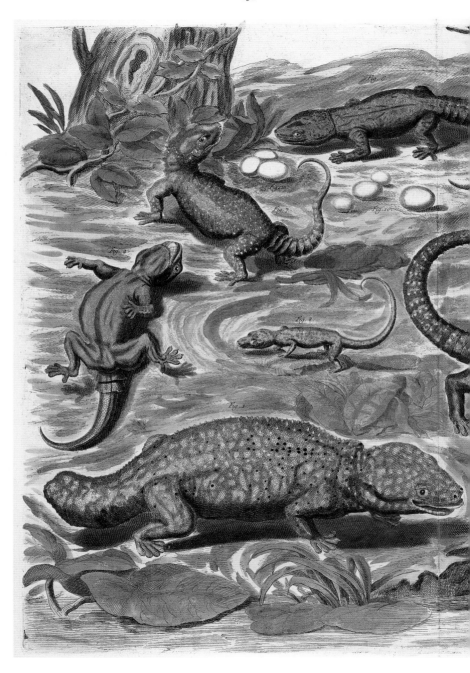

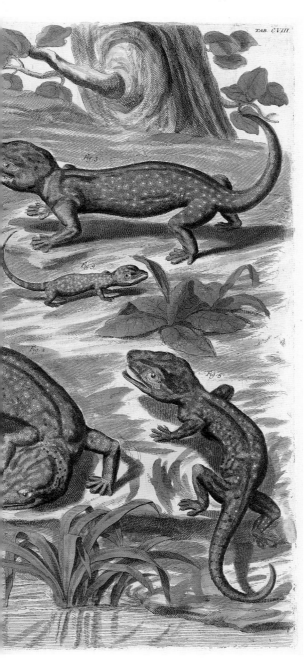

TAB. CVIII.

**1-10** Gekkonidae
**1-10** Gekkos · Geckos ·
Gekkonidés

1-3 Serpentes 4-5 Sauria
1-3 Various snakes · Verschiedene
Schlangen · Serpents divers
4-5 Lizards · Eidechsen · Lézards

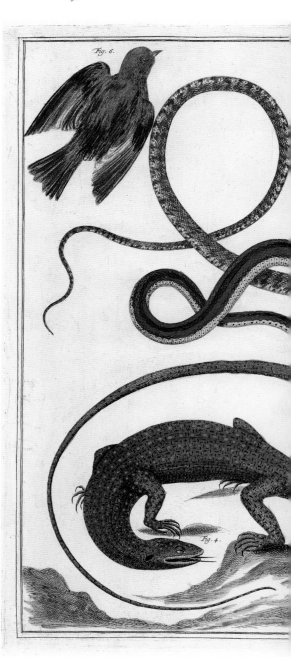

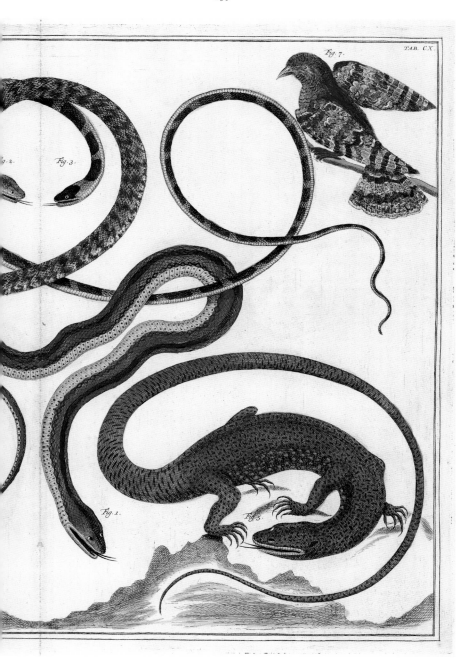

TAB. CX.

Fig. 7.

Fig. 2. Fig. 3.

Fig. 1. Fig. 5.

1 *Elephas maximus* 2 *Homo sapiens*
3 *Ovis* 4 *Sus* 5-6 *Mus*
1 Asiatic elephant (foetus) ·
Indischer Elefant (Fötus) ·
Eléphant d'Asie (fœtus)
2 Human (foetus) · Mensch
(Fötus) · Homme (fœtus)
3 Sheep (embryo) · Schaf
(Embryo) · Mouton (embryon)
4 Pig (embryo) · Schwein
(Embryo) · Porc (embryon)
5-6 Mice · Mäuse · Souris

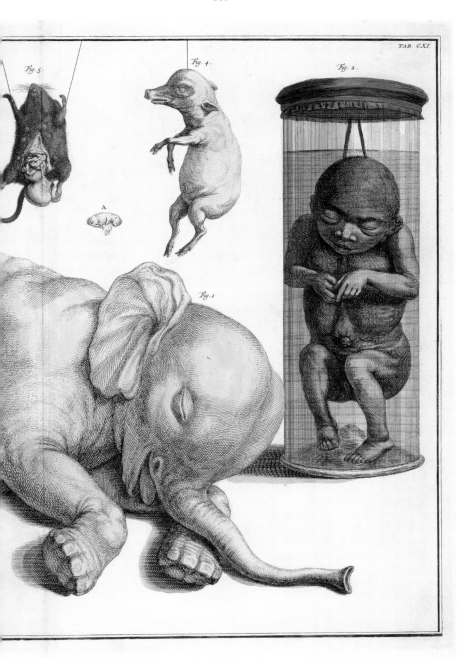

TAB. CXI.

Fig. 5.

Fig. 4.

Fig. 2.

A

Fig. 1.

TAB. I.

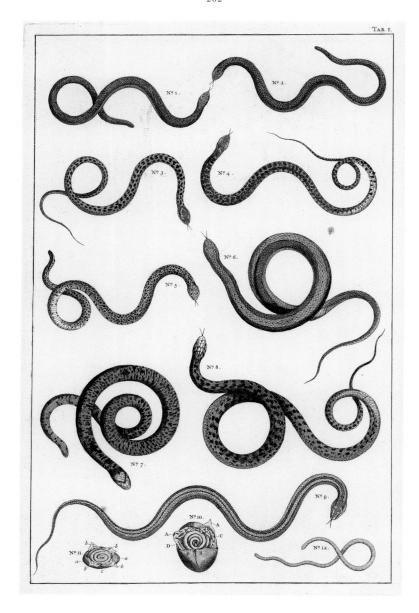

1-9 Serpentes 10-11 Ova serpentum 12 Typhlopidae
**1-9** Snakes from different continents · Schlangen von verschiedenen Kontinenten ·
Serpents de différents continents **10-11** Snake eggs · Schlangeneier · Œufs de serpent
**12** Blind Snake · Blindschlange · Typhlopidé

TAB. II.

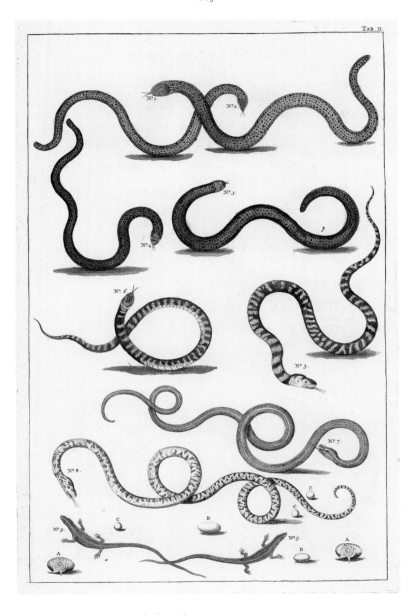

1-4 Amphisbaenidae? 5-8 Serpentes 9 Squamata
1-4 Ringed lizards · Doppelschleichen · Amphisbènes
5-8 Snakes from different continents · Schlangen aus verschiedenen Kontinenten ·
Serpents de différents continents 9 Lizard · Eidechse · Saurien

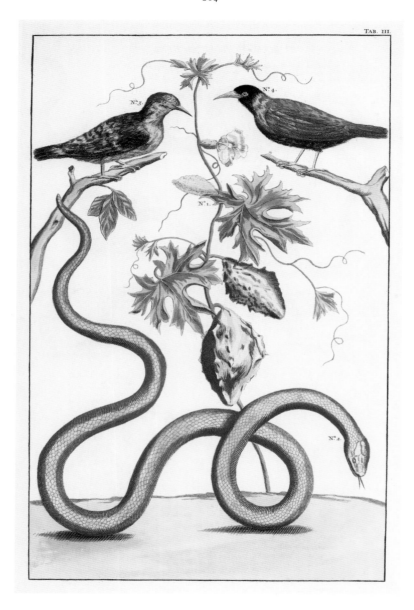

**2** Serpentes **3-4** Aves
**2** Snake, according to Seba from America · Schlange, nach Seba aus Amerika ·
Serpent, d'Amérique selon Seba **3-4** Birds, according to Seba from America · Vögel, nach Seba
aus Amerika · Oiseaux, d'Amérique selon Seba

TAB. IV.

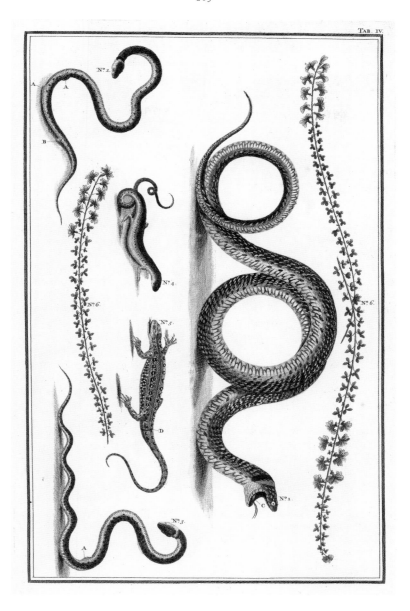

1 *Coronella austriaca* 2-3 *Natrix natrix* 4 *Lacerta muralis* 5 *Lacerta agilis* 6 *Cytisus canariensis*
1 Southern smooth snake · Schlingnatter/Glattnatter · Couleuvre lisse
3 Grass snakes · Ringelnattern · Couleuvres à collier 4 Wall lizard · Mauereidechse · Lézard des murailles
5 Sand lizard · Zauneidechse · Lézard agile 6 Trefoil shrub · Geißklee · Cytise

Tab. V.

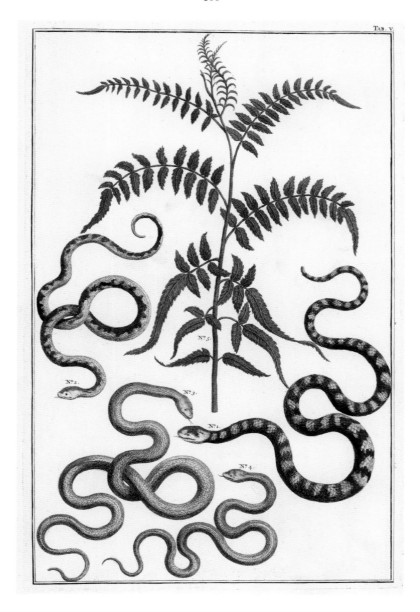

1-2 *Vipera aspis hugyi* 3-4 Serpentes 5 *Schinus molle*
**1-2** Asp vipers · Aspisvipern · Vipères aspics **3-4** Snakes, according to Seba from Africa ·
Schlangen, nach Seba aus Afrika · Serpents, d'Afrique selon Seba
**5** Peruvian Peppertree · Peruanischer Pfefferbaum · Poivrier du Pérou

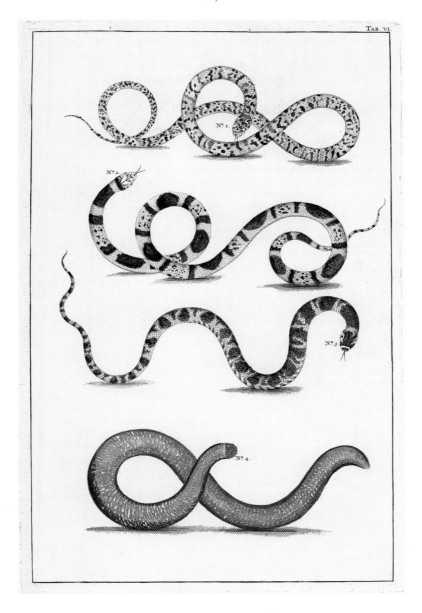

Tab. VI.

**1-3** Serpentes **4** *Amphisbaena alba*
**1-3** Snakes, according to Seba from Brasil (1), Senegal (2) and America (3) · Schlangen, nach Seba aus Brasilien (1), dem Senegal (2) und Amerika (3) · Serpents, du Brésil (1), du Sénégal (2) et d'Amérique (3), selon Seba **4** White-bellied worm lizard · Rote Doppelschleiche · Amphisbène blanche

TAB. VII.

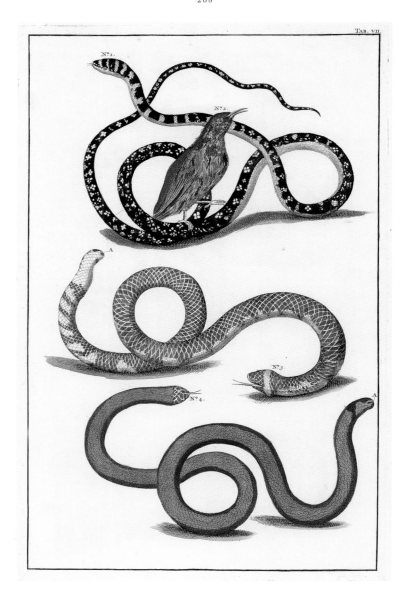

1 Serpentes 2 Aves 3-4 Amphisbaenia sp.
1 Snake, described by Seba as a *flying snake from Ambon* · Schlange, nach Seba
*Fliegende Schlange aus Ambon* · Serpent, Seba l'appelle *Serpent volant d'Amboine*
2 Bird · Vogel · Oiseau 3-4 Worm lizards · Doppelschleichen · Amphisbénidés

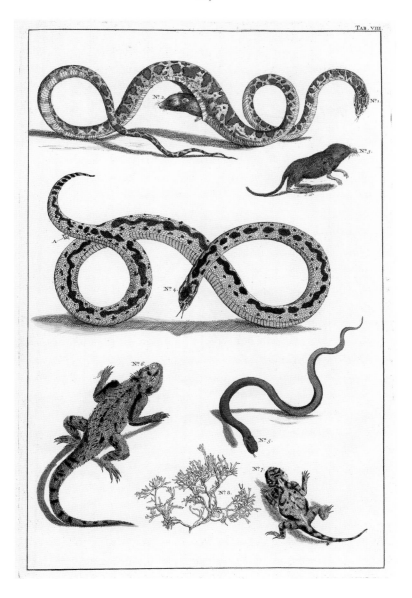

**1, 5** Serpentes **2** Muridae **3** Soricidae **4** *Vipera berus* **6-7** Squamata
Snake, according to Seba from Ceylon · Schlange, nach Seba aus Ceylon · Serpent, de Ceylan selon Seba
**2** Rat · Ratte · Rat **3** Shrew · Spitzmaus · Musaraigne **4** Adder/Common viper · Kreuzotter ·
Vipère péliade **5** Snake, according to Seba from Surinam · Schlange, nach Seba aus Surinam ·
Serpent, du Surinam selon Seba **6-7** Lizards · Echsen · Sauriens

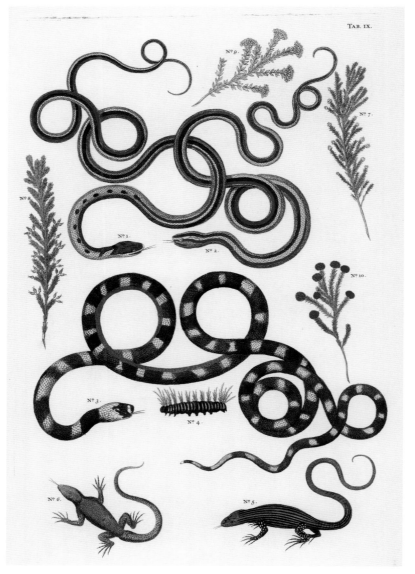

TAB. IX.

1-3 Serpentes 4 Lepidoptera 5-6 Squamata: Sauria 7-10 Ericaceae
1 Snake, described by Seba as a species known by the Portuguese as *Chayquarona* · Schlange, nach Seba eine Art, die von den Portugiesen *Chayquarona* genannt wird · Serpent, d'après Seba une espèce qui fut appelée *Chayquarona* par les Portugais 3 Snake, according to Seba from Africa · Schlange, nach Seba aus Afrika · Serpent, d'Afrique selon Seba 4 Caterpillar · Schmetterlingsraupe · Larve de papillon
5-6 Lizards · Echsen · Sauriens 7-10 Heath family · Heidekrautgewächse · Ericacées

TAB. X

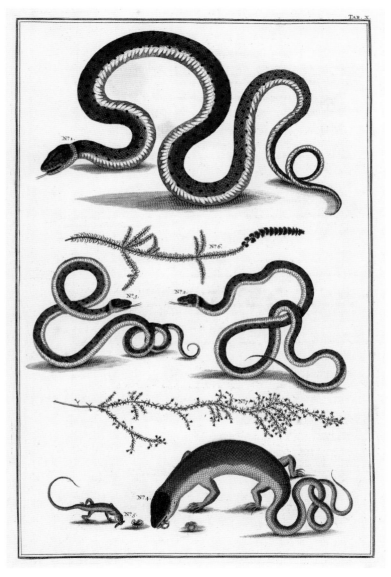

1-3 *Natrix natrix* 4-5 Squamata: Scincidae 6-7 Ericaceae
1-3 Grass snakes · Ringelnattern · Couleuvres à collier 4-5 Skink · Skink · Scinque
6-7 Heath family · Heidekrautgewächse · Ericacées

TAB. XI.

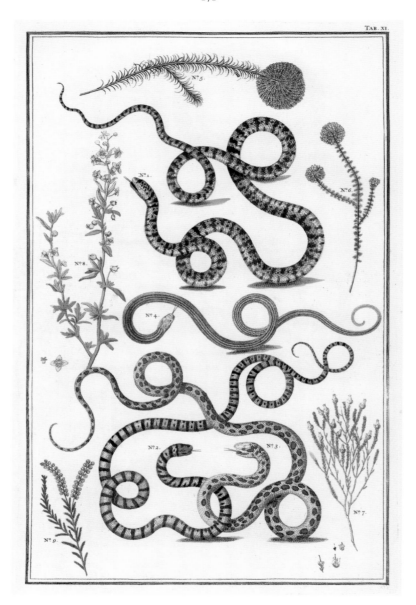

**1, 3** Serpentes **2** *Chionactis occipitalis?* **4** *Stenorrhina freminvillil* **9** *Erica carnea*
**1, 2** Western shovelnose snake · Schaufelnasennatter · Serpent corail **3** Snake, according to Seba from
America · Schlange, nach Seba aus Amerika · Serpent, d'Amérique selon Seba **4** Scorpion eater/Scorpion
eating snake · Schlange · Serpent mangeur de scorpions **9** Spring heath · Schneeheide · Bruyère incarnat

TAB. XII.

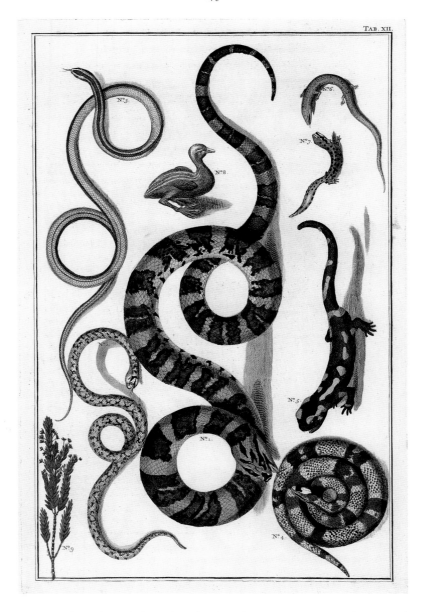

1-4 Serpentes 5 Caudata, Salamandridae: *Salamandra salamandra* 6 Squamata 7 *Triturus alpestris?* 8 Podicepidae
1-4 Snakes, according to Seba from America · Schlangen, nach Seba aus Amerika · Serpents,
d'Amérique selon Seba 5 Fire salamander · Feuersalamander · Salamandre terrestre/Salamandre tachetée
6 Lizard · Echse · Saurien 7 Alpine newt · Bergmolch · Triton alpestre 8 Grebe · Lappentaucher · Grèbe

Tab. XIII.

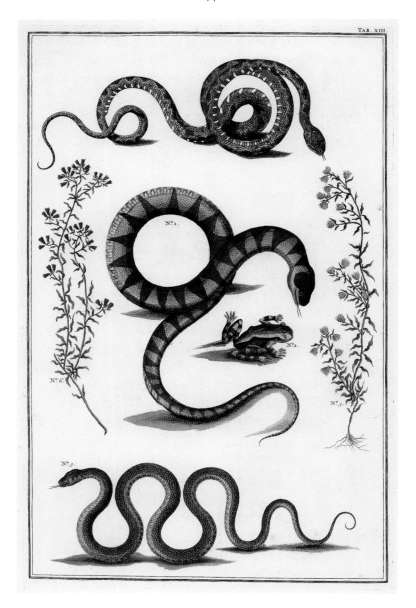

*1 Vipera ammodytes* **2** *Hyla arborea?* **3-4** Serpentes **5-6** *Helichrysum*
**1** Nose-horned viper · Sandotter · Vipère des sables **2** Tree frog · Laubfrosch · Grenouille arboricole
**3-4** Snakes, according to Seba from America (3) and Africa (4) · Schlangen, nach Seba aus Amerika (3) und
Afrika (4) · Serpents, d'Amérique (3) et d'Afrique (4), selon Seba **5-6** Everlasting flower · Strohblume · Hélichrys

TAB. XIV.

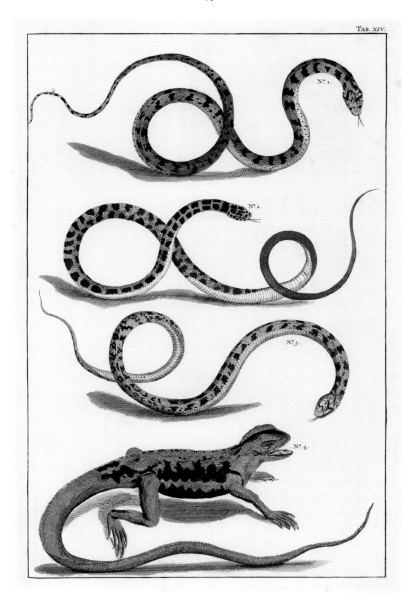

**1-3** Serpentes **4** Agamidae
Snakes, according to Seba from America and Ambon · Schlangen, nach Seba aus Amerika und Ambon ·
Serpents, d'Amérique et d'Amboine selon Seba **4** Agama · Agame · Agame

TAB. XV.

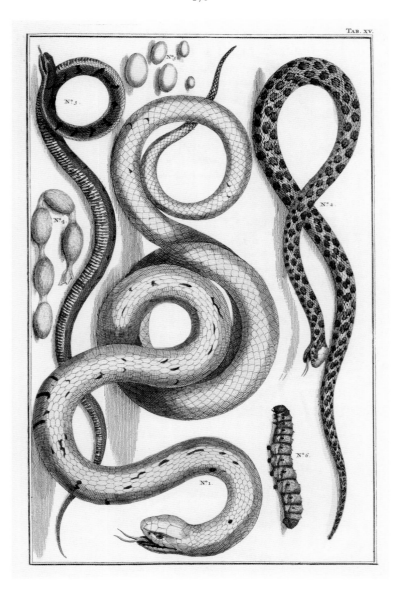

1 *Natrix natrix astreptophora* 2-3 Serpentes 4-5 Ova 6 Lepidoptera

**1** South-western grass snake · Spanische Ringelnatter · Couleuvre à collier d'Espagne **2** Snake, according to Seba from Ambon · Schlange, nach Seba aus Ambon · Serpent, d'Amboine selon Seba **3** Snake, according to Seba from America · Schlange, nach Seba aus Amerika · Serpent, d'Amérique selon Seba **4-5** Eggs of a snake · Schlangeneier · Œufs de serpent **6** Caterpillar · Schmetterlingsraupe · Larve de papillon

TAB. XVI.

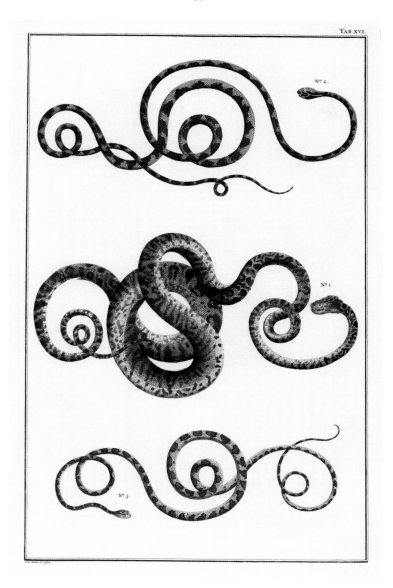

1 Serpentes **2-3** *Imantodes cenchoa*
1 Snake, according to Seba from America · Schlange, nach Seba aus Amerika ·
Serpent, d'Amérique selon Seba **2-3** Blunt-headed tree snake · Riemennatter · Imantodes

TAB. XVII.

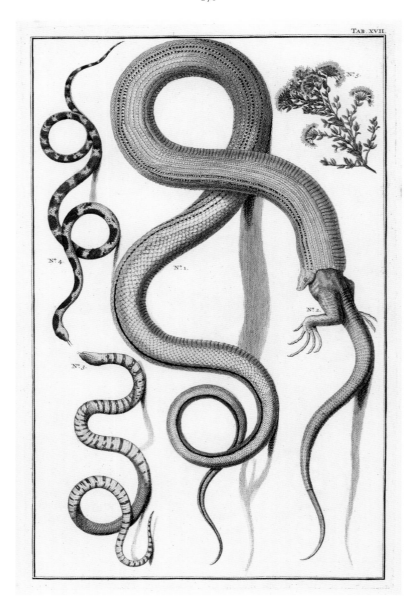

**1, 3-4** Serpentes **2** Squamata
**1, 3-4** Snakes, according to Seba from Ambon (1), Africa (3), and America (4) ·
Schlangen, nach Seba aus Ambon (1), Afrika (3) und Amerika (4) · Serpents, d'Amboine (1),
d'Afrique (3) et d'Amérique (4), selon Seba **2** Lizard · Echse · Saurien

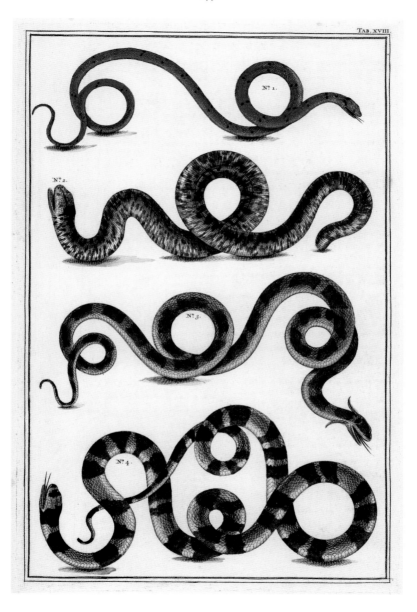

Tab. XVIII.

1-4 Serpentes 2 Erycinae?
1-4 Snakes from various regions · Schlangen aus verschiedenen Regionen ·
Serpents de différentes régions
2 Sand boa · Sandboa · Boa des sables

TAB. XIX.

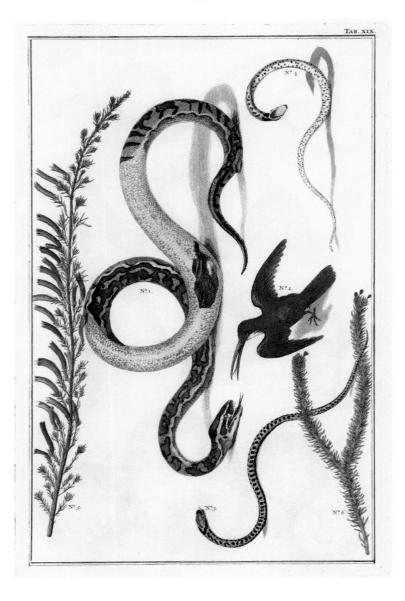

**1, 3-4** Serpentes **2** Aves **5** Ericaceae
**1, 3-4** Various snakes · Verschiedene Schlangen · Serpents divers
**2** Bird, according to Seba from the Orient · Vogel, nach Seba aus dem Orient · Oiseau, d'Orient selon Se
**5** Heath family · Heidekrautgewächse · Ericacées

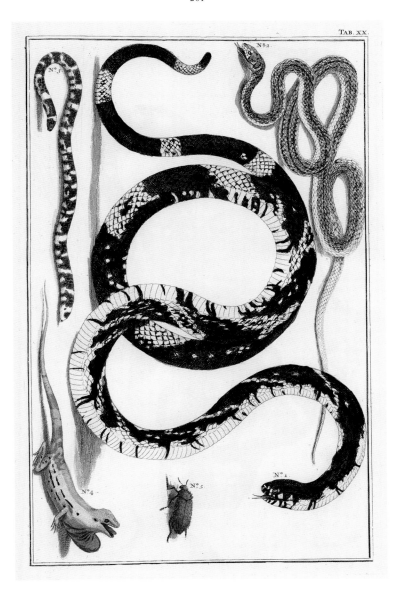

TAB. XX.

1-2 Serpentes 3 Amphisbaenia sp. 4 Polychrotidae 5 *Julodis fascicularis*
Snake, according to Seba from Ambon · Schlange, nach Seba aus Ambon · Serpent, d'Amboine selon Seba
2 Snake, according to Seba from Brazil · Schlange, nach Seba aus Brasilien · Serpent, du Brésil selon Seba
3 Worm lizard · Doppelschleiche · Amphisbénidé 4 Anole · Anolis · Anolis
5 Jewel beetle · Prachtkäfer · Bupreste

TAB. XXI.

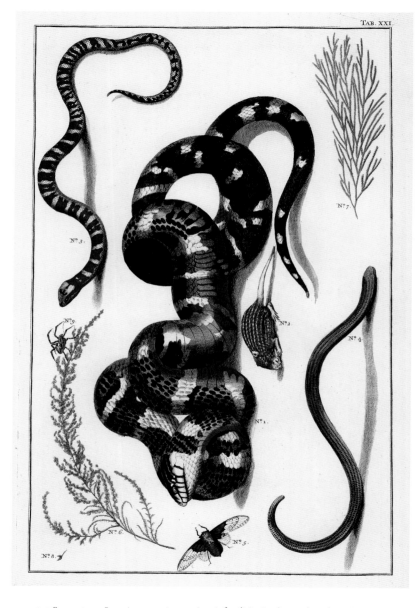

1, 3 Serpentes 2 *Lemniscomys striatus* 4 *Anguis fragilis?* 5 Auchenorrhyncha 9 Araneae
1, 3 Snakes · Schlangen · Serpents 2 Striped grass mouse · Afrikanische Streifen-Grasmaus · Rat rayé
4 Slow worm or Glass lizard · Blindschleiche · Orvet
5 Cicada · Zikade · Cigale 9 Spider · Spinne · Aranéen

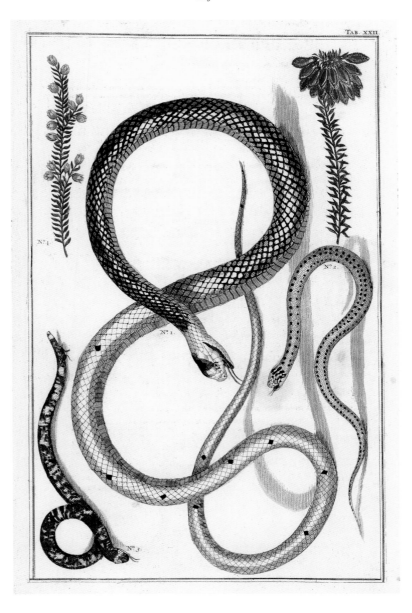

TAB. XXII.

**1-2** Serpentes **3** *Amphisbaena fulginosa* **4-5** Ericaceae
**1-2** Snakes, according to Seba from America · Schlangen, nach Seba aus Amerika ·
Serpents, d'Amérique selon Seba **3** Spotted ringed lizard · Gefleckte Doppelschleiche ·
Amphisbénidé **4-5** Heath family · Heidekrautgewächse · Ericacées

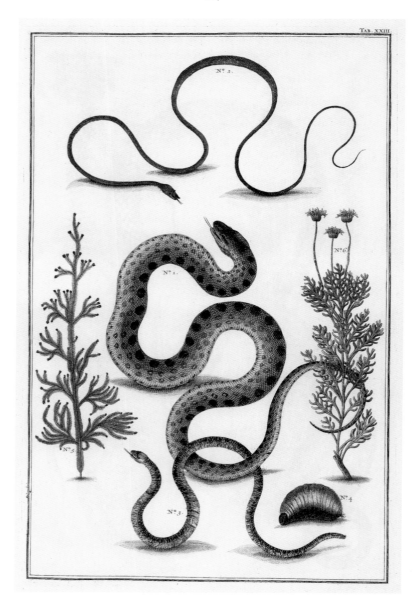

TAB. XXIII

1 *Eunectes murinus* 2 *Ahaetulla mycterizans?* 3 Serpentes 4 Coleoptera 6 Compositae
1 Anaconda · Anakonda · Anaconda 2 Green ribbon snake · Baumschleicher · Serpent arboricole
3 Snake, according to Seba from Guinea · Schlange, nach Seba aus Guinea · Serpent, de Guinée selon Seb
4 Beetle larva · Käferlarve · Larve de coléoptère 6 Sunflower family · Korbblütler · Composées

TAB. XXIV.

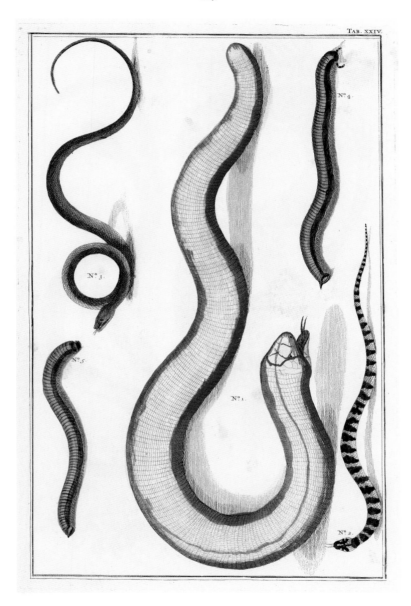

1 *Amphisbaena alba* 2-3 Serpentes 4-5 Diplopoden
1 White-bellied worm lizard · Rote Doppelschleiche · Amphisbène blanche
2-3 Snakes, according to Seba from America · Schlangen, nach Seba aus Amerika ·
Serpents, d'Amérique selon Seba 4-5 Diplopods · Tausendfüßer · Mille-pattes

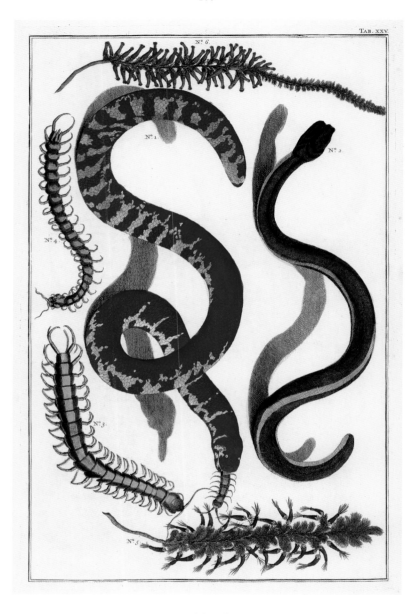

TAB. XXV.

N.º 6.

N.º 1.

N.º 2.

N.º 4.

N.º 3.

N.º 5.

1-2 Serpentes 3-4 Chilopoden 5-6 Ericaceae
1-2 Snakes, according to Seba from South Asia · Schlangen, nach Seba aus Südasien ·
Serpents, d'Asie du Sud selon Seba 3-4 Centipedes · Hundertfüßer: Skolopender · Scolopendres
5-6 Heath family · Heidekrautgewächse · Ericacées

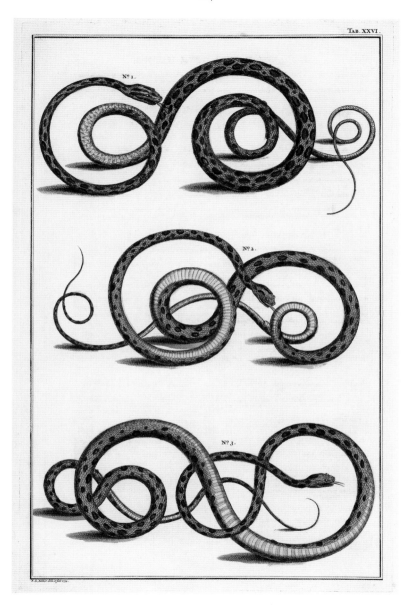

**1-3** Serpentes
**1** Snake, according to Seba from Nova Hispania · Schlange, nach Seba aus Nova Hispania ·
Serpent, de Nova Hispania selon Seba **2-3** Snakes from different continents · Schlangen von
verschiedenen Kontinenten · Serpents de différents continents

Tab. XXVII.

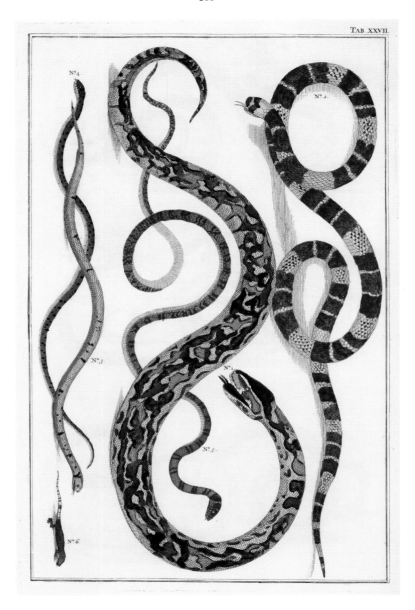

1 Boidae **2-5** Serpentes **6** Squamata
**1** Boid Snake · Riesenschlange · Boïde **2-5** Snakes from different continents ·
Schlangen aus verschiedenen Kontinenten · Serpents de différents continents
**6** Lizard or Agama · Eidechse oder Agame · Saurien ou Agame

Tab. XXVIII.

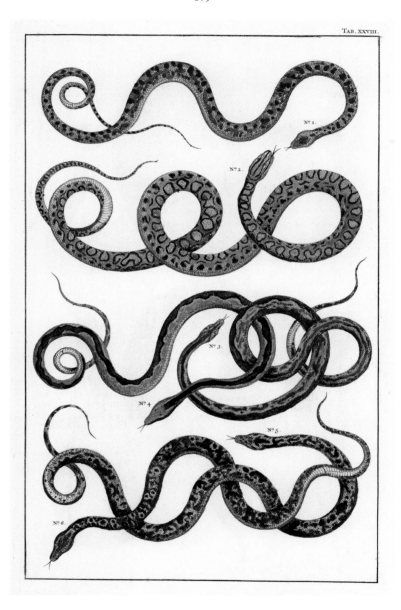

**1-6** Serpentes
**1-6** Snakes, according to Seba from South America · Schlangen, nach Seba aus Südamerika ·
Serpents, d'Amérique du Sud selon Seba

TAB. XXIX.

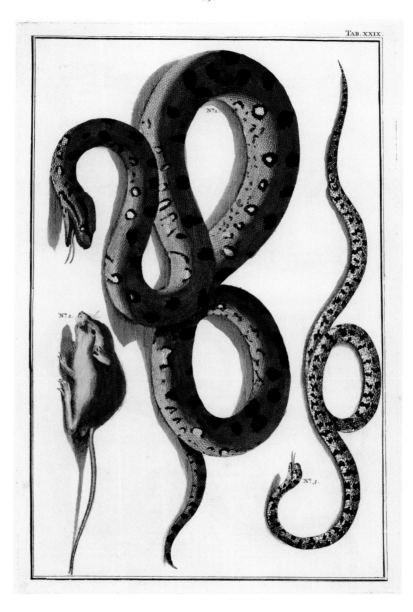

1 *Eunectes murinus* 2 Muridae 3 *Elaphe obsolata spiloides?*
1 Anaconda · Anakonda · Anaconda 2 Mouse · Maus · Souris
3 American ratsnake · Graue Erdnatter · Couleuvre grise d'Amérique

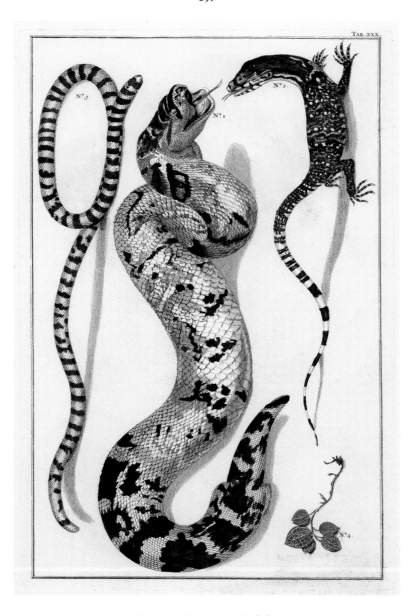

TAB. XXX.

N.° 3.

N.° 1.

N.° 2.

N.° 4.

**1, 3** Serpentes **2** Squamata **4** Orchidaceae
Snake, according to Seba from Ambon · Schlange, nach Seba aus Ambon · Serpent, d'Amboine selon Seba
Lizard · Echse · Saurien **3** Snakes, according to Seba from America · Schlangen, nach Seba aus Amerika ·
Serpents, d'Amérique selon Seba **4** Orchid family · Orchideengewächse · Orchidacées

TAB. XXXI

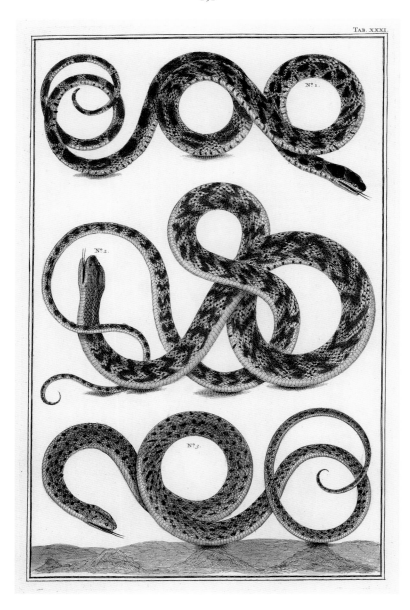

**1-3** Serpentes
**1-2** Snakes, according to Seba from America · Schlangen, nach Seba aus Amerika ·
Serpents, d'Amérique selon Seba **3** Snake, according to Seba from the Cape of Good Hope · Schlange,
nach Seba vom Kap der Guten Hoffnung · Serpent, du cap de Bonne-Espérance selon Seba

TAB. XXXII.

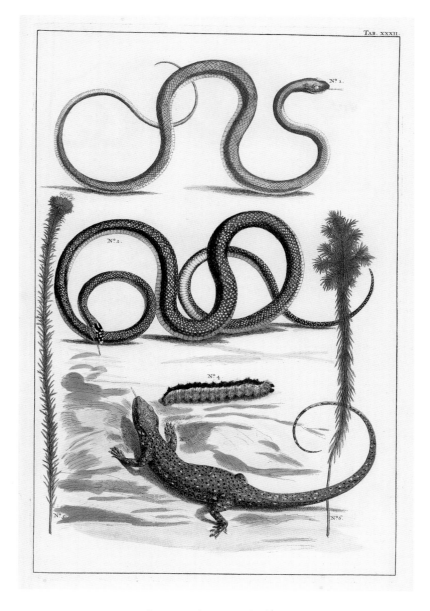

**1, 2** Serpentes **3** Squamata **4** Lepidoptera
Snake, according to Seba from Surinam · Schlange, nach Seba aus Surinam · Serpent, du Surinam selon Seba
2 Snake, according to Seba from Ceylon · Schlange, nach Seba aus Ceylon · Serpent, de Ceylan selon Seba
**3** Lizard · Echse · Saurien **4** Caterpillar · Schmetterlingsraupe · Larve de papillon

TAB. XXXIII.

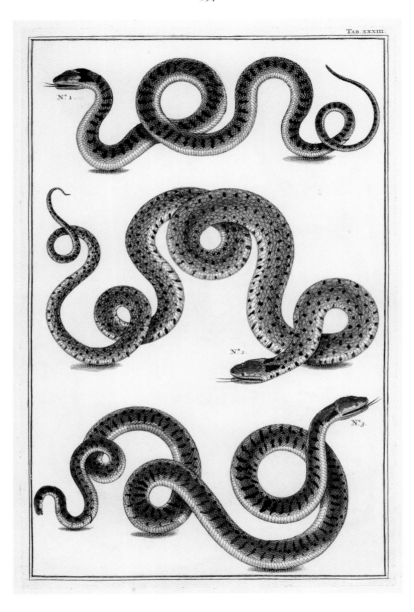

1 *Coluber sp.?* **2-3** Colubridae
**1** Whip snake · Zornnatter · Couleuvre
**2-3** Colubrine snakes · Nattern · Couleuvres

TAB. XXXIV.

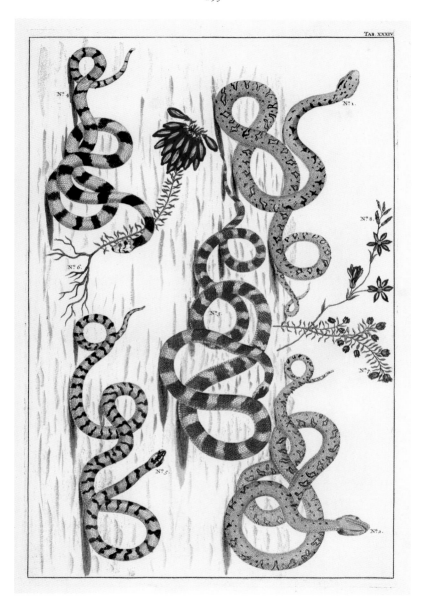

**1-5** Serpentes **6-7** Ericaceae
**1-5** Snakes, according to Seba from Siam · Schlangen, nach Seba aus Siam ·
Serpents, du Siam selon Seba
**6-7** Heath family · Heidekrautgewächse · Ericacées

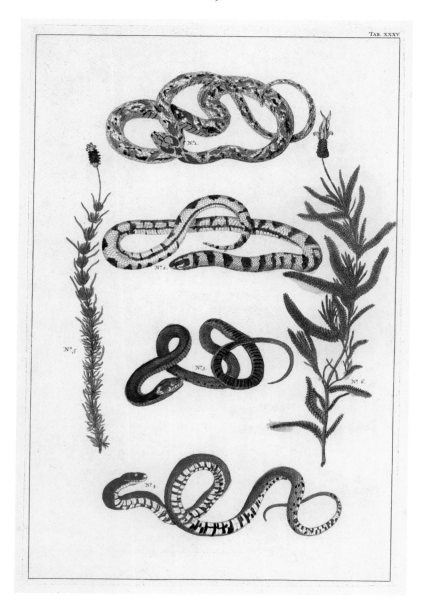

TAB. XXXV.

1-4 Serpentes 5 *Lavandula stoechas* 6 *Lavandula sp.*
1-2 Snakes, according to Seba from America · Schlangen, nach Seba aus Amerika · Serpents, d'Amérique selon Seba 3-4 Snakes, according to Seba from Africa · Schlangen, nach Seba aus Afrika · Serpents, d'Afrique selon Seba 5 Lavender · Schopflavendel · Lavande papillon

TAB. XXXVI.

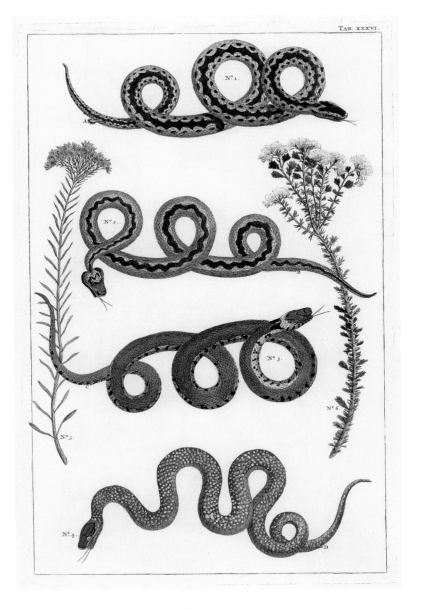

1 *Vipera berus?* 2-4 Serpentes
1 Adder or Common viper · Kreuzotter · Vipère péliade
2-4 Snakes, according to Seba from America ·
Schlangen, nach Seba aus Amerika · Serpents, d'Amérique selon Seba

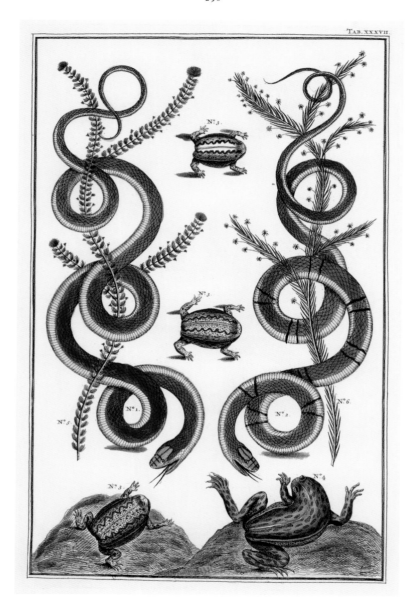

TAB. XXXVII.

1-2 Serpentes 3 Microhylidae 4 Anura
1-2 Snakes, according to Seba from Africa · Schlangen, nach Seba aus Afrika ·
Serpents, d'Afrique selon Seba 3 Narrow-mouthed toad · Engmaulfrosch · Microhylidé
4 Frog · Froschlurch · Grenouille

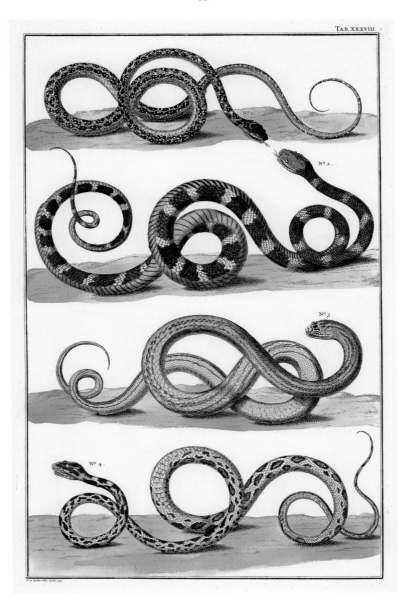

TAB. XXXVIII.

**1-4** Serpentes
**1-2, 4** Snakes, according to Seba from America · Schlangen, nach Seba aus Amerika ·
Serpents, d'Amérique selon Seba **3** Snake, according to Seba from Egypt ·
Schlange, nach Seba aus Ägypten · Serpent, d'Egypte selon Seba

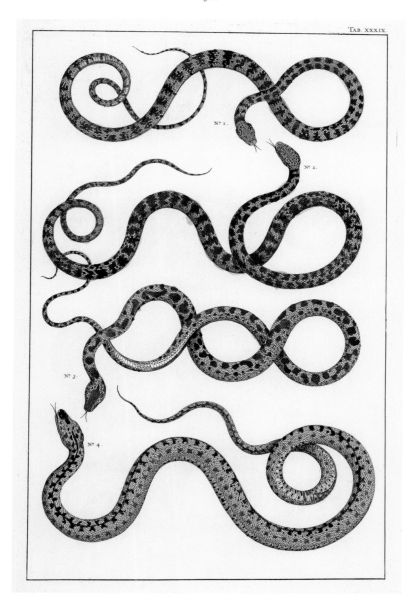

TAB. XXXIX.

**1-4** Serpentes
**1-2** Snakes, according to Seba from Arabia · Schlangen, nach Seba aus Arabien ·
Serpents, d'Arabie selon Seba **3-4** Snakes, according to Seba from Ceylon · Schlangen,
nach Seba aus Ceylon · Serpents, de Ceylan selon Seba

TAB. XL.

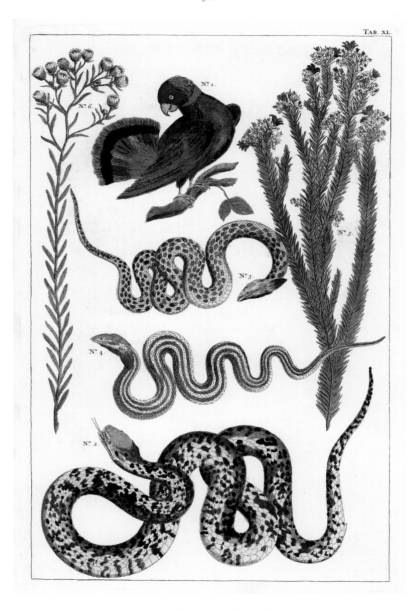

1 Aves 2-4 Serpentes 5 Compositae
Bird, according to Seba from America · Vogel, nach Seba aus Amerika · Oiseau, d'Amérique selon Seba
2-4 Various Snakes · Verschiedene Schlangen · Serpents divers
6 Sunflower family · Korbblütler · Composées

TAB. XLI.

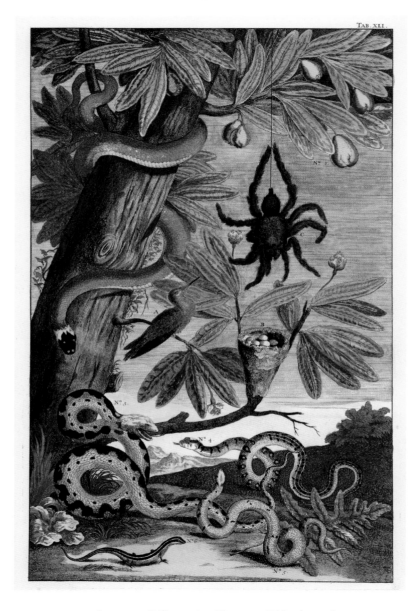

**1, 3-4** Serpentes **2** *Psidium guajava* **6** Squamata **C** Mygalomorphae
**1, 3-4** Snakes, according to Seba from America · Schlangen, laut Seba aus Amerika ·
Serpents, d'Amérique selon Seba **2** Guava · Guave · Goyavier **6** Lizard · Echse · Saurien
**C** Mygalomorph spider · Vogelspinne · Mygalomorphe

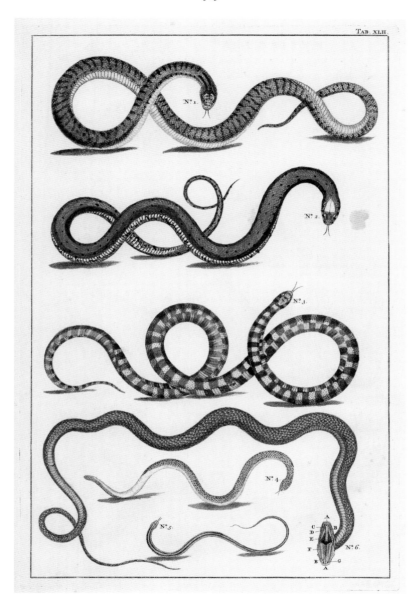

**1-6** Serpentes
**1-6** Snakes, according to Seba from America · Schlangen, nach Seba aus Amerika ·
Serpents, d'Amérique selon Seba

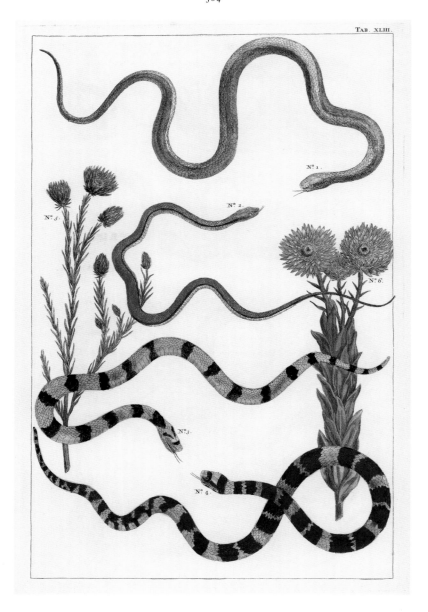

TAB. XLIII.

**1-4** Serpentes **5-6** *Helichrysum*
**1-2** Snakes, according to Seba from America · Schlangen, nach Seba aus Amerika · Serpents,
d'Amérique selon Seba **3-4** Snakes, according to Seba from Africa · Schlangen, nach Seba aus Afrika ·
Serpents, d'Afrique selon Seba **5-6** Everlasting flower · Strohblume · Hélichryse

TAB. XLIV.

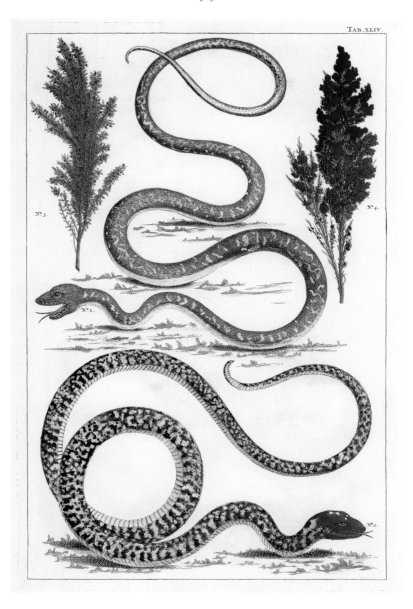

1 *Chrysopelea?* 2 Serpentes
1 Flying snake · Flugschlange · Serpent volant
2 Snake, according to Seba from Ambon · Schlange, nach Seba aus Ambon ·
Serpent, d'Amboine selon Seba

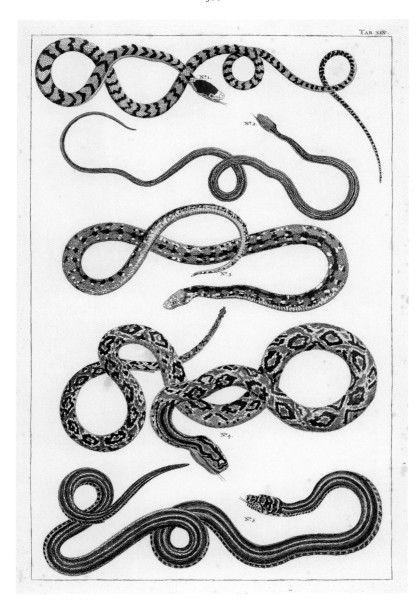

Tab. XLV.

**1-5** Serpentes
**1-5** Snakes, according to Seba from Ceylon · Schlangen, nach Seba aus Ceylon ·
Serpents, de Ceylan selon Seba

TAB. XLVI.

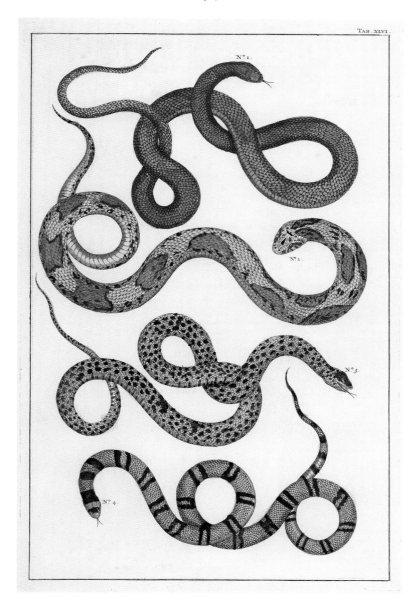

1-4 Serpentes
**1-4** Snakes from different continents · Schlangen aus verschiedenen Kontinenten ·
Serpents de différents continents

TAB. XLVII.

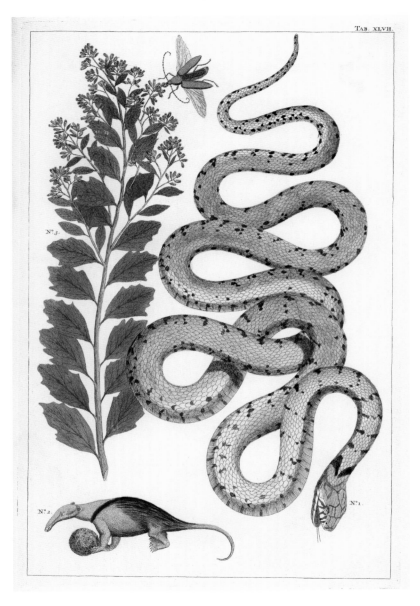

1 *Natrix natrix* 2 *Myrmecophaga tridactyla* 3 *Baccharis halinifolia* ∗ *Cerambycidae*
1 Grass snake · Ringelnatter · Couleuvre à collier 2 Giant anteater (young) ·
Ameisenbär (Jungtier) · Grand fourmilier · (jeune animal) 3 Tree groundsel · Kreuzstrauch ·
Séneçon en arbre ∗ Long horned beetle · Bockkäfer · Capricorne

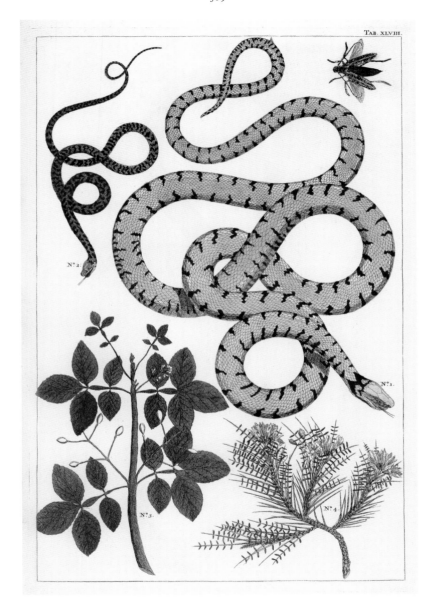

TAB. XLVIII.

**1** *Natrix natrix* **2** Serpentes **3** *Pistacia sp.* **4** *Astragalus sp.* * *Cerambycidae*
**1** Grass snake · Ringelnatter · Couleuvre à collier **2** Snake, according to Seba from Ceylon ·
Schlange, nach Seba aus Ceylon · Serpent, de Ceylan selon Seba **3** Pistache · Pistazie · Pistachier
**4** Milk vetch · Tragant · Astragale * Long horned beetle · Bockkäfer · Capricorne

TAB. XLIX.

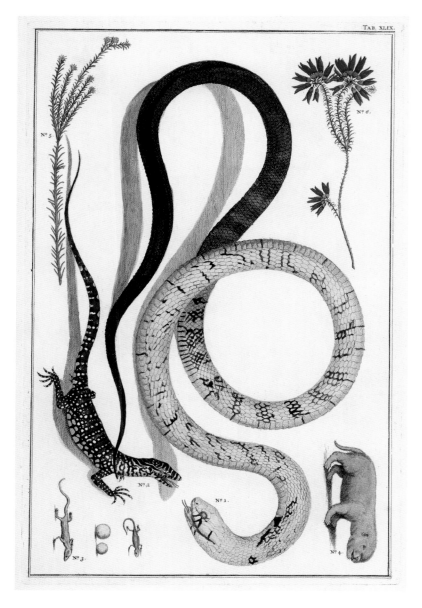

1 *Drymarchon corais* 2 *Varanus sp.* 3 Squamata 4 *Herpailurus yagouarundi?* 5-6 Ericaceae
1 Indigo snake · Indigonatter · Serpent indigo 2 Monitor · Waran · Varanidé
3 Lizards · Eidechsen · Lézards 4 Jaguarondi (albino) · Wieselkatze (Albino) · Jaguarondi (albinos)
5-6 Heath family · Heidekrautgewächse · Ericacées

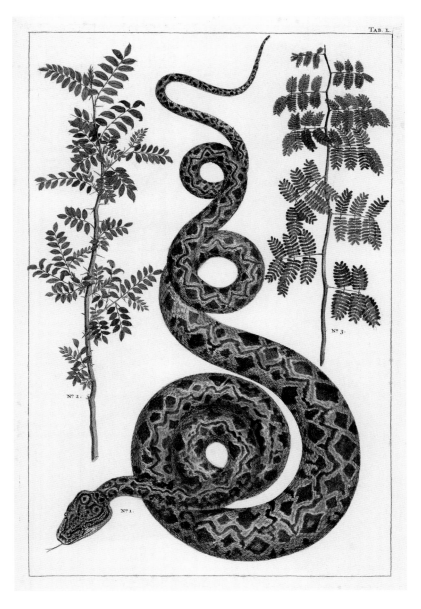

1 *Corallus hortulanus* 3 Mimosaceae
1 Garden boa · Gemeine Hundskopfboa · Boa
3 Australian blackwood family · Mimosengewächse · Mimosacées

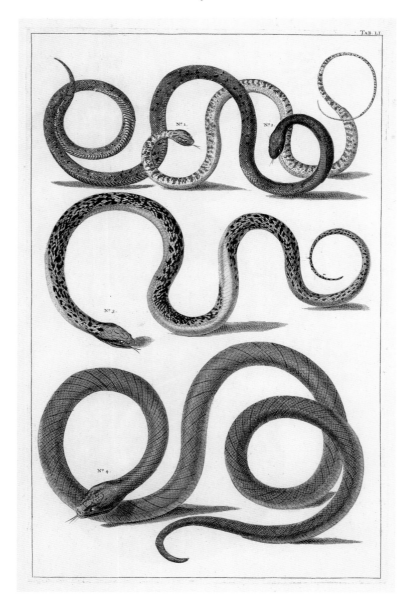

**1, 3-4** Serpentes **2** *Virginia striatula*
**1** Snake, according to Seba from Armenia · Schlange, nach Seba aus Armenien · Serpent, d'Arménie
selon Seba **2** Rough earth snake · Erdschlange · Serpent fouisseur **3-4** Snakes, according to Seba from Brazil
Schlangen, nach Seba aus Brasilien · Serpents, du Brésil selon Seba

TAB. LII.

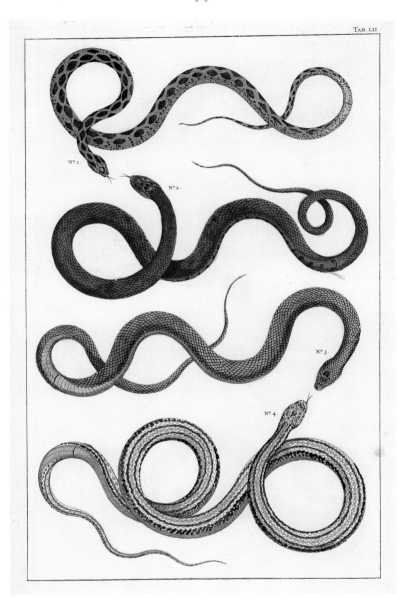

**1-4** Serpentes
**1-4** Various Snakes · Verschiedene Schlangen · Serpents divers

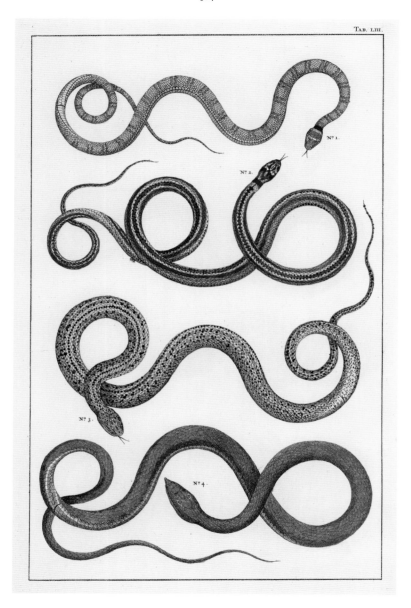

TAB. LIII.

1-3 Serpentes 4 *Ahaetulla sp.?*
**1-3** Snakes, according to Seba from Java (1), Martinique (2) and Cuba (3) · Schlangen, nach Seba von
Java (1), Martinique (2) und Kuba (3) · Serpents, de Java (1), de la Martinique (2) et de Cuba (3), selon Seb
**4** Asian longnose whipsnake · Baumschleicher · Serpent arboricole

TAB. LIV.

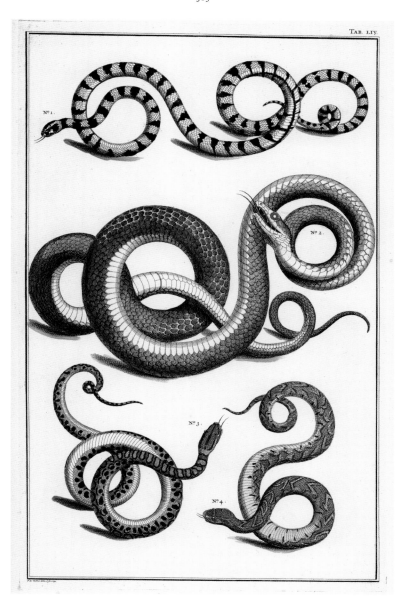

**1-4** Serpentes
**1-2** Snakes, according to Seba from Ambon · Schlangen, nach Seba aus Ambon ·
Serpents, d'Amboine selon Seba **3-4** Snakes, according to Seba from Africa ·
Schlangen, nach Seba aus Afrika · Serpents, d'Afrique selon Seba

TAB. LV.

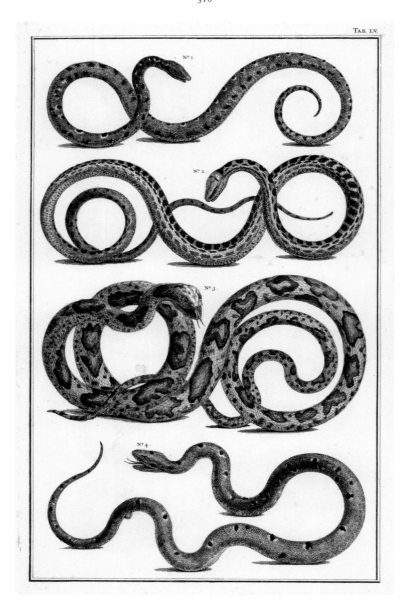

**1-2, 4** Serpentes **3** *Vipera ammodytes?*
**1-2, 4** Snakes, according to Seba from Ceylon · Schlangen, nach Seba aus Ceylon ·
Serpents, de Ceylan selon Seba **3** Nose-horned viper · Sandotter · Vipère des sables

TAB. LVI.

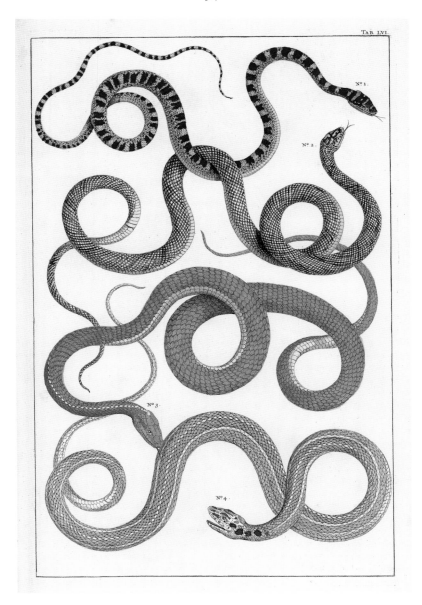

**1-4** Serpentes
**1-4** Snakes, according to Seba from Ambon, Ceylon, Bali and the Cape of Good Hope ·
Schlangen, nach Seba aus Ambon, Ceylon, Bali und vom Kap der Guten Hoffnung ·
Serpents, d'Amboine, de Ceylan, de Bali et du cap de Bonne-Espérance selon Seba

TAB.LVII.

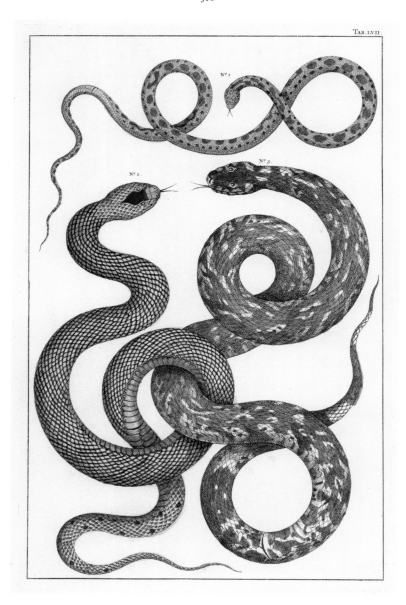

**1-3** Serpentes
**1-3** Various Snakes · Verschiedene Schlangen · Serpents divers

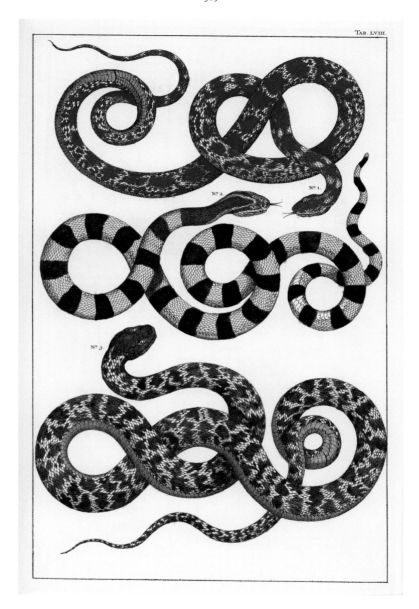

TAB. LVIII.

**1-3** Serpentes
**1** Snake, according to Seba from Asia · Schlange, nach Seba aus Asien · Serpent, d'Asie selon Seba
nake, according to Seba from Guadeloupe · Schlange, nach Seba aus Guadeloupe · Serpent, de Guadeloupe
n Seba **3** Snake, according to Seba from Japan · Schlange, nach Seba aus Japan · Serpent, du Japon selon Seba

TAB. LIX.

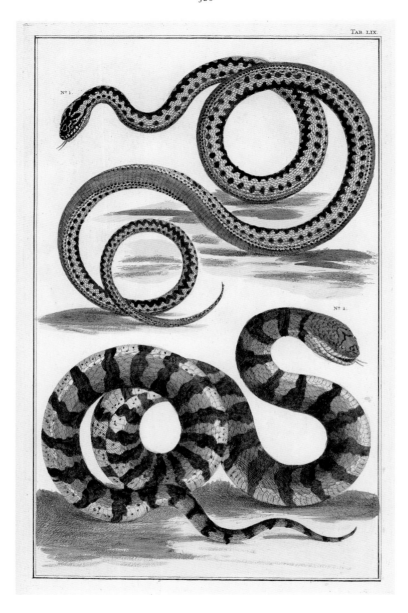

**1-2** Serpentes
**1-2** Snakes, according to Seba from Celebes (1) and Surinam (2) ·
Schlangen, nach Seba aus Celebes (1) und Surinam (2) ·
Serpents, de Célèbes (1) et du Surinam (2) selon Seba

TAB. LX.

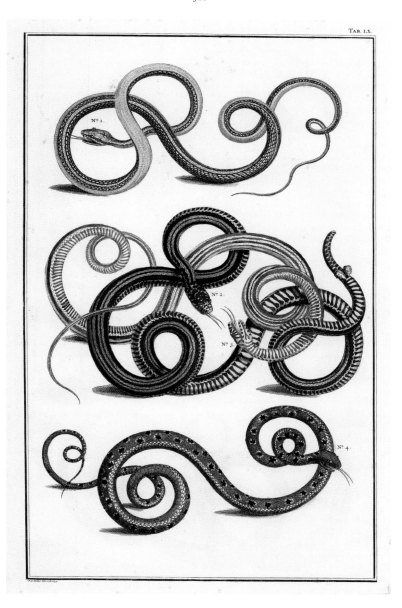

1-4 Serpentes
**1-4** Various snakes · Verschiedene Schlangen · Serpents divers

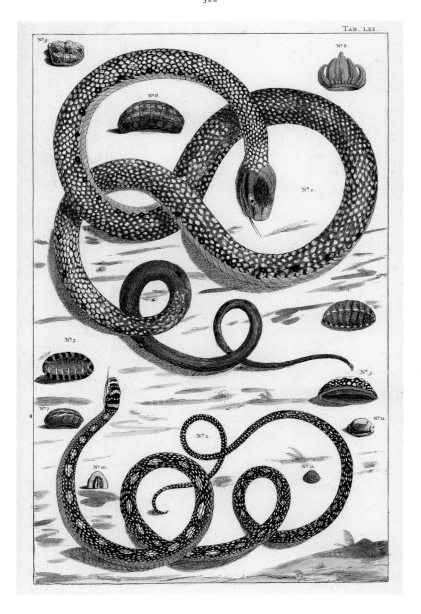

TAB. LXI.

**1-4** Serpentes **3-7** Polyplacophara
**1** Snake, according to Seba from America · Schlange, nach Seba aus Amerika · Serpent,
d'Amérique selon Seba **2** Snake, according to Seba from Ceylon · Schlange, nach Seba aus Ceylon ·
Serpents, de Ceylan selon Seba **3-7** Chitons · Käferschnecken · Placophores

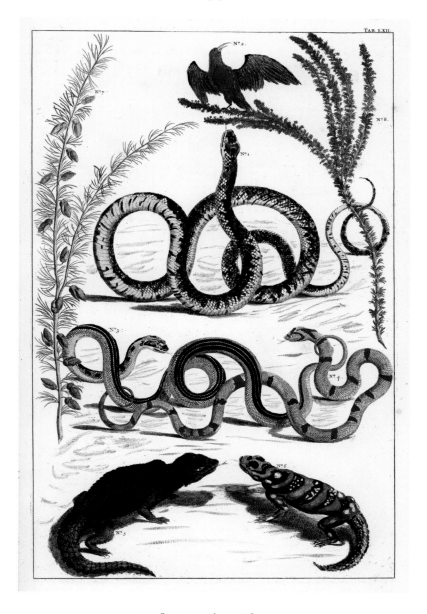

**1, 3-4** Serpentes **2** Aves **5-6** Squamata
**1, 3-4** Snakes from various regions · Schlangen aus verschiedenen Regionen ·
erpents de différentes régions **2** Bird, according to Seba from Ambon · Vogel, nach Seba aus Ambon ·
Oiseau, d'Amboine selon Seba **5-6** Lizards · Echsen · Sauriens

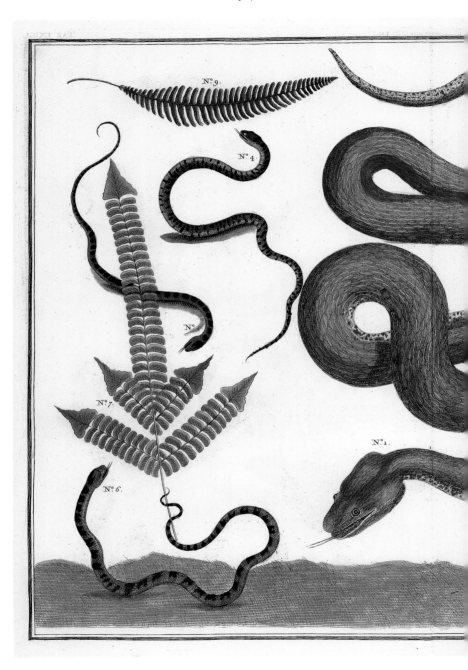

TAB. LXIIII.

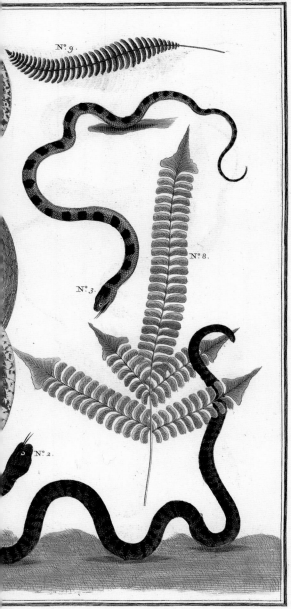

1-3, 5-6 Serpentes
4 Squamata 7-9 *Adiantum*
1 Snake, according to Seba
from St. Cruz · Schlange,
nach Seba aus St. Cruz ·
Serpent, de Santa Cruz selon
Seba 2-6 Snakes, according to
Seba from America · Schlangen,
nach Seba aus Amerika ·
Serpents, d'Amérique selon Seba
4 Lizard · Echse · Saurien
7-9 Maidenhair fern · Frauen-
haarfarn · Cheveux-de-Vénus

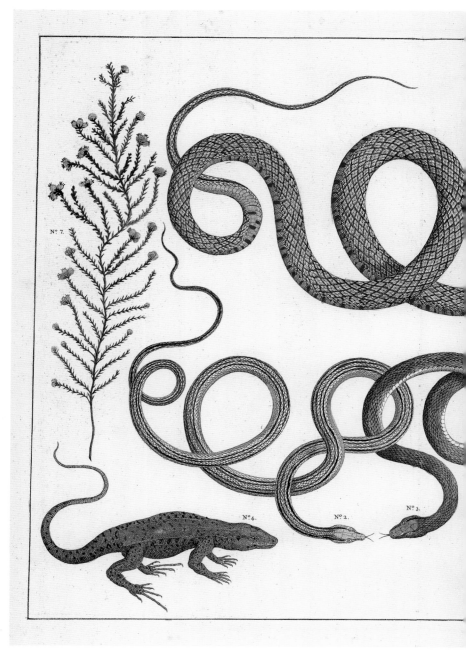

TAB. LXIII.

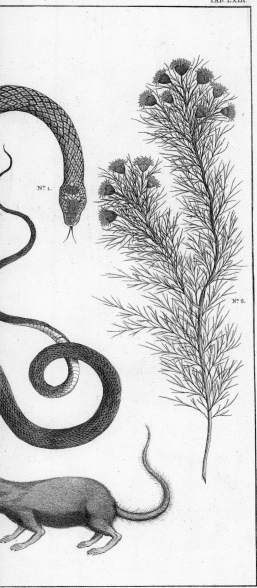

N.º 1.

N.º 6.

**1-3** Serpentes **5** Soricidae
**6** Compositae **7** Ericaceae
**1** Snake, according to Seba from
Mexico · Schlange, nach Seba aus
Mexiko · Serpent, du Mexique
selon Seba **2** Snake, according to
Seba from Nova Hispania ·
Schlange, nach Seba aus Nova
Hispania · Serpent, de Nova
Hispania selon Seba **3** Snake,
according to Seba from Africa ·
Schlange, nach Seba aus Afrika ·
Serpent, d'Afrique selon Seba
**5** Shrew · Spitzmaus · Musaraigne
**6** Sunflower family · Korbblütler ·
Composées **7** Heath family ·
Heidekrautgewächse · Ericacées

1-4 Serpentes **5-6** Compositae
**1-4** Snakes, according to Seba
from America · Schlangen,
nach Seba aus Amerika ·
Serpents, d'Amérique selon
Seba **5-6** Sunflower family ·
Korbblütler · Composées

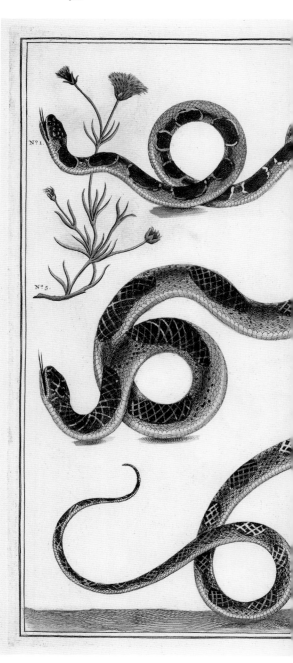

TAB. LXVI.

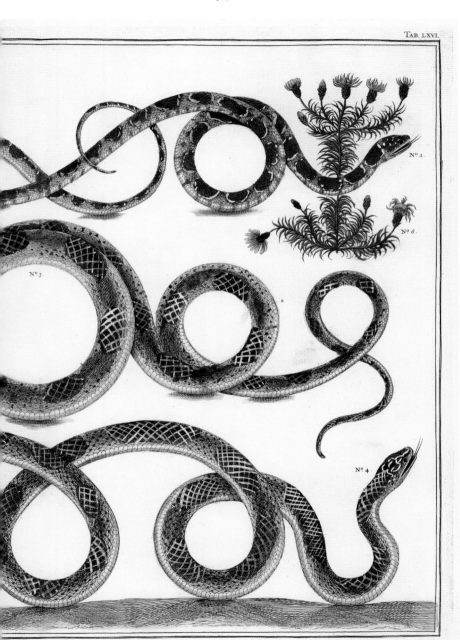

No 2.

No 6.

No 3.

No 4.

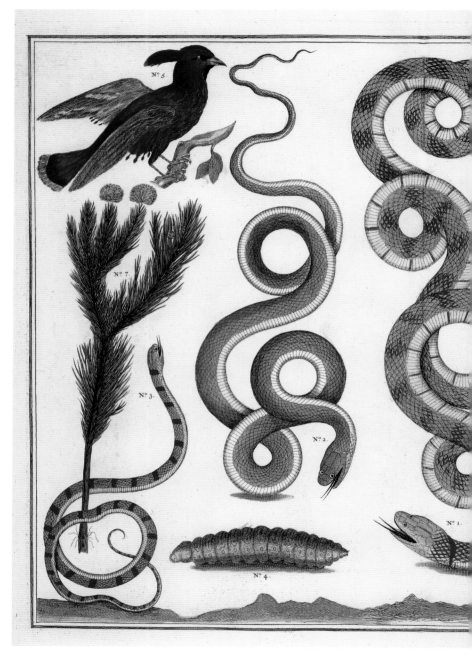

TAB. LXV.

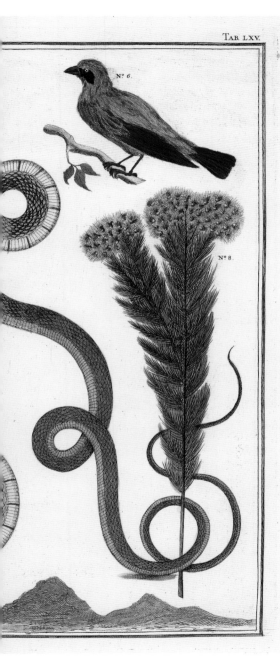

1-3 Serpentes 4 Larva insectorum
5 *Bombycilla garrulus* 6 Ploceidae
1 Snake, according to Seba from the
Orient · Schlange, nach Seba aus
dem Orient · Serpent, d'Orient
selon Seba 2 Snake, according to
Seba from Ambon · Schlange,
nach Seba aus Ambon · Serpent,
d'Amboine selon Seba 3 Snake,
according to Seba from America ·
Schlange, nach Seba aus Amerika ·
Serpent, d'Amérique selon Seba
4 Insects found in snake no. 2 ·
In Schlange Nr. 2 gefundene
Insektenlarve · Larve d'insecte
trouvée dans le serpent n° 2
5 Bohemian waxwing ·
eidenschwanz · Jaseur boréal
6 Weaver · Webervogel · Tisserin

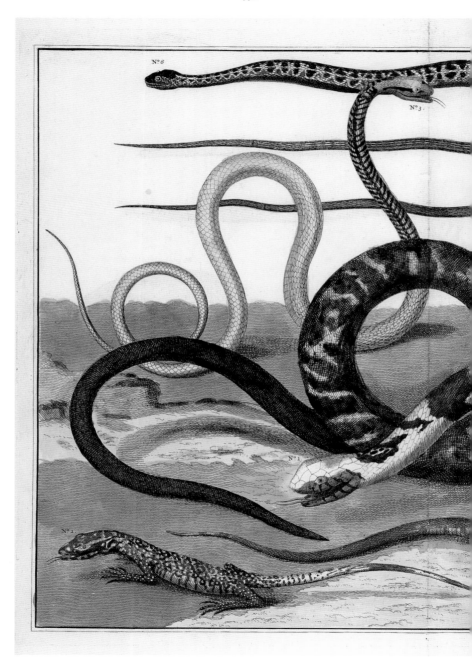

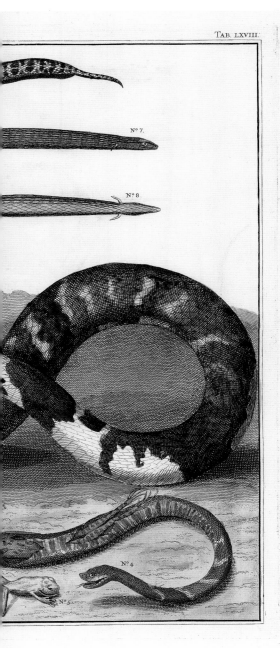

TAB. LXVIII.

Nº 7.

Nº 8.

Nº 4.

Nº 5.

**1, 3-4, 6** Serpentes **2** Squamata
**5** Anura
**1, 3** Snakes, according to Seba from
Brazil · Schlangen, nach Seba aus
Brasilien · Serpents, du Brésil selon
Seba **2** Lizard · Echse · Saurien
**4, 6** Snakes, according to Seba from
America · Schlangen, nach Seba aus
Amerika · Serpents, d'Amérique
selon Seba **5** Frog · Frosch ·
Grenouille

1 Muraenidae 2 Muraenidae
3 *Gymnomuraena zebra* 4 Hylidae
**1-2** Moray eels · Muränen ·
Murènes **3** Zebra moray eel ·
Muräne · Murène zèbre
**4** Tree frog · Laubfrosch ·
Grenouille verte

TAB. LXX.

Nº 8

Nº 3

Nº 4.

Nº 1.

Nº 6.

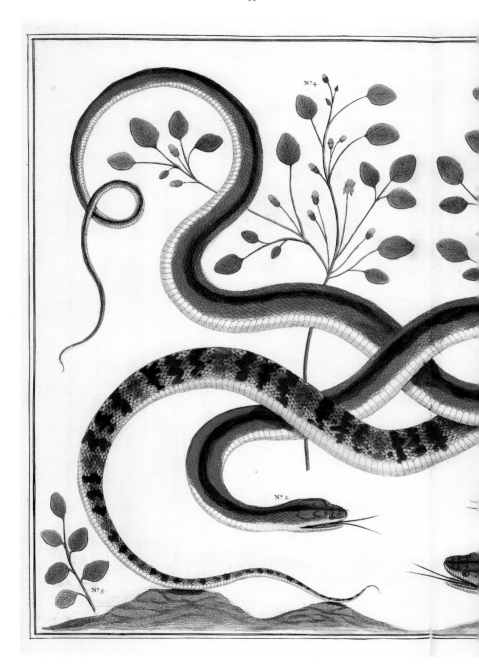

Tab. LXVII.

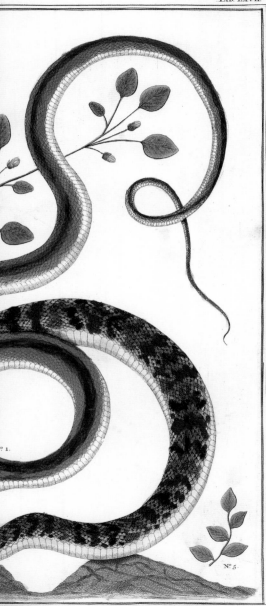

**1-3** Serpentes
**1-2** Snakes, according to Seba from
Surinam · Schlangen, nach Seba aus
Surinam · Serpents, du Surinam
selon Seba **3** Snake, according to
Seba from Brazil · Schlange,
nach Seba aus Brasilien ·
Serpent, du Brésil selon Seba

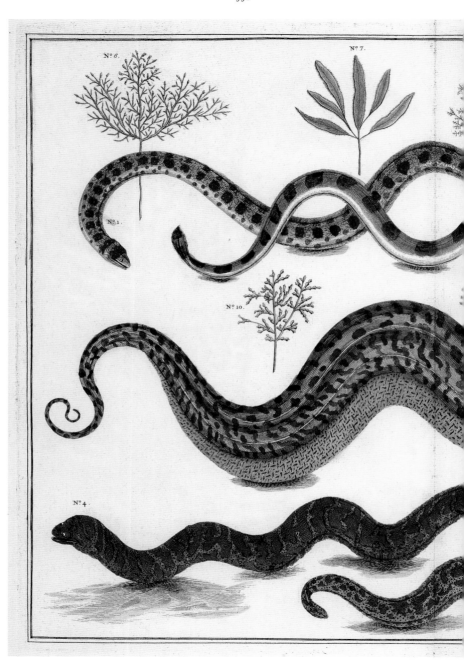

TAB. LXIX.

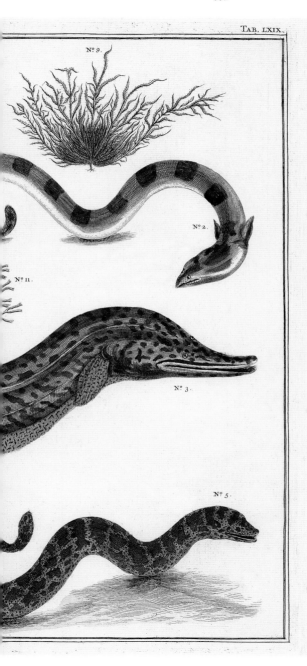

1-2 Muraenidae 3 *Gymnotus carapo* 4-5 *Echidna catenata* 6-11 Cnidaria: Anthozoa 1-2 Moray eels · Muränen · Murènes 3 Banded knifefish · Gebänderter Messerfisch · Gymnote rayée (Guyane française) 4-5 Chainlink moray eels · Schlangen- muränen · Murènes enchaînées 6-11 Corals · Korallen · Coraux

**1-3** Serpentes **6-7** Leguminosae
**1-3** Snakes, according to Seba
from America · Schlangen,
nach Seba aus Amerika ·
Serpents, d'Amérique selon
Seba **6-7** Pea family ·
Hülsenfruchtgewächse ·
Légumineuses

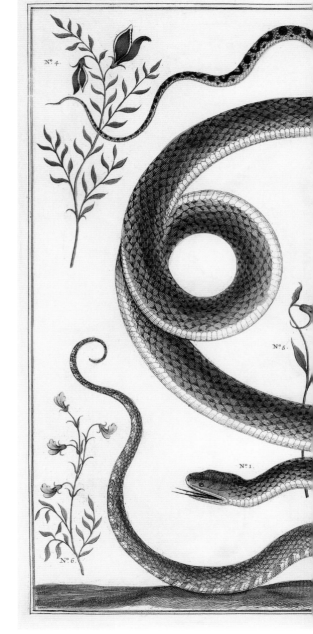

TAB. LXXI.

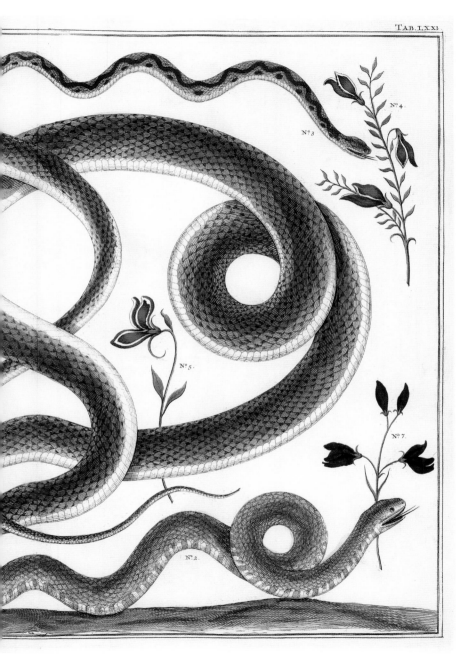

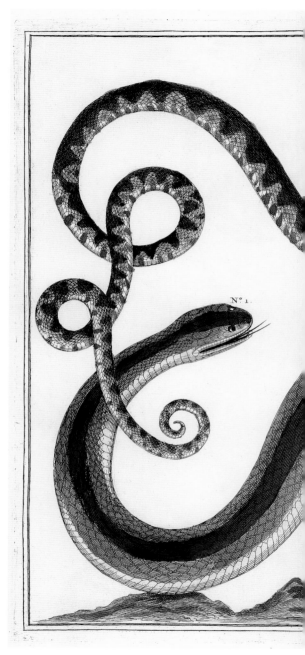

1-2 Serpentes
**1-2** Snakes, according to Seba
from Ambon · Schlangen,
nach Seba aus Ambon ·
Serpents, d'Amboine selon Seba

Nº 1.

TAB. LXXII.

N.º 2.

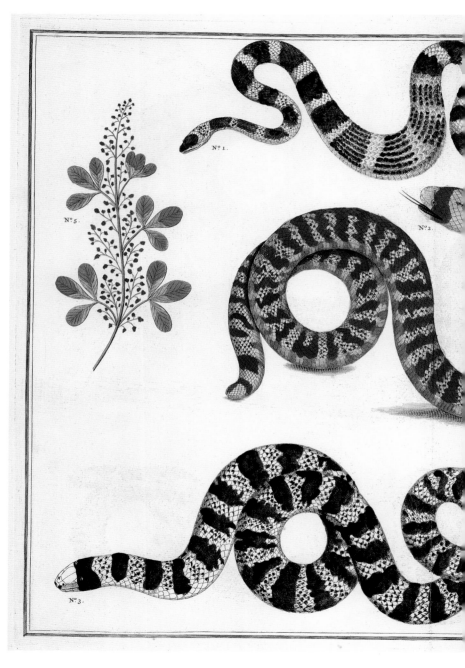

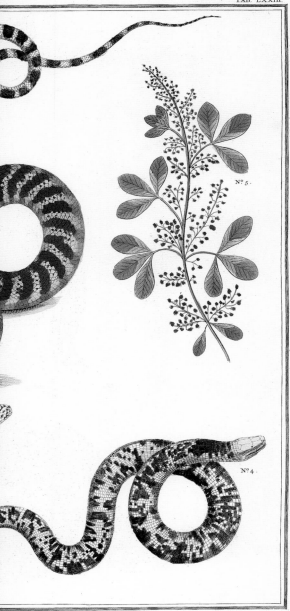

Tab. LXXIII.

N° 5.

N° 4.

**1** *Pituophis melanoleucus?*
**2** Serpentes
**3-4** *Amphisbaenia sp.*
**1** Pine snake/Bull snake ·
Büffelschlange · Serpent (de)
Bison **2** Snake, according to
Seba from Brazil · Schlange,
nach Seba aus Brasilien ·
Serpent, du Brésil selon Seba
**3-4** Ringed lizards ·
Doppelschleichen ·
Amphisbènes

1 *Corallus enydris?*
1 Garden tree boa · Baumboa · Boa

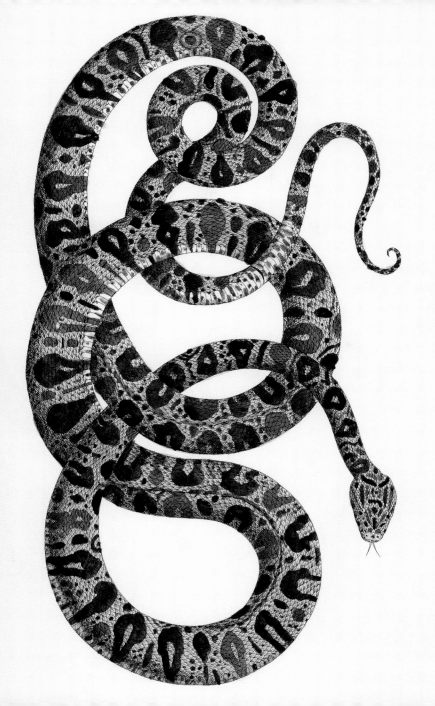

**1-5** *Serpentes*
**1-5** Snakes, according to Seba from America · Schlangen, nach Seba aus Amerika · Serpents, d'Amérique selon Seba

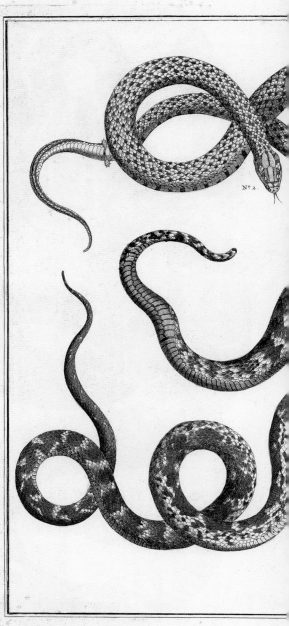

No. 2.

TAB. LXXV.

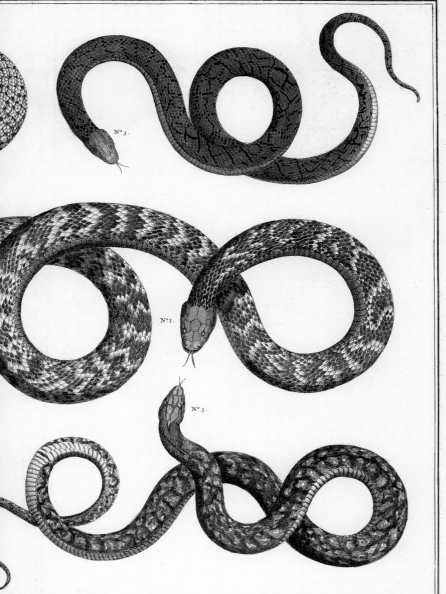

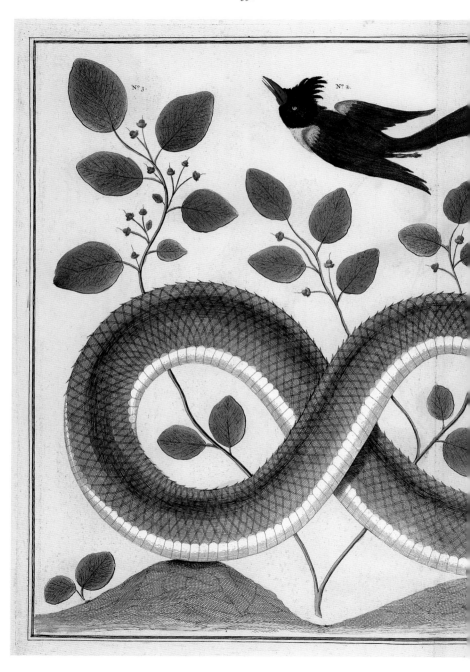

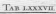

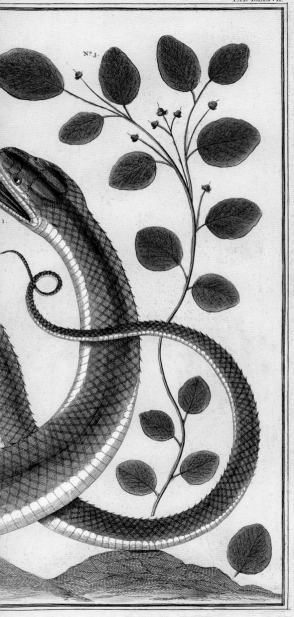

1 Serpentes
2 *Taeniotricus andrei*
1 Snake, according to Seba
from Brazil · Schlange,
nach Seba aus Brasilien ·
Serpent, du Brésil selon Seba
2 Black-crested tyrant ·
Schwarzkopftyrann ·
Tyranneau d'André

Nº 1.

Nº 2.

Nº 4

TAB. LXXVI.

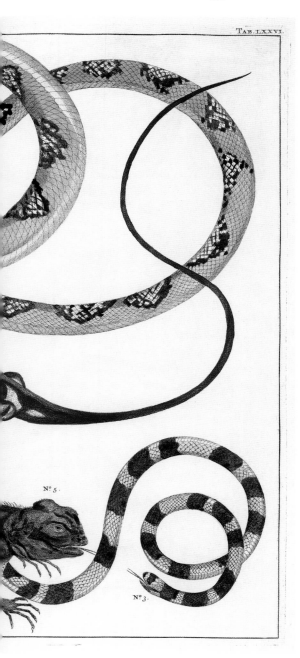

N° 5.

N° 3.

**1** *Lachesis muta?* **2-3** Serpentes
**4-5** Squamata
**1** Bushmaster · Buschmeister ·
Surucucu **2-3** Snakes, according
to Seba from Ceylon ·
Schlangen, nach Seba aus
Ceylon · Serpents, de Ceylan
selon Seba **4-5** Lizards ·
Echsen · Sauriens

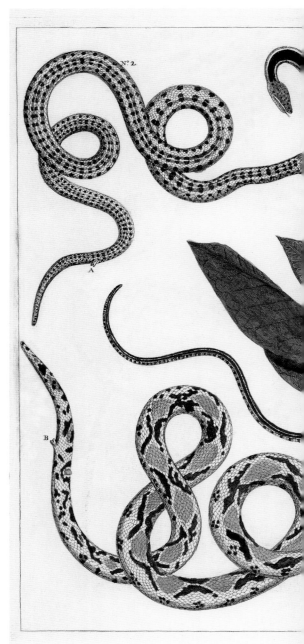

1-3, 6 Serpentes 4-5 *Epicrates?*
8 Melastomataceae
**1-3, 6** Snakes, according to Seba
from America · Schlangen,
nach Seba aus Amerika ·
Serpents, d'Amérique selon
Seba **4-5** Slender boa ·
Schlankboa · Boa
**8** Melastoma family ·
Schwarzmundgewächse ·
Mélastomacées

Tab. LXXVII.

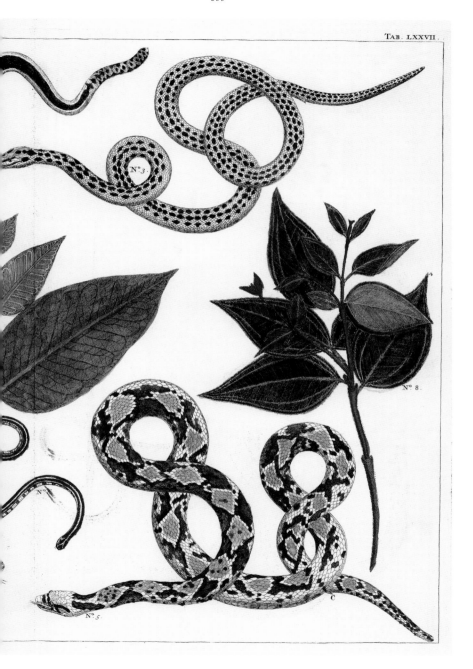

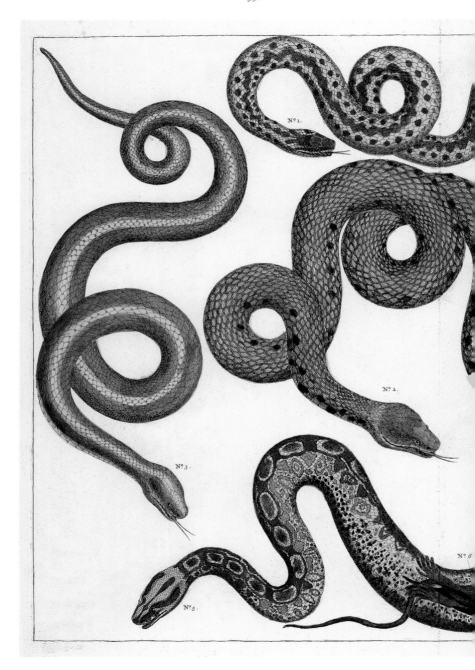

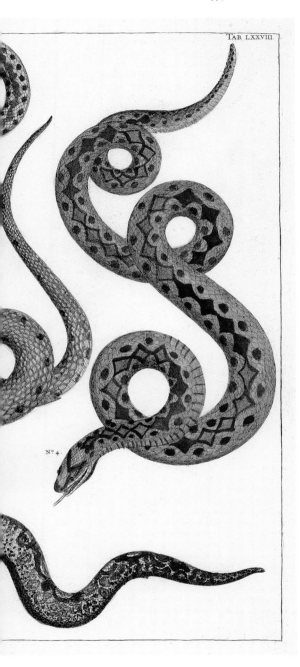

TAB. LXXVIII

N.° 4.

1 *Vipera berus?* 2, 4-5 Serpentes
3 *Lamprophis aurora* 6 Squamata
1 Adder/Common viper ·
Kreuzotter · Vipère péliade
2, 4-5 Snakes from different
continents · Schlangen aus
verschiedenen Kontinenten ·
Serpents de différents
continents 3 Aurora house
snake · Goldene Hausschlange ·
Serpent 6 Lizard · Echse ·
Saurien

1 Boidae: Pythoninae
2 Serpentes 3 *Siphlophis cervina*
4 Squamata 5 *Lacerta agilis*
1 Python · Python · Python
2-3 Snakes, according to Seba
from America · Schlangen,
nach Seba aus Amerika ·
Serpents, d'Amérique selon
Seba 4 Lizard · Echse · Saurien
5 Sand lizard · Zauneidechse ·
Lézard agile

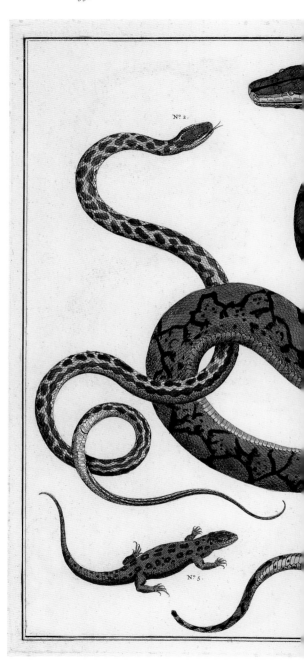

TAB. LXXIX.

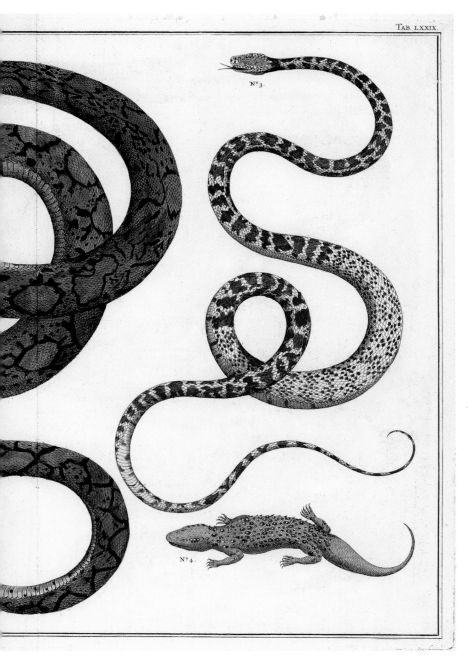

N°3.

N°4.

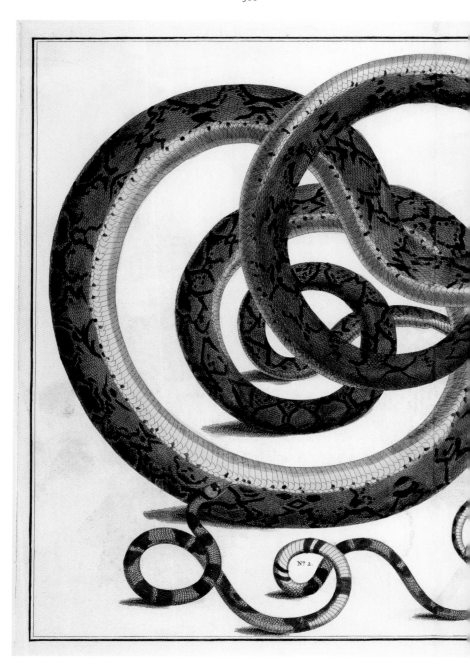

Tab. LXXX.

1 Boinae 2 Serpentes 3 *Ipomoea*
1 Boine snake · Riesenschlange ·
Boïné 2 Snake, according to
Seba from Mexico · Schlange,
nach Seba aus Mexiko · Serpent,
du Mexique selon Seba
3 Morning-glory · Prunkwinde ·
Ipomée

TAB. LXXXI

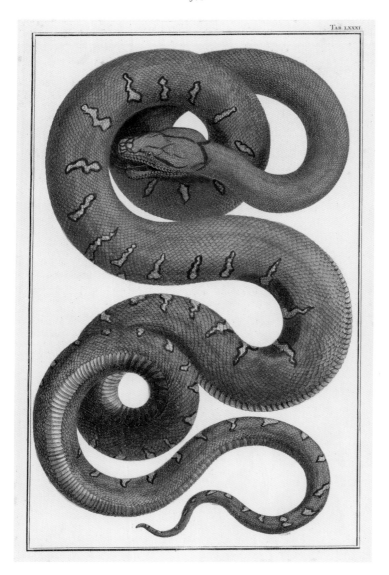

1 *Corallus caninus*
1 Emerald Tree Boa · Hundskopfboa · Boa canin

*Opposite page*
1 *Ahaetulla sp.* 2-3 Serpentes
1-3 Various snakes · Verschiedene Schlangen · Serpents divers

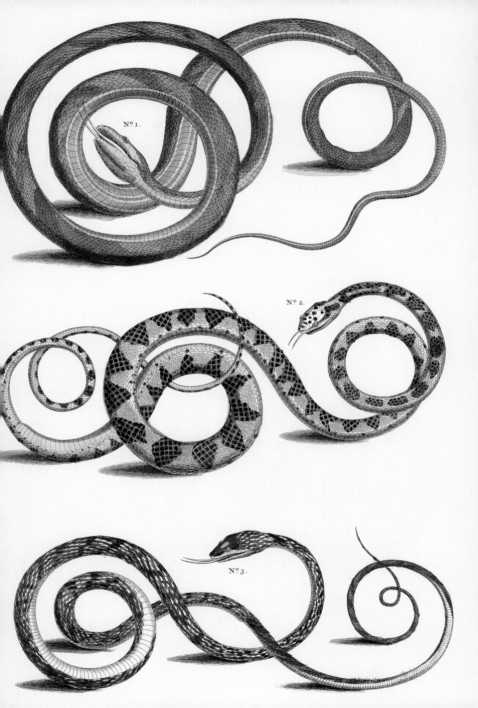

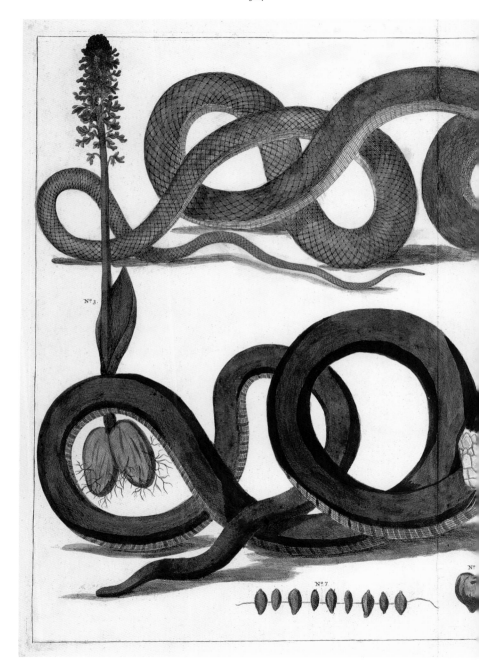

N.º 3.

N.º 7

N.º

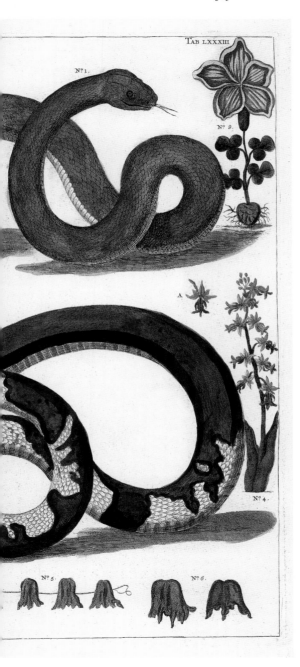

1-2 Serpentes **3** *Orchis sp.*
**4** Orchidaceae **5** *Oxalis sp.*
**6** Lauraceae
**1** Snake, according to Seba
from India · Schlange, nach
Seba aus Indien · Serpent, de
l'Inde selon Seba
**2** Snake, according to Seba
from Ceylon · Schlange, nach
Seba aus Ceylon · Serpent, de
Ceylan selon Seba
**3** Orchis · Knabenkraut · Orchis
**4** Orchid family · Orchideen-
gewächse · Orchidacées
**5** Wood sorrel · Sauerklee ·
Surelle **6** Laurel family ·
Lorbeergewächse · Lauracées

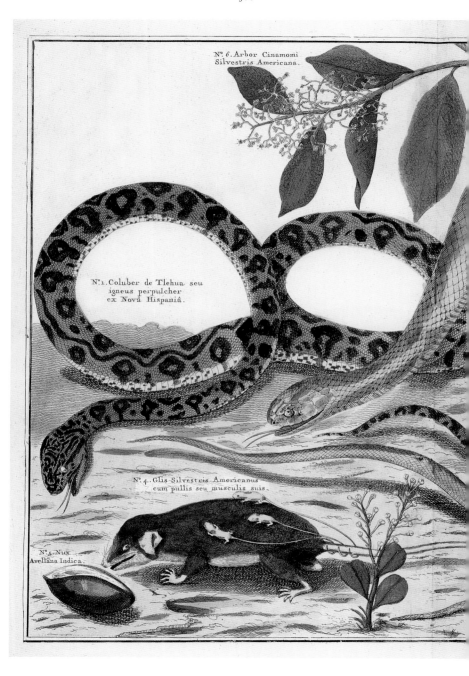

Nº. 6. Arbor Cinamomi Silvestris Americana.

Nº. 1. Coluber de Tlehua seu igneus perpulcher ex Novâ Hispaniâ.

Nº. 4. Glis Silvestris Americanus cum pullis seu musculis suis.

Nº. 5. Nux Avellana Indica.

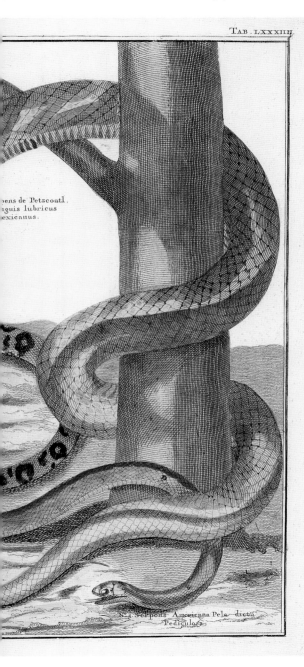

ens de Petzcoatl.
guis lubricus
exicanus.

No. 7. Serpens Americana Pela dicta
Pediculosa

1 Boinae 2-3 Serpentes
4 *Myoxis glis* 5 »Nux Avelana,
Indica« (Seba) 6 Lauraceae
1 Boine snake · Riesen–
schlange · Boïné 2-3 Snakes,
according to Seba from
America · Schlangen,
nach Seba aus Amerika ·
Serpents, d'Amérique selon
Seba 4 Fat dormouse ·
Siebenschläfer · Loir gris
5 "Nut from India" (Seba) ·
„Nuß aus Indien" (Seba) ·
« Noix d'Inde » (Seba)
6 Laurel family · Lorbeer-
gewächse · Lauracées

1 *Naja naja* 2 Serpentes
1 Common cobra · Brillenschlange/Kobra · Cobra indien 2 Snake, according to Seba from Peru ·
Schlange, nach Seba aus Peru · Serpent, du Pérou selon Seba

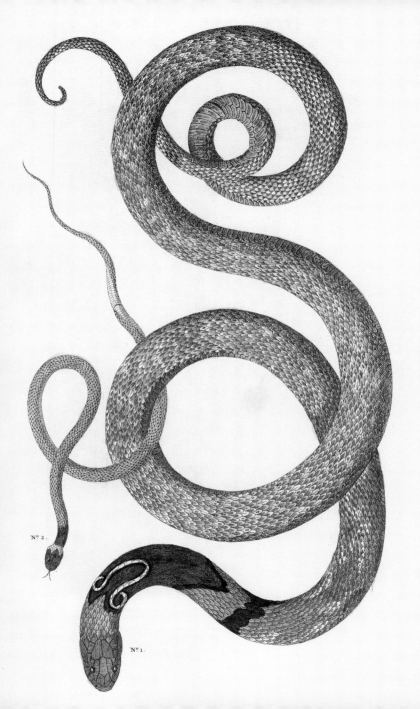

N.º 2.

N.º 1.

1 Serpentes 2 *Varanus sp.*
3 *Draco sp.* 4-5 Serpentes
6 Ericaceae
1 Snake, according to Seba from
Asia · Schlange, nach Seba aus
Asien · Serpent, d'Asie selon
Seba 2 Monitor · Waran ·
Varanidé 3 Flying dragon ·
Flugdrache · Dragon volant

TAB. LXXXVI.

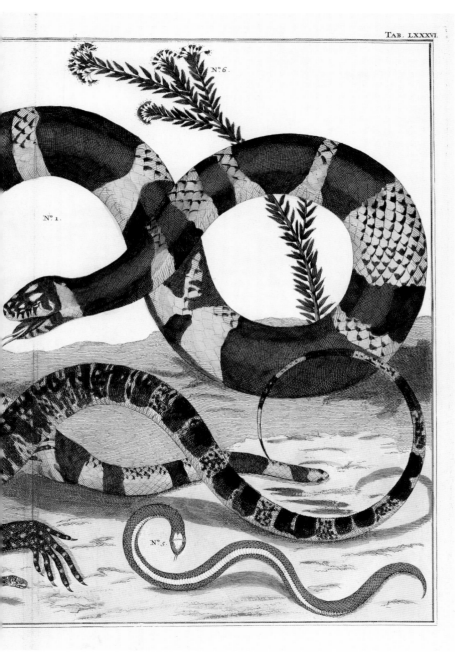

TAB. LXXXVIII.

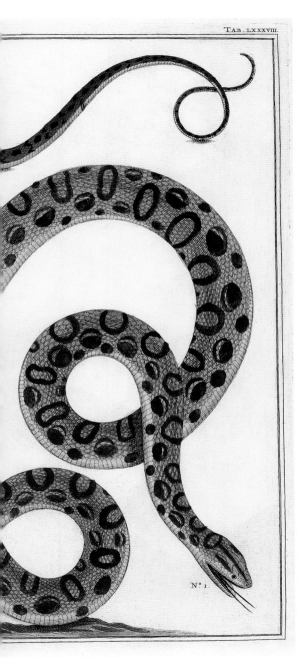

N.º 1.

**1** *Epicrates cenchria* **2** Serpentes
**1** Rainbow boa · Regenbogen-
boa · Boa arc-en-ciel
**2** Snake, according to Seba from
Ceylon · Schlange, nach Seba
aus Ceylon · Serpent, de Ceylan
selon Seba

1-4 *Naja naja* 5 Compositae
1-4 Common cobra ·
Brillenschlange/Kobra · Cobra
indien 5 Sunflower family ·
Korbblütler · Composées

Tab. LXXXIX.

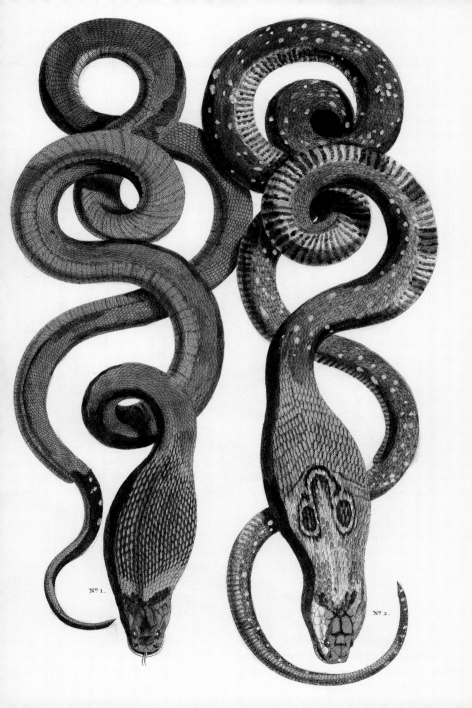

N.º 1.

N.º 2.

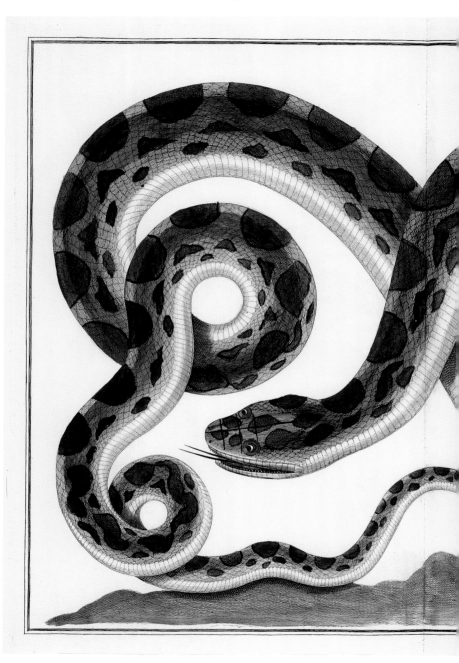

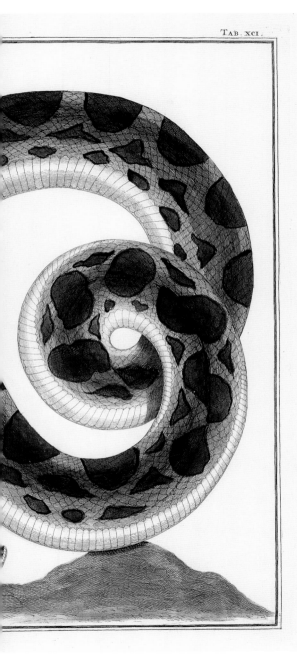

1 Boidae
**1** Boid snake · Riesenschlange ·
Boïdé

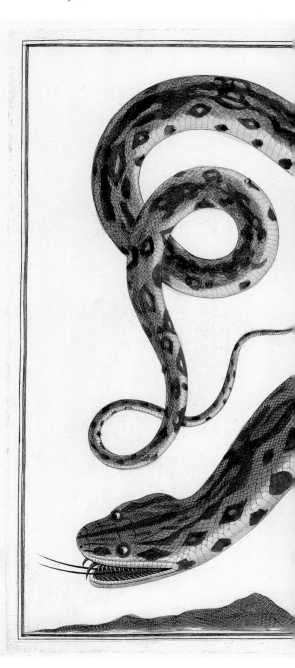

1 *Boa constrictor?*
1 Common boa · Abgott-
schlange · Boa constricteur

TAB. XCII.

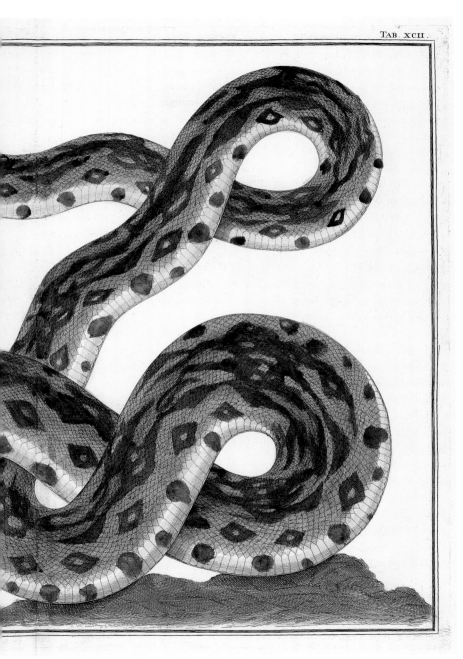

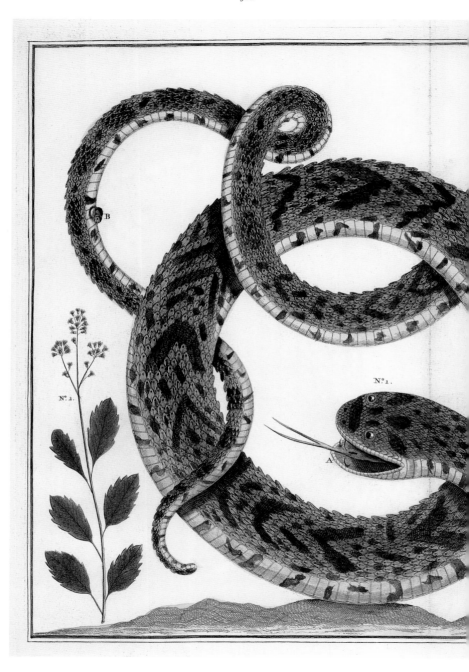

Nº 1.

Nº 2.

B

A

TAB. XCIII.

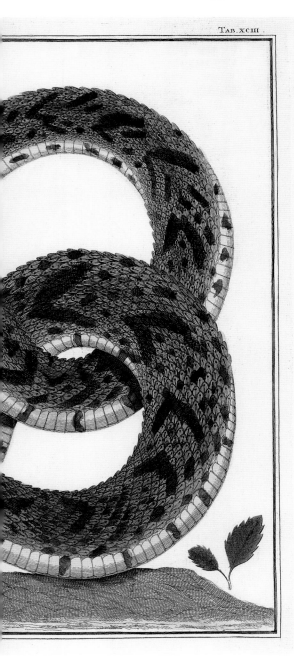

1 Serpentes
1 Poisonous snake · Viper ·
Serpent venimeux

1 *Naja naja* 2 Serpentes
1 Common cobra ·
Brillenschlange/Indische
Kobra · Cobra indien 2 Snake,
according to Seba from Ceylon ·
Schlange, nach Seba aus Ceylon
· Serpent, de Ceylan selon Seba

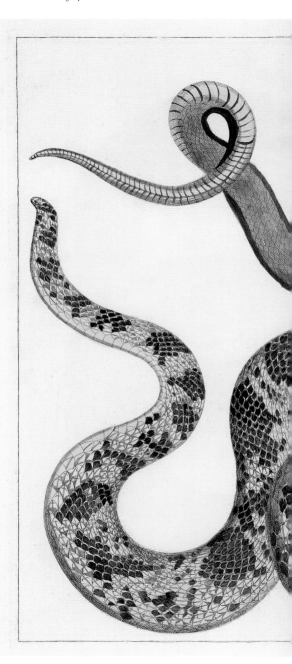

TAB. XCIV.

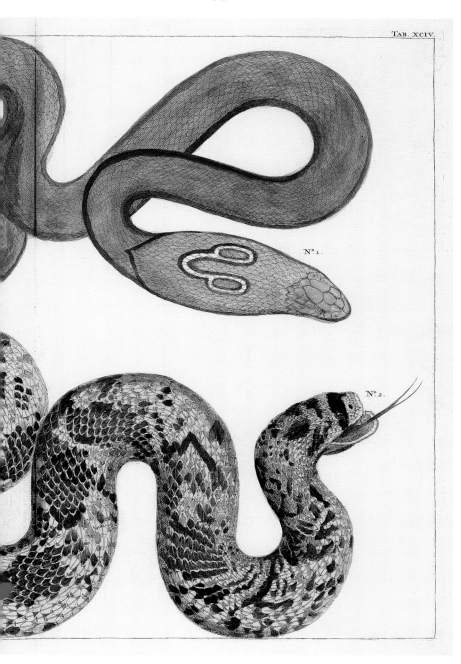

Nº 1.

Nº 2.

**1-3** *Crotalus sp.*
**1-3** Rattlesnakes · Klapperschlangen · Crotales

TAB. XCV.

A    B    C    N°1.    N°2.    N°3.

1 Serpentes 2 *Corallus caninus*
3 *Cotinga cayana* 4 *Icterus
chrysater* 5 *Pipra pipra* 6 Aves
1 Snake, according to Seba from
Asia · Schlange, nach Seba aus
Asien · Serpent, d'Asie selon
Seba 2 Emerald tree boa ·
Hundskopfboa · Boa canin
3 Spangled cotinga ·
Halsbandkotinga · Cotinga de
Cayenne 4 Yellow-backed
oriole · Schwarzflügeltrupial ·
Oriole noir et or
5 White-crowned manakin ·
Weißscheitelpipra · Manakin
à tête blanche 6 Skeleton of a
bird · Vogelskelett · Squelette
d'oiseau

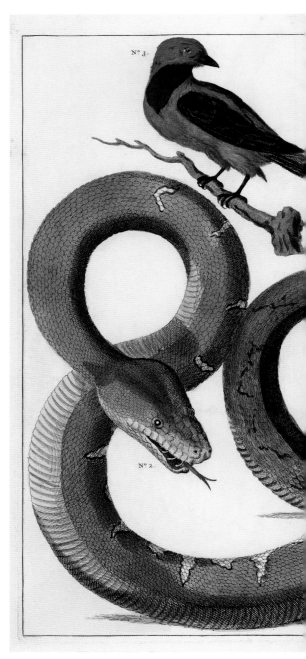

TAB. XCVI.

N.º 6.

N.º 5.

N.º 4.

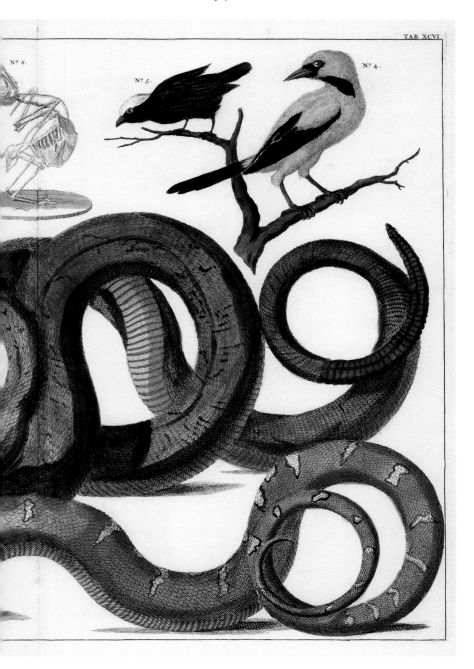

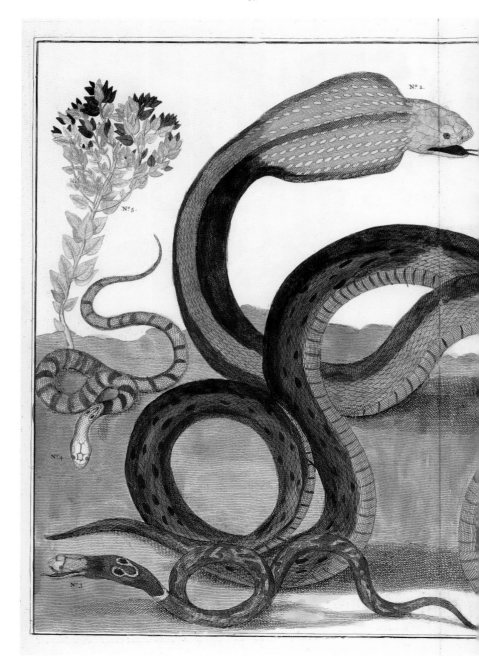

TAB. XCVII.

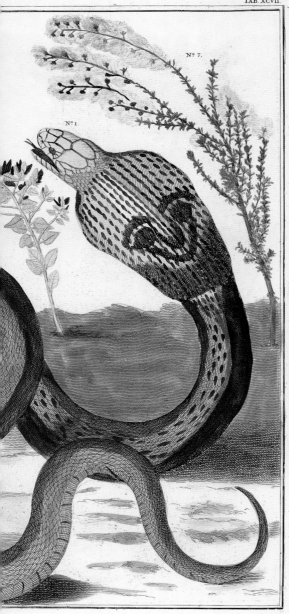

Nº 7.

Nº 1.

**1-3** *Naja naja* **4** Serpentes
**1-3** Common cobra ·
Brillenschlange/Indische
Kobra · Cobra indien **4** Snake,
according to Seba from Nova
Hispania · Schlange, nach Seba
aus Nova Hispania · Serpent, de
Nova Hispania selon Seba

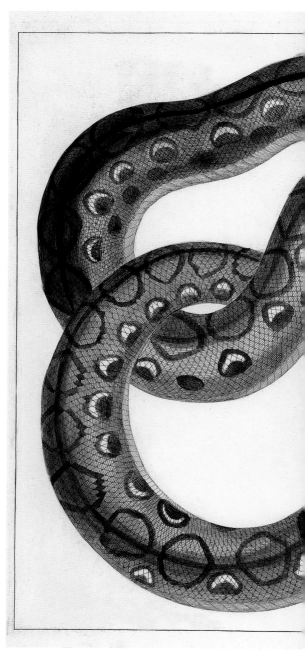

1 *Epicrates cenchria*
1 Rainbow boa ·
Regenbogenboa ·
Boa arc-en-ciel

TAB. XCVIII.

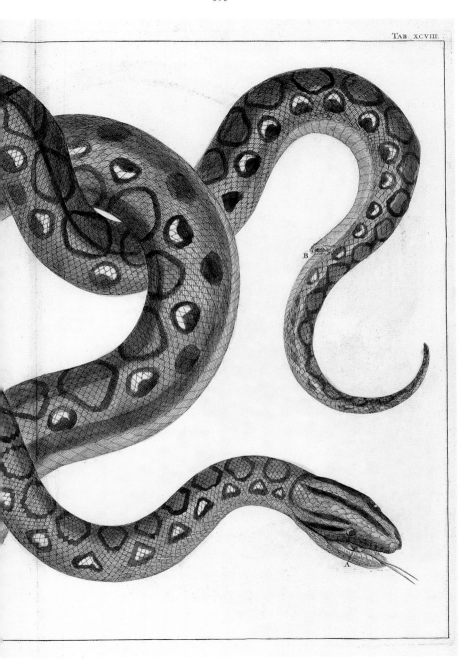

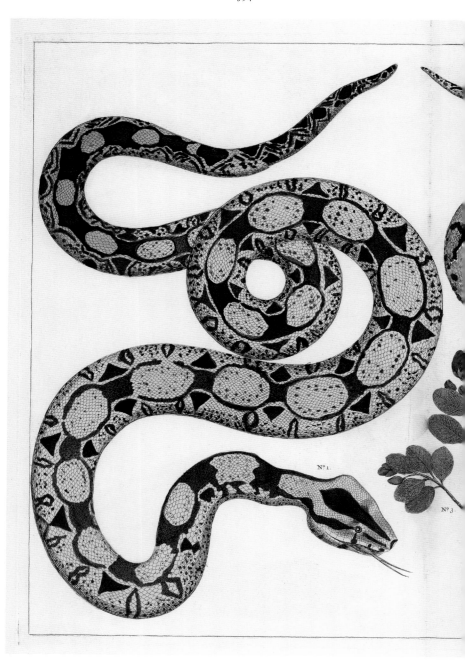

N°.1.

N°.3.

395

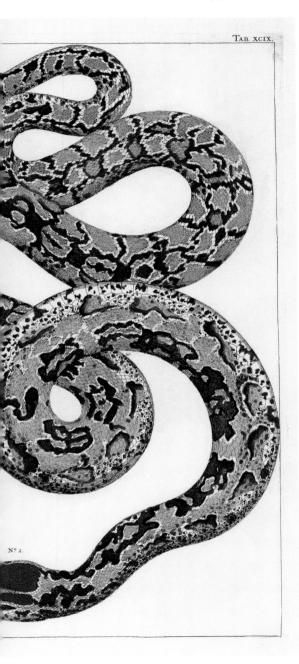

Tab. xcix.

1 *Boa constrictor?* 2 Boinae
1 Common boa ·
Abgottschlange · Boa
constricteur 2 Boine snake ·
Riesenschlange · Boïné

Nº 2.

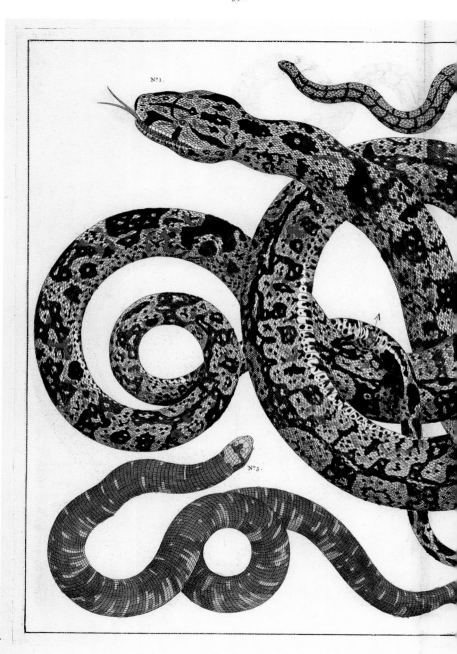

TAB. C.

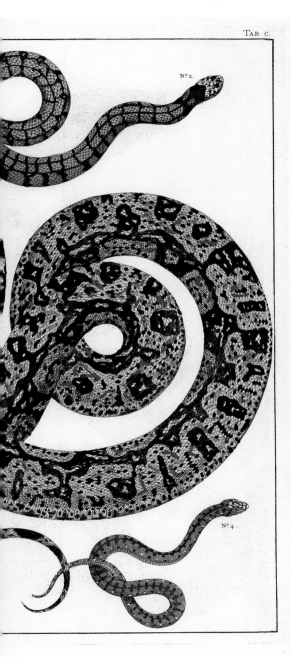

1 *Boa constrictor?* **2, 4** Serpentes
**3** Amphisbaenia sp.
**1** Common boa ·
Abgottschlange · Boa
constricteur **2** Snake, according
to Seba from Brazil · Schlange,
nach Seba aus Brasilien ·
Serpent, du Brésil selon Seba
**3** Ringed lizard ·
Doppelschleiche ·
Amphisbène **4** Snake, according
to Seba from Ambon ·
Schlange, nach Seba aus
Ambon · Serpent, d'Amboine
selon Seba

1 *Python molurus*
1 Indian python · Tiger Python ·
Python indien

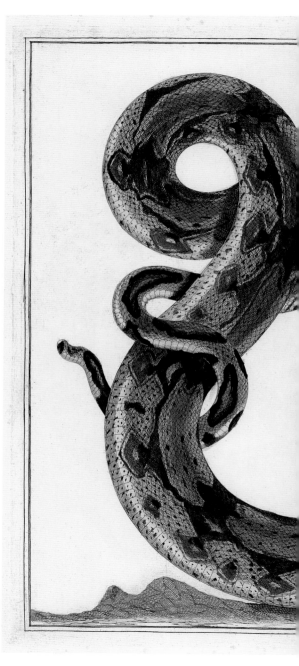

TAB. CI.

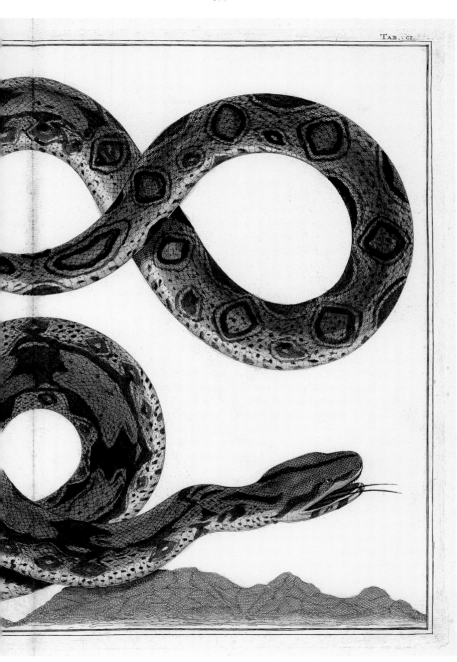

1 *Python regius*
1 Royal python · Königspython · Python royal

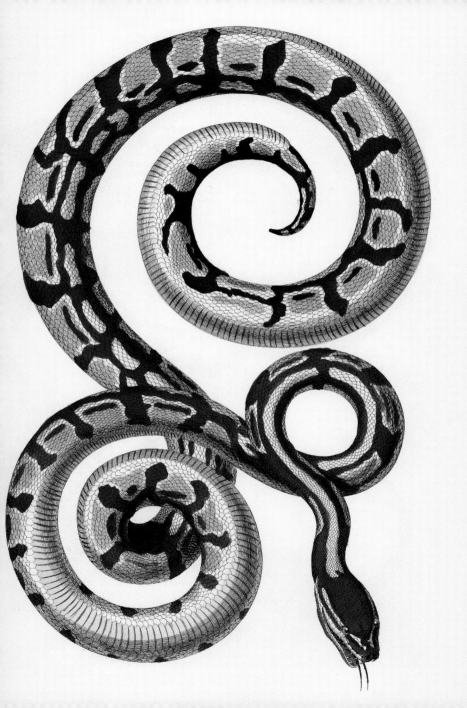

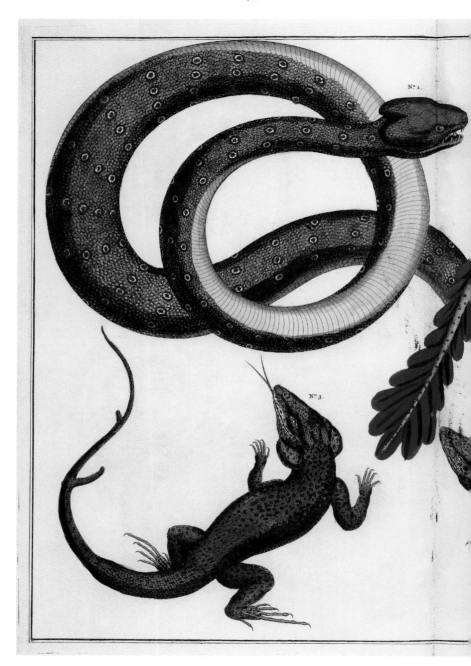

Tab. CIII.

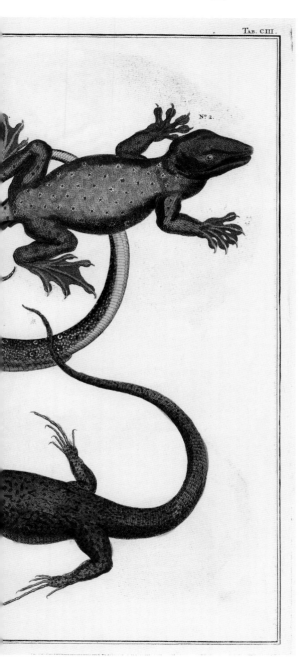

N.º 2.

1 Serpentes 2-4 Squamata
1 Snake, according to Seba from
Africa · Schlange, nach Seba aus
Afrika · Serpent, d'Afrique
selon Seba 2-4 Lizards · Echsen ·
Sauriens

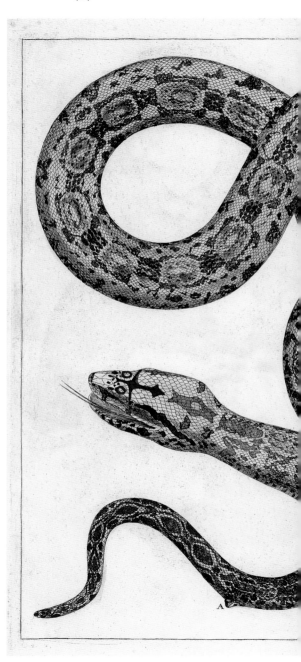

1 *Python reticulatus?*
1 Reticulated python ·
Netzpython · Python réticulé

TAB. CIIII.

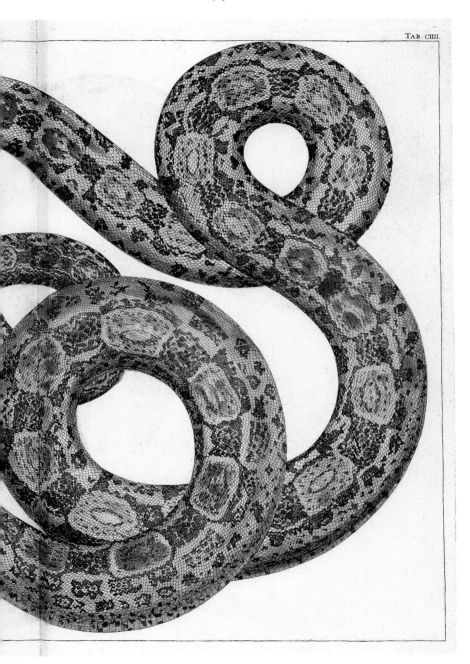

1 *Varanus sp.* **2-3** Squamata
**4** Serpentes
**1** Monitor · Waran ·
Varanidé **2-3** Lizards · Echsen ·
Sauriens **4** Snake, according to
Seba from Nova Hispania ·
Schlange, nach Seba aus Nova
Hispania · Serpent, de Nova
Hispania selon Seba

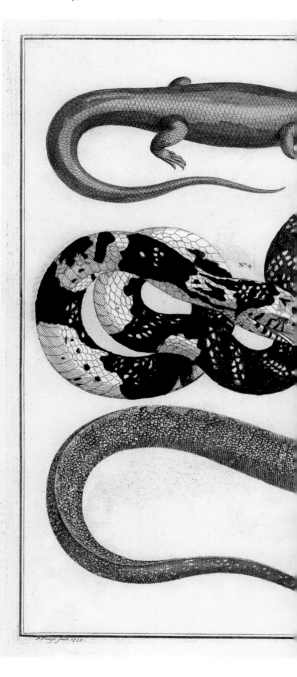

TAB. CV.

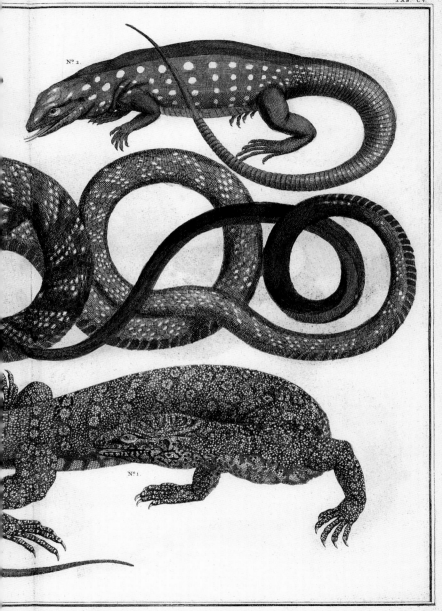

Nº 2.

Nº 1.

**1-2** Serpentes
**1-2** Opened European snakes · Geöffnete europäische Schlangen ·
Serpents européens ouverts

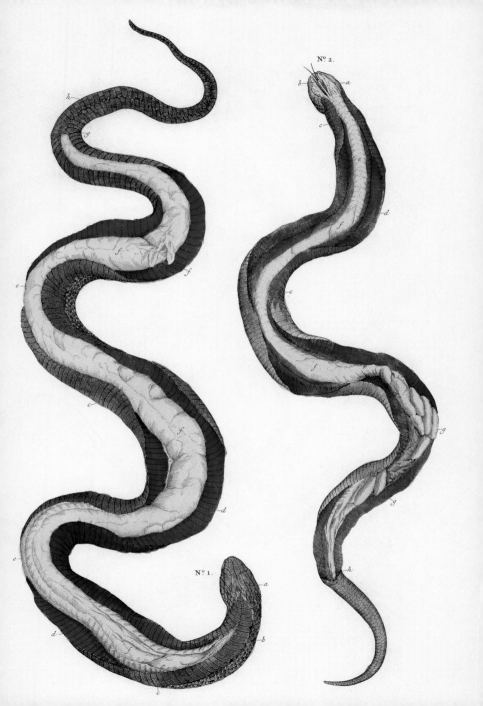

Nº 2.

Nº 1.

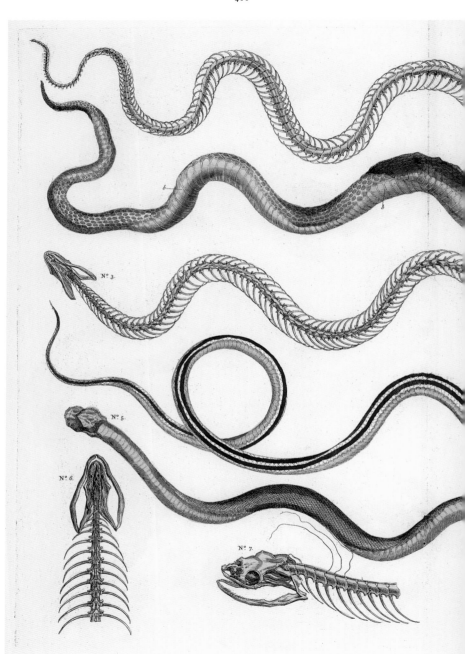

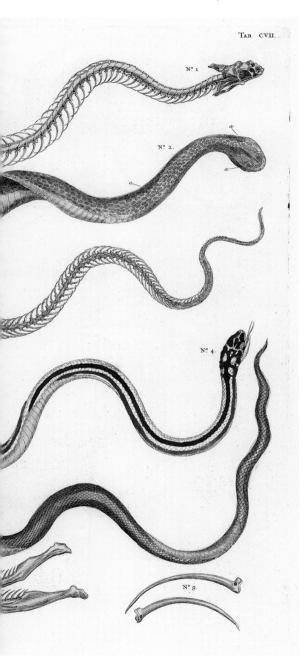

TAB. CVII.

N.º 1

N.º 2.

N.º 4.

N.º 9.

Osteologia serpentis
Snake osteology · Skelette von
Schlangen · Ostéologie du
serpent **6-7** Skull in detail ·
Schädel im Detail · Détail du
crâne **8** Lower jaw · Unter-
kiefer · Mâchoire inférieure
**9** Ribs · Rippen · Côtes

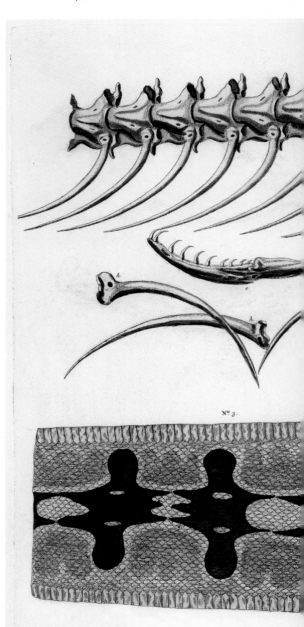

1-4 Boidae
**1-4** Parts of the skeleton and
skins of Boid snakes ·
Skelettteile und Haut von
Riesenschlangen · Parties du
squelette et peaux de boïdés

Tab. CVIII.

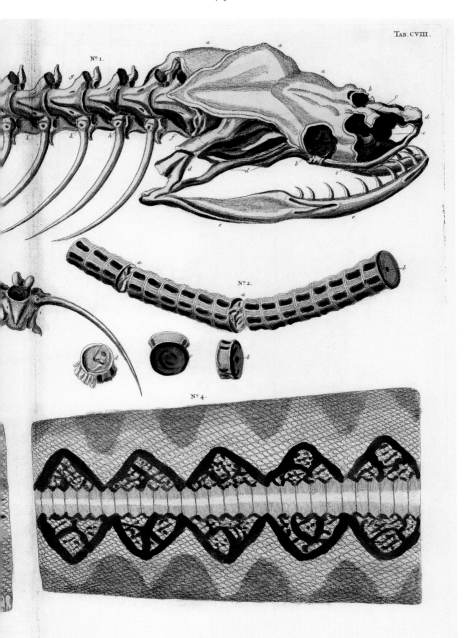

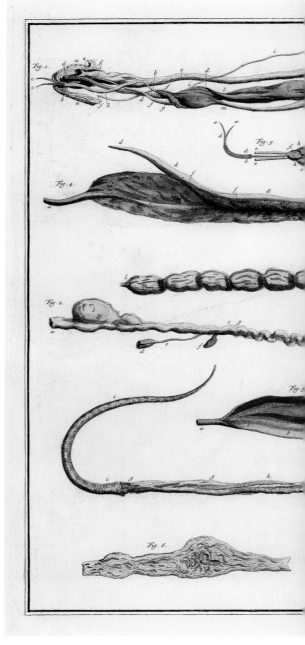

**1-8** Anatomia serpentis
**1-8** Anatomy of a snake ·
Anatomie einer Schlange ·
Anatomie d'un serpent

TAB. CIX.

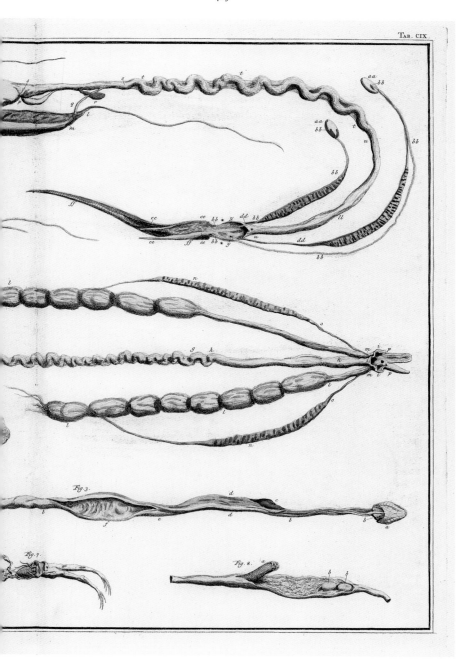

1 Crocodilia 2-3 Squamata 4-5 Intestinum ranae infantae cauda gestans
1 Crocodile · Krokodilskopf · Tête de crocodile 2-3 Anatomy of a lizard · Anatomie einer Echse ·
Anatomie d'un saurien 4-5 Entrails of a young frog that still has its tail · Innereien eines Jungfrosches,
der noch seinen Schwanz trägt · Les entrailles d'une jeune grenouille ayant encore sa queue

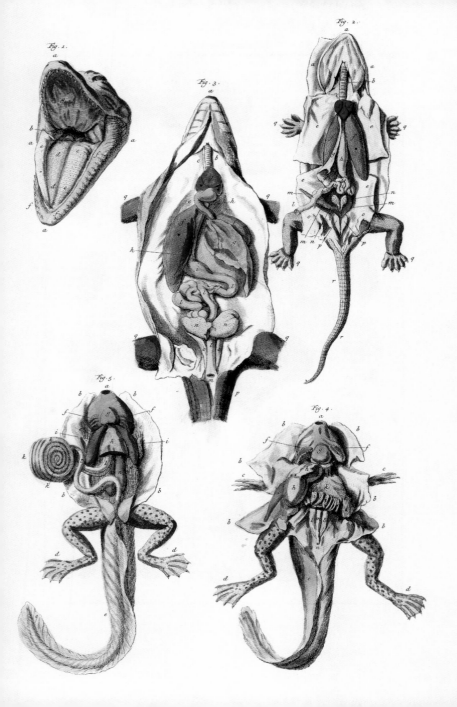

Fig. 1.

Fig. 2.

Fig. 3.

Fig. 4.

Fig. 5.

TAB. CXI.

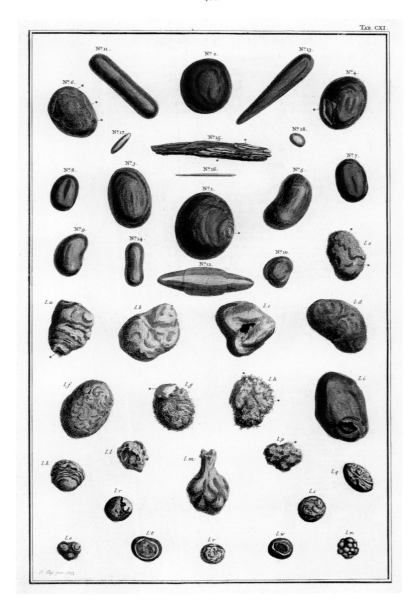

Lapides Bezoardici animantium variorum
Bezoars from various animals · Bezoarsteine von verschiedenen Tieren ·
Pierres de Bézoard d'animaux divers

Tab. CXII.

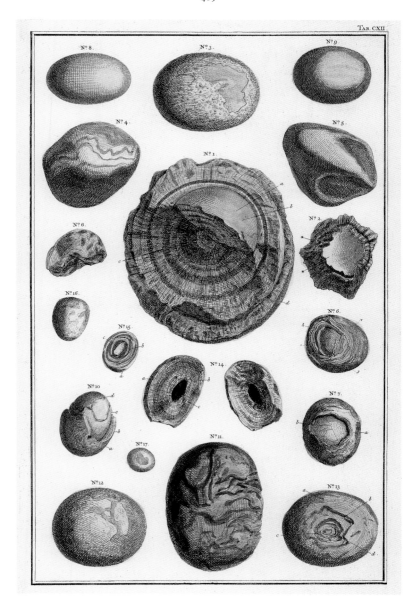

Lapides Bezoardici animantium variorum
Bezoars from various animals · Bezoarsteine von verschiedenen Tieren ·
Pierres de Bézoard d'animaux divers

Lapides animantium variorum
Stones from various animals · Steine von verschiedenen Tieren ·
Pierres d'animaux divers

TAB. CXIII.

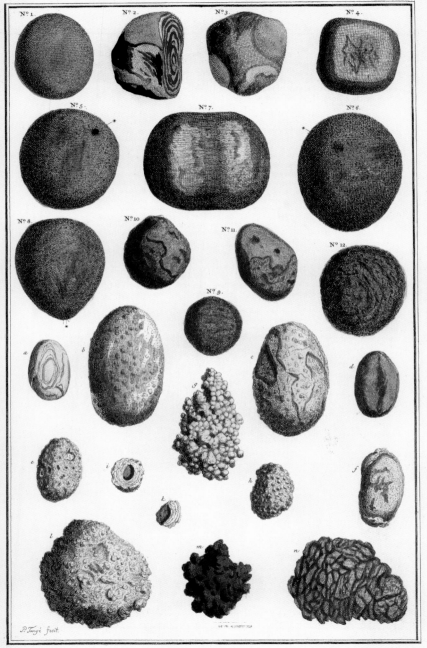

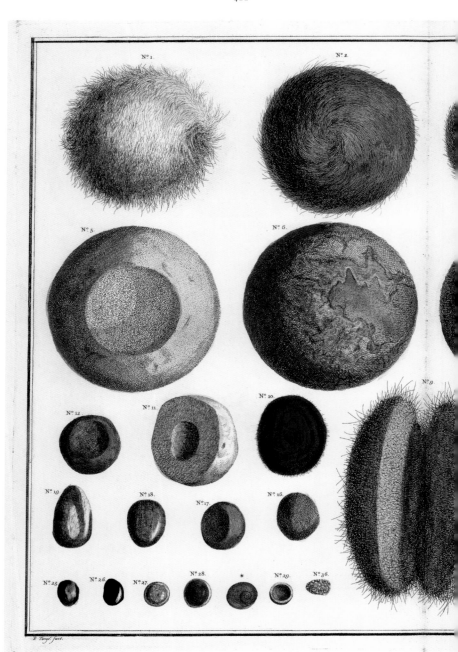

E. Tardi. fecit.

Tab. CXIV.

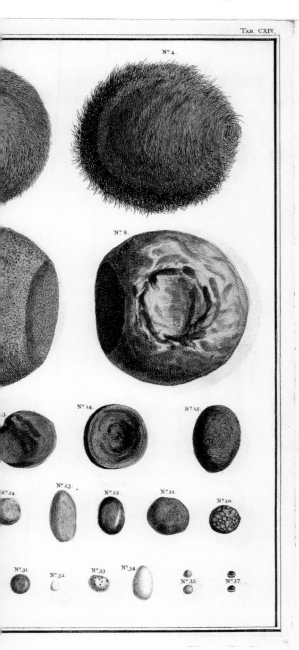

Nº 4.

Nº 8.

Nº 14.

Nº 15.

Nº 24.

Nº 23.

Nº 22.

Nº 21.

Nº 20.

Nº 31.

Nº 32.

Nº 33.

Nº 34.

Nº 35.

Nº 37.

Pilae pilosea et lapides
Bezoardici animantium
variorum
Pilous balls and stones from
various animals · Haarkugeln
und Steine von verschiedenen
Tieren · Boules velues et
pierres d'animaux divers

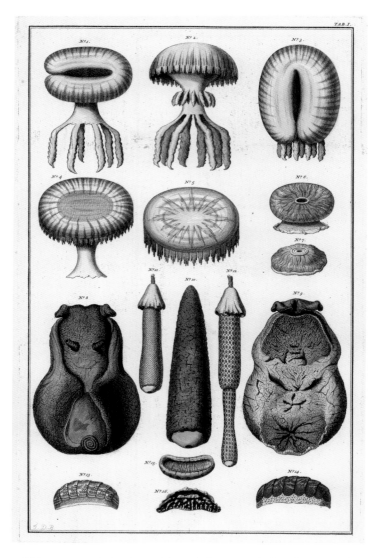

1-3 Rhizostomea 5-7 Actinaria 8-9 *Aplysina depilans* 13-14 Polyplacophora 15-16 *Chiton*
1-3 Crown jellyfishes · Wurzelmundquallen · Rhizostomes
5-7 Sea anemones · Seeanemonen · Actinies  8-9 Sea hare · Geringelter Seehase · Lièvre de mer
13-16 Chitons · Käferschnecken · Chitons

*Opposite page*
1-8 Octopodidae
1-8 Octopuses · Kraken · Octopodes

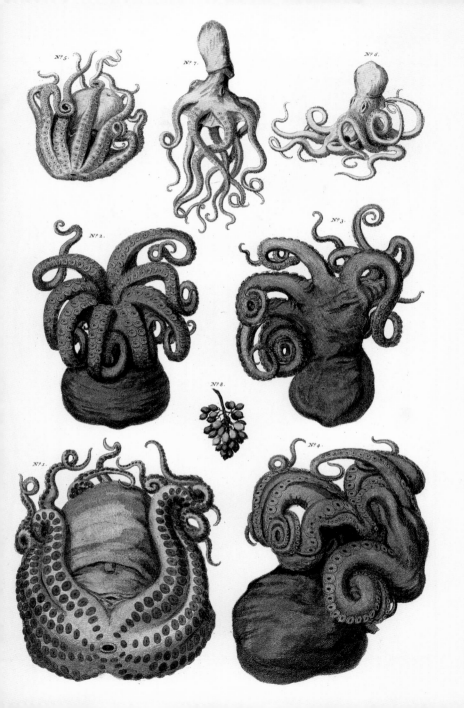

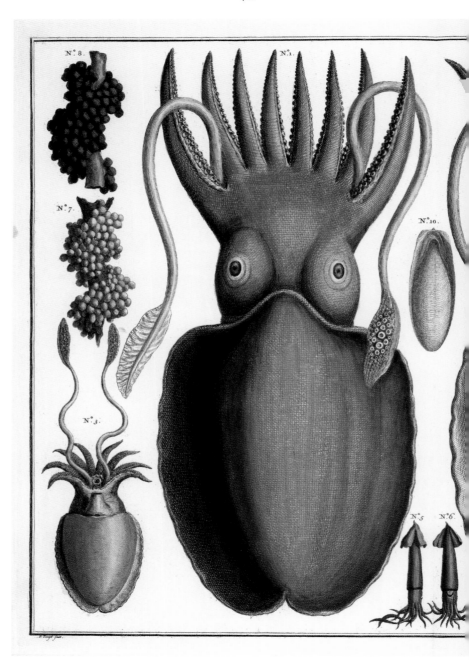

TAB. III.

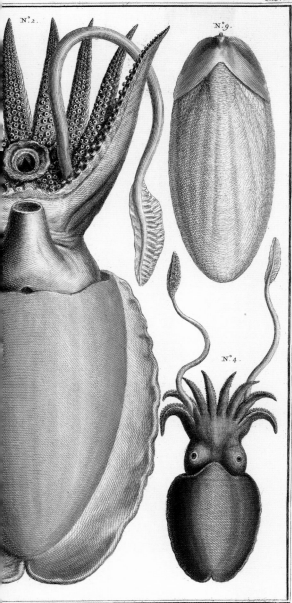

N°. 2.

N°. 9.

N°. 4.

**1-4** Sepiida **5-6** Teuthida
**7-8** Ovum **9-10** Sepiidae
**1-4** Sepias · Sepien · Seiches
**5-6** Arrow squids/ Flying
squids · Pfeilkalmare ·
Encornets volants ou
calmars **7-8** Sepia eggs ·
Sepia-Eier · Œufs de seiches
**9-10** Cuttlebones of Sepia ·
Schulpe · Os de seiches

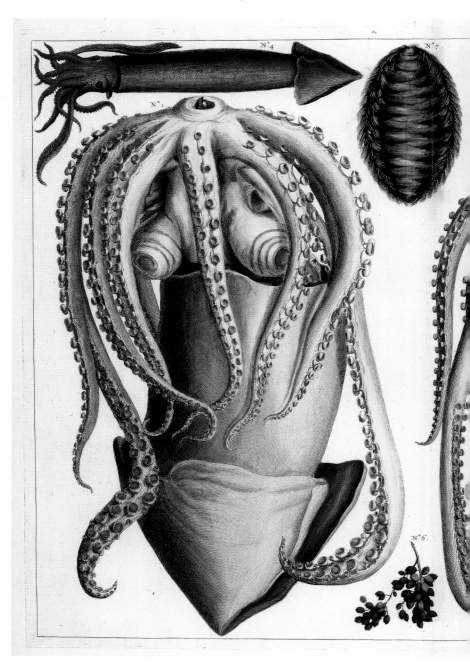

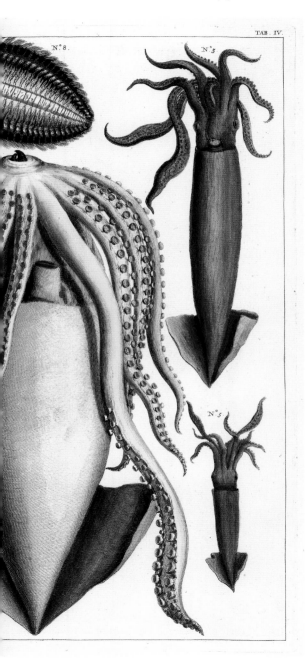

N.° 8.

N.° 5.

N.° 5.

1-2 *Loligo?* 3-5 Teuthida
7-8 Annelida (Aphrodite)
**1-2** Squids · Kalmare · Calmars
**3-5** Arrow squids⁄
Flying squids · Pfeilkalmare ·
Encornets volants ou calmars
**7-8** Sea mice · Seemäuse ·
Aphrodites épineuses

1-2 Phrynophiurida **3** *Asterias rubens* **9-10** *Astropecten aranciacus* **13-15** *Asterina gibbosa*
**1-2** Serpent star · Krötenschlangenstern · Ophiure **3** Common starfish · Gewöhnlicher Seestern ·
Etoile de mer commune **9-10** Red comb stars · Große Kammseesterne · Grandes étoiles de mer
**13-15** Common cushion stars · Kissenseesterne · Etoiles de mer pentagonales

TAB. V.

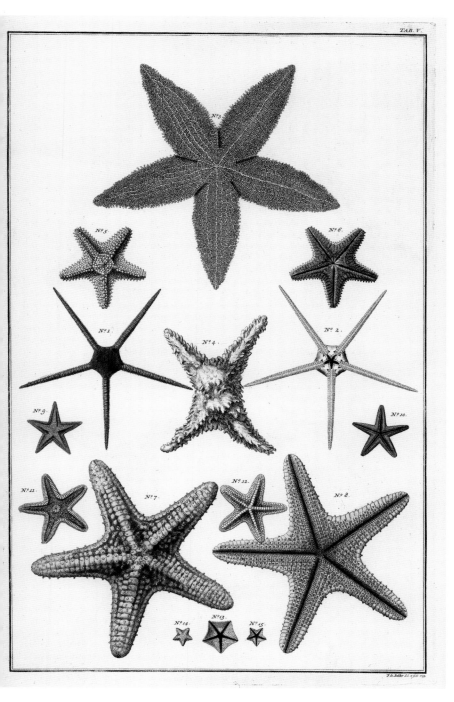

J. de Bakker del. et fecit 1734.

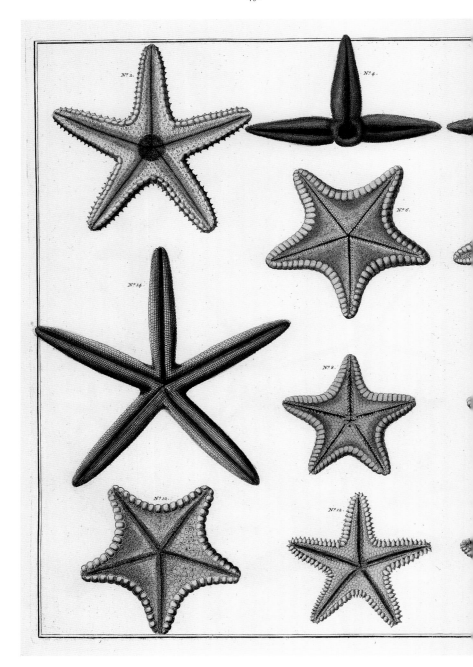

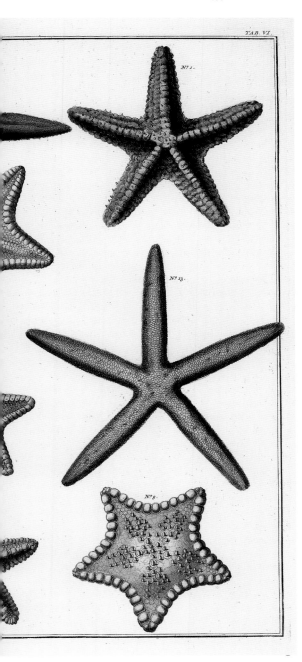

TAB. VI.

Asteroida **3-4** *Asterias rubens*
**5-6, 9-10** *Ceramaster*
**7-8** *Dipsacaster* **11-12** *Oreaster
reticularis* **13-14** *Ophidiaster
ophidianus*
Starfishes · Seesterne · Etoiles
de mer **3-4** Common starfish ·
Gewöhnlicher Seestern ·
Etoile de mer commune
**11-12** Cushion sea star ·
Kissenseestern · Etoile de
mer **13-14** Purple sea star ·
Violettroter Seestern · Astérie
pourpre

1-3, 8-10 Phanerozonia
4 Marthasterias glacialis
5 Spinulosa 6-7 Ophiurida
1-3, 8-10 Edged starfishes ·
Großplattenseesterne · Etoiles
de mer 4 Spiny starfish ·
Eisseestern · Etoile de mer
glaciaire 5 Orange starfish ·
Purpurseestern · Etoile de mer
rouge 6-7 Serpent stars ·
Schlangensterne · Ophiures

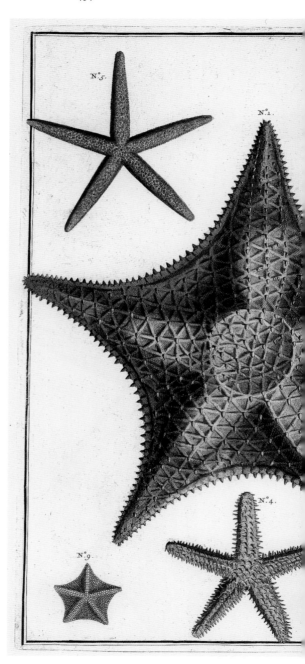

TAB. VII

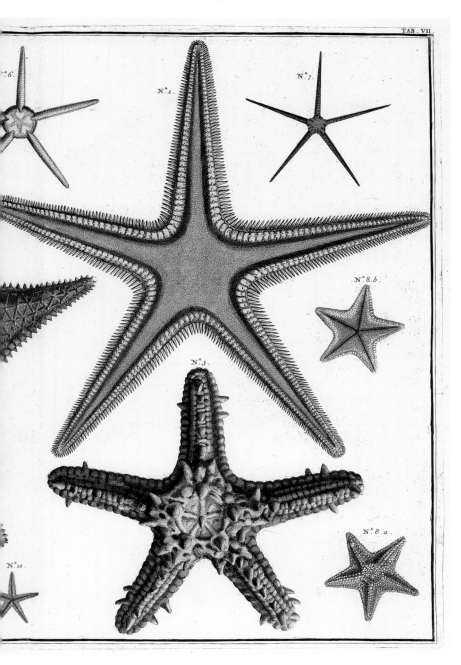

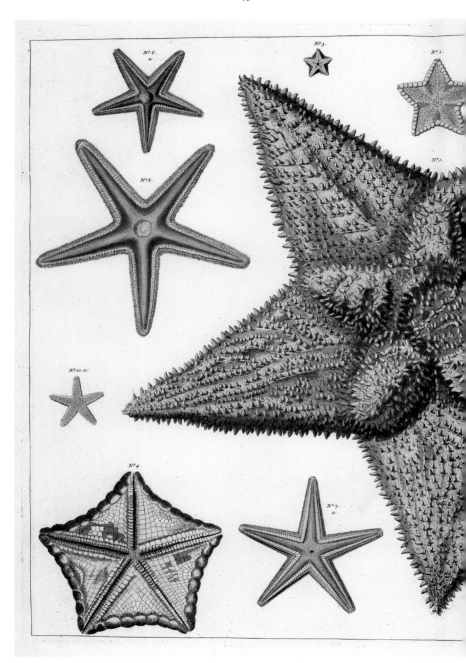

TAB. VIII.

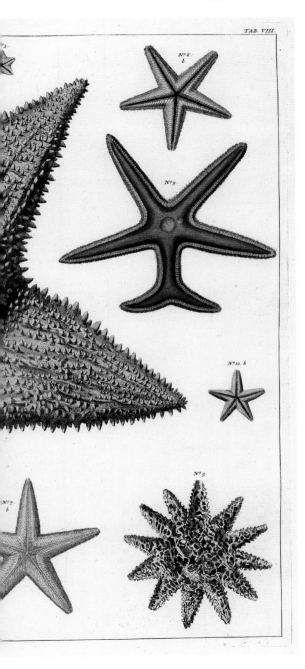

**1** *Hymenaster pellucidus* **3** *Asterina gibbosa* **5** *Crossaster papposus* **6-7** *Astropecten aranciacus* **8-10** *Astropecten typicus*
**1** Starfish · Seestern · Etoile de mer **3** Common cushion star · Polsterseestern · Etoile de mer pentagonale **5** Common sun star · Sonnenseestern · Soleil de mer épineux **6-7** Red comb stars · Große Kammseesterne · Grandes étoiles de mer **8-10** Sand stars · Kammsee-sterne · Etoiles des sables

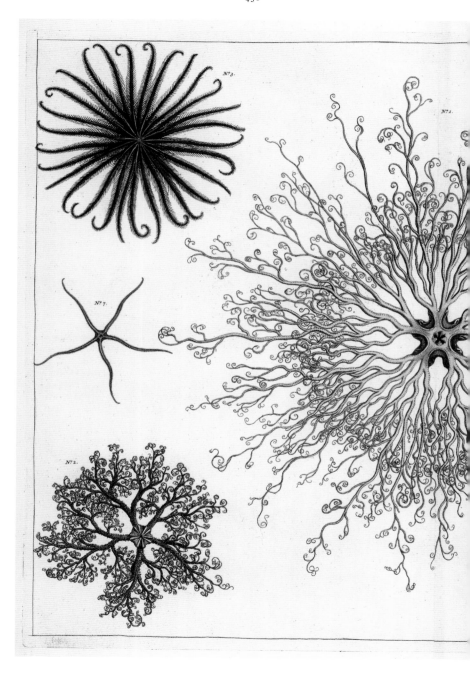

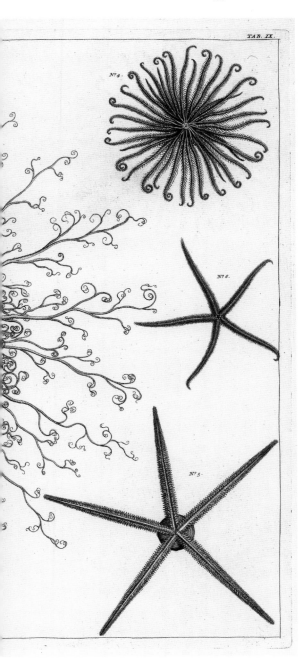

TAB. IX.

**1-2** *Gorgonocephalus caput medusae* **3-4** *Comanthina* **5-6** *Ophiothrix* **7** *Ophioderma longicauda*
**1-2** Gorgon's heads · Gorgonenhäupter · Gorgonocéphales (Crinoïdes) **3-4** Feather stars · Haarsterne · Lys de mer **5-6** Common brittle stars · Zerbrechliche Schlangensterne · Ophiures fragiles **7** Brown brittlestar · Brauner Schlangenstern · Ophiure lisse

1-4, 6, 8-18 Echinacea 7 Echinoneus 19, 21-22 Spatangoida 20 Cidaroida
1-4, 6, 8-18 Sea urchins · Seeigel · Oursins 7 Sand dollar · Sanddollar · Dollar des sables
19, 21-22 Heart urchins · Herzseeigel · Oursins cœurs ou spatangues
20 Lance urchin · Lanzenseeigel · Oursin porte-lance

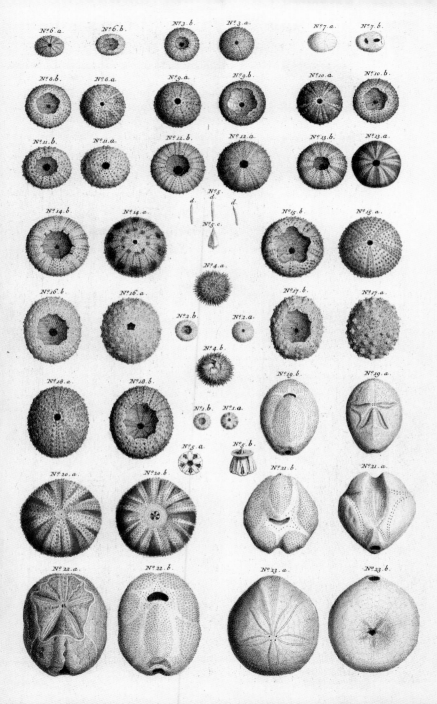

1 *Gorgonocephalus caryi*
2-3 Clypeasteroida
4-9, 11 Echinacea
10 Diadematoida
1 Gorgon's head ·
Gorgonenhaupt ·
Gorgonocéphale (Crinoïde)
2-3 Sand dollars · Sanddollars ·
Dollars des sables 4-9, 11 Sea
urchins · Seeigel · Oursins
10 Hatpin urchin ·
Diademseeigel · Oursin
diadème

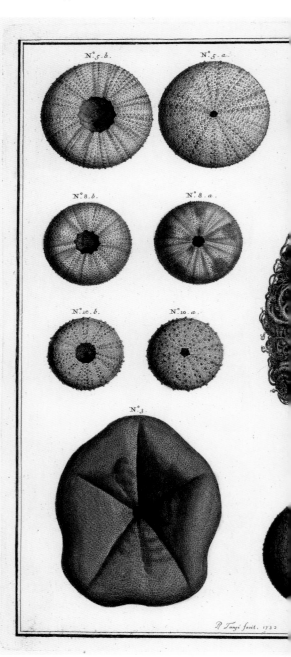

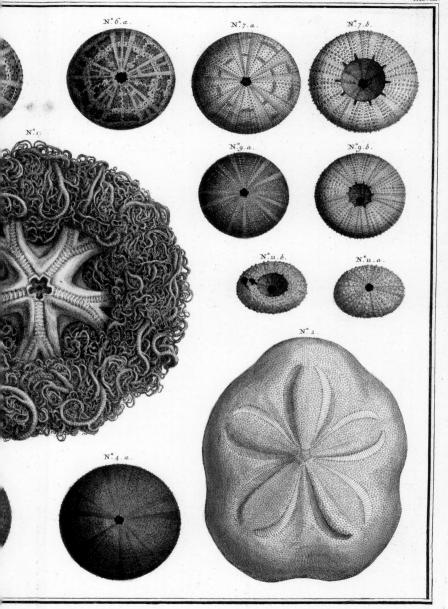

TAB. XI.

Nº 6. a.

Nº 7. a.

Nº 7. b.

Nº 1.

Nº 9. a.

Nº 9. b.

Nº 11. b.

Nº 11. a.

Nº 2.

Nº 4. a.

TAB. XII.

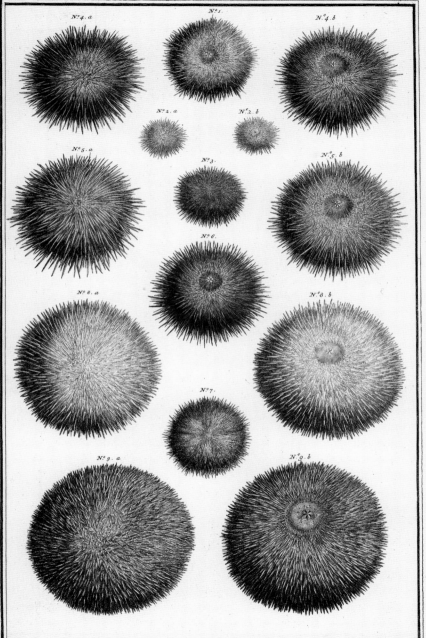

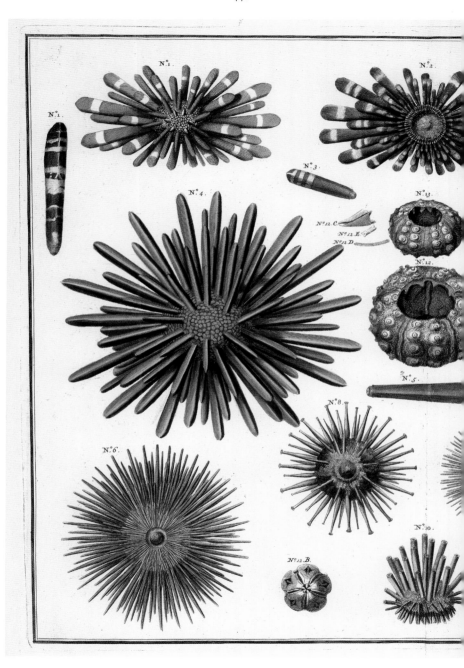

TAB. XIII.

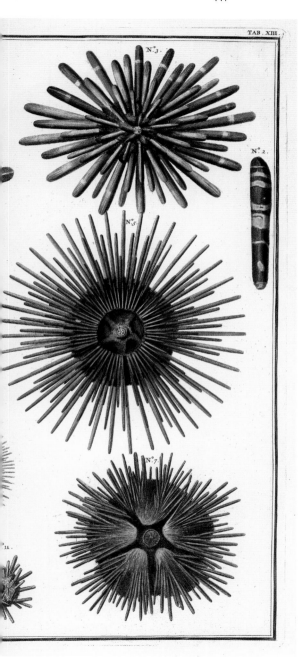

**1-2** *Heterocentrotus mamillatus*
**3, 12-13** *Heterocentrotus*
**4** *Heterocentrotus trigonarius*
**5** *Diadema setosum*
**6, 8-9** *Diadema* **7** *Echinothrix*
*diadema* **10-11** *Eucidaris*
**1-2, 3-4, 12-13** Slate pencil sea
urchins · Griffelseeigel · Oursins
crayons **5** Long spined sea
urchin · Gewöhnlicher
Diademseeigel · Oursin
diadème **6, 8-9** Hatpin urchins ·
Diademseeigel · Oursins
diadèmes **7** Black sea urchin ·
Schwarzer Diademseeigel ·
Oursin diadème noir
**10-11** Mine urchins ·
Lanzenseeigel · Oursins

**1-2** *Cidaris radiata* **3-6** *Brissus*
**1-2** Pencil urchin · Lanzensee-
igel · Oursin porte-lance
**3-6** Heart urchins · Herzseeigel ·
Oursins cœurs ou spatangues

TAB. XIV.

N.º 2.

N.º 3.

N.º 6.

N.º 4.

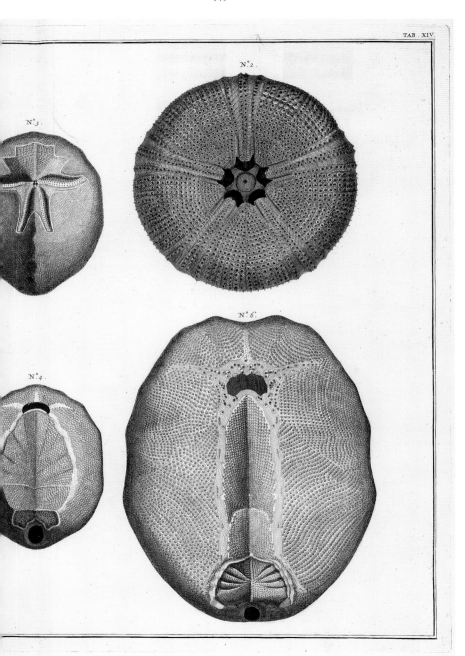

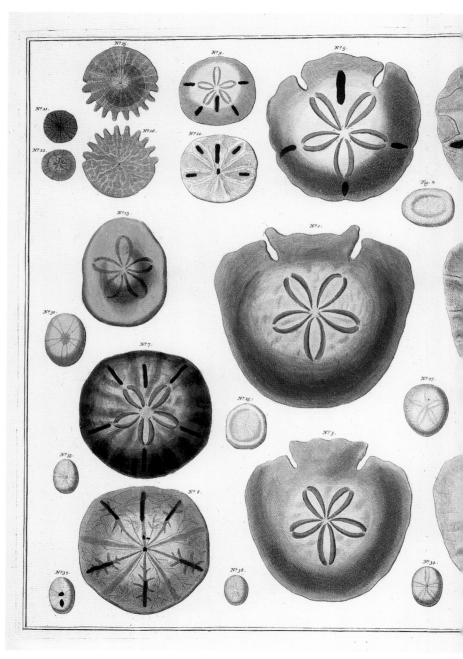

TAB. XV

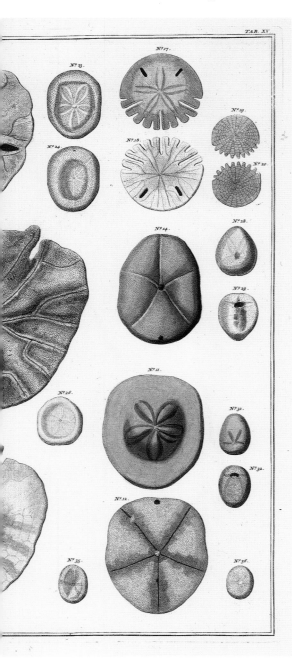

**1-27** Clypeasteroida
**28-36** Spatangoida
**37-38** Holectypoida
**1-27** Sand dollars · Sanddollars ·
Dollars des sables
**28-36** Heart urchins ·
Herzseeigel · Oursins cœurs

1-3, 5 Cirripedia 1-2 *Lepas
anatifera* 3 *Scalpellum*
4 Brachiopoda 5 Lepadomorpha
6 *Pholas dactylus* 8 *Pteroeides*
1-3, 5 Barnacles · Rankenfüßer ·
Cirripèdes 1-2 Common goose
barnacles · Gewöhnliche
Entenmuscheln ·
Anatife ou pousse-pied 3 Goose
barnacle · Entenmuschel ·
Bernacle 4 Lamp shell ·
Armfüßer · Brachiopode
5 Goose barnacle ·
Entenmuschel · Bernacle
6 Clam · Bohrmuschel ·
Coquillage pholade
8 Sea-pen · Seefeder · Pennatule

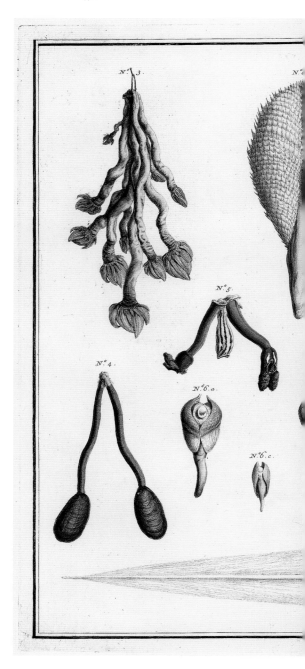

TAB. XVI.

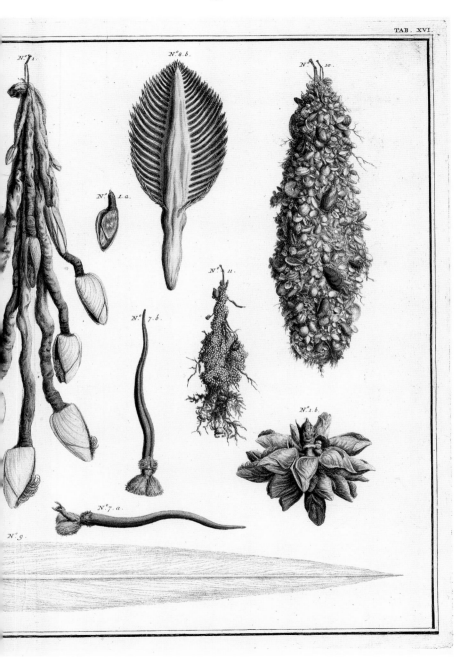

N° **1a, b** Xiphosura **N° 2** Penaeidae **N° 3** Homarus **N° 4** Majidae
N° **5** Brachyura **N° 6** Ovum **1-4** Porcellanidae
**1a, b** Horseshoe crab · Schwertschwanz · Limule (Xiphosure) **2** Penaeid shrimp · Geißelgarnele · Creve
pénéide **3** Lobster · Hummer · Homard **4** Spider crab · Dreieckskrabbe/Seespinne · Araignée de mer
**5** Crab · Kurzschwanzkrebs/Echte Krabbe · Crabe **6** Eggs of a crab · Eier eines Krebses · Œufs de crab
**1-4** Porcelain crabs · Porzellankrebse · Crabes porcelaines

TAB. XVII.

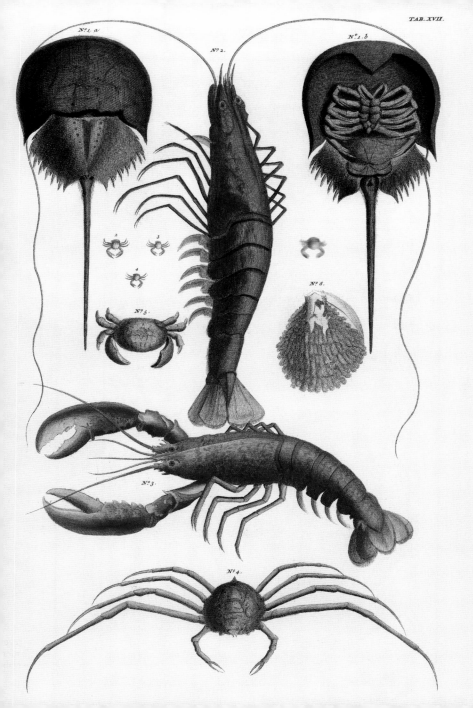

N.º 1. a
N.º 2
N.º 1. b
2
3
4
N.º 5.
N.º 6.
N.º 3.
N.º 4.

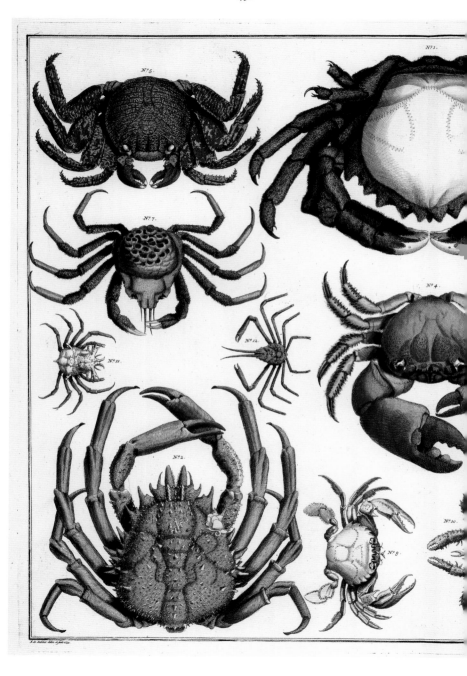

TAB. XVIII.

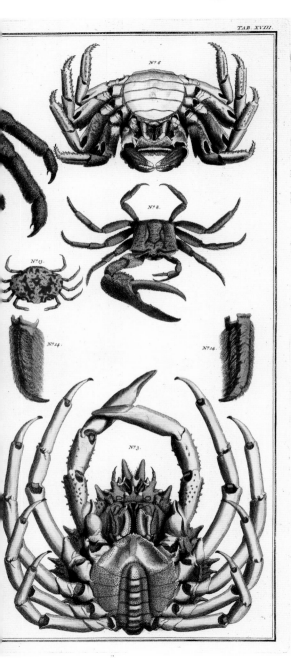

1 Dromiidae
2-3, 7, 11-12 Majidae
4 Gecarcinidae 5-6 Grapsidae
8 *Uca* 9 Portunidae
10 Lithodidae 13 Brachyura
1 Dromid crab · Wollkrabbe ·
Dromie velue/Dromidé
2-3, 7, 11-12 Spider crabs ·
Dreieckskrabben/Seespinnen ·
Araignées de mer 4 Land crab ·
Landkrabbe · Gécarcinidé
5-6 Rock crabs · Springkrabben ·
Grapsidés 8 Fiddler crab ·
Winkerkrabbe · Crabe à signaux
9 Swimming crab · Schwimm-
krabbe · Portunidé 10 Lithodid
crab · Steinkrabbe · Lithodidé
13 Crab · Krabbe · Crabe

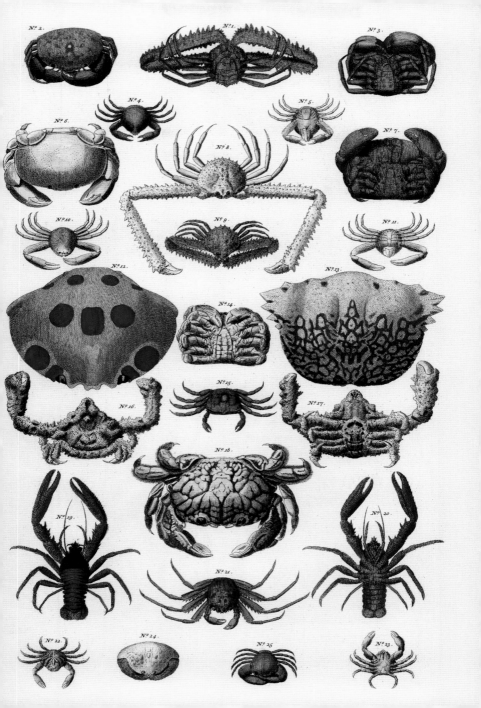

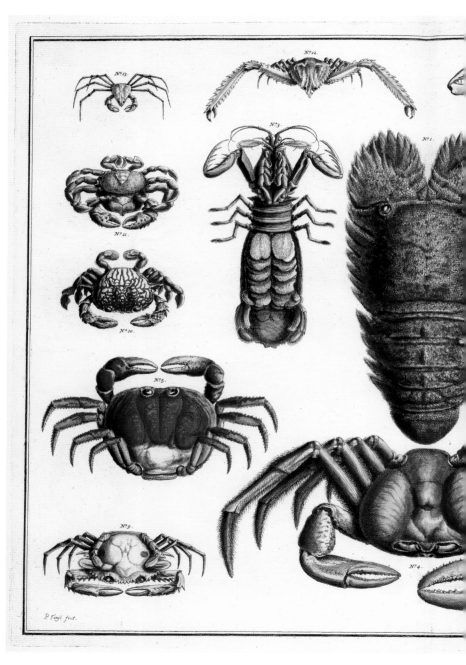

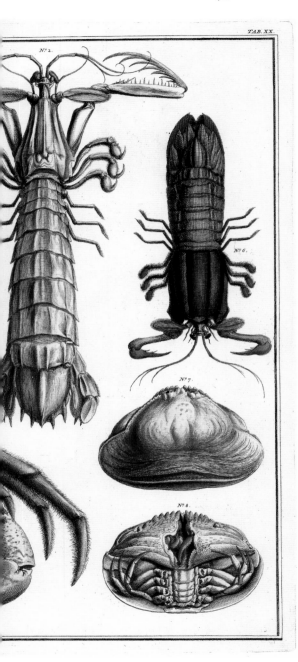

1 Scyllaridae
2-3, 6 Stomatopoda
4-5 Gecarcinidae
7-8, 10-11 Calappidae
9 Portunidae 12 Parthenopidae
13 Majidae
1 Scyllarid · Bärenkrebs ·
Scyllaridé 2-3, 6 Stomatopods ·
Fangschreckenkrebse/
Maulfüßer · Stomatopodes
4-5 Land crabs · Landkrabben ·
Gécarcinidés 7-8, 10-11 Box
crabs · Schamkrabben · Crabes
honteux 9 Swimming crab ·
Schwimmkrabbe · Portunidé
12 Elbow crab · Langarmkrabbe/
Ellbogenkrabbe · Crabe
parthenopidae
13 Spider crab · Dreieckskrabbe/
Seespinne · Araignée de mer

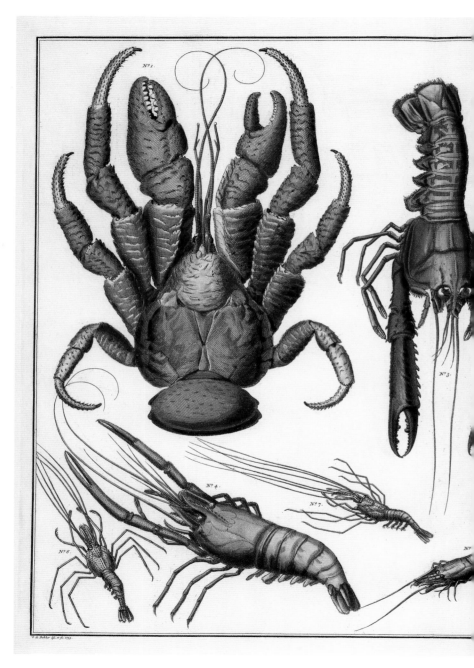

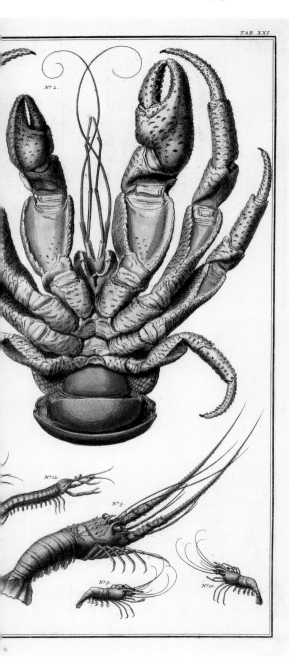

TAB. XXI.

**1-2** *Birgus latro* **3** *Nephrops norvegicus* **4, 9-10** Palaemonidae **5** Palinuridae **8** *Crangon crangon* **11** Amphipoda
**1-2** Coconut/Robber crab · Palmendieb · Crabe des cocotiers **3** Norway lobster · Norwegischer Hummer/-Kaisergranat · Langoustine **4, 9-10** Palaemonid shrimps · Felsengarnelen · Crevettes palémonides **5** Spiny lobster · Languste · Palinuridé **8** Common shrimp · Nordsee-/Sandgarnele · Crevette grise **11** Amphipod · Flohkrebs · Amphipode

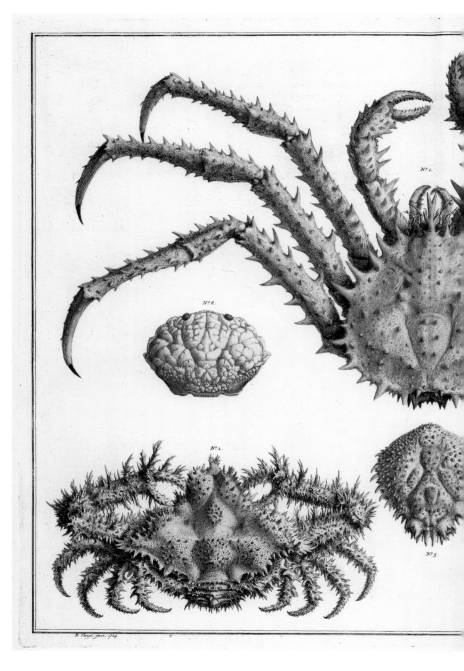

TAB. XXII.

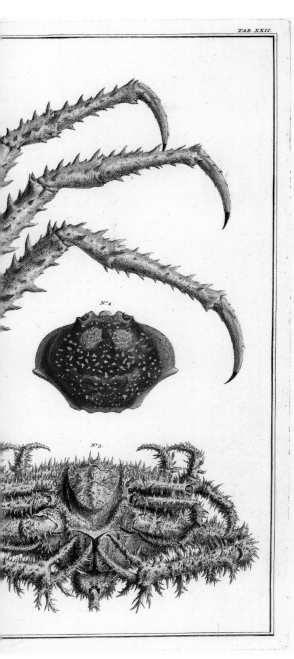

1 Lithodidae
2-3 Parthenopidae
4-6 Brachyura
1 Lithodid crab · Steinkrabbe ·
Lithodidé 2-3 Elbow crabs ·
Langarmkrabben/
Ellbogenkrabben · Crabes
parthenopidae 4-6 Carapaces
of crabs · Rückenschilder von
echten Krabben · Carapaces de
crabes

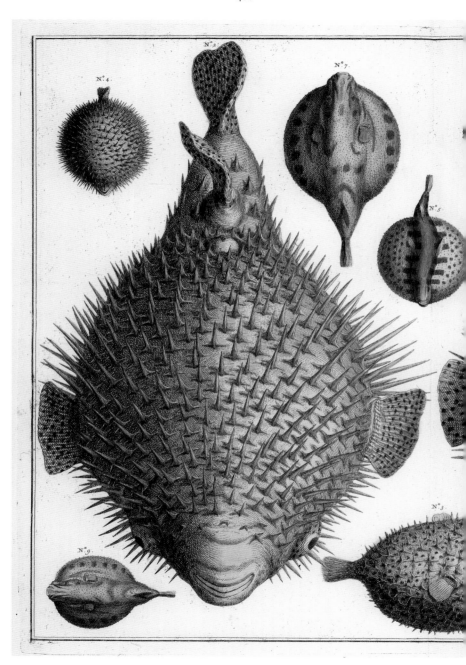

TAB. XXIII.

N.° 1.

N.° 6.

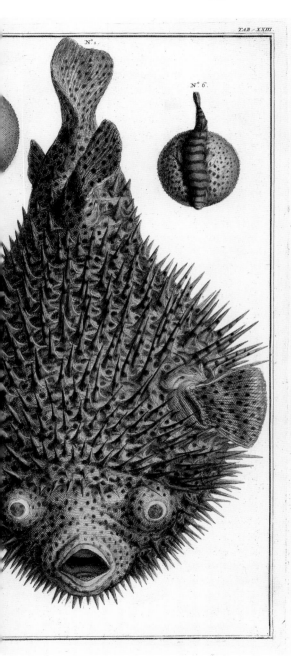

**1-2** *Diodon hystrix* **3** *Chilomycterus reticulatus* **4** Diodontidae
**5** *Lagocephalus lagocephalus*
**6** *Colomesus psittacus*
**7-8** Tetraodontidae
Partly poisonous puffer fish from tropical waters, which inflate themselves when threatened · Teilweise giftige Kugelfische aus tropischen Gewässern, die sich bei Bedrohung aufblasen · Poissons-globes des eaux tropicales, partiellement venimeux, qui se gonflent lorsqu'ils sont menacés

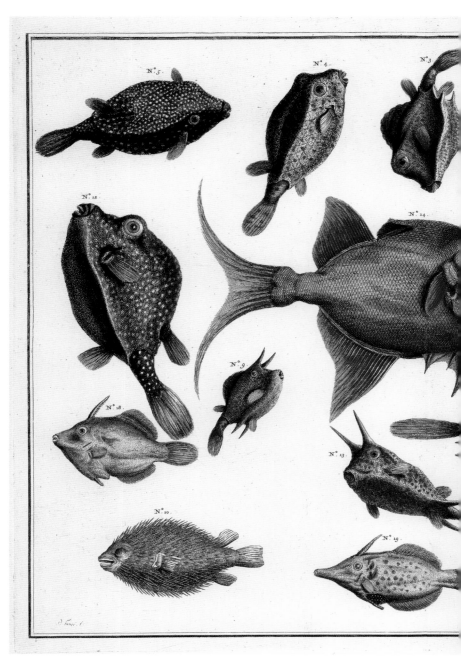

TAB. XXIV.

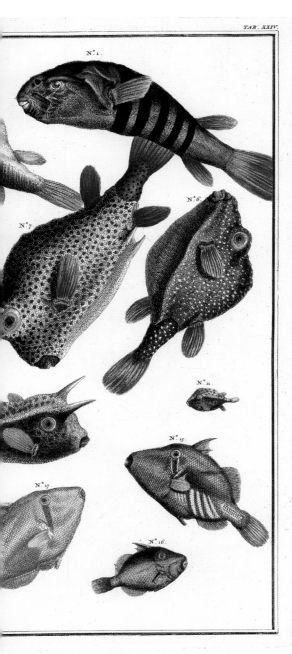

1-2 Tetraodontidae
3-9, 11-13 Ostraciidae
10 *Diodon hystrix* 14, 16 *Balistes*
15, 17 *Rhinecanthus* 18 *Acreichthys*
19 *Oxymonacanthus*
Chiefly tropical coral fish from
the Atlantic and Indo-Pacific ·
Hauptsächlich tropische
Korallenfische aus Atlantik und
Indopazifik · Principalement des
poissons tropicaux vivant dans
les récifs de l'Atlantique et de
l'aire indopacifique

1-4 *Acanthurus* 5 *Pomacanthus*
6-7 *Zanclus* 8 *Heniochus*
9-12, 16, 18 *Chaetodon*
13-14 Perciformes 15 *Platax*
17 *Chelmon*
Tropical coral fish from the
Caribbean and Indo-Pacific ·
Tropische Korallenfische aus
Karibik und Indopazifik ·
Poissons tropicaux vivant dans
les récifs aux Caraïbes et dans
l'aire indopacifique

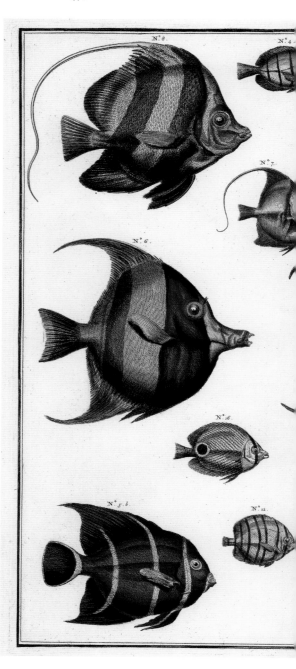

TAB. XXV.

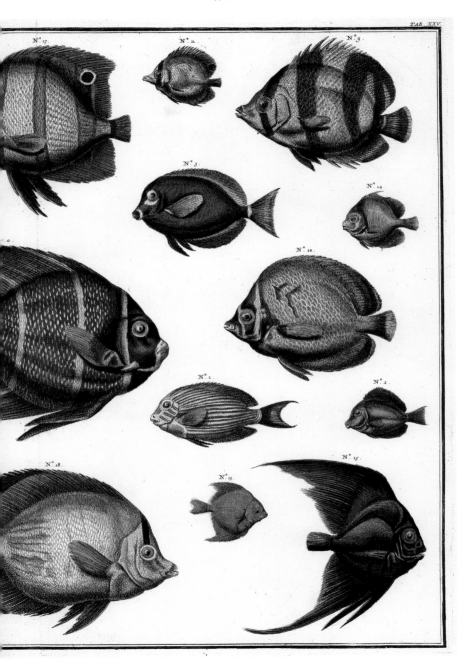

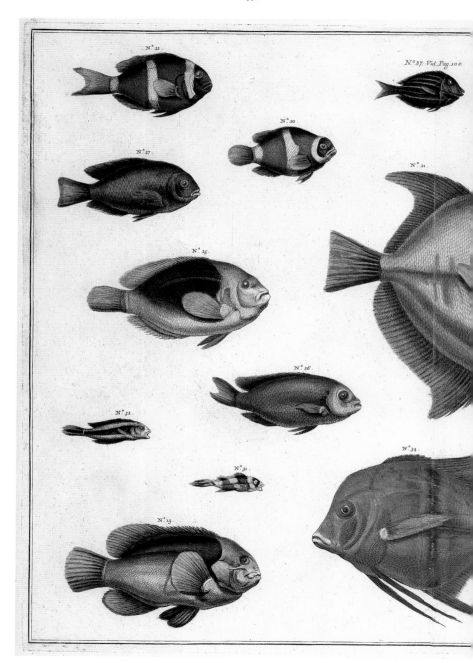

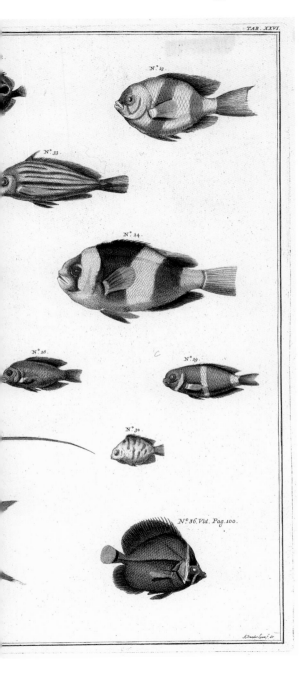

19 *Premnas biaculeatus*
20, 22, 24-25, 29 *Amphiprion*
21 *Monodactylus sebae*
23 *Dascyllus aruanus*
26-28 Pomacentridae
30-32 Perciformes 33 *Equetus
acuminatus* 34 *Alectis ciliaris*
35-36 *Chaetodon*
Tropical coral fish from the
Atlantic and Indo-Pacific ·
Tropische Korallenfische aus
Atlantik und Indopazifik ·
Poissons tropicaux vivant dans
les récifs dans l'Atlantique dans
l'aire indopacifique

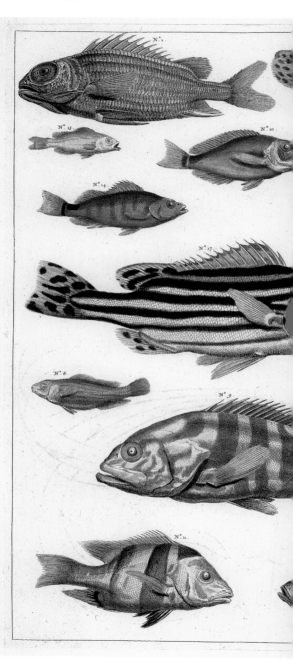

1 *Holocentrus ascensionis*
2 *Pentanemus quincarius*
3 *Caranx hippos* 4 Sparidae
5-7, 9-10, 15 Serranidae
8 Scaridae 11-12 Perciformes
13 Pomacentridae
14 Lutjanidae 16 *Parapercis cylindrica* 17-18 *Plectorhinchus diagrammus*
Tropical fish from the Atlantic and Indo-West Pacific ·
Tropische Fische aus Atlantik und Indo-Westpazifik · Poissons tropicaux de l'Atlantique et de l'océan Indien et du Pacifique occidental

TAB. XXVII.

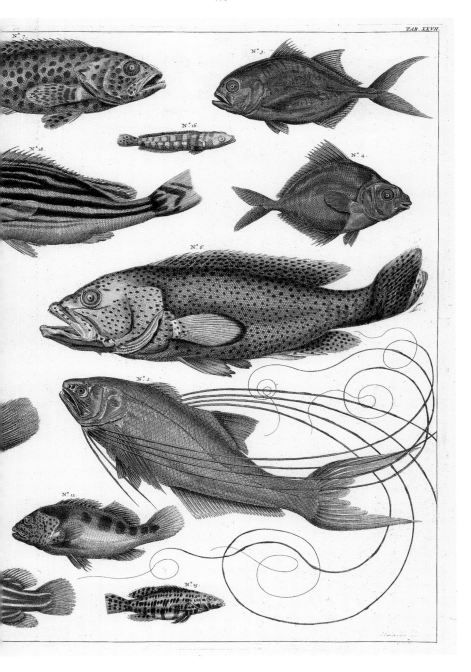

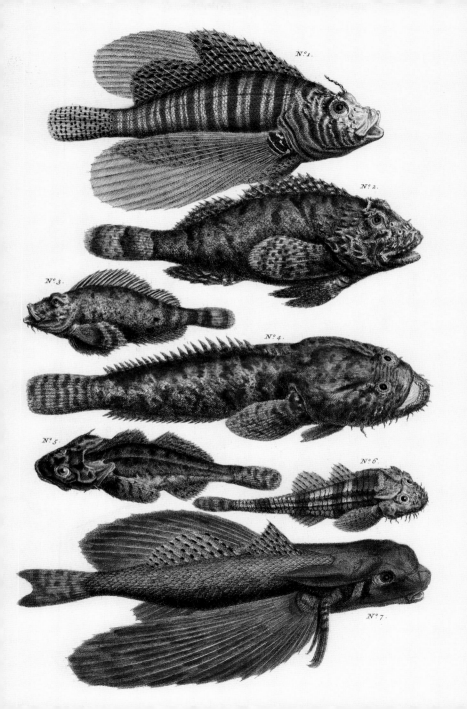

N.º 1.

N.º 2.

N.º 3.

N.º 4.

N.º 5.

N.º 6.

N.º 7.

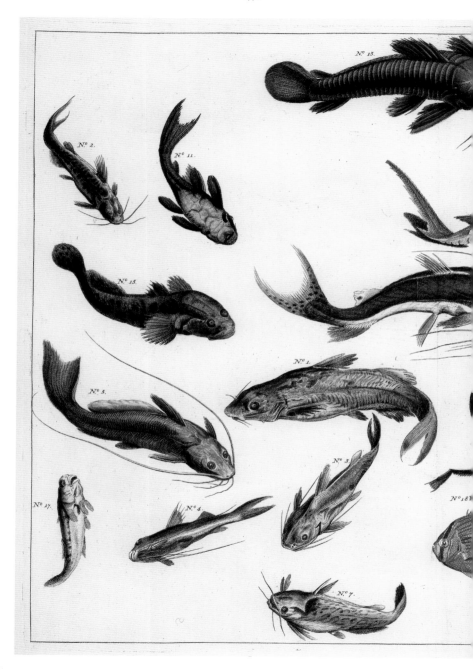

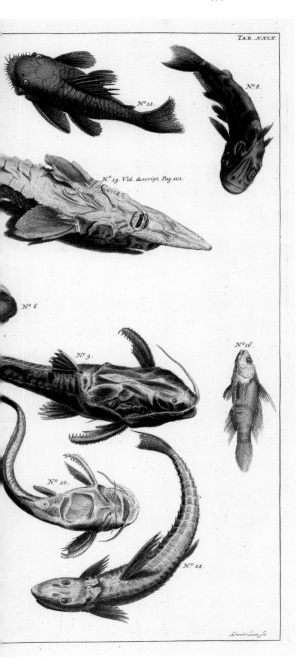

TAB. XXIX.

N° 12.

N° 8.

N.° 19. Vid. descript. Pag.101.

N° 6.

N° 9.

N°16.

N° 10.

N° 14.

**1-5 , 8, 12, 17** Siluriformes
**6** *Pseudoplatystoma*
**7** *Trachelyopterus*
**9-10** Aspredinidae
**11, 14** Loricariidae
**13** *Callichthys* **15-16** Gobiidae
**18** Chaetodontidae
**19** *Acipenser sturio*
Silurids found in fresh and
brackish waters in the Amazon
Basin and the north coast of
South America ·
Welsartige Süß- und
Brackwasserfische aus dem
Amazonasbecken und von
der Nordküste Südamerikas ·
Siluridés trouvés dans les eaux
douces et saumâtres du bassin
de l'Amazone et sur la côte
nord de l'Amérique du Sud

1 *Clinus dorsalis* 2-4 Clinidae 5 *Cirripectes castaneus* 6 *Pholis gunnellus* 7 *Callionymus lyra* 8 Clinidae
Rare fish from temperate waters of both hemispheres ·
Seltene Fische aus gemäßigten Gewässern beider Hemisphären ·
Poissons rares vivant dans les eaux tempérées des deux hémisphères

TAB.XXX.

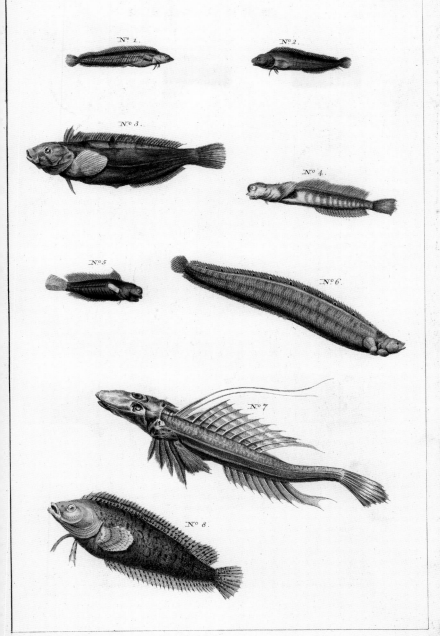

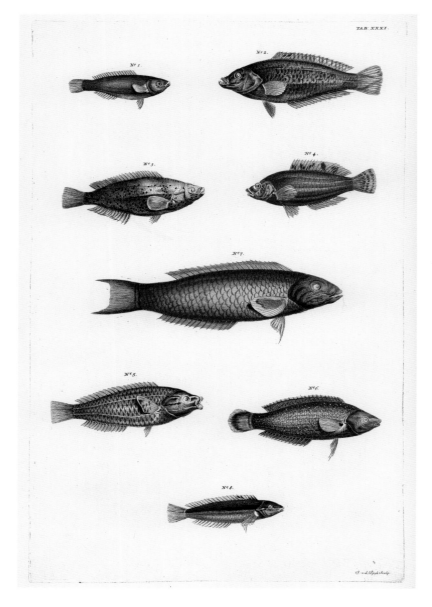

**1-4, 8** Labridae **5** *Stethojulis trinlineata* **6** *Halichoeres leucurus* **7** *Thalassoma lunare*
Fish of the Labridae family, from Indo-Pacific coral reefs · Fische aus der Familie der
Labridae, aus indopazifischen Korallenriffen · Poissons de la famille des Labridés, des récifs
coralliens de l'aire indopacifique

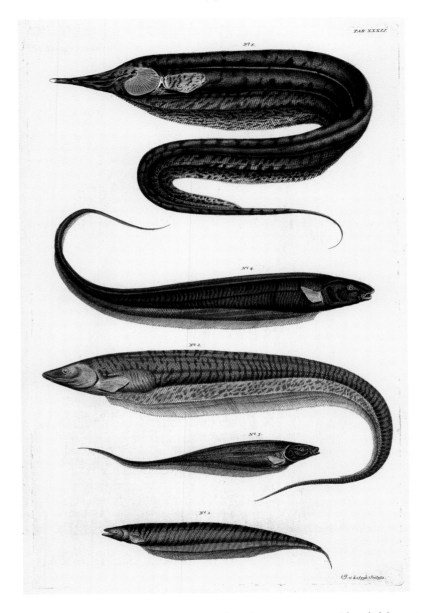

*Gymnotus carapo* **2** *Brachyhypopomus* **3** *Sternopygus astrabes* **4** *Sternopygus macrurus* **5** *Rhamphichthyes rostratus*
Weakly electric freshwater fish from the Amazon Basin or Surinam ·
Messerfische aus dem Amazonasbecken oder Surinam, die schwache elektrische Ströme aussenden ·
Poissons faiblement électriques des eaux douces du bassin de l'Amazone ou du Surinam

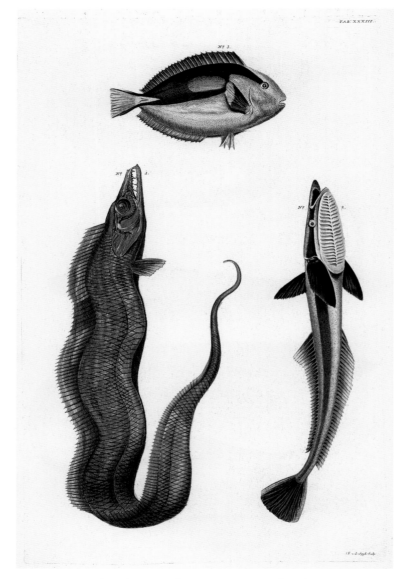

*TAB. XXXIII.*

1 *Trichiurus lepturus* 2 *Echeneis naucrates* 3 *Paracanthurus hepatus*
Fish from tropical waters · Fische aus tropischen Gewässern ·
Poissons d'eaux tropicales

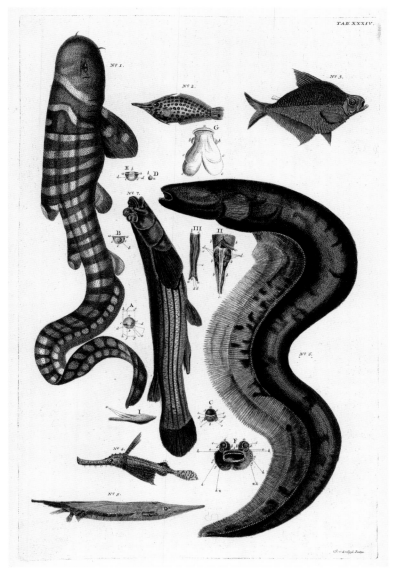

TAB XXXIV.

1 *Stegostoma fasciatum* 2 *Stephanolepis hispidus* 3 *Astyanax bimaculatus* 4 *Solenostomus cyanopterus*
5 *Centriscus scutatus* 6 *Electrophorus electricus* 7 *Anableps anableps*
1 Zebra shark · Pazifischer Zebrahai · Requin zèbre 2 Planehead filefish · Flachkopf-Feilenfisch · Baliste
Mauritanie) 3 Twospot astyanax · Rautensalmler · Yaya (Guyane française) 4 Ghost pipefish · Blauflossiger
Röhrenmund 5 Grooved razorfish · Rassiermesserfisch · Poisson-rasoir 6 Electric eel · Zitteraal · Anguille
tremblante (Guyane française) 7 Largescale foureye · Vieraugenfisch · Quatre-yeux à grandes écailles

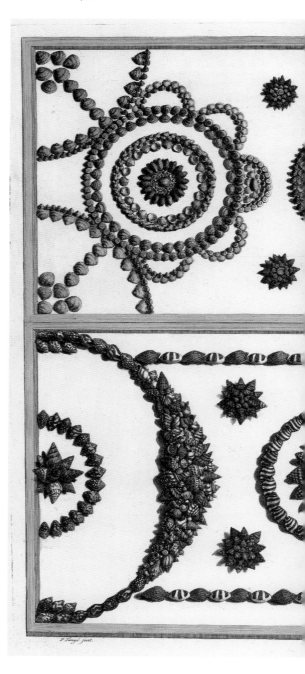

SEBA 1758: »Capsa prima & secunda, in quibus minutissnna Conchyliorum genera, areolarum in modum, concinne digesta exhibentur.«
Various mollusc shells arranged as ornaments · Verschiedene zu Ornamenten angeordnete Gehäuse von Weichtieren · Arrangements ornementaux de diverses coquilles de mollusques

TAB. XXXV.

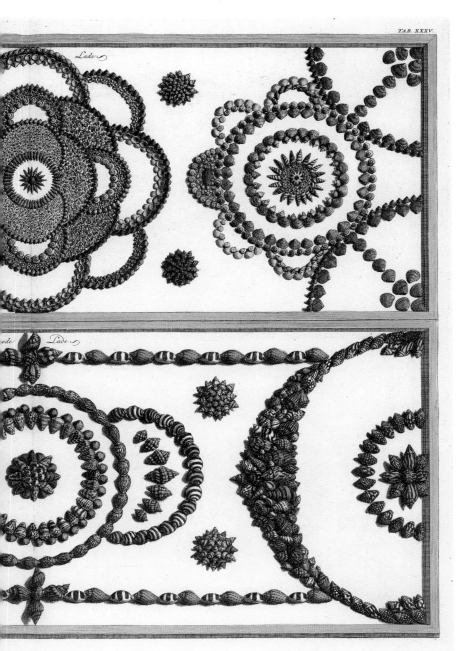

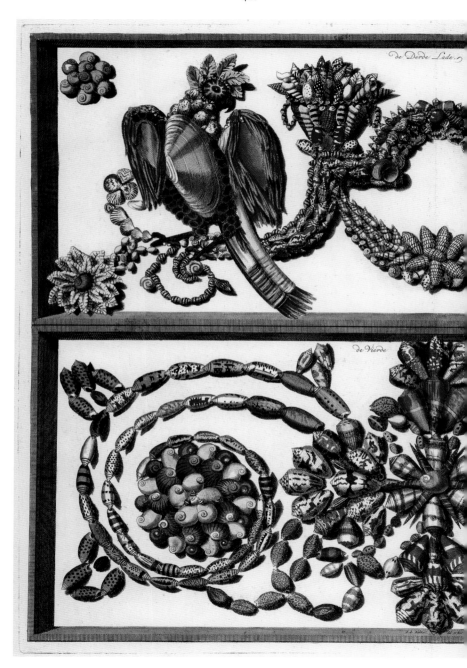

*de Derde Lade.*

*de Vierde*

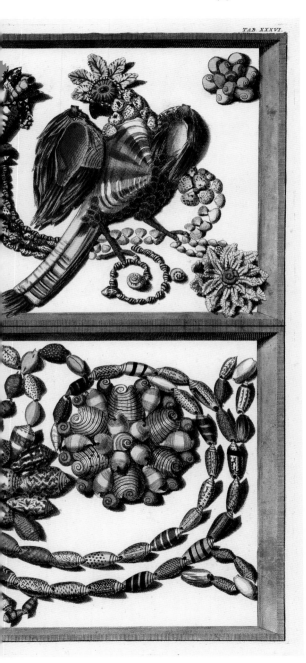

TAB XXXVI.

SEBA 1758: »Capsa tertia & quarta, quae majuseula Conchyliorum specimina, familiter, at diverso a superioribus ordine inter se composita monstrant.« Various mollusc shells arranged as ornaments or garlands with pictorial motifs · Verschiedene zu Ornamenten und Girlanden mit bildhaften Motiven angeordnete Gehäuse von Schnecken und Muscheln · Arrangements ornementaux et en guirlandes de diverses coquilles de mollusques

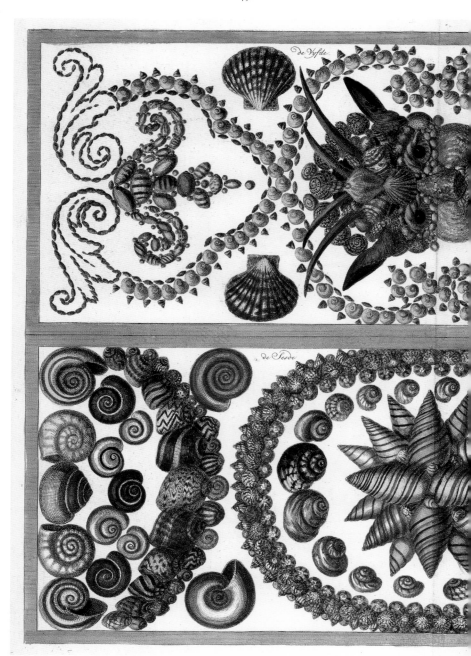

*de Vyfde.*

*de Jesde.*

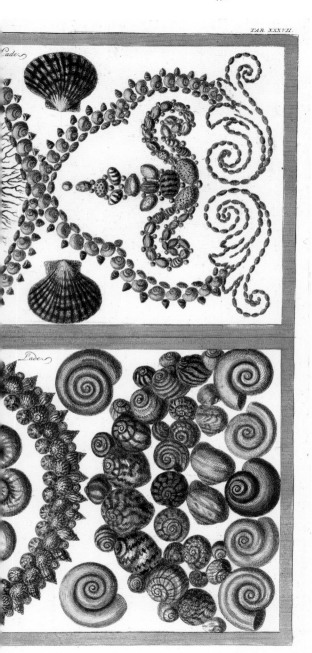

TAB. XXXVII.

SEBA 1758: »Capsa quinta & sexta, Conchyliis, uti priores, sed alia rursus rationae dispositis, conspicae.« Ornaments made with mollusc shells, depicting a stylised face · Ornamente aus Gehäusen von Weichtieren mit Darstellung eines stilisierten Gesichts · Arrangement ornemental de coquilles de mollusques représentant un visage stylisé

**13-16, 18-20, 22-23** *Rapa rapa* **26-27, 51-53, 60-65** *Natica canrena* **31** *Neverita helicoides*
**33** *Natica fulminea* **34-44** *Bulla ampulla* **45-45\*** *Atys naucum*
Rapa shells, moon shells, spiny conches and cephalaspidean opisthobranchs from the Indo-Pacific,
as well as African and American coastal regions · Kopfschildschnecken, Nabelschnecken und
Stachelschnecken aus dem Indopazifik sowie afrikanischen und amerikanischen Küstengebieten ·
Coquilles de rapa, de natices, de murex et d'opisthobranches céphalaspidés de l'aire indopacifique ainsi
que des zones côtières d'Afrique et d'Amérique

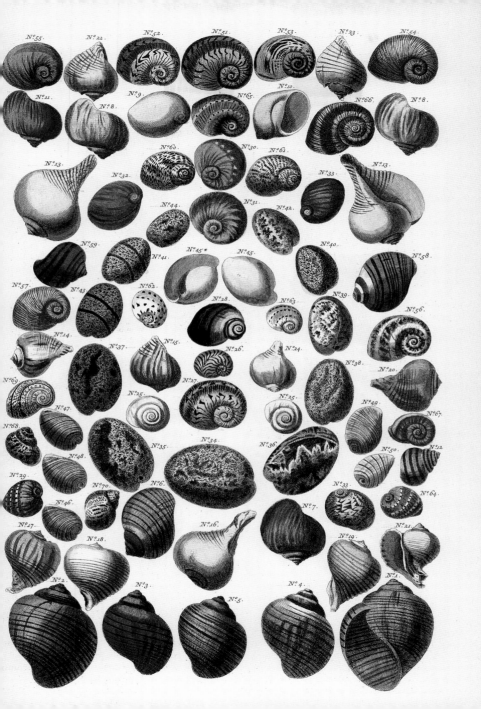

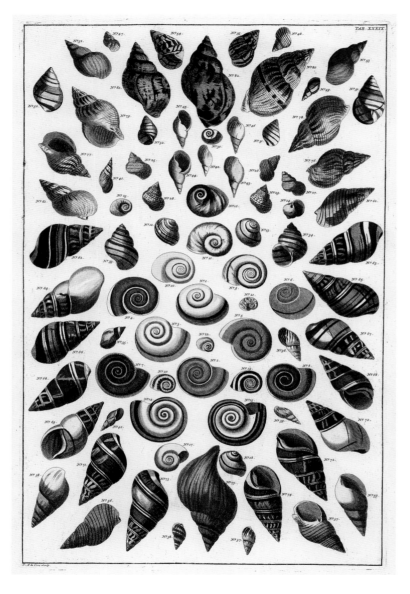

TAB. XXXIX.

1-3, 9 *Naninia citrina* 16 *Neverita helicoides* 33-34 *Viviparus viviparus* 56-57, 60 *Nassarius glans*
62-74 *Liguus fasciatus* 75 *Neptunea antiqua* 76-82 *Buccinum undatum*
Land, freshwater and sea shells from Europe, North America and Indo-Pacific · Land-, Süßwasser-
und Meeresschnecken aus Europa, Nordamerika und dem Indopazifik · Mollusques marins, d'eau
douce et terrestres d'Europe, d'Amérique du Nord et de l'aire indopacifique

*TAB. XL.*

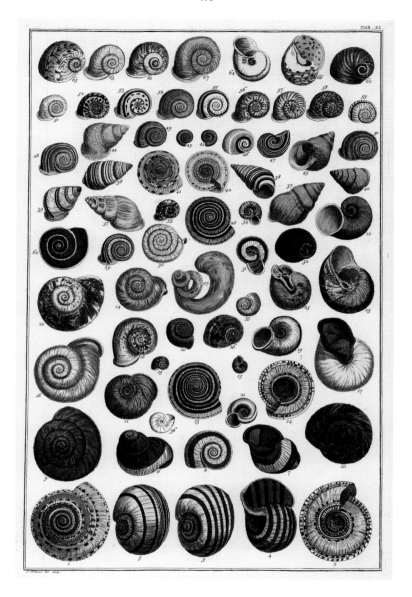

**9-10** *Planorbarius* **16-17** *Chloritis* **24-25** Polygyridae **28** *Architectonica perspectiva*
**38** *Liguus virgineus* **41-42** *Architectonica picta*
Land, freshwater and sea shells from Europe, Atlantic and Indo-Pacific · Land-, Süßwasser- und
Meeresschnecken aus Europa, dem Atlantik und dem Indopazifik · Mollusques marins, d'eau douce
et terrestres d'Europe, de l'Atlantique et de l'aire indopacifique

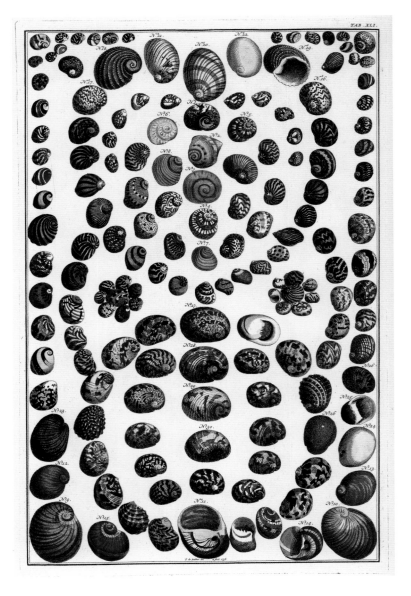

*1,5* Neritina virginea *4-6* Gibbula magus *9-11* Neverita albumen *14-15* Natica vitellus *18-19* Neritopsis radula
*20-21* Polinices melanostomus *23* Nerita *25-26* Neritina pulligera
Nerites, top shells and moon shells from the Indo-Pacific, Atlantic and Mediterranean Sea · Schwimm-
schnecken, Spitzkreiselschnecken und Nabelschnecken aus dem Indopazifik, Atlantik und Mittelmeer ·
Nérites, troques (gibbules) et natices de l'aire indopacifique, de l'Atlantique et de la mer Méditerranée

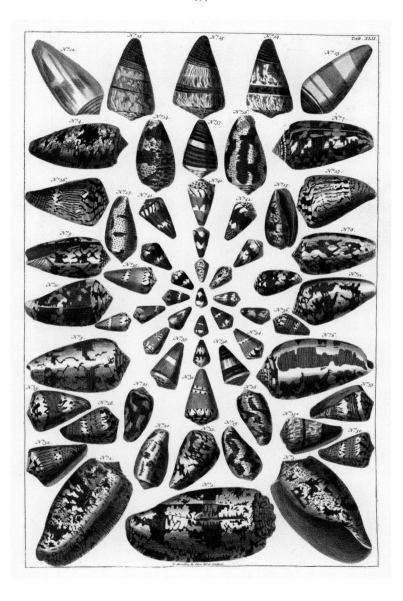

TAB. XLII.

1-42 *Conus* 1-2, 4, 14-15 *Conus geographus* 5-6, 8-9, 16 *Conus striatus* 13 *Conus terebra* 22 *Conus mustelinus* 23-25* *Conus miles* 26-28, 30, 32-34 *Conus capitaneus* 39 *Conus lividus*
Poisonous cone shells, chiefly from the Indo-Pacific · Giftige Kegelschnecken, überwiegend aus dem Indopazifik · Cônes venimeux, originaires principalement de l'aire indopacifique

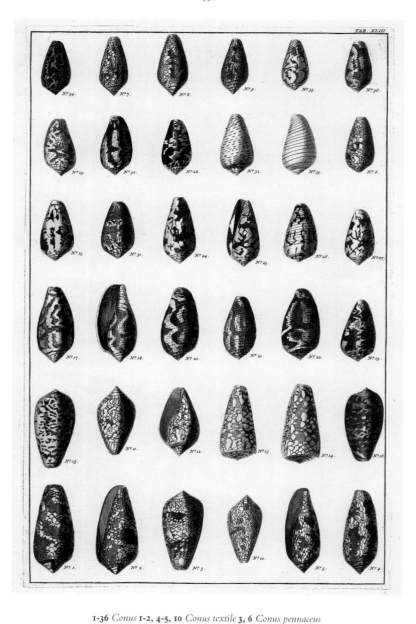

1-36 *Conus* 1-2, 4-5, 10 *Conus textile* 3, 6 *Conus pennaceus*
7-9 *Conus canonicus* 11-12 *Conus retifer* 13-14 *Conus nobilis*
Poisonous cone shells, chiefly from the Indo-Pacific · Giftige Kegelschnecken, überwiegend aus dem
Indopazifik · Cônes venimeux, originaires principalement de l'aire indopacifique

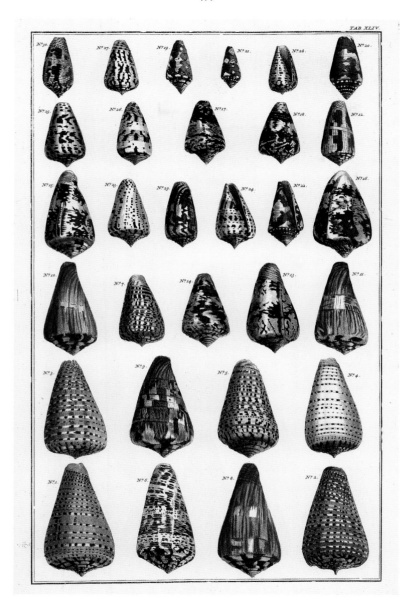

TAB. XLIV.

1-30 *Conus* 1-4, 23 *Conus betulinus* 5 *Conus suratensis* 6 *Conus imperialis* 8-11 *Conus vexillum*
15 *Conus ammiralis* 19-21 *Conus aurantius* 24 *Conus spurius*
onous cone shells from the Indo-Pacific and the Caribbean · Giftige Kegelschnecken aus dem Indopazifik
und der Karibik · Cônes venimeux, originaires principalement de l'aire indopacifique et des Caraïbes

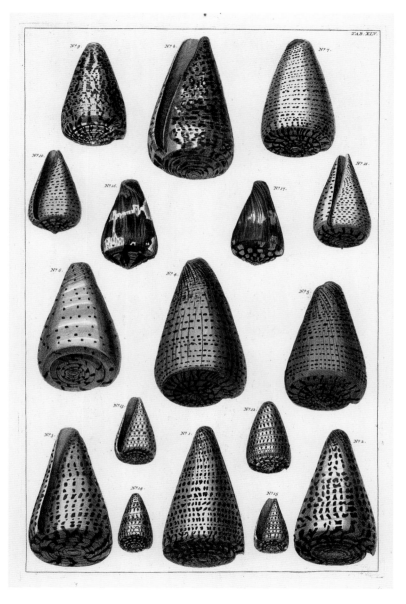

1-17 *Conus* 1-3, 12-15 *Conus litteratus* 6, 10-11 *Conus betulinus*
8 *Conus pulcher* 16-17 *Conus vexillum*
Poisonous cone shells from tropical waters · Giftige Kegelschnecken aus tropischen Meeren ·
Cônes venimeux des mers tropicales

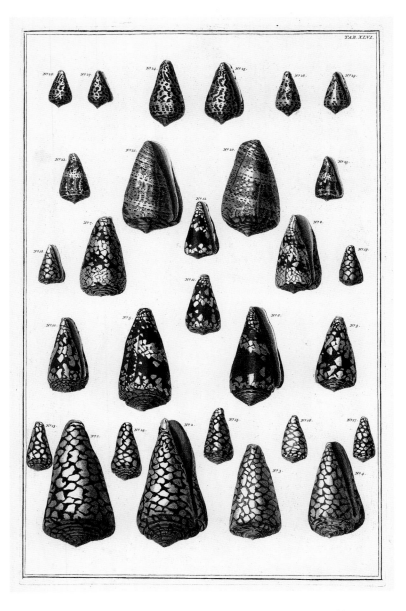

TAB. XLVI.

**1-29** *Conus* **1-4, 13-19** *Conus marmoreus* **7-8** *Conus vidua* **20-21** *Conus pulcher*
Poisonous cone shells, chiefly from the Indo-Pacific ·
Giftige Kegelschnecken, überwiegend aus dem Indopazifik ·
Cônes venimeux, originaires principalement de l'aire indopacifique

TAB. XLVII.

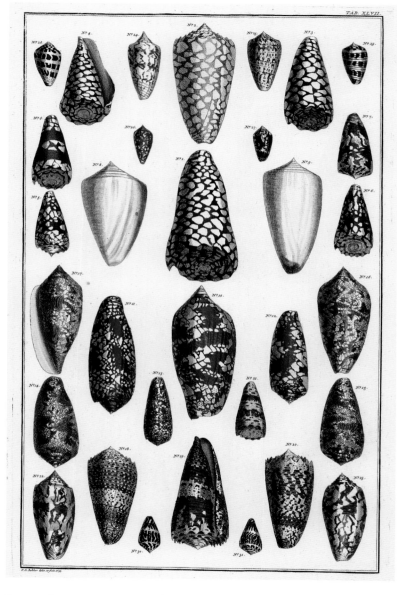

1-31 *Conus* 1-4 *Conus marmoreus* 5-6 *Conus bandanus* 8 *Conus quercinus* 10-12 *Conus aulicus* 13 *Conus aulicus?*
14-17 *Conus textile* 18-21 *Conus imperialis* 22-23 *Conus striatus* 28-29 *Conus ebraeus* 30-31 *Conus chaldeus*
Poisonous cone shells from the Indo-Pacific · Giftige Kegelschnecken aus dem Indopazifik ·
Cônes venimeux, originaires de l'aire indopacifique

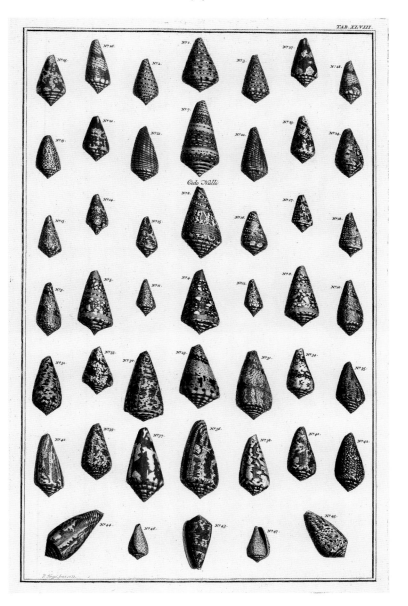

TAB. XLVIII.

Cedo Nulli

1-47 *Conus* 1-3 *Conus genuanus* 4-7 *Conus ammiralis* 8 *Conus cedonulli*
21 *Conus tenuistriatus* 25, 29 *Conus regius* 27, 37 *Conus aurantius* 42 *Conus dalli*
Cone shells from the Atlantic, Indian Ocean and Pacific · Kegelschnecken aus Atlantik, Indischem
Ozean und Pazifik · Cônes originaires de l'Atlantique, de l'océan Indien et du Pacifique

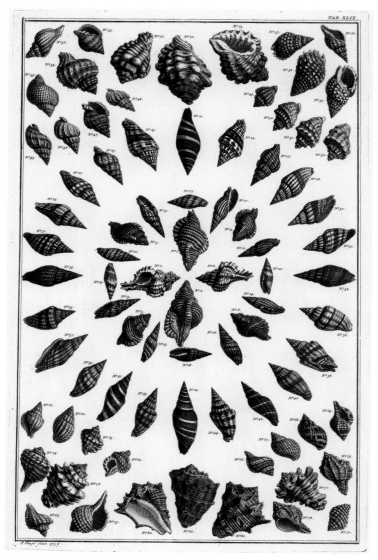

TAB. XLIX.

1-6 *Cymatium rubeculum* 11-44 *Vexillum* 11-18 *Vexillum sanguisugum* 19-20 *Vexillum taylorianum*
21-22, 33-34, 41 *Vexillum vulpecula* 23-24 *Vexillum plicarium* 30, 39, 44 *Vexillum rugosum* 45-48 *Phos senticosus* 53, 55
*Cancellaria reticulata* 57-59 *Nassarius papillosus* 63-64, 71-73 *Cabestana cutacea* 76-77 *Vasum turbinellus* 80-82 *Vasum*
Tritons, miter shells, nassas, and vase shells from the Indo-Pacific, Atlantic and Mediterranean Sea ·
Tritonshörner, Giftwalzenschnecken, Netzreusenschnecken und Vasenschnecken aus dem Indopazifik,
Atlantik und Mittelmeer · Tritons, cônes, mitres, nasses et vases de l'aire indopacifique, de l'Atlantique
et de la mer Méditerranée

TAB. I.

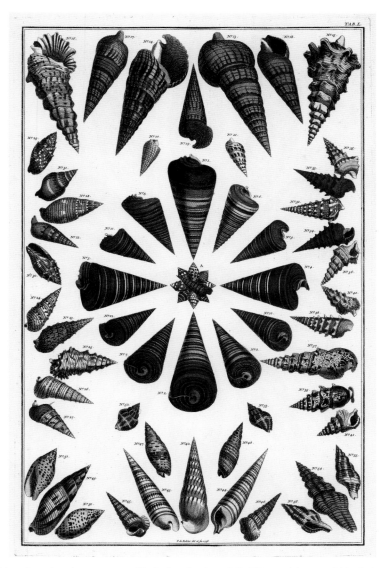

**1-12** *Telescopium telescopium* **13-14, 17-19** *Terebralia palustris* **15-16** *Cerithium nodulosum* **22** *Rhinoclavis vertagus*
**23-24** *Rhinoclavis sinensis* **26-27** *Neocancilla* **28** *Mitra imperialis* **29-30** *Mitra puncticulata* **31** *Buccinidae*
**32-38, 40** *Cerithium* **37** *Cerithium aluco* **42** *Rhinoclavis* **43-44** *Rhinoclavis fasciatus* **47** *Neocancilla papilio*
**48** *Neocancilla granatina* **49** *Mitra incompta* **50-51** *Mitra cardinalis* **52-53** *Canthariidae* **54** *Latirus infundibulum*
**55-56** *Latirus nagasakiensis*
Sea shells of different families from the Indo-Pacific · Meeresschnecken verschiedener Familien
aus dem Indopazifik · Mollusques marins de différentes familles de l'aire indopacifique

TAB. LI.

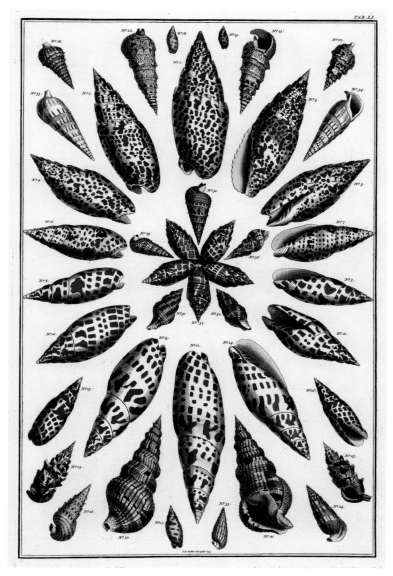

**1-5** *Mitra papalis* **6-7** *Mitra cardinalis* **8-16** *Mitra mitra* **17-19** *Mitra* **20-21** *Colubraria muricata*
**22-23, 29-30** Cerithiidae **24, 26-27, 35, 38** *Rhinoclavis* **25** *Pseudovertagus aluco* **31-32** *Latirus nagasakiensis*
**33-34** *Rhinoclavis fasciatus* **36** *Colubraria* **37** *Mitra stictica*
Miter shells, ceriths and a few other species from the Indo-Pacific · Indopazifische Meeresschnecken,
hauptsächlich Bischofsmützenschnecken, Mitras, Nadelschnecken und einige andere Arten aus dem
Indopazifik · Mitres, cérinthes (cornets) et autres espèces de l'aire indopacifique

TAB. LII

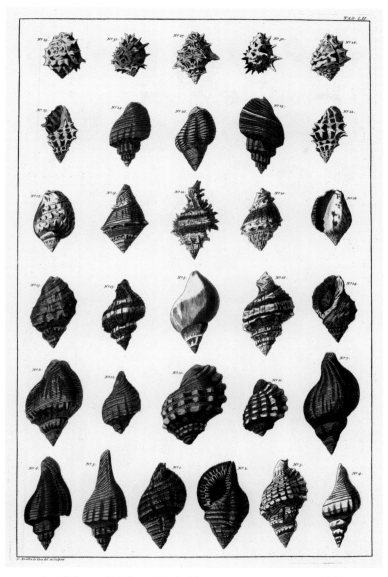

**1-3** Ranellidae **5-6** *Hemifusus* **7** Buccinoidea **9** *Neptunea* **10-11** *Cymatium doliarium*
**13-14, 27** *Thais* **15-16** Muricidae **17-18** *Strombus pipus* **19-20** Melongenidae **21** *Chicoreus* **22-23** *Thais*
**24-25, 28-29** Muricoidea **26** *Cantharus undosus* **30-31** *Drupa*
Sea snails, including murex shells and tritons, chiefly from the Indo-Pacific · Meeresschnecken,
uptsächlich aus dem Indopazifik, darunter Stachelschnecken und Tritonschnecken · Mollusques marins,
incluant des murex et des tritons, principalement de l'aire indopacifique

TAB. LIII.

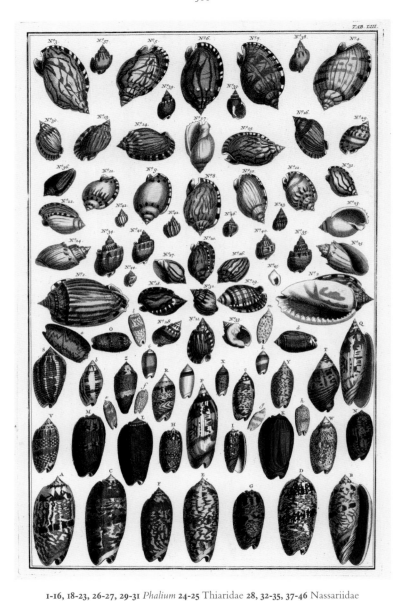

**1-16, 18-23, 26-27, 29-31** *Phalium* **24-25** Thiaridae **28, 32-35, 37-46** Nassariidae
**A-F** *Oliva miniacea* **G-R, V-Y, a, c-m** Olividae **s, z** *Conus*

Tropical sea shells, including bonnet shells, mud shells, mudcreepers, olive shells, and cone shells ·
Tropische Meeresschnecken, darunter Helmschnecken, Reusenschnecken, eine
Turmdeckelschnecke (Thiaridae), Olivenschnecken (Olividae) und Kegelschnecken (Conidae) ·
Mollusques marins tropicaux, dont des casques, des nasses, un Thiaridae, des olives et des cônes

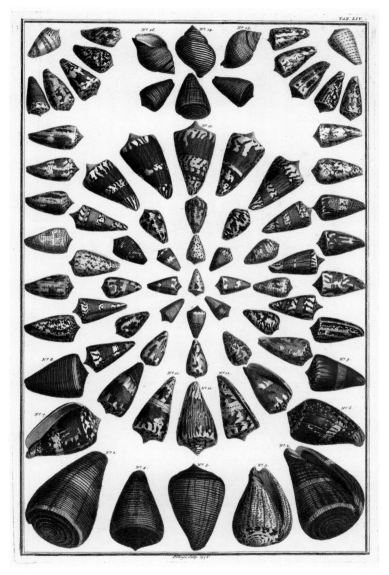

All except **14-16** *Conus* **1-4**, below **14-16** *Conus figulinus* **5** *Conus glaucus* **9** *Conus vexillum*
**11-13** (next to **7, 8**, three shells at both sides of **13**) *Conus generalis* **14-16** *Latirogena smaragdula*
oisonous cone shells and stone shells from tropical seas · Giftige Kegelschnecken und Spindelschnecken
aus den tropischen Meeren · Cônes venimeux et fasciolariidés des mers des Tropiques

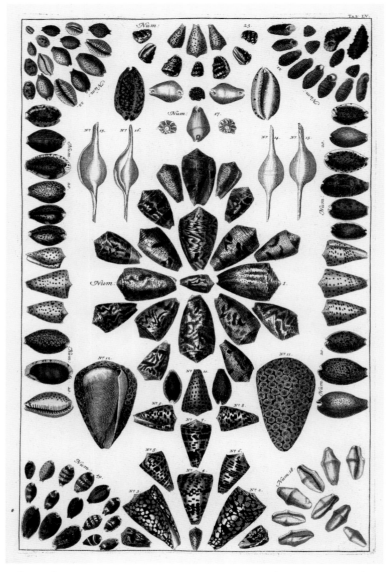

I-12 *Conus* I *Conus stercusmuscarum* 2-3 *Conus marmoreus* 4-9 *Conus eburneus* 10, 20 *Conus litteratus*
II-12 *Conus* 13-16 *Volva volva* 17 *Calpurnus verrucosus* 18 *Cyphoma gibbosum* 19 *Cypraea felina* 20 *Conus leopardu*
21 *Pupilloidea* 22 *Trivia pedicula*
Cone shells and cowries from the Indo-Pacific and West Atlantic · Kegelschnecken und Porzellan-
schnecken aus dem Indopazifik und dem Westatlantik · Cônes et porcelaines (cyrées et ovules) de l'aire
indopacifique et de l'Atlantique occidental

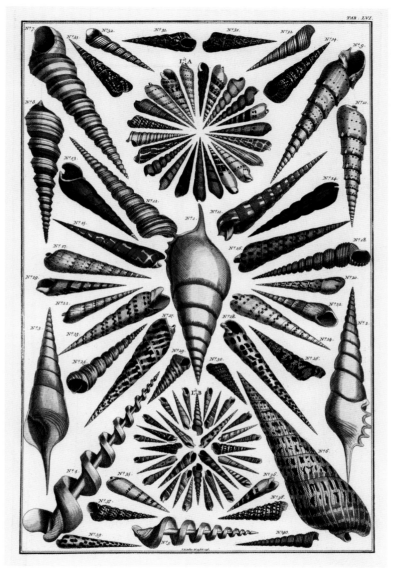

TAB. LVI.

bia insulaechorab 2 Tibia fusus 3 Tibia **4-5, 8, 17, 19, 22, 41-42, A-B** Terebridae **6, 12** Terebra maculata **7** Turritella
duplicata **9-10** Terebra crenulata **11** Terebra guttata **12, 25** Turritella terebra **13-14** Faunus ater **15** Terebra dimidiata
**16, 23-24** Terebra areolata **18, 25-26, 29-34, 37-38, 40** Turritella **20-21** Melanoides **26, 31, 33-34** Turritella variegata
Turret shells, auger shells and tibias from the Indo-Pacific and the Caribbean · Indopazifische und
bische Turmschnecken, Schraubenschnecken, Turmdeckelschnecken und Flügelschnecken · Turritelles,
térèbres et tibias de l'aire indopacifique et des Caraïbes

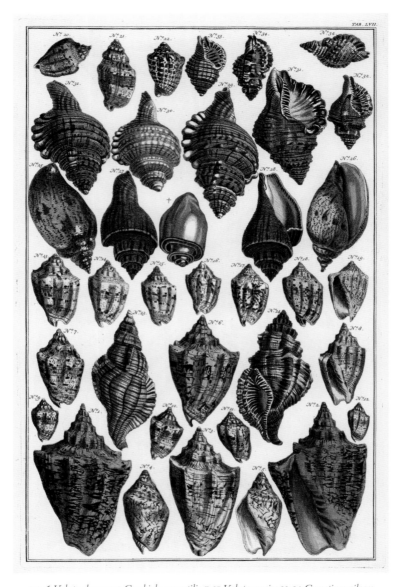

*TAB. LVII.*

1-3, 6 *Voluta ebraea* 4-5 *Cymbiola vespertilio* 7-21 *Voluta musica* 23-24 *Cymatium pileare*
25-26 *Harpulina lapponica* 27-28 *Pugilina morio* 29-31 *Cymatium parthenopeum*
Volutes, tritons and giant hairy melongena from the Pacific, West Atlantic and the South Indian
coastal region · Walzenschnecken, Tritonshörner und Kronenschnecken aus dem Pazifik, Westatlantik
und der südindischen Küstenregion · Volutes, tritons et mélongénidés du Pacifique, de l'Atlantique
occidental et de la région côtière du sud de l'Inde

TAB. LVIII.

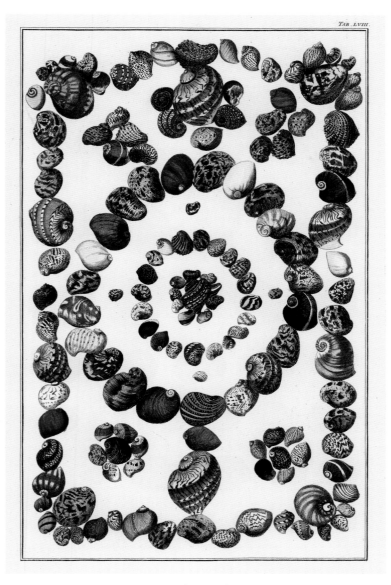

*Neritidae, Naticidae*
Nerite shells and moon shells ·
Schwimmschnecken und Nabelschnecken ·
Nérites et natices

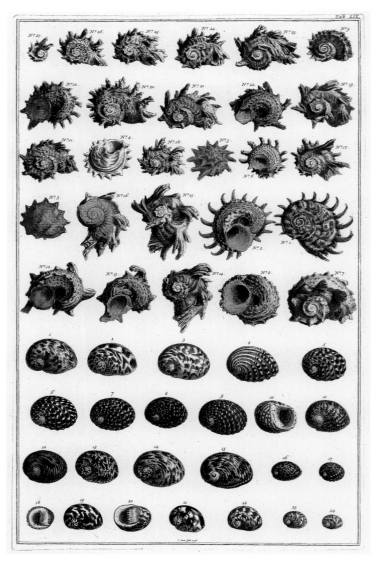

1-3 (bottom) *Nerita polita* 4-18 (bottom) *Nerita exuvia* 19-24 (bottom) *Nerita* 1-2 (top) *Stellaria solaris*
3-4 (top) *Astrea* 5-6 (top) *Astrea calcar* 7-27 (top) *Angaria delphinus, Neorapana muricata*
Nerite shells, star shells and angaria shells from the Indo-Pacific and West Atlantic · Schwimmschnecke
Kreiselschnecken und Stachelschnecken aus dem Indopazifik und dem Westatlantik · Nérites, astreas d
anarias de l'aire indopacifique et de l'Atlantique occidental

TAB. LX.

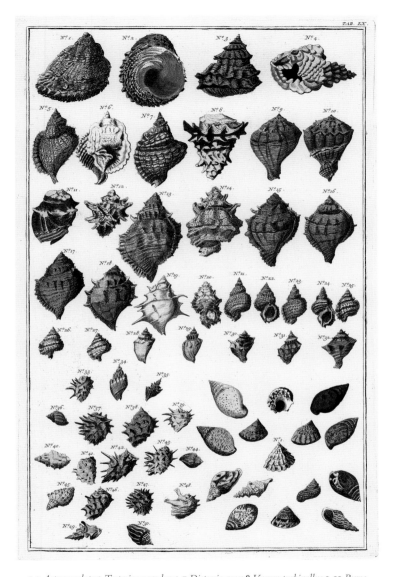

1-2 *Astrea caelata* 3 *Tectarius pagodus* 4-7 *Distorsio anus* 8 *Vasum turbinellus* 9-10 *Bursa*
12 *Thais armigera* 13, 15-18 *Bursa rana* 19 *Bursa echinata* 21-27 *Gyrineum gyrinum* 28-29 *Strombus*
30-32 *Thais* 33, 37-39, 41-43, 46-47 *Drupa* 48 *Drupa grossularia*
Star shells, periwinkles, tritons, vase shells, murex shells and conchs from the Indo-Pacific and
West Atlantic · Kreiselschnecken, Strandschnecken, Tritonshörner, Vasenschnecken, Stachelschnecken
und Flügelschnecken aus dem Indopazifik und Westatlantik · Astreas, bigorneaux, tritons, vases,
murex et strombes de l'aire indopacifique et de l'Atlantique occidental

**1-6** *Strombus aurisdianae* **7** *Strombus lentiginosus* **8** *Strombus labiatus* **9-10** *Lambis lambis*
**11-12, 20-21** *Strombus luhuanus* **13-14, 17-19, 51-53** *Strombus gibberulus* **15-16** *Strombus marginatus*
**24, 26-33, 35-39, 50, 57-64, 66-68** *Strombus* **25, 41-47, 55** *Strombus dentatus*
Conchs and spider conch shells from the Indo-Pacific · Flügelschnecken und Spinnenschnecke
aus dem Indopazifik · Strombes et coquillage araignée de l'aire indopacifique

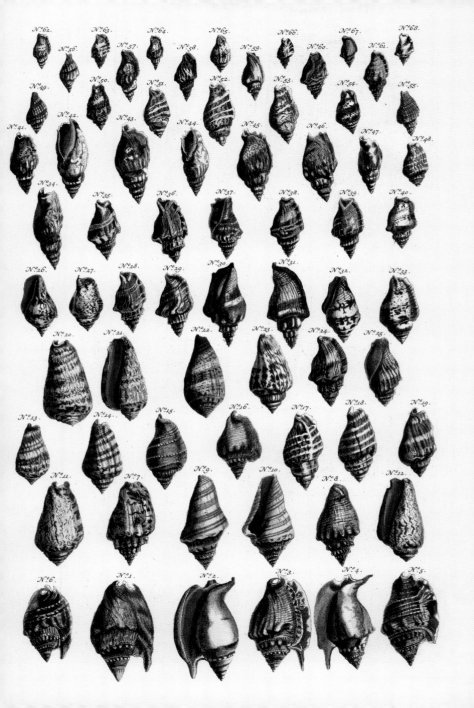

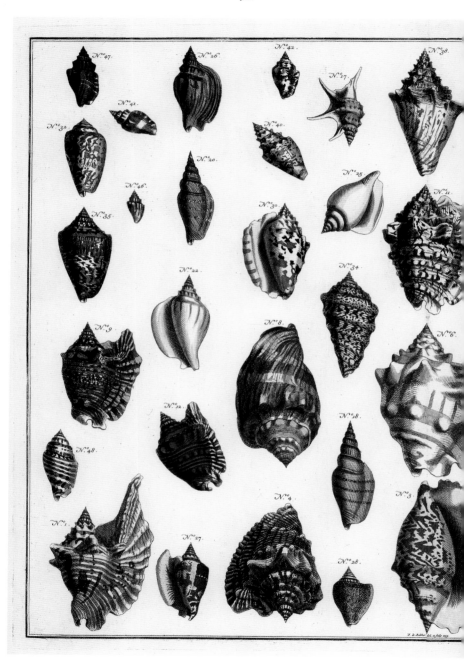

F. de Bakker del. et Sulp 1757.

*TAB. LXII.*

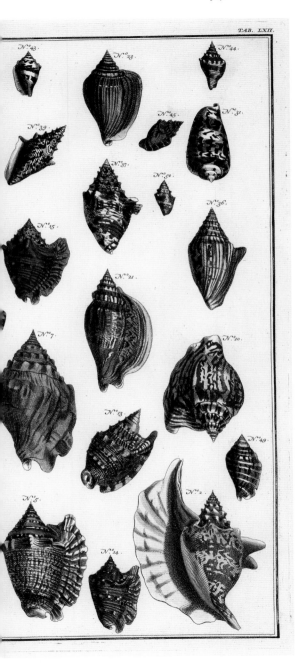

**1-16, 18-32, 35-41, 44-50** *Strombus*
**1-2, 4-5, 9-10, 12, 14-15, 27, 35-37**
*Strombus gallus* **3** *Strombus sinuatus*
**6-8** *Strombus fasciatus*
**11, 30** *Strombus lentiginosus*
**17** *Aporrhais pespelicani*
**18-20** *Strombus vittatus*
**21-22, 26** *Strombus epidromis*
**33** *Lambis* **34** *Lambis chiragra*
**41, 45-47** *Strombus urceus*
**48, 49** *Strombus gibberulus*
Conchs, spider conch shells and
the common pelican's foot ·
Flügelschnecken, Spinnen-
schnecken und der Pelikanfuß ·
Strombes, coquillages araignées
et pied de pélican

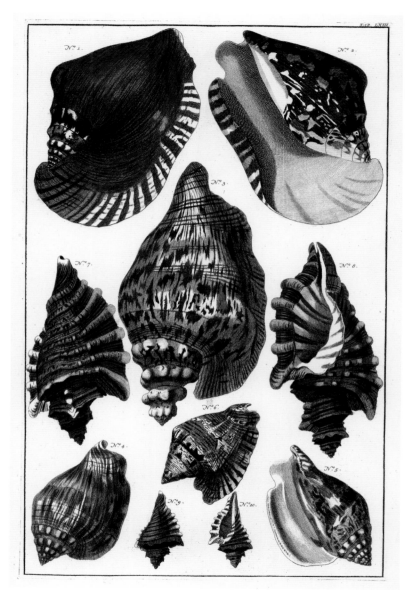

*1-2 Strombus latissimus* **3** *Lambis truncata sebae* **4-5** *Strombus epidromis*
**6** *Strombus raninus* **7-8** *Cymatium femorale* **9-10** *Eupleura*
Chiefly conchs from tropical seas · Hauptsächlich Flügelschnecken aus tropischen Meeren ·
Principalement des strombes des mers tropicales

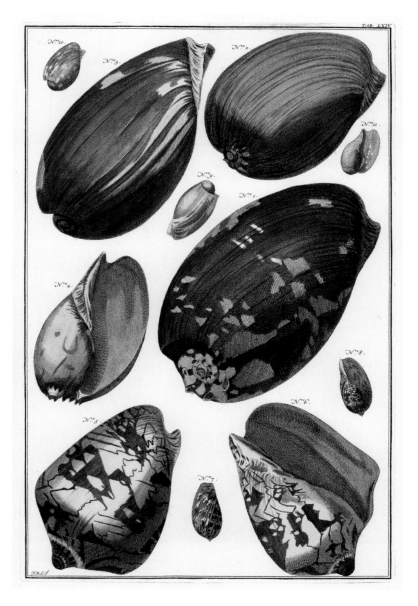

1 *Melo amphora* 2 *Melo* 3 Volutidae 4 *Melo broderipii* 5-6 *Cymbiola nobilis* 7-11 Volutidae
Volutes from the tropical seas around Australia, Indonesia and West Africa ·
Walzenschnecken aus den tropischen Meeren bei Australien, Indonesien und Westafrika ·
Volutes des mers tropicales de l'Australie, de l'Indonésie et de l'Afrique occidentale

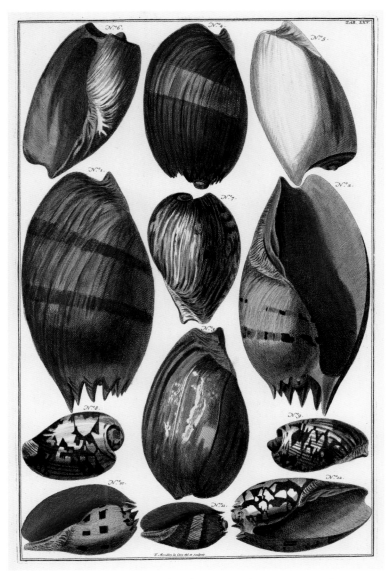

1-2 *Melo georginae* 3 *Melo melo* 4 *Melo broderipii* 5-6 *Cymbium cucumis* 7 *Cymbium pepo*
8-9, 11 *Melo* 10 *Melo aethiopica* 12 *Melo miltonis*
Volutes from the Indo-West Pacific near Australia and Indonesia, and from the Atlantic near West Afric
Walzenschnecken aus dem Indo-Westpazifik bei Australien und Indonesien, und aus dem
Atlantik bei Westafrika · Volutes de l'aire indopacifique, près de l'Australie et de l'Indonésie, ainsi
que de l'Atlantique près de l'Afrique occidentale

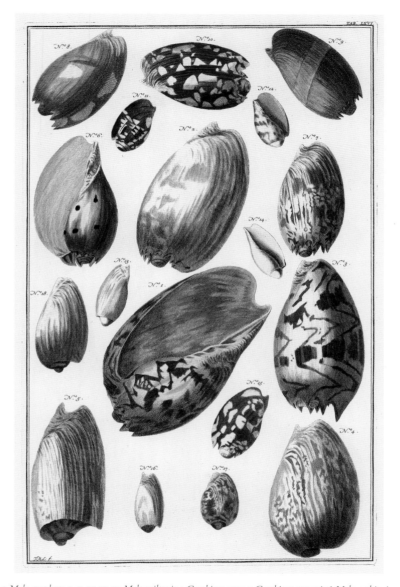

1 *Melo amphora* **2, 7, 10-12, 15** *Melo miltonis* **4** *Cymbium pepo* **5** *Cymbium cucumis* **6** *Melo aethiopica*
**8** *Melo umbilicatus* **9** *Melo broderipii* **13-14, 16** *Cymbium* **18** *Cymbium olla*
Volutes from the tropical seas near West Africa, Indonesia and Australia · Walzenschnecken aus
den tropischen Meeren bei Westafrika, Indonesien und Australien · Volutes des mers tropicales près de
l'Afrique occidentale, de l'Indonésie et de l'Australie

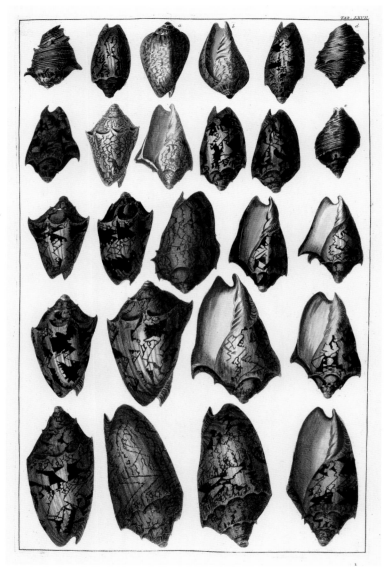

*Cymbiola vespertilio*
Volutes from tropical seas ·
Walzenschnecken aus den tropischen Meeren ·
Volutes des mers tropicales

TAB. LXVIII

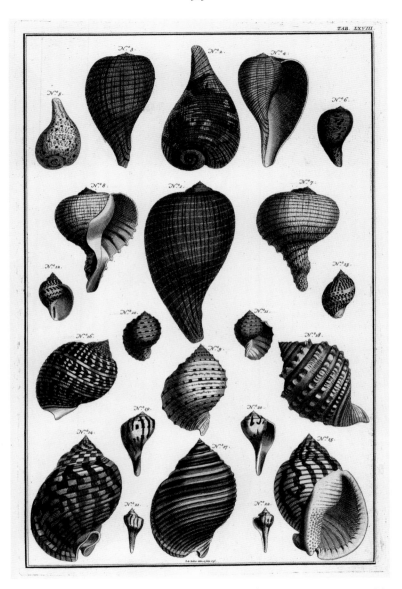

**1, 3-4** *Ficus communis* **2** *Ficus* **5** *Ficus variegata* **6** *Ficus subintermedia* **7-8** *Rapa rapa* **9-11** *Tonna dolium*
**14-15** *Phalium undulatum* **16** *Tonna perdix* **17** *Galeodea rugosa* **18** *Galeodea echinophora*
un shells, helmet shells, fig shells and other sea shells from North-East America, the Mediterranean, and the
ndo-West Pacific · Tonnenschnecken, Helmschnecken, Feigenschnecken und andere Meeresschnecken aus
ordost-Amerika, dem Mittelmeer und dem Indo-Westpazifik · Tonnes, casques, figues et a autres mollusques
marins du nord-est de l'Amérique, de la mer Méditerranée et de l'océan Indien et Pacifique occidental

**1, 3, 20** *Tonna cepa* **2** *Tonna*
**4** *Phalium* **5, 7, 13, 23, 29** *Tonna*
*perdix* **6** *Phalium areola*
**8-9, 18** *Tonna dolium* **10, 12** *Tonna*
*maculosa* **11** *Tonna sulcosa*
**14-17, 19, 21-22, 24-28** Tonnidae
Tun shells and helmet shells
from the Indo-Pacific and West
Atlantic · Tonnenschnecken und
Helmschnecken aus dem
Indopazifik und dem
Westatlantik · Tonnes et casques
de l'aire indopacifique et
de l'Atlantique occidental

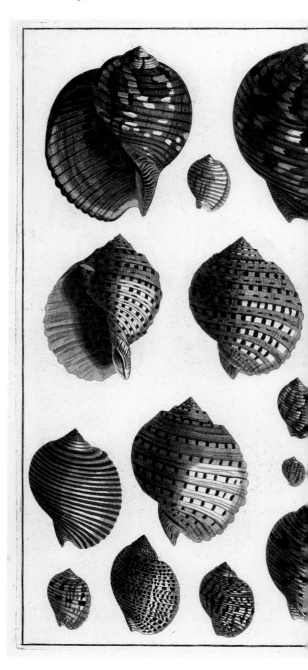

TAB. LXIX.

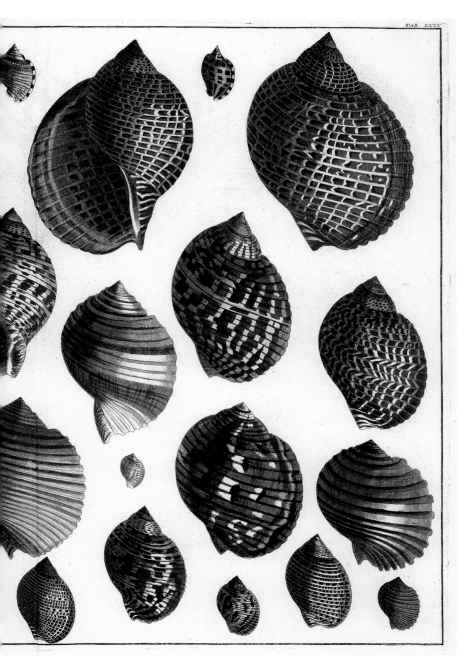

**1** *Tonna marginata* **2** *Galeodea echinophora* **3-4** *Malea pomum* **5-6** *Malea ringens* **7-9** *Phalium areola*
**10, 13-14, 17-22, 24** *Harpa davidis*-complex **11-12, 16** *Harpa articularis* **15, 23, 27** *Harpa ventricosa* **25-30** *Harpa amoure*
Tun shells, helmet shells and harp shells from the Indo-Pacific, the Caribbean and the Mediterranean Se
Tonnenschnecken, Helmschnecken und Harfenschnecken aus dem Indopazifik, der Karibik und dem
Mittelmeer · Tonnes, casques et harpes de l'aire indopacifique, des Caraïbes et de la mer Méditerranée

TAB. LXX.

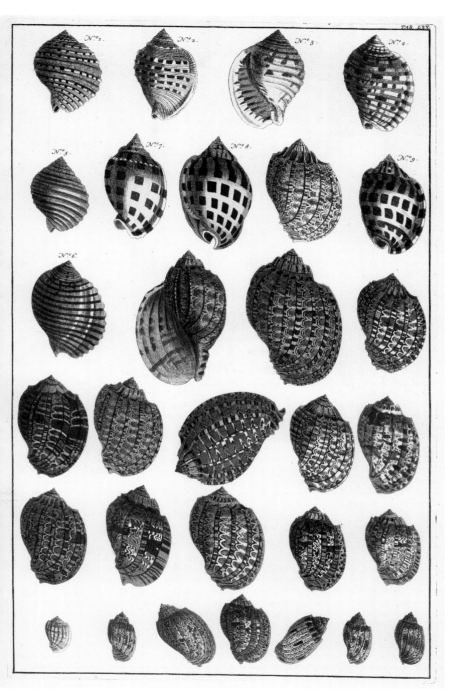

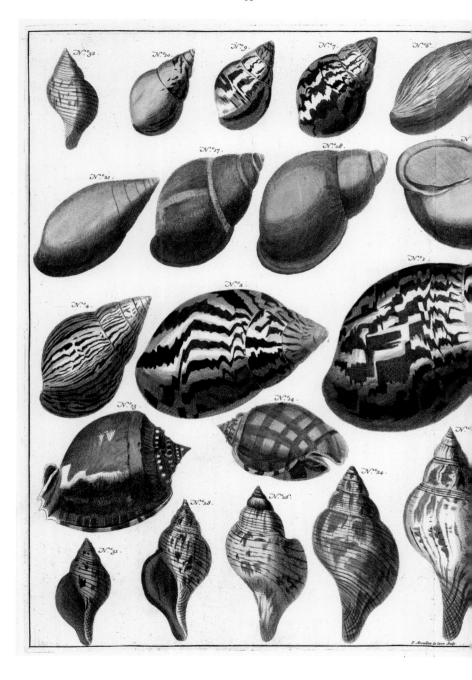

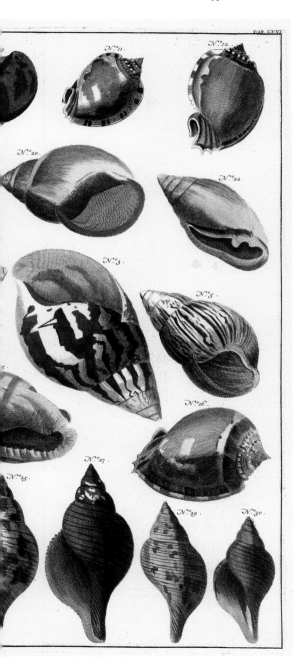

**1-3, 7, 9** *Achatina achatina*
**4-5** *Achatina* **6** Pulmonata
**8** *Archachatina marginata*
**10** Bulimulidae **11** *Phalium*
**13-16** *Phalium glaucum*
**17-20** *Megalobulimus oblongus*
**21-22** *Ellobium aurismidae*
Spindle shells and helmet shells
from the Indo-Pacific and the
Caribbean, and land snails from
Africa and South America ·
Meeresschnecken der Familien
Fasciolariidae und Cassidae aus
dem Indopazifikund der Karibik,
sowie Landschnecken aus Afrika
und Südamerika · Fuseaux et
casques de l'aire indopacifique et
de la mer des Caraïbes, ainsi que
des mollusques terrestres
(achatines et bulimes) d'Afrique
et d'Amérique du Sud

1-9 *Melongena melongena* 10-11 *Purpura persica* 12-15 *Thais haemastoma* 16 *Purpura panama* 17-21 *Cypraecassis testic*
Helmet shells and sea shells of the Melongenidae and Thaididae families, from the Indo-Pacific, the
Atlantic, the Caribbean and the Mediterranean Sea · Helmschnecken und Meeresschnecken der Familie
Melongenidae und Thaididae aus dem Indopazifik, dem Atlantik, der Karibik und dem Mittelmeer ·
Casques et mollusques marins de la famille des Melongenidae et des Thaididae de l'aire indopacifique
de l'Atlantique, des Caraïbes et de la mer Méditerranée

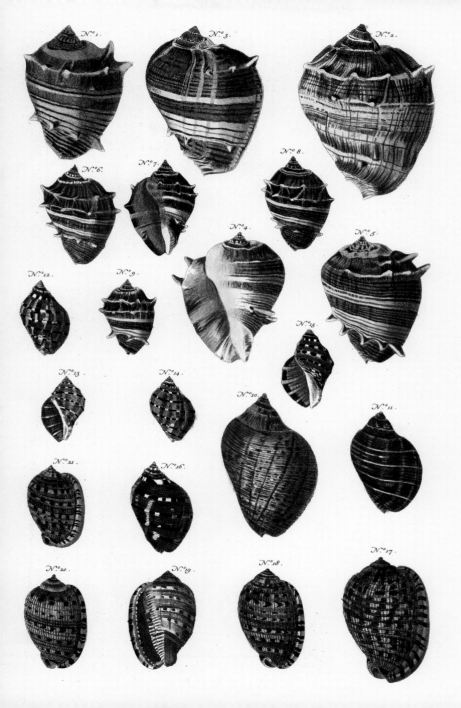

1, 12, 15 *Cassis tessellata* 2 *Cassis tuberosa* 3-4, 9 *Cypraecassis rufa* 5-6, 10-11, 13-14, 16-18 Cassidae 7-8 *Cassis cornuta* 19-20 *Cassis flammea* 21-22, 24-25 *Babylonia spirata* 23, 26 *Babylonia areolata* 27-28 *Conus pulcher* Helmet shells, cone shell and whelks from the Indo-Pacific, West Africa and the Caribbean · Helmschnecken, Kegelschnecke und Wellhornschnecken aus dem Indopazifik, Westafrika und der Karibik · Casques, cône et buccins de l'aire indopacifique, de l'Afrique occidentale et des Caraïbes

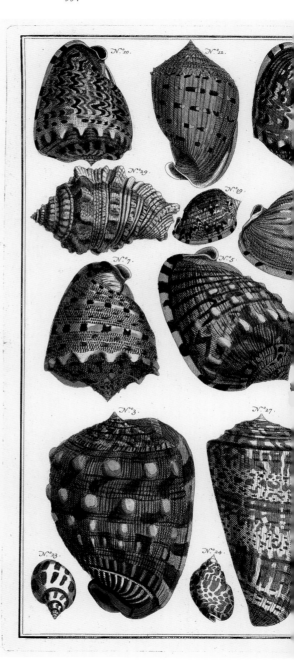

TAB. LXXIII.

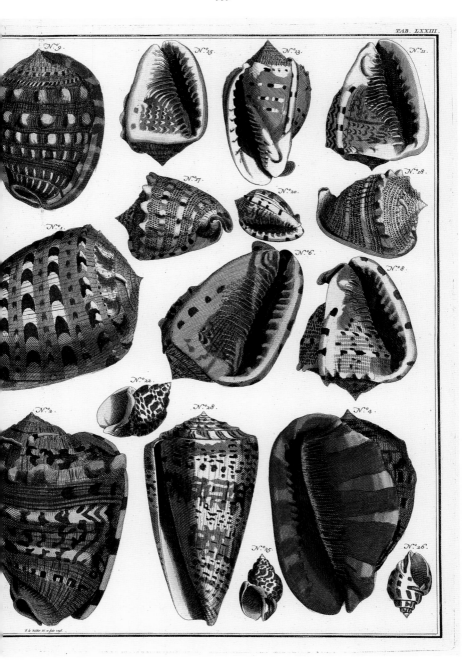

F. de Valder del. et fecit 1756.

1-2 *Turbo marmoratus* 3-5, 7-8, 16-19, 22-30 *Turbo petholatus* 6, 20-21 *Turbo argyrostoma*
9-11 *Turbo chrysostomus* 12 *Astraea tuber* 13-15 *Turbo cidaris*
Turban shells from the Indo-Pacific, the West Atlantic and the South African coastal region ·
Turbanschnecken aus dem Indopazifik, Westatlantik und der südafrikanischen Küstenregion ·
Turbos de l'aire indopacifique, de l'Atlantique occidental et du littoral sud-africain

TAB. LXXIV.

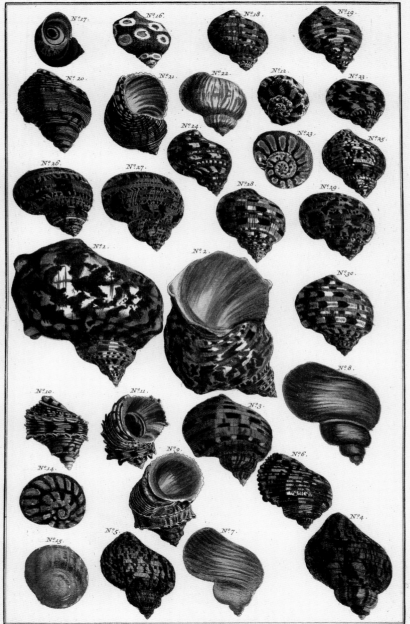

Pleurotomariidae, Trochidae, Turbinidae
Slit shell, top shells, and turban shells · Schlitzbandschnecke, Spitzkreiselschnecken und Turbanschnecken · Pleurotomaire, troques et turbos

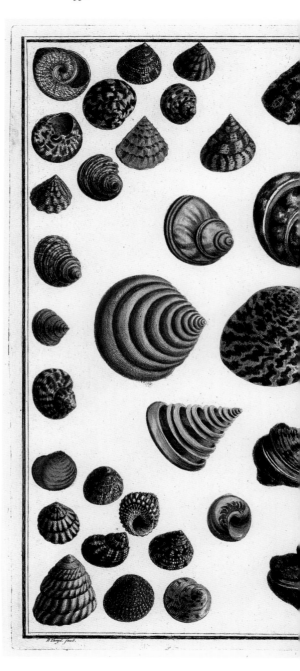

TAB. LXXV.

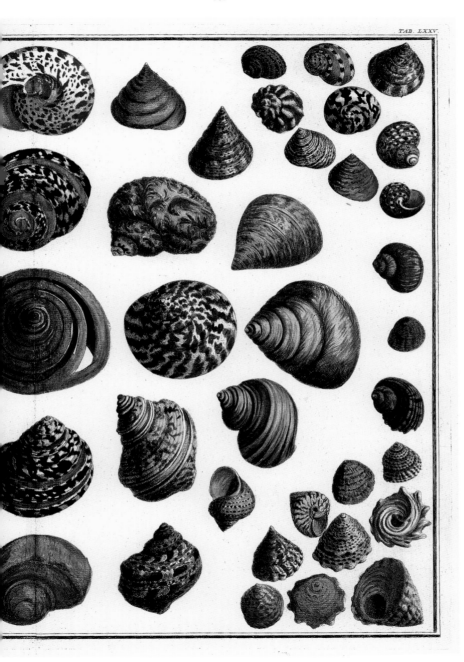

TAB. LXXVI.

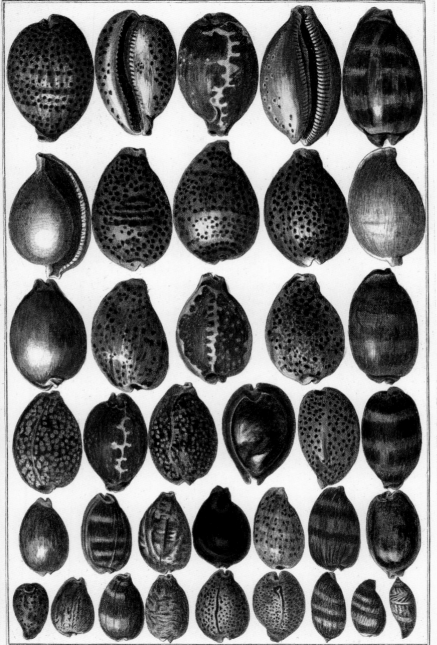

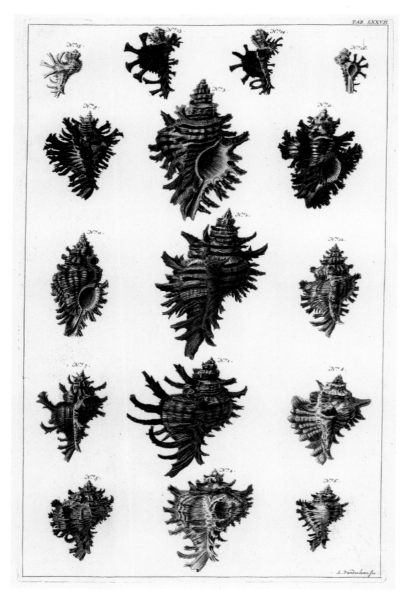

**1, 5-6** *Chicoreus cichoreum* **2-3** *Chicoreus brevifrons?* **4** *Chicoreus ramosus* **7, 11-12** *Chicoreus*
**8** *Hexaplex* **9-10** *Chicoreus brunneus* **13-16** *Homolacantha scorpio*
Murex shells, chiefly from the Indo-Pacific · Stachelschnecken der Familie Muricidae,
hauptsächlich aus dem Indopazifik · Murex (ou rochers), principalement de l'aire indopacifique

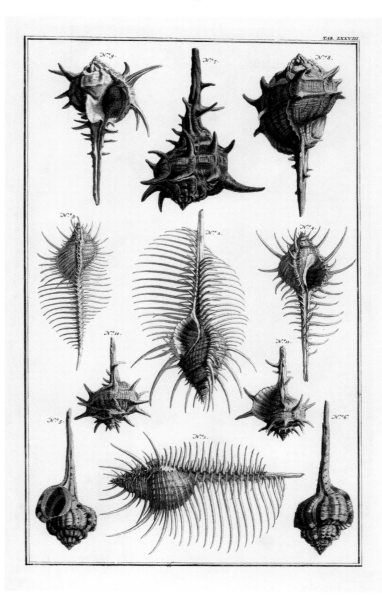

TAB. LXXVIII

**1-3** *Murex pecten* **4** *Murex troscheli* **5-6** *Haustellum haustellum* **7-9** *Bolinus cornutus* **10-11** *Bolinus brandaris*
Murex shells from the Indo-Pacific, West Africa and the Mediterranean Sea · Stachelschnecken der
Familie Muricidae aus dem Indopazifik, Westafrika und dem Mittelmeer · Murex peignes et autres
murex de l'aire indopacifique, de l'Afrique occidentale et de la mer Méditerranée

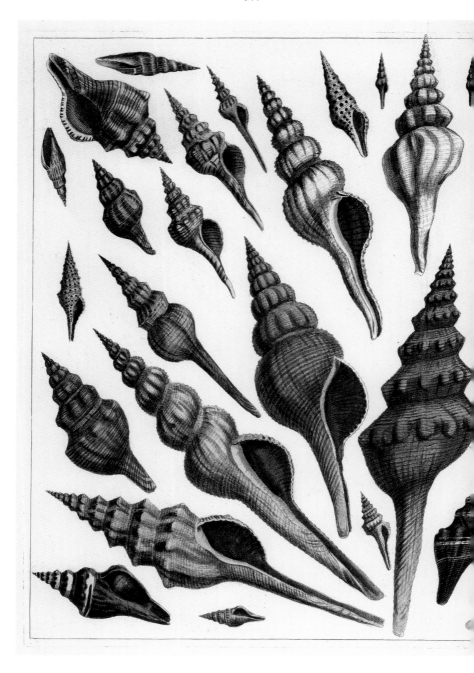

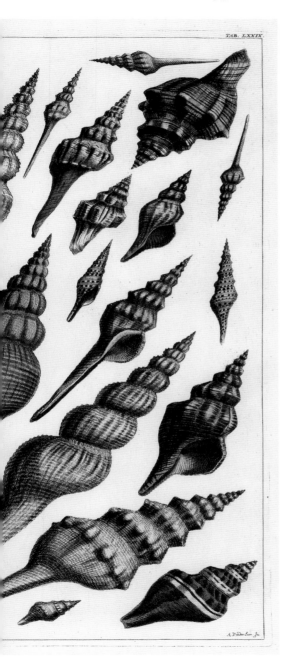

TAB. LXXIX.

Fasciolariidae, Melongenidae,
Turridae
Spindles, crown shells and turrid
shells from tropical seas ·
Spindelschnecken,
Kronenschnecken und
Turmschnecken aus tropischen
Meeren ·
Fasciolaires ou fuseaux,
mélongenidés et turridés des eaux
tropicales

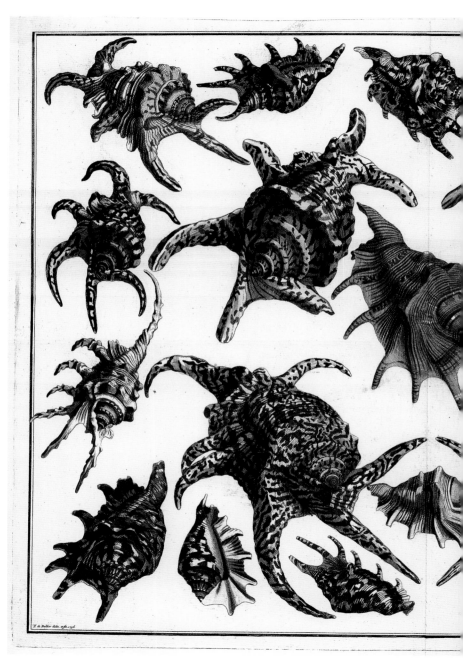

*TAB. LXXXII.*

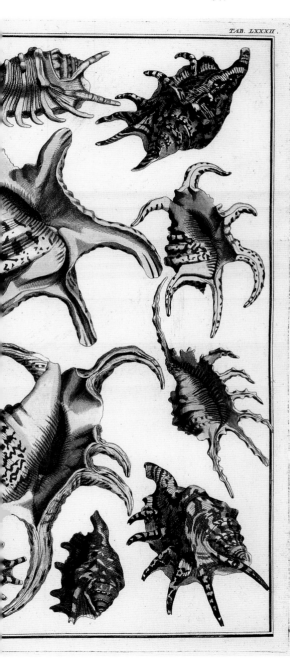

**1, 5, 8-13, 17-18, 21** *Lambis lambis* **2, 19** *Lambis scorpius* **3-4, 6-7, 14-15, 20** *Lambis chiragra* **16** *Lambis millepeda*
Spider conchs or lambis shells (Strombidae family), from the Indo-Pacific · Spinnenschnecken der Familie Strombidae aus dem Indopazifik · Coquillages araignées ou lambis (famille des Strombidae) de l'aire indopacifique

1 -2, 6, 26 *Melongena* 3-5, 9, 11, 13-25 *Pugilina morio* 7-8, 10, 12 Melongenidae
Melongenids from tropical waters ·
Kronenschnecken aus tropischen Gewässern ·
Mélongénidés des eaux tropicales

TAB LXXX.

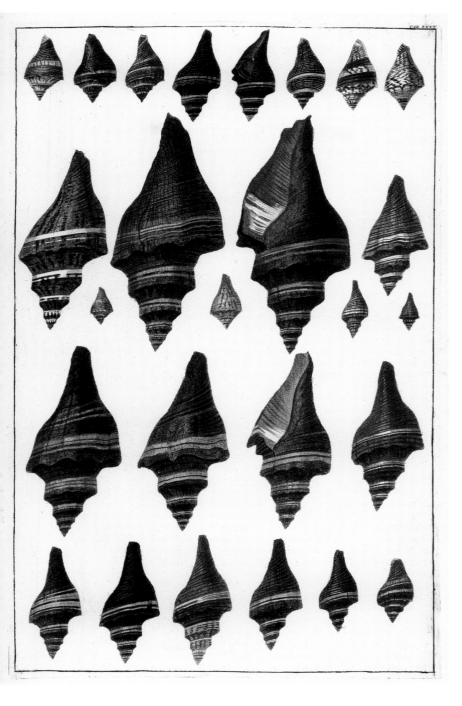

**1-2, 12-14** *Lambis lambis* **3-6** *Neptunea antiqua* **7** *Buccinum undatum* **8-9** *Lambis truncata sebae* **10-11** Strombidae
Juvenile spider conchs (Strombidae family) from the Indo-Pacific, and two species of whelk from the
northern Atlantic · Jungtiere von Spinnenschnecken der Familie Strombidae aus dem Indopazifik und zw
Wellhornschnecken-Arten aus dem Nordatlantik · Jeunes coquillages araignées ou lambris (famille des
Strombidae) de l'aire indopacifique et deux espèces de buccin de l'Atlantique Nord

TAB. LXXXIII.

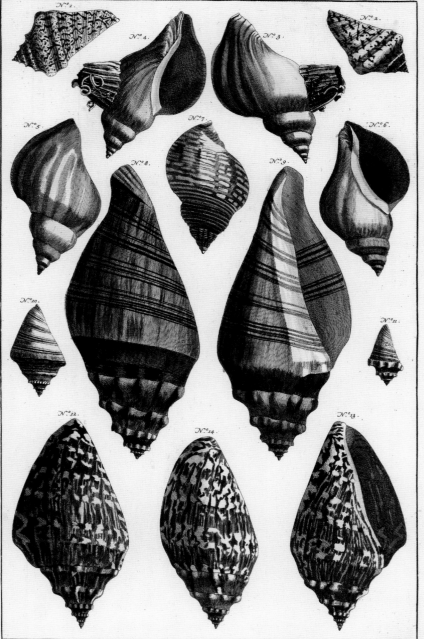

*Charonia tritonis*
Triton trumpets · Tritons-
hörner · Grands tritons

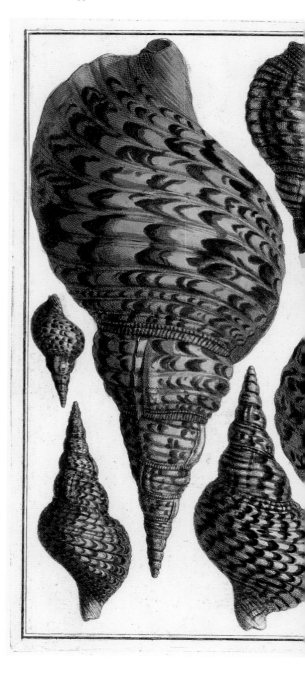

TAB. LXXXI.

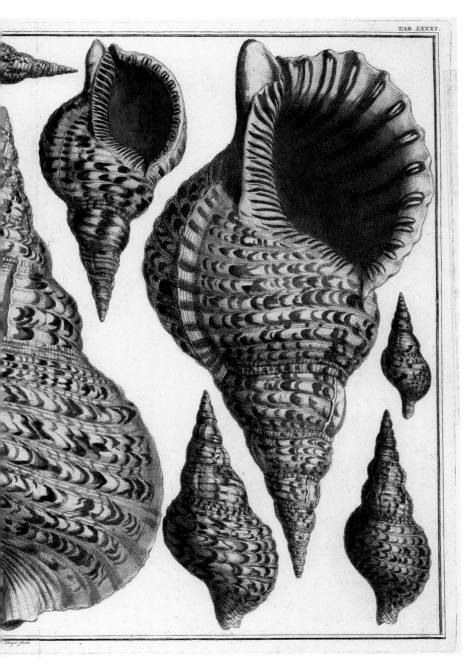

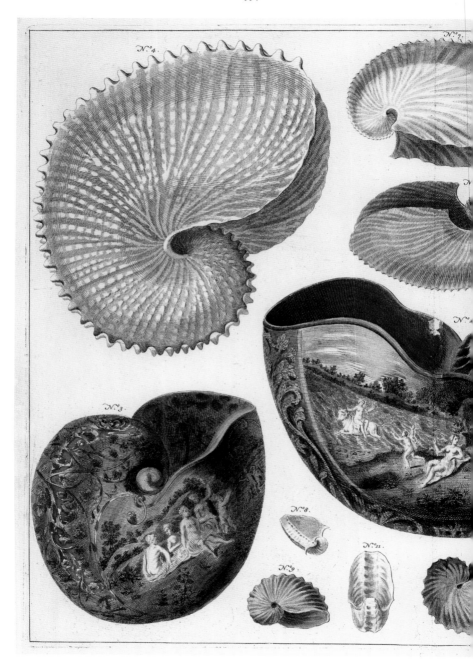

TAB. LXXXIV.

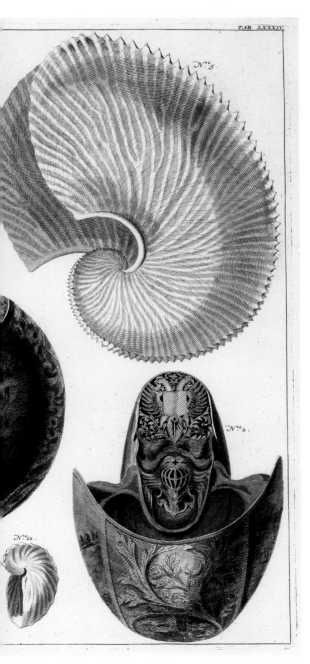

**1-3** Nautiloidea
**4-12** *Argonauta* **4** *Argonauta*
*nodosa* **5-6** *Argonauta argo*
**7** *Argonauta sp.*
**9-12** *Argonauta hians*
**1-3** Chambered nautilus∕
Pearly nautilus (etched) ·
Perlboote (graviert) ·
Nautiles (décorés et gravés)
**4-12** Paper nautilus ·
Papierboote · Argonautes

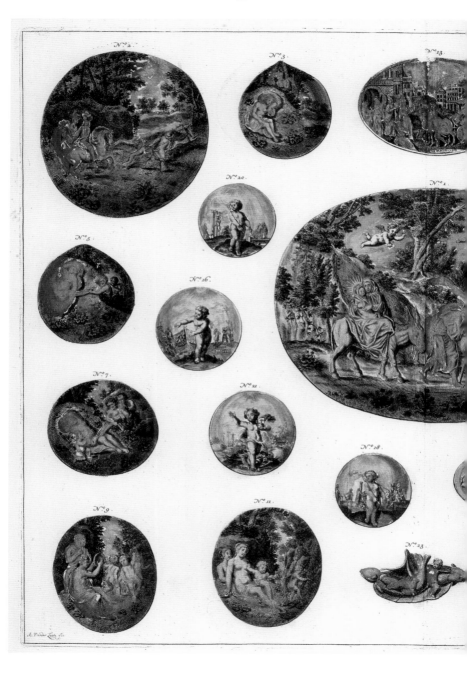

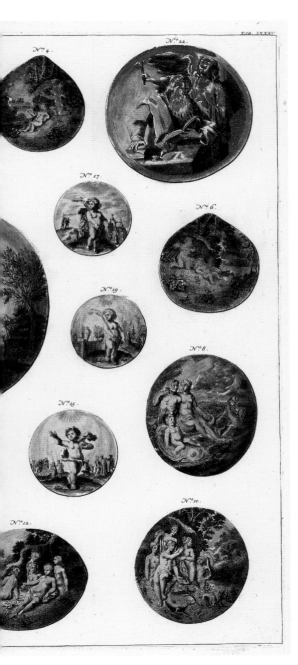

*Nautilus*
Drawings etched into the mother-
of-pearl plates of Nautilus ·
Ritzzeichnungen auf
Perlmuttplättchen von Nautilus ·
Dessins gravés dans de la nacre de
nautile

**1-7, 9-11** *Spondylus gaederopus* **8** *Chama macerophylla* **12** *Chama lazarus* **13** *Barbatia*
Thorny oysters, Lazarus jewel boxes and an ark shell from the West Atlantic, Mediterranean Sea and the Indo-Pacific · Stachelaustern, Lazarus-Schmuckkästchen und Archenmuschel aus dem Westatlantik, Mittelmeer und Indopazifik · Spondyles pieds d'âne, chames lazarus et ache barbue de l'Atlantique occidental, de la mer Méditerranée et de l'aire indopacifique

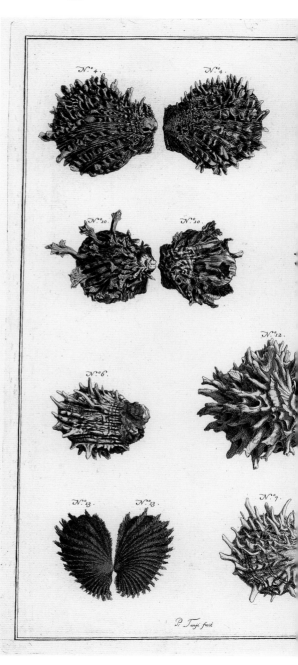

P. Tanjé fecit

TAB. LXXXVIII.

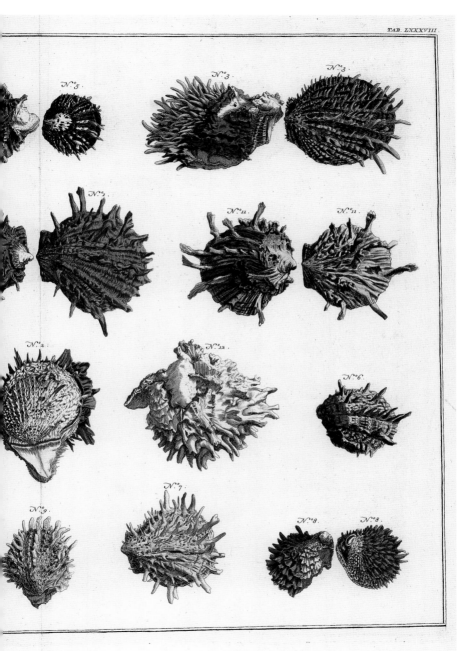

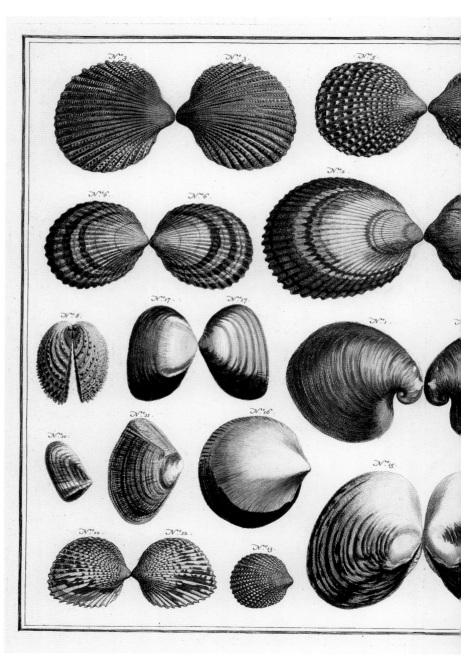

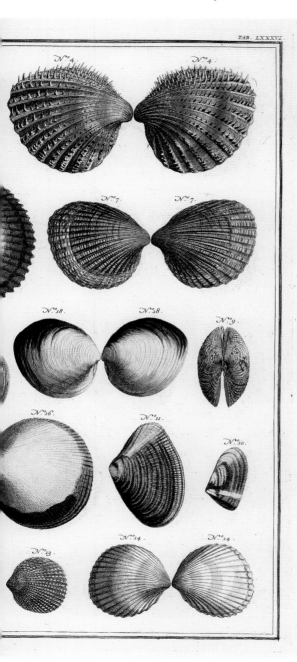

1 *Glossus humanus*
2, 6 *Trachycardium*
3, 13 *Acanthocardia echinata*
4-5, 8 *Acanthocardia aculeata*
7, 14 *Acanthocardia*
*tuberculata* 10-11 *Donax rugosus*
12 *Fragum unedo*
18 *Arctica islandica*
Ox heart, cockles, donax shells
and ocean quahog from the
Atlantic, Mediterranean Sea and
the Indo-Pacific ·
Ochsenherz, Herzmuscheln,
Donaxmuscheln und
Islandmuscheln aus dem
Atlantik, Mittelmeer und
Indopazifik · Cœur de bœuf,
coques ou cardiidés, donax et
cyprines nordiques de
l'Atlantique, de la mer
Méditerranée et de l'aire
indopacifique

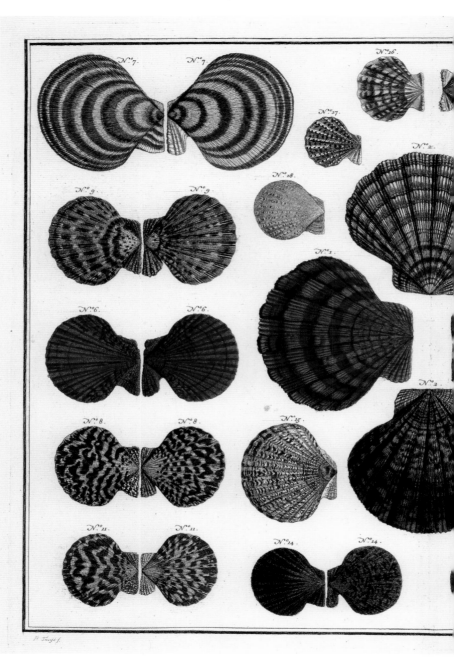

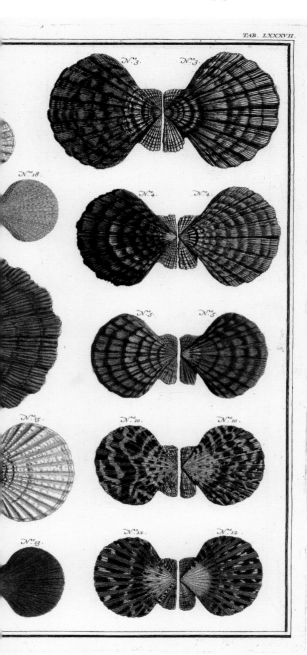

**1-5** *Lyropecten nodosa*
**7** *Chlamys* **8-12** *Cryptopecten*
*pallium* **13, 18** Pectinidae
Scallops from the
West Atlantic and the
Indo-Pacific ·
Kammmuscheln aus dem
Westatlantik und
Indopazifik ·
Peignes de l'Atlantique
occidental et de l'aire
indopacifique

1-4, 7-8 *Spondylus versicolor*
5 *Spondylus sinensis* 6, 9, 11 *Chama lazarus* 10 Anthozoa 12 *Chama*
Thorny oysters, Lazarus jewel boxes and a coral from the Indo-Pacific ·
Stachelaustern, Lazarus-Schmuckkästchen und eine Koralle aus dem Indopazifik ·
Spondyles pieds d'âne, chames lazarus et un corail de l'aire indopacifique

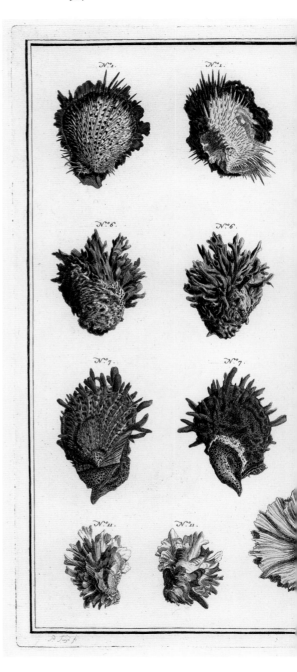

TAB. LXXXIX.

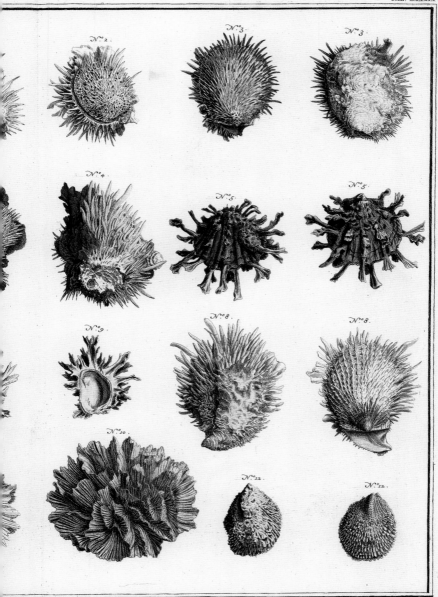

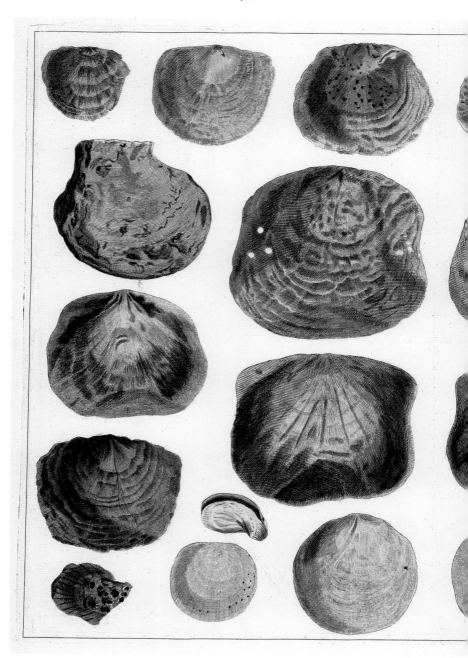

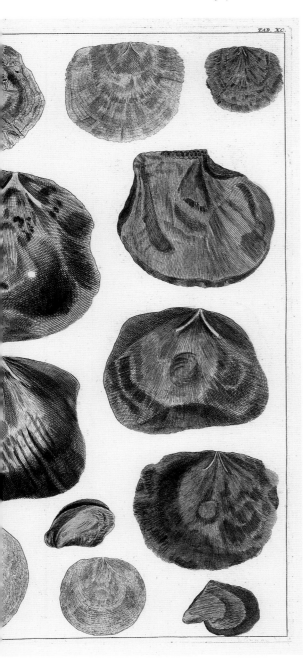

*Perna, Placuna sella, Placuna placenta, Anomia ephippium*
Mussels, oysters and European jingle shells from the Indo-Pacific, Atlantic and Mediterranean Sea · Muscheln, Austern und Europäische Sattelaustern aus dem Indopazifik, Atlantik und Mittelmeer · Coquillages, huîtres et anomie pelure d'oignon, de l'aire indopacifique, de l'Atlantique et de la mer Méditerranée

1 *Pinna nobilis* 2 *Atrina vexillum*
3 *Atrina rigida* 4-5 *Malleus*
*malleus* 6-8 *Isognomon isognomon*
Noble Pen shells and other pen
shells, hammer oysters and tree
oysters from the Mediterranean
Sea, Indo-Pacific and West
Atlantic · Steckmuscheln,
Hammermuscheln und
Flügelmuscheln aus dem
Mittelmeer, Indopazifik und
Westatlantik · Jambonneau
hérissé, malleus et autres huîtres
nacrées de la mer Méditerranée,
l'aire ndopacifique et de
l'Atlantique occidental

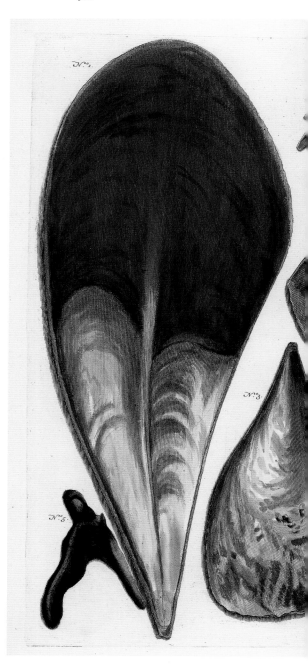

TAB. XCI.

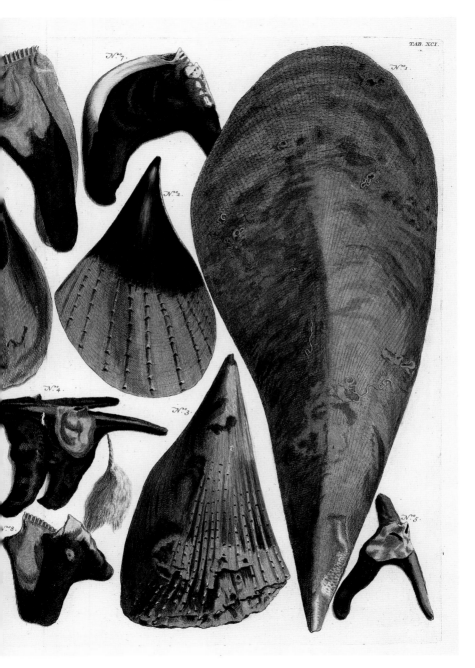

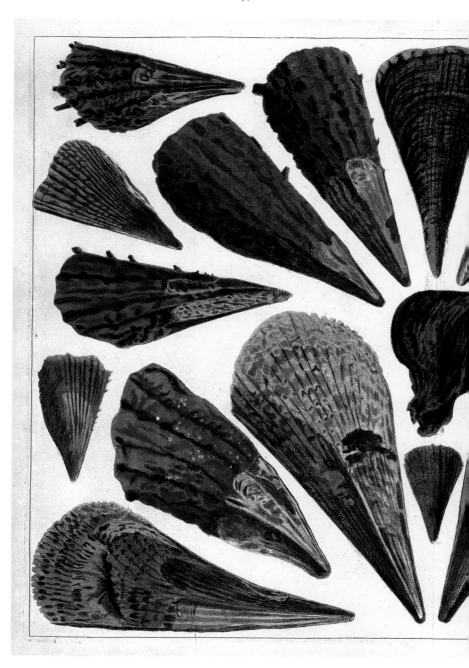

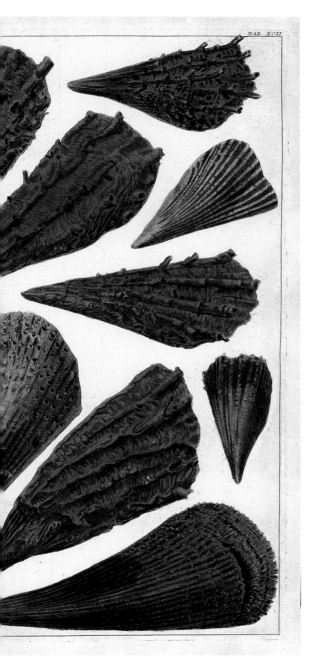

*Pinna muricata, Pinna rudis*
Prickly pen shells and rude pen shells from the Indian Ocean, Atlantic and Mediterranean Sea · Steckmuscheln aus dem Indischen Ozean, Atlantik und Mittelmeer · Pinnes de l'océan Indien, de l'Atlantique et de la mer Méditerranée

**1-2** *Malleus malleus* **3** *Neptunea* **4, 6-9** Serpulidae **5** *Planorbarius*
Common hammer oysters, neptune shell with barnacles, ramshorn snail, and sea worm tubes (Serpulidae
from the Indo-Pacific, the Atlantic and freshwater areas · Hammermuscheln, Neptunschnecke mit
Seepocken, Posthornschnecke und Wohnröhren von Borstenwürmern aus dem Indopazifik, Atlantik und
aus dem Süßwasser · Malleus/marteaux, buccins avec des balanes et des serpules, planorbes d'eau douce, et
tubes de vers serpulidés (chétopodes) de l'aire indopacifique, de l'Atlantique et de milieux dulcicoles

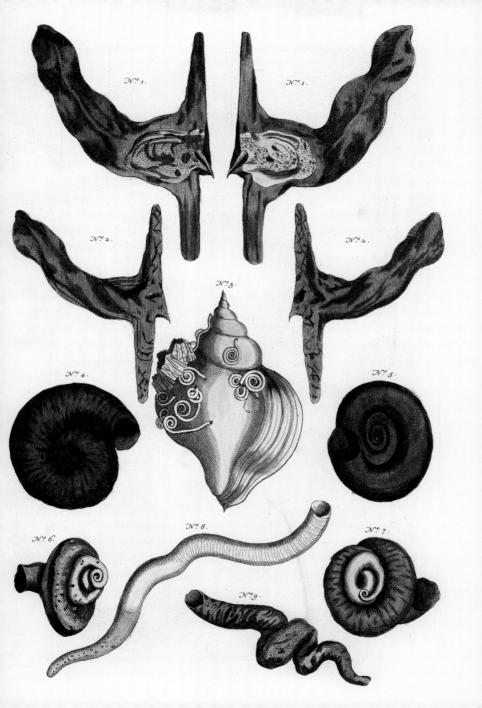

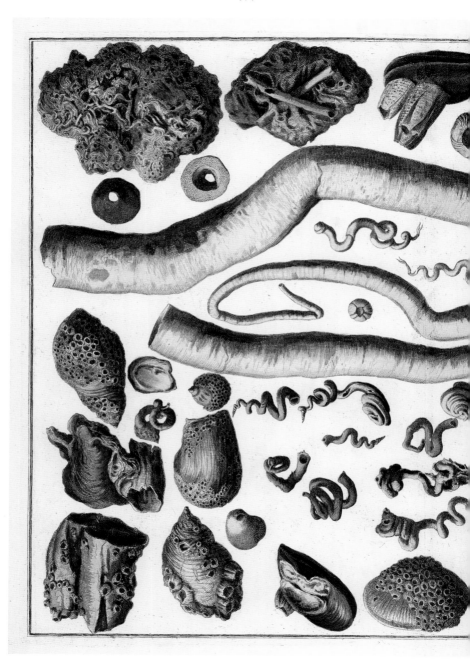

TAB. XCIV.

*Polychaeta, Cirripedia*
Sea worm tubes and barnacles on
stones and mollusc shells ·
Borstenwürmer und Seepocken
(Rankenfußkrebse) auf
Steinen, Muscheln und
Schneckengehäusen · Tubes de
vers marins (chétopodes)
et crustacés cirripèdes (balanes) sur
des pierres, des moules et d'autres
coquillages

1, 7 *Aplysina fistularis*
2, 4 *Rhipidogorgia flabellum*
3 *Isodictya* 8 *Phakellia*
*ventilabrum* 9 *Axinella cannabina*
1, 7 Yellow tube sponges ·
Neptunschwämme · Eponges
2, 4 Venus sea fans ·
Venusfächer · Corbeilles de
Vénus ou gorgone 3 Finger
sponge · Fingerschwamm ·
Eponge 8 Chalice sponge ·
Venusfächer · Corbeille de
Vénus ou gorgone 9 Staghorn
sponge · Höckriger
Geweihschwamm · Eponge

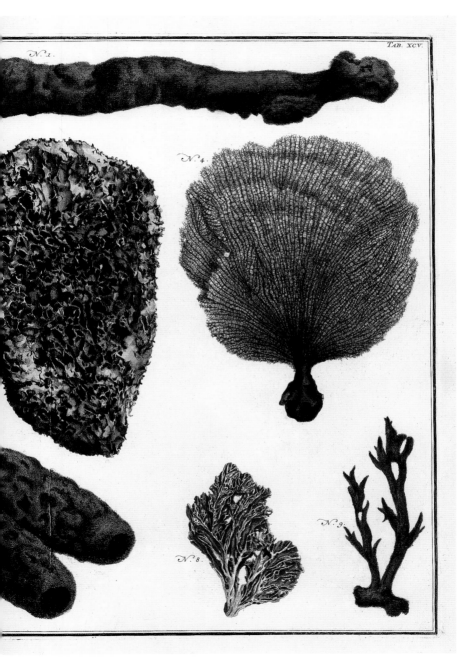

TAB. XCV.

**1** *Isodictya quatsinoensis* **2** *Axinella* **3** *Oceanapia* **4** Halichondria panicea **6** Flustra foliacea **1** Finger sponge · Fingerschwamm · Eponge **2** Staghorn sponge · Geweihschwamm · Eponge **3** Sponge oceanopia · Schwamm · Eponge **4** Breadcrumb sponge · Brotkrumenschwamm · Eponge mie de pain **6** Hornwrack · Blättermoostier · Bryozoaires foliacés

TAB. XCVI.

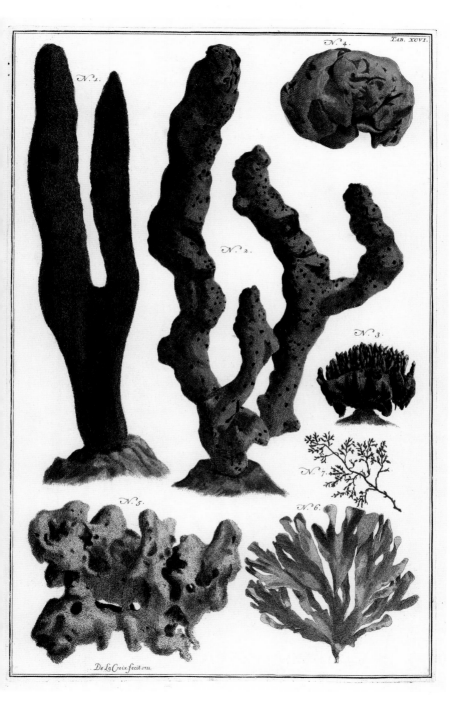

N. 1.
N. 4.
N. 2.
N. 3.
N. 7.
N. 5.
N. 6.

De La Croix fecit. 1722.

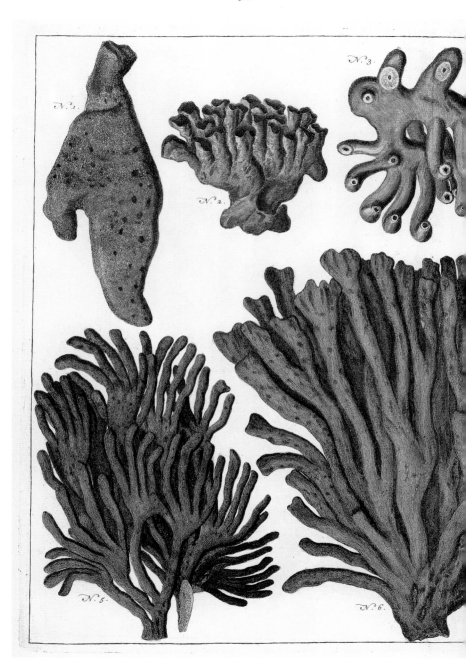

1 *Calyx* 2 *Zoanthus*
3 *Siphonochalina* 4 *Oscarella
lobularis* **5-7** *Haliclona oculata*
**1** Fan sponge · Schwamm ·
Eponge **2** Colonial anemone ·
Krustenanemone · Anémone
encroûtante **4** Flesh sponge ·
Fleischschwamm · Eponge
bleue **5-7** Eyed finger
sponges/Mermaid's gloves ·
Geweihschwamm ·
Chalines/Eponges pourpres

1-3 Plantae 4 *Alcyonidium gelatinosum* 5 *Porella compressa*
1-3 Sea plants · Meeresalgen ·
Plantes de la mer
4 Gelatinous bryozoan ·
Gallertmoostier · Bryozoaire
gélatineux 5 Moss animal ·
Korallenmoostier · Bryozoaire

*TAB. XCVIII.*

*N. 2.*

*N. 5.*

*TAB. XCIX.*

**1** *Porella compressa* **2** *Securiflustra securifrons* **3** *Halichondria panicea* **4** *Rosella fibulata* **5** *Turbinaria mesenterina* **7** Porife
**1** Moss animal · Korallenmoostier · Bryozoaire **2** Narrow-leaved hornwrack · Schmalblättriges Moostierche
Bryozoaire **3** Breadcrumb sponge · Brotkrumenschwamm · Eponge mie de pain **4** Pipe sponge/Chimney
sponge · Schwamm · Eponge **5** Lettuce coral · Salatkoralle · Tubinaire jaune **7** Sponge · Schwamm · Epong

*Tab. C.*

I, 16-19 Cnidaria 2, 9-10, 12 Bryozoa 8 *Filograna* 13-15 *Corallina officinalis* 17a, 18-19 *Thuiaria thuja* 17b *Ophioderma*
, II, 16-19 Cnidarians · Nesseltiere (Korallen) · Cnidaires 2, 9-10, 12 Moss animals · Moostiere · Bryozoaires
8 Sea worm · Röhrenwurm · Salmacine 13-15 Coral weeds · Korallenmoos · Algues 17b Serpent star ·
Schlangenstern · Ophiure 17a, 18-19 Bottle brushes · Flaschenputzer Hydroiden · Hydraires

1 Cnidaria 2 *Sertularia cupressina* 3 Plantae **5-6** *Sertella septentrionalis*
**8** *Corallium rubrum, Sertularella rugosum* **9** *Smittina cervicornis*
**1** Cnidarian · Nesseltier (Koralle) · Cnidaire **2** White weed · Zypressenmoos · Hydroïde **3** Sea plant ·
Meeresalge · Plante marine **5-6** Sea laces (Moss animals) · Neptunsschleier · Dentelles de Neptune
(Bryozoaires) **8** Precious coral with hydroids · Edelkoralle mit Hydroiden · Corail rouge et hydroïde
**9** Staghorn bryozoan · Hirschgeweihmoostierchen · Bryozoaire

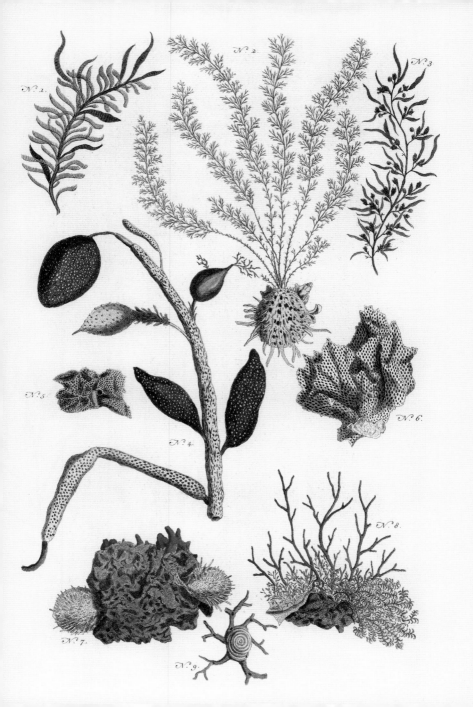

**3** *Amphisbetia operculata*
**4** *Sertularella spec.* **5** *Bugula neritina*
**3** Cnidarian · Nesseltier
(Koralle) · Cnidaire
**4** Hydroid · Hydroid ·
Hydroïde **5** Moss animal ·
Moostier · Bryozoaire

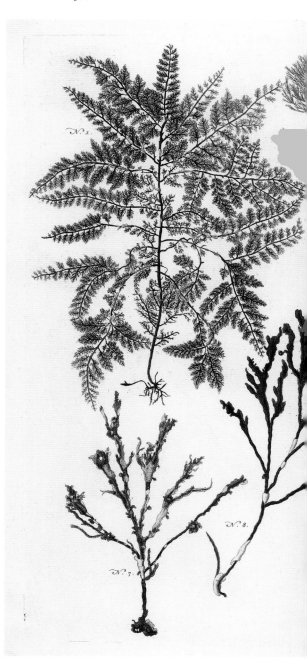

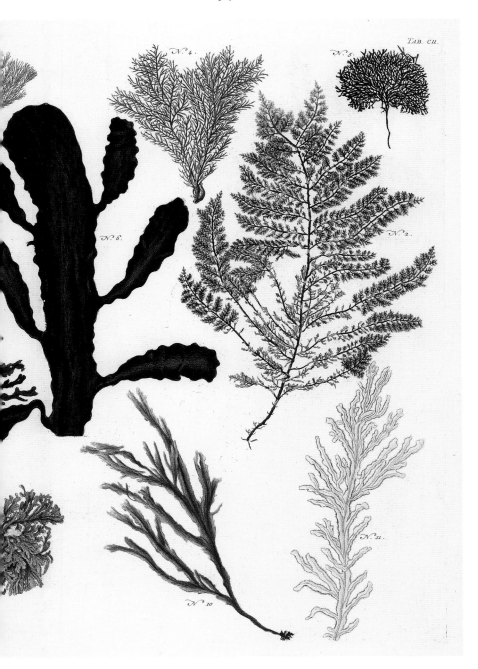

Tab. CII.

N.°4.

N.°5.

N.°6.

N.°2.

N.°11.

N.°10.

**6** *Sertularella gayi*
Sedentary sea organisms, mostly algae · Festsitzende Organismen aus dem Meer,
die meisten davon Algen · Organismes marins sédentaires, pour la plupart des algues
**6** Hydroid · Hydroid · Hydroïde

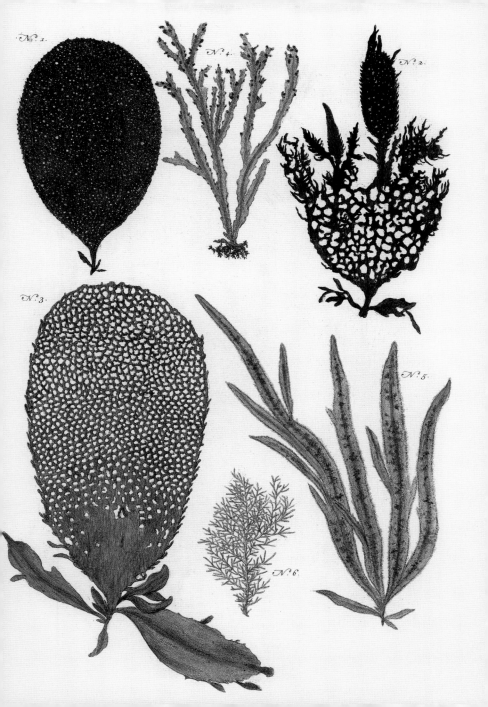

1-8 Cnidaria **1, 2** *Madrepora oculata* **3** *Lophelia prolifera* **4** *Favia* **5** *Acropora* **6** *Seriatopora aculecita*
**1-8** Cnidarians · Nesseltiere (Korallen) · Cnidaires
**1-2** Ocular corals · Augenkorallen · Coraux blancs
**4** Star coral · Sternkoralle · Corail étoile
**5** Staghorn coral · Geweihkoralle · Corail bois
**6** Needle coral · Nadelkoralle · Corail seriatopora

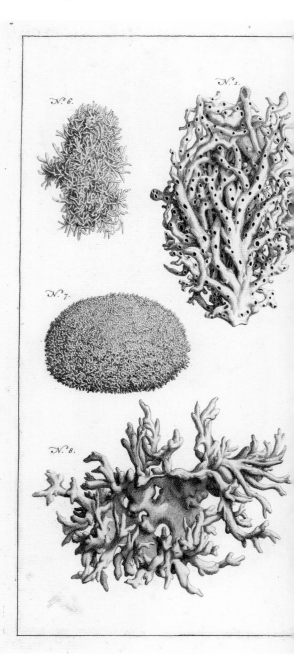

TAB. CXVI.

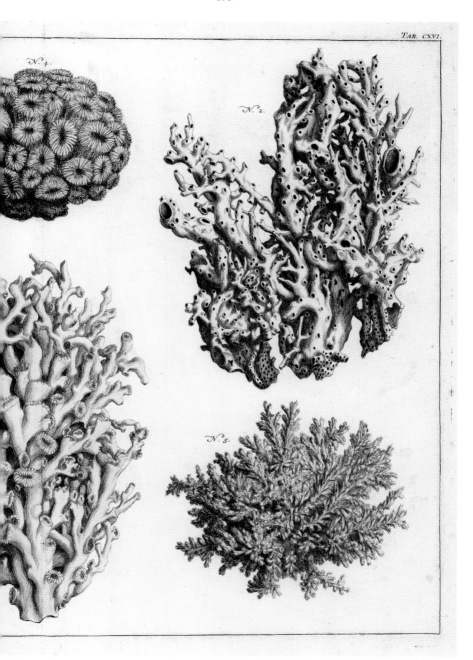

N. 4.

N. 2.

N. 3.

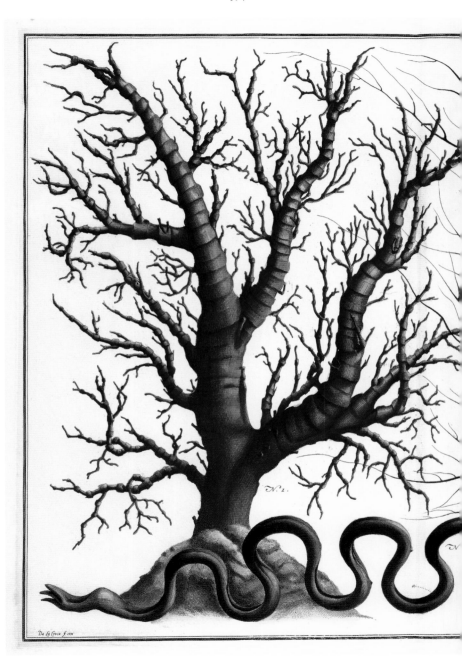

*N.1.*

*De La Croix f. 1771*

*TAB. CIV.*

1 *Dendronephythya* 2 *Antipathes*
1 Carnation coral · Rote
Lederkoralle · Corail mou
2 Black coral · Schwarze Gorgonie ·
Corail noir

TAB. CV.

N.º 3.

N.º 4.

**1-4** Cnidaria **1a** *Juncella &
Ellisella* **1b** *Eunicella*
**1-4** Cnidarians · Nesseltiere
(Korallen) · Cnidaires
**1a** Sea whip · Seepeitsche ·
Fouet de mer
**1b** Violescent sea whip · Rote
Gorgonie · Gorgone rouge

*Tab. CVI.*

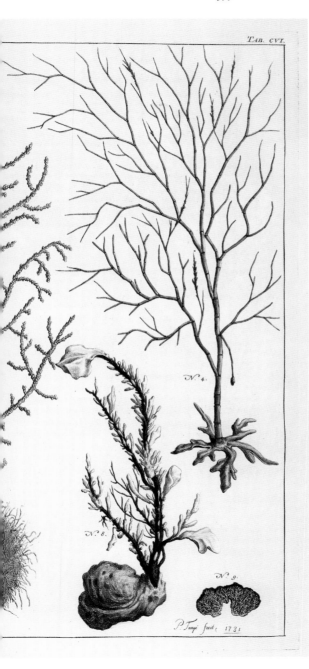

**1-4, 6-8** Cnidaria **1** Hydroida
**2** *Thuiaria thuja*
**3** *Eunicella verrucosa*
**4** *Rumphella*
**6** Cnidaria
**7** *Tubularia* **8** *Millepora alcicornis*
**1-4, 6-8** Cnidarians ·
Nesseltiere (Korallen) ·
Cnidaires **1** Hydroid ·
Hydroid · Hydroïde
**2** Bottlebrush hydroid ·
Flaschenbürstenmoos ·
Cnidaire hydroïde **3** Pink
sea fan · Warzenkoralle ·
Gorgone rosée
**4** Sea whip · Rumphella
Koralle · Gorgone
rumphella **6** Cnidarian with
a thorny oyster ·
Nesseltier (Koralle) mit
Stachelauster · Cnidaire avec
un mollusque spondyle
**7** Flower head ·
Röhrenpolyp · Tubulaire
**8** Fire coral · Feuerkoralle ·
Corail de feu

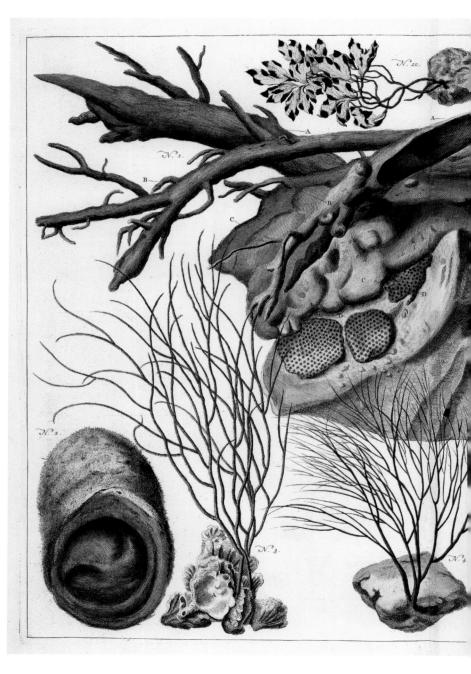

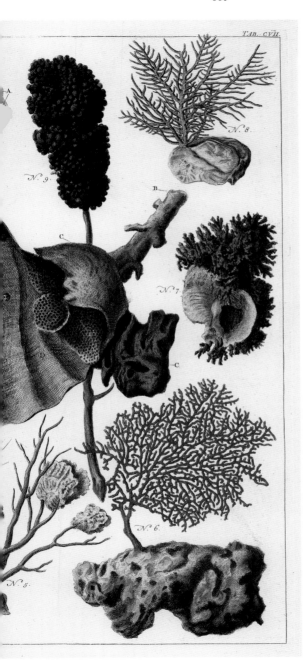

*TAB. CVII.*

**3-6, 8** Cnidaria **3** *Lophogorgia ceratophyta* **4** *Ellisella* **6** *Paramuricea clavata* **8** *Antipathes ulex* **9** *Caulerpa* **3-6, 8** Cnidarians · Nesseltiere (Korallen) · Cnidaires **3** Orange gorgonian · Orangerote Gorgonie · Gorgone orange **4** Sea whip · Seepeitsche · Fouet de mer **6** Violescent sea whip · Rote Gorgonie · Gorgone rouge **8** Feathery black coral · Schwarze Koralle · Corail noir **9** Caulerpa · Caulerpa · Caulerpa

2-**11** Cnidaria
**2**, **4** Sarcophyton
**3**, **5** *Trachyphyllia*
**6** *Pocillopora damicornis*
**8** *Seriatopora aculecita*
**9** *Astroides* **10** Cnidaria
**11** *Gorgonia*
**2-11** Cnidarians ·
Nesseltiere (Korallen) ·
Cnidaires **2**, **4** Toadstools ·
Pilzlederkorallen ·
Corail cuir **3**, **5** Open brain
corals · Wulstkorallen ·
Trachyphyllidés/coraux
cerveaux **6** Raspberry
coral · Himbeerkoralle ·
Corail *Pocillopora damicornis*
**8** Needle coral ·
Nadelkoralle ·
Corail seriatopora
**9** Cup coral · Kelchkoralle ·
Corail stelliforme
**10** Cnidarian · Nesseltier
(Koralle) · Cnidaire
**11** Gorgonian · Gorgonie ·
Gorgone

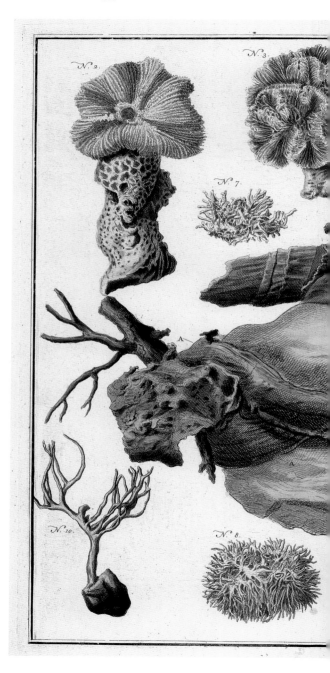

TAB. CVIII.

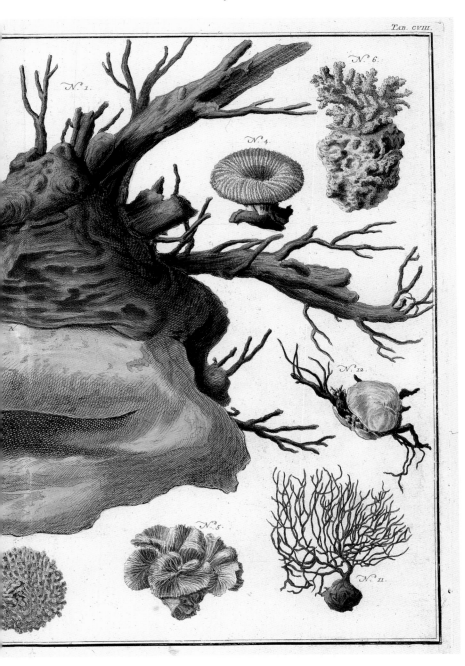

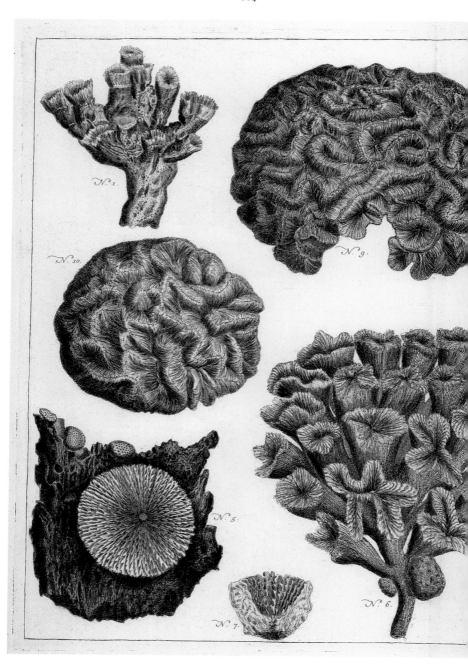

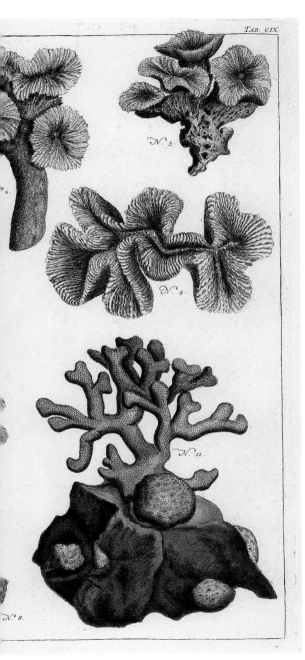

*Tab. CIX.*

**1-11** Cnidaria **1** *Eusmilia fastigiata* **2-3** *Mussa angulosa* **4** *Lobophyllia* **5** *Fungia* **6** *Lobophyllia hemprichii* **9-10** *Colpophyllia* **11** *Porites porites* **1-11** Cnidarians · Nesseltiere (Korallen) · Cnidaires **1** Smooth flower coral · Glatte Blumenkoralle · Corail fleur **2-3** Large flower corals · Atlantische dickstielige Doldenkorallen · Corail fleur **4** Open brain coral · Wulstkoralle · Corail cerveau **5** Plate coral · Pilzkoralle · Corail champignon **6** Brain coral · Doldenkoralle · Corail cerveau **9-10** Brain corals · Hirnkorallen · Coraux cerveaux **11** Finger coral · Fingerkoralle · Corail doigt

**1-10** Cnidaria
**1-2** *Isis hippuris*
**3** *Eusmilia fastigiata*
**6** *Agaricia agaricites & Fungia*
**7** *Millepora platyphylla*
**8-9** *Tubipora musica*
**1-10** Cnidarians · Nesseltiere
(Korallen) · Cnidaires
**1-2** Golden sea fans · Goldene
Seefächer/ Königs-
gliederkorallen · Coraux dorés
**3** Smooth flower coral · Glatte
Blumenkoralle · Corail fleur
**6** Lettuce coral & plate corals ·
Salatkoralle & Pilzkorallen ·
Tubinaire jaune & coraux
champignons **7** Fire coral ·
Brettartige Feuerkoralle ·
Corail feu en plaque
**8-9** Organ pipe corals ·
Orgelkorallen · Tubipore ou
orgue de mer

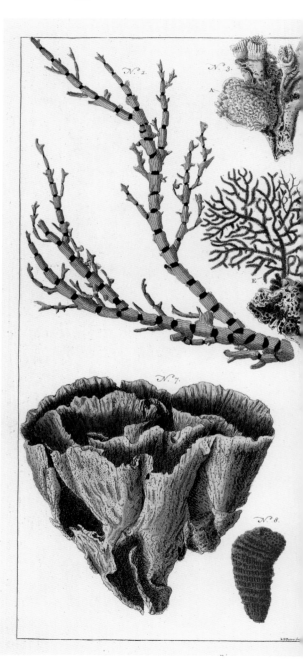

TAB. CX.

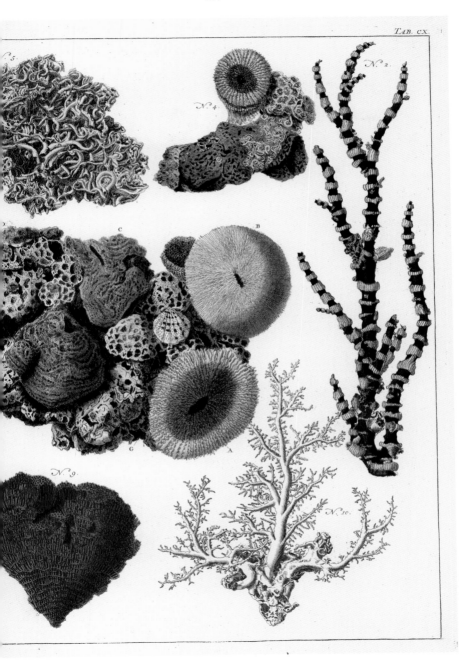

1-9 Fungiidae 1-2, 9 *Fungia*
3-6 *Herpolitha limax*
7-8 *Isophyllia sinuosa*
1-9 Plate corals · Pilzkorallen ·
Fungias/Coraux champignon
3-6 Tongue corals/Slipper
corals · Pantoffelkorallen ·
Coraux pommes de terre
7-8 Sinous cactus corals ·
Gewellte Kaktuskorallen ·
Coraux cactus

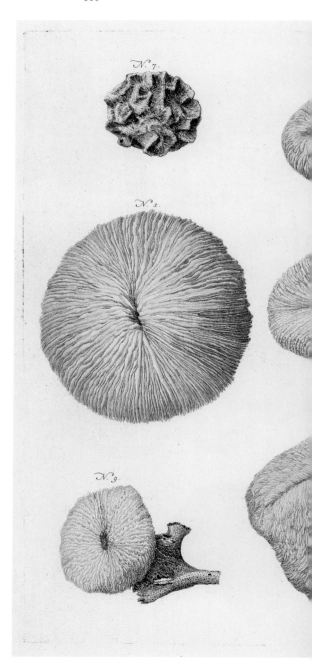

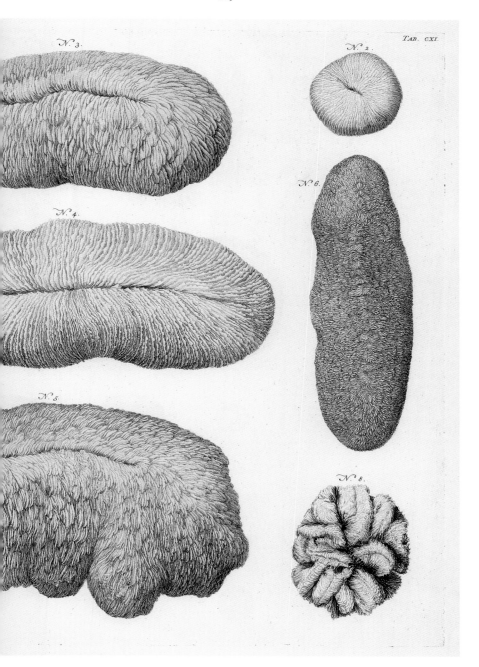

TAB. CXI.

1-30 Cnidaria
1, 4-8, 10-11, 13, 15-16,
18, 20-22 Faviidae
2-3 Meandrinidae
9, 12, 14, 17, 19 Acroporidae
23-27 Pectiniidae 28-30
Fungiidae 31 Plathelminthes
1-30 Cnidarians · Nesseltiere
(Korallen) · Cnidaires
1, 4-8, 10-11, 13, 15-16, 18, 20-22
Brain corals · Hirnkorallen ·
Coraux cerveaux 2-3 Maze brain
corals · Hirnkorallen ·
Coraux cerveaux
9, 12, 14, 17, 19 Staghorn corals ·
Geweihkorallen · Coraux
bois 23-27 Hibiscus corals ·
Faltensteinkorallen · Coraux
hibiscus 28-30 Plate corals ·
Pilzkorallen · Coraux
champignons 31 Flat worms ·
Plattwürmer · Vers plats

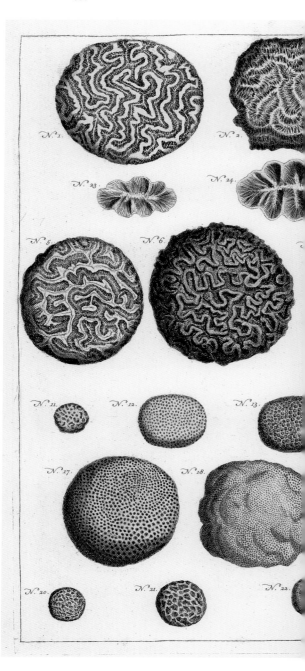

TAB. CXII.

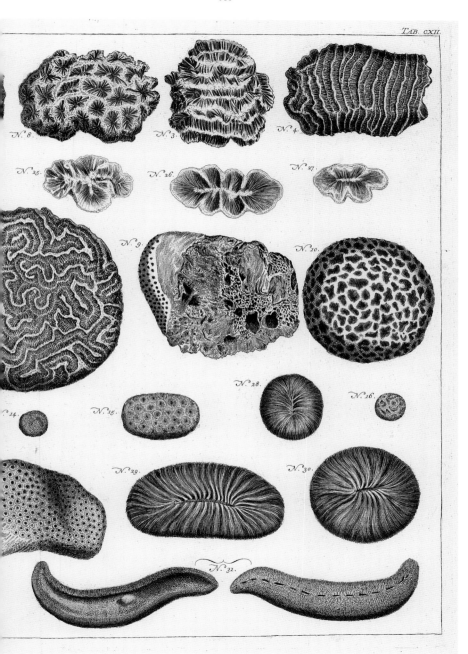

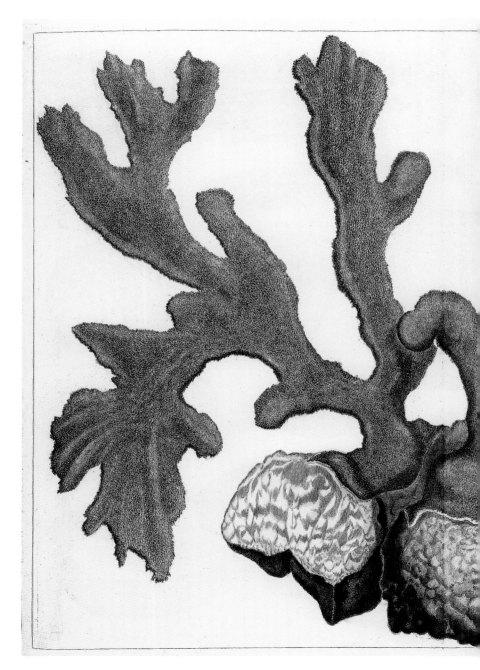

*TAB. CXIII.*

*Acropora palmata*
Elkhorn coral ·
Elchgeweihkoralle · Corail de
bois caribou

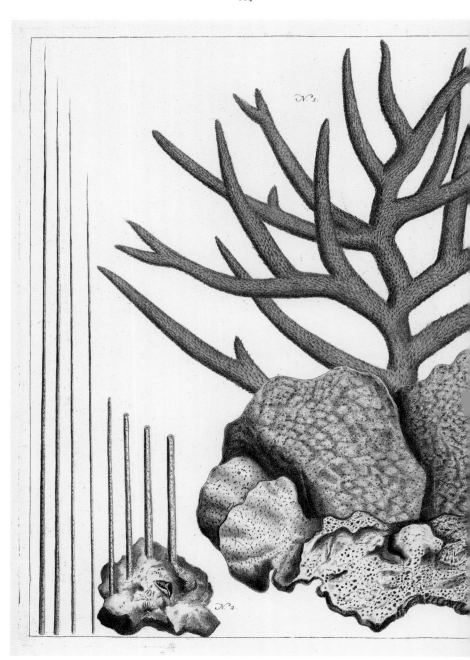

N.1.

N.2.

TAB. CXIV

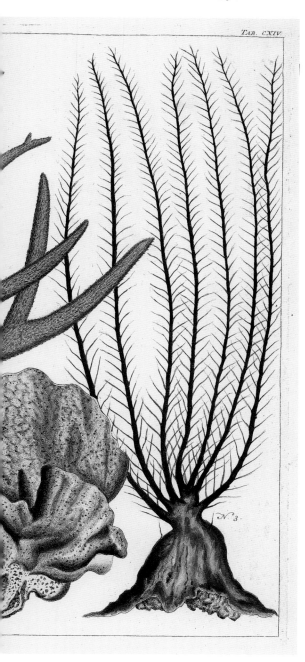

**1-2** Cnidaria **1** *Acropora*
**3** *Antedon mediterranea*
**1-2** Cnidarians · Nesseltiere
(Korallen) · Cnidaires
**1** Staghorn coral ·
Geweihkoralle · Corail bois
**3** Mediterranean feather star ·
Mittelmeerhaarstern · Lys de
mer de Méditerrannée

*N. 3.*

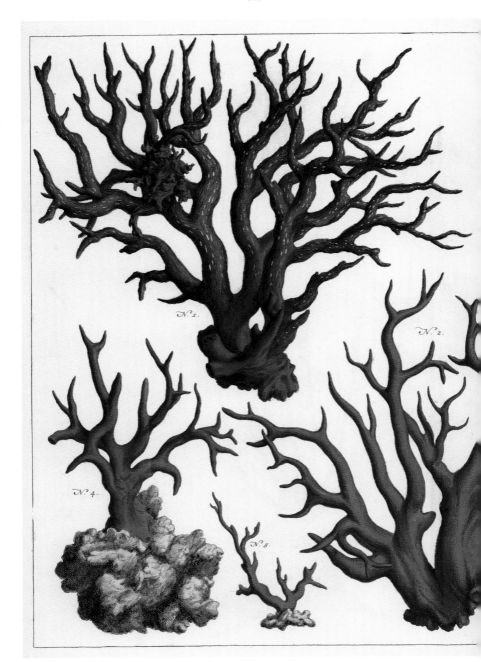

TAB. CXV.

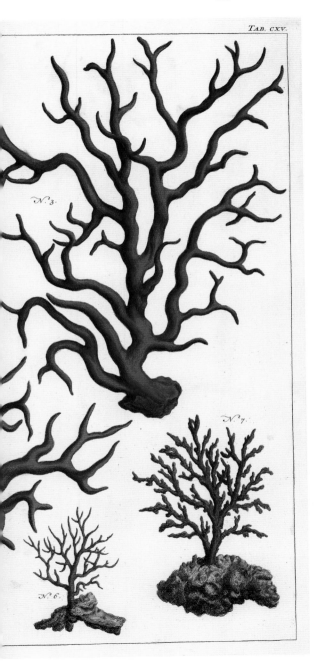

N.° 3.

N.° 7.

N.° 6.

**1-7** *Corallium rubrum*
**1-7** Precious corals ·
Edelkorallen · Coraux rouges

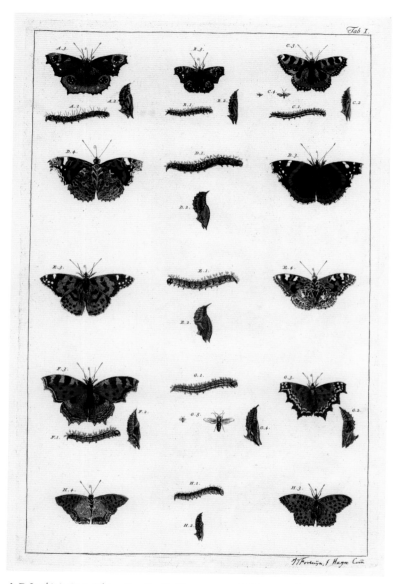

Tab I.

A-B *Inachis io* **C1-3** *Aglais urticae* **C4, G5** Hymenoptera **D** *Vanessa atalanta* **E** *Vanessa cardui*
**F** *Nymphalis polychloros* **G1-4** *Polygonia c–album* **H** *Issoria lathonia*

**A-B** Peacocks · Tagpfauenaugen · Paons de jour **C1-3** Small tortoiseshell · Kleiner Fuchs · Petite tortue
**D** Red admiral · Admiral · Vulcain **C4, G5** Wasps and bees · Hautflügler · Hyménoptères **E** Painted lady ·
Distelfalter · Belle-dame **F** Large tortoiseshell · Großer Fuchs · Grande tortue **G1-4** Comma butterfly ·
C-Falter · Robert-le-diable **H** Queen of Spain fritillary · Perlmuttfalter · Petit nacré

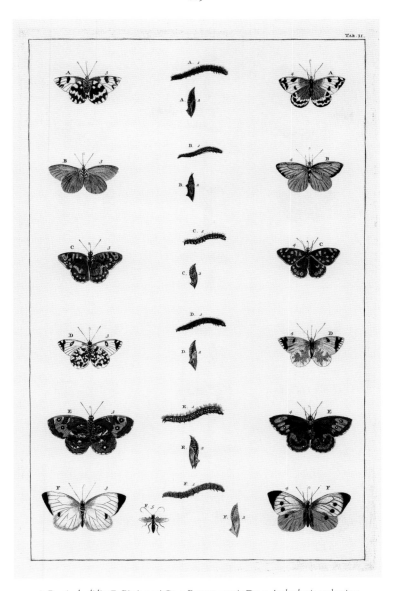

TAB. II.

**A** *Pontia daplidice* **B** *Pieris napi* **C3-4** *Pararge aegeria* **D3-4** *Anthocharis cardamines*
**E** *Hipparchia semele* **F1-4** *Pieris brassicae* **F5** Ichneumonoidea

**A** Bath white · Resedaweißling · Marbré de vert **B** Green-veined white · Heckenweißling · Piéride du navet **C3-4** Specled wood · Laubfalter · Tircis **D3-4** Orange tip · Aurorafalter · Aurore printanière **E3-4** Rock grayling · Rostbinde · Agreste **F1-4** Large white · Großer Kohlweißling · Piéride du chou **F5** Ichneumon wasp · Schlupfwespe · Ichneumon

TAB. III.

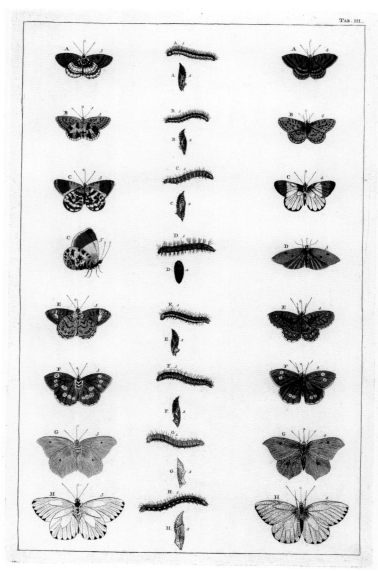

A *Euphydryas maturna* B Nymphalidae **C3-5** *Anthocharis cardamines* D *Lithosia quadra*
**E3-4** Satyridae **F3-4** *Erebia ligea* **G3-4** *Gonepteryx rhamni* H *Aporia crataegi*
**A** Scarce fritillary · Eschenscheckenfalter · Damier du frêne **B** Brush-footed butterfly · Fleckenfalter ·
Nymphalidé **C3-5** Orange tip · Aurorafalter · Aurore printanière **D** Large footman · Mittelwald-Flechtenbär ·
Lithosie quadrille **E3-4** Brown · Augenfalter · Satyridé **F3-4** Arran brown · Milchfleck · Grand nègre hongroi
**G3-4** Common brimstone · Zitronenfalter · Citron **H** Black-veined white · Baumweißling · Gazé

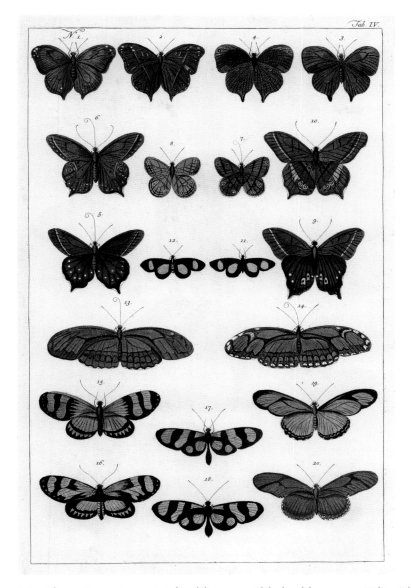

**1-4, 7-8** Satyridae **3-4** *Bia actorion* **9-10** *Antirrhea philoctetes* **13-14** *Philaethria dido* **11-12, 15-20** Heliconiidae
Butterflies from tropical America · Tagfalter aus dem tropischen Amerika ·
Papillons diurnes d'Amérique tropicale

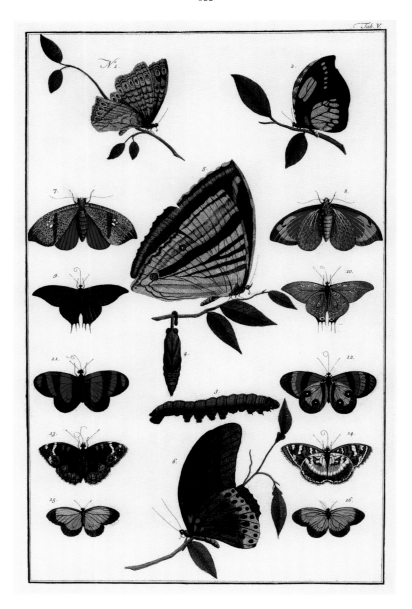

5 *Amathusia phidippus* 6 *Papilio memnon* **9-10** *Pseudolycaena marsyas* **11-12** Satyridae **13-14** *Junonia orithya*
Butterflies from America, Africa, Arabia and the region encompassing South-East Asia to North Australia
Tagfalter aus Amerika, Afrika, Arabien und von Südostasien bis nach Nordaustralien ·
Papillons diurnes d'Amérique, d'Afrique, d'Arabie et de la zone Asie du Sud-Est – Australie du Nord

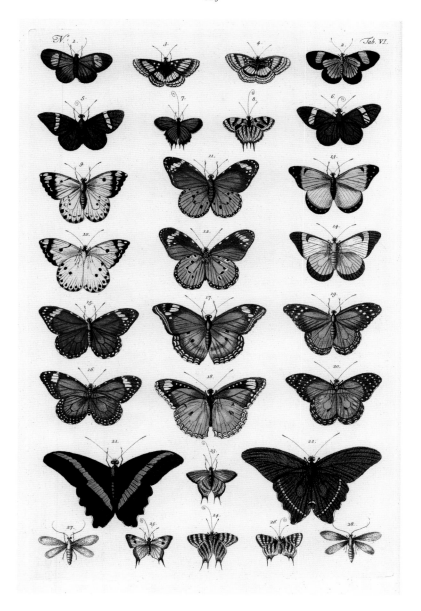

1-2 *Actinote* 7-8, 23-26 Theclinae 9-10 *Belenois calypso* 11-12 *Danaus chrysippus* 13-14 Pieridae
15-16 *Danaus plexippus* 17-18 *Hypolimnas misippus* 19-20 Danaidae 21-22 *Papilio nireus* 27-28 Trichoptera
tropical butterflies distributed worldwide and caddis flies · Tropische Tagfalter mit weltweiter Verbreitung
und Köcherfliegen · Papillons diurnes tropicaux répandus dans le monde entier et trichoptères

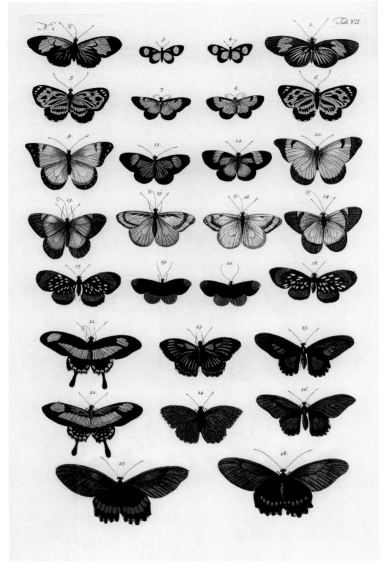

1-2 Papilionoidea **5-6** *Stalachtis calliope* **9-10, 13-16** Pieridae **17-18** *Stalachtis euterpe*
**21-22** *Papilio torquatus* **23-24** *Elymnias hypermnestra* **25-26** *Parides aeneas* **27-28** *Parides anchises*
Butterflies from South America and South-East Asia · Tagfalter aus Südamerika und Südostasien ·
Papillons diurnes d'Amérique du Sud et d'Asie du Sud-Est

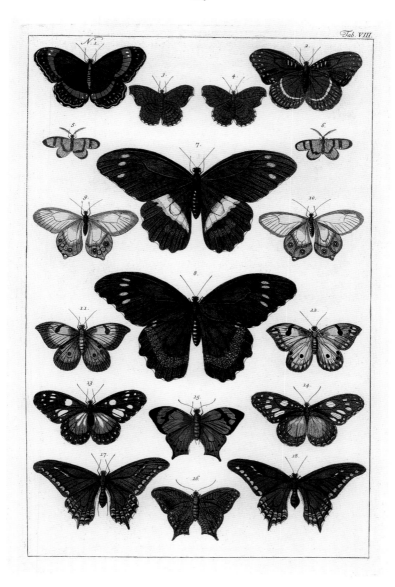

**1-2** *Hypolimnas alimena* **7-8** *Papilio gambrisius* **9-10** *Haetera piera* **15-16** Nymphalidae **17-18** *Papilio*
Butterflies distributed variously from South America, the region encompassing the Malay Archipelago and New Guinea to Australia, and worldwide · Tagfalter aus Südamerika, vom Malaiischen Archipel und Neuguinea bis nach Australien und mit weltweiter Verbreitung · Papillons diurnes originaires l'Amérique du Sud, de la zone de l'Archipel indomalais et de Nouvelle-Guinée – Australie, et répandus dans le monde entier

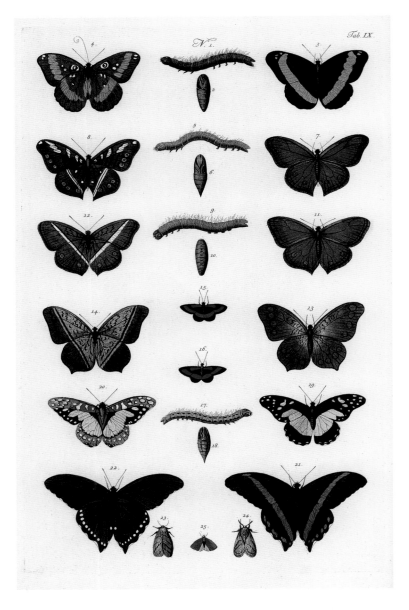

**3-4** *Lexias aeropa* **21-22** *Papilio nireus*
Butterflies from the Malay Archipelago and New Guinea ·
Tagfalter aus dem Malaiischen Archipel und Neuguinea ·
Papillons diurnes de l'Archipel indomalais et de Nouvelle-Guinée

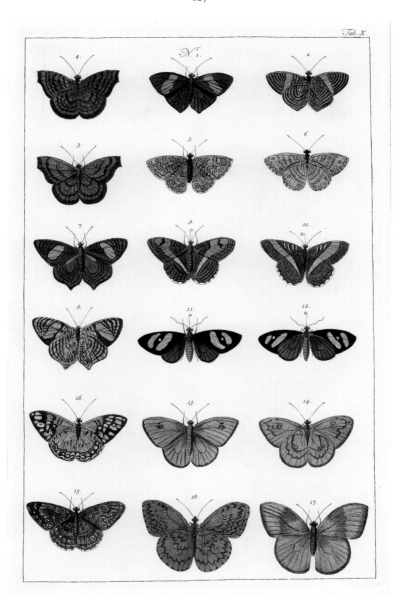

*7-8* Colobura dirce **11-12** *Heliconius* **13-14, 17-18** *Phoebis sennae*
Butterflies from tropical America ·
Tagfalter aus dem tropischen Amerika ·
Papillons diurnes d'Amérique tropicale

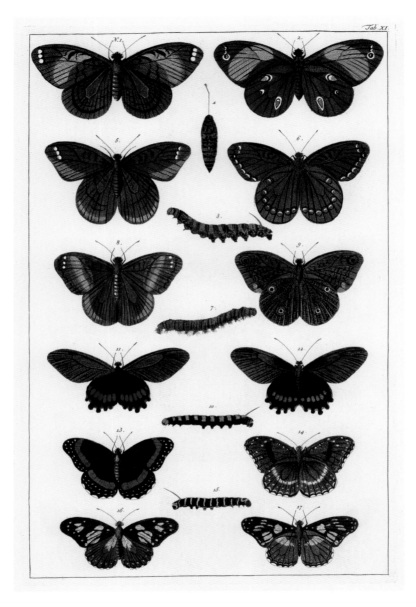

*Tab. XI.*

**1-2** *Brassolis sophorae* **3-9** Nymphalidae **11-12** *Parides anchises* **13-14** *Hypolimnas alimena* **16-17** Papilionoidea
Butterflies from South America and the region encompassing the Malay Archipelago and New Guinea to
Australia · Tagfalter aus Südamerika und vom Malaiischen Archipel und Neuguinea bis nach Australien ·
Papillons diurnes d'Amérique du Sud et de la zone de l'Archipel indomalais et de Nouvelle-Guinée – Austral

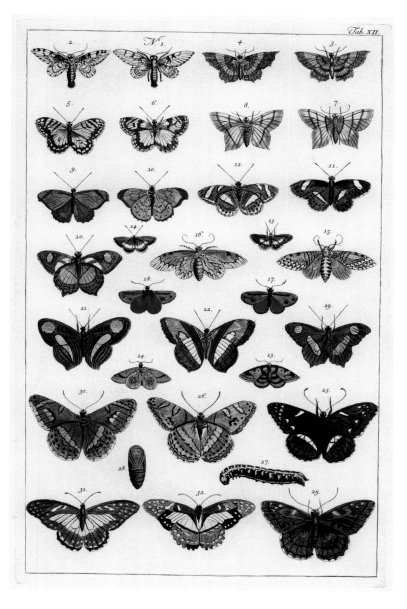

**15-16** Sphingidae **17-18** Zygaenidae **19-20** *Pyrrhogyra neaerea* **25-30** *Limenitis populi* **31-32** Nymphalidae
Butterflies and hawkmoths from Europe and tropical Central and South America ·
Tagfalter und Schwärmer aus Europa und dem tropischen Mittel- und Südamerika ·
Papillons diurnes et sphinx d'Europe et des zones tropicales d'Amérique Centrale et du Sud

*Tab. XIII.*

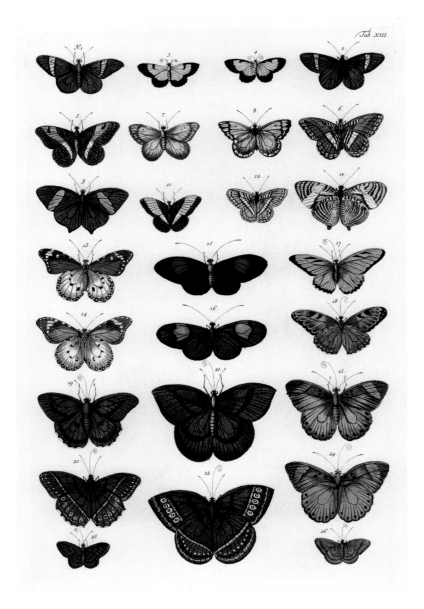

1-2 Brassolinae 5-6 *Adelpha* 9-10 *Colobura dirce* 11-12 *Adelpha cytherea* 13-14 *Danaus chrysippus*
15-16 *Heliconius melpomene* 19-20 Satyridae 21-21 *Euptychia* 25-26 *Emesis lucinda*
Butterflies from the tropics of America and the Caribbean · Tagfalter aus den Tropen Amerikas
und der Karibik · Papillons diurnes des zones tropicales d'Amérique et des Caraïbes

Tab. XIV.

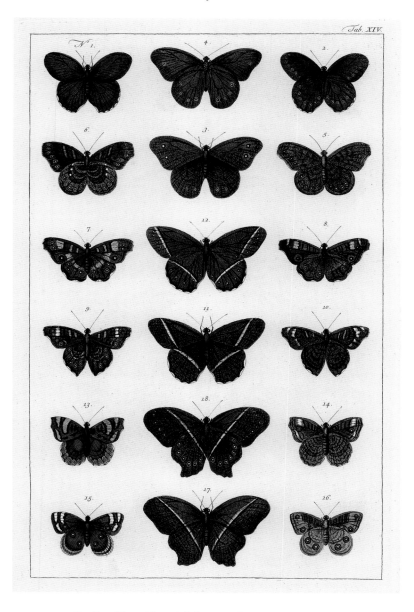

1-4 Papilionoidea **5-6** *Junonia hedonia* **13-14** *Junonia* **15-16** *Junonia oenone*
Tropical butterflies distributed worldwide ·
Tropische Tagfalter mit weltweiter Verbreitung ·
Papillons diurnes tropicaux répandus dans le monde entier

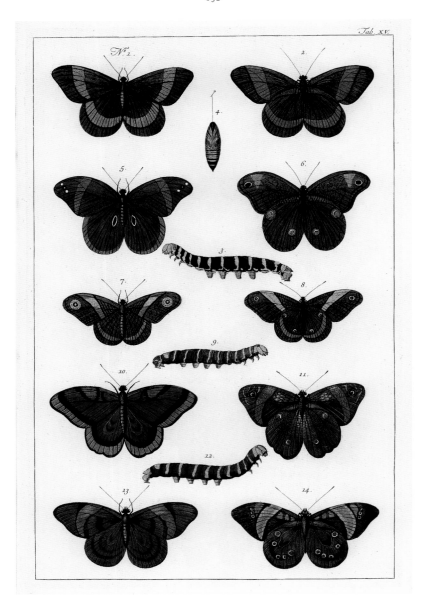

**5-6** Brassolinae **10-11** Nymphalidae **13-14** *Brassolis sophorae*
Butterflies from tropical Central and South America and the Indo-Australian faunal region · Tagfalter
aus dem tropischen Mittel- und Südamerika und dem indo-australischen Faunengebiet · Papillons diurne
des zones tropicales d'Amérique Centrale et du Sud, et de la région faunique indo-australienne

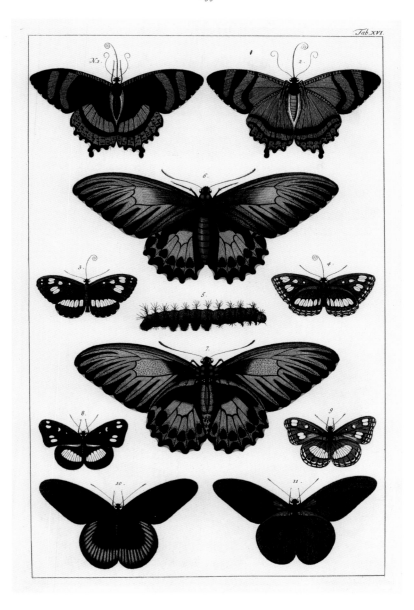

*Tab.XVI*

**1-2** *Papilio* **3-4, 8-9** *Pantoporia venilia* **6-7** *Troides oblongomaculatus* **10-11** *Euploea*
Butterflies from the Malay Archipelago and New Guinea to Australia ·
Tagfalter vom Malaiischen Archipel und Neuguinea bis nach Australien ·
Papillons diurnes de la zone de l'Archipel indomalais et de Nouvelle-Guinée – Australie

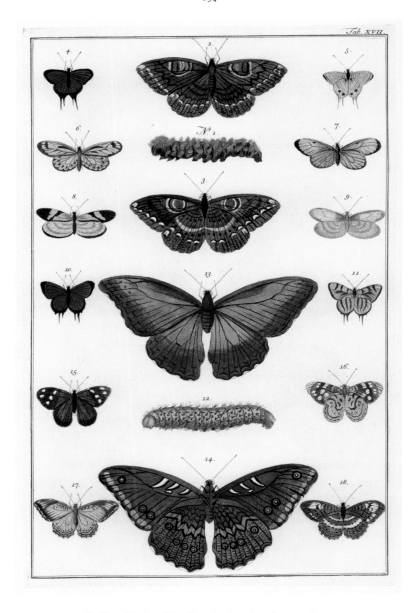

*Tab. XVII.*

1-3 Papilionoidea? **4-5** Theclinae **8-9** *Enantia melite* **10-11** *Arawacus*
**13-14** *Morpho telemachus* **15-16** *Eunica orphise*
Butterflies from tropical Central and South America · Tagfalter aus dem tropischen Mittel-
und Südamerika · Papillons diurnes des zones tropicales d'Amérique Centrale et du Sud

Tab. XVIII.

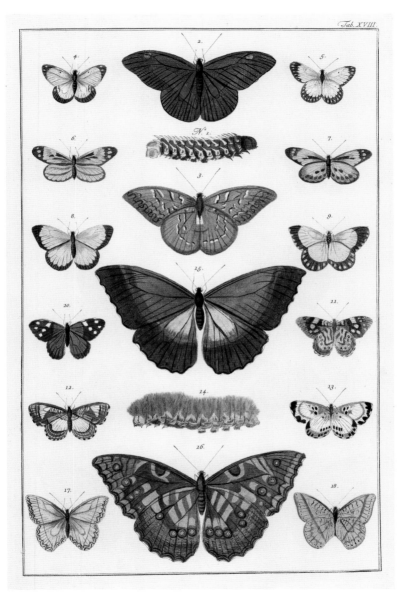

**2-3** *Archaeoprepona demophon* **4-5** *Colias* **6-7** *Heliconius hecale*
**8-9** *Colias palaeno* **10-11** *Eunica orphise* **15-16** *Morpho telemachus*
Butterflies distributed worldwide · Tagfalter mit weltweiter Verbreitung ·
Papillons diurnes répandus dans le monde entier

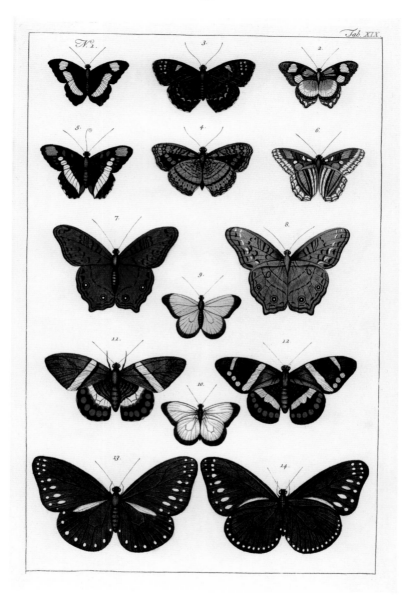

Tab. XIX.

**1-2** *Pyrrhogyra neaerea* **7-8** *Vindula arsinoe* **9-10** *Colias* **11-12** *Aeropetes tulbaghia* **13-14** *Euploea midamus*
Butterflies distributed worldwide ·
Tagfalter mit weltweiter Verbreitung ·
Papillons diurnes répandus dans le monde entier

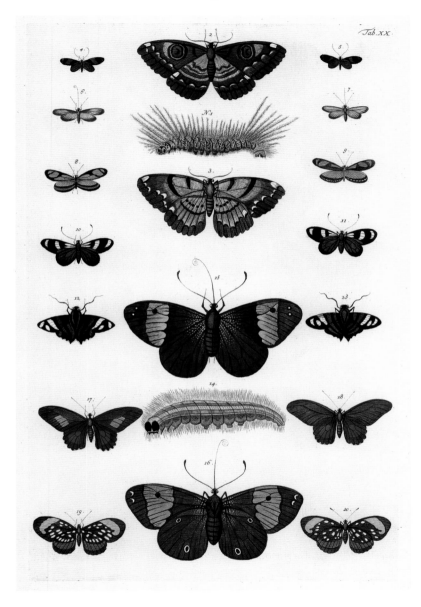

**8-9** Riodininae **12-13** *Jemadia gnetus* **15-16** *Brassolis sophorae* **17-18** *Parides aeneas* **19-20** *Stalachtis euterpe*
Butterflies from tropical South America ·
Tagfalter aus dem tropischen Südamerika ·
Papillons diurnes des zones tropicales d'Amérique du Sud

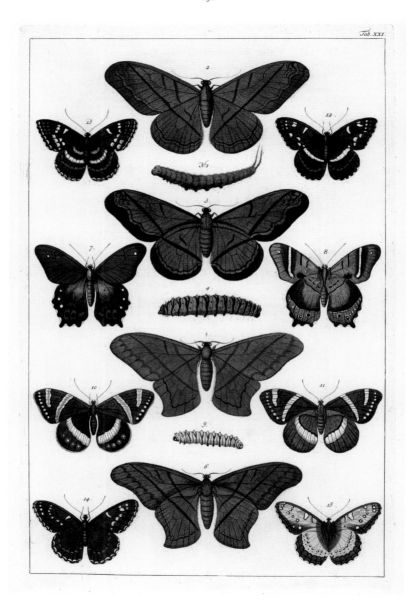

*Tab. XXI.*

**1-3, 5-6** *Arsenura sp.* **7-8** *Antirrhea philoctetes* **12-15** *Limenitis populi*
Butterflies and moths from South America and Eurasia ·
Tag- und Nachtfalter aus Südamerika und Eurasien ·
Papillons diurnes et nocturnes d'Amérique du Sud et d'Eurasie

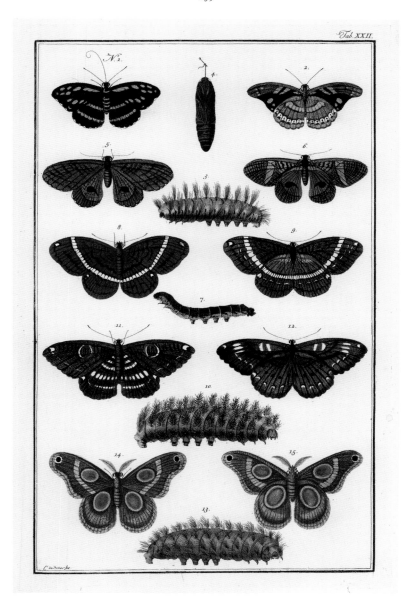

*Tab. XXII.*

**1-2** *Lexias* **14-15** *Rothschildia prionia*
Butterflies from Indonesia and New Guinea and silkmoths from Central and South America ·
Tagfalter aus Indonesien und Neuguinea sowie Augenspinner aus Mittel- und Südamerika ·
Papillons diurnes d'Indonésie et de Nouvelle-Guinée ainsi que saturniidés d'Amérique Centrale et du Sud

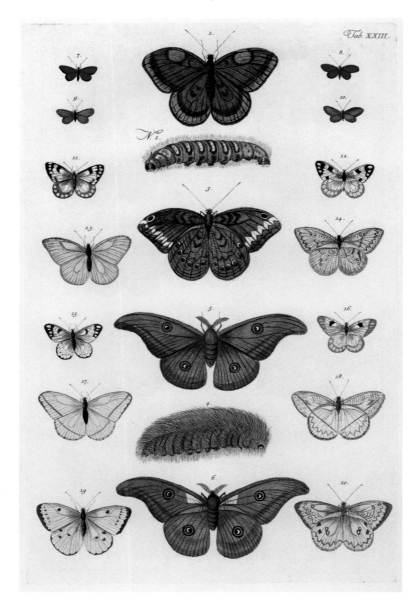

Tab. XXIII.

**5-6** *Antheraea helferi* **11-12, 15-16** *Pontia daplidice* **13-14, 19-20** *Phoebis sennae* **17-18** *Phoebis trite*
Butterflies from Europe, America and North Africa and silkmoths from South-East Asia ·
Tagfalter aus Europa, Amerika und Nordafrika sowie Augenspinner aus Südostasien ·
Papillons diurnes d'Europe, d'Amérique et d'Afrique du Nord ainsi que saturniidés d'Asie du Sud-Est

Tab. XXIV

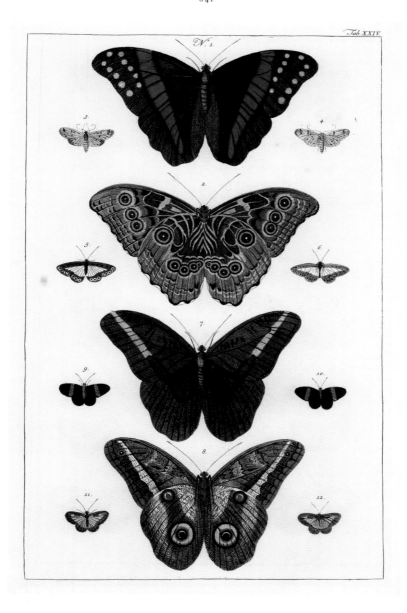

1-2 *Morpho* 5-6 Riodininae 7-8 *Caligo idomeneus* 9-12 Arctiinae
Butterflies and tiger moths from South America ·
Tagfalter und Bärenspinner aus Südamerika ·
Papillons diurnes et arctiidés d'Amérique du Sud

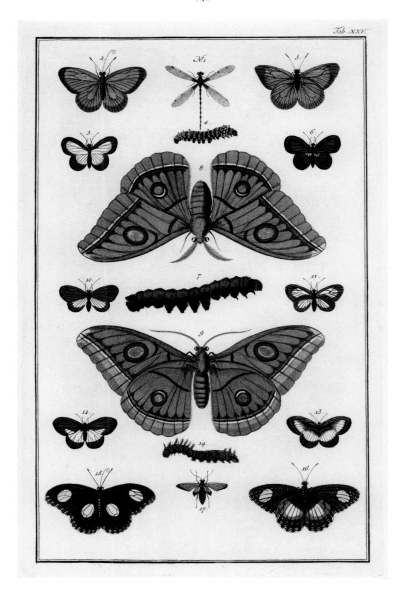

Tab. XXV.

1 Odonata **5-6** *Danis* **8-9** *Antheraea helferi* **10-11** Polyommatinae
**12-13** *Danis danis* **15-16** *Hypolimnas bolina* **17** *Trichura coarctata*
One dragonfly, butterflies and silkmoths from South-East Asia to Australia · Eine Libelle, Tagfalter
und Augenspinner von Südostasien bis Australien · Une libellule, des papillons diurnes ainsi que des
saturniidés de la zone Asie du Sud-Est – Australie

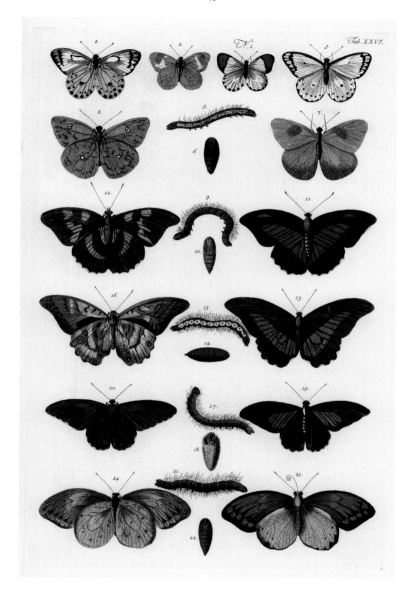

1-2 *Colotis sp.* 3-4 *Belenois calypso* 7-8 Coliadinae 11-16 *Archaeoprepona demophon*
19-20 *Parides sesostris* 21-22 *Hebomoia leucippe*
Butterflies from Africa, Central and South America and the Moluccas · Tagfalter aus Afrika,
Mittel- und Südamerika und den Molukken · Papillons diurnes d'Afrique, d'Amérique Centrale
et du Sud et des Moluques

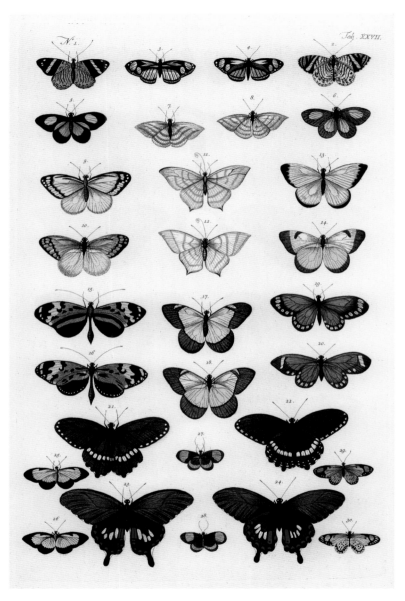

1-2 *Tigridia acesta* **5-6** *Setabis epitus* **9-10** Pierinae **11-12** Coliadinae
**13-14** *Melete lycimnia* **15-16** *Melinaea mneme* **21-24** *Papilio polytes*
Butterflies and moths from South America and South-East Asia · Tag- und Nachtfalter aus Südamerika
und Südostasien · Papillons diurnes et nocturnes d'Amérique du Sud et d'Asie du Sud-Est

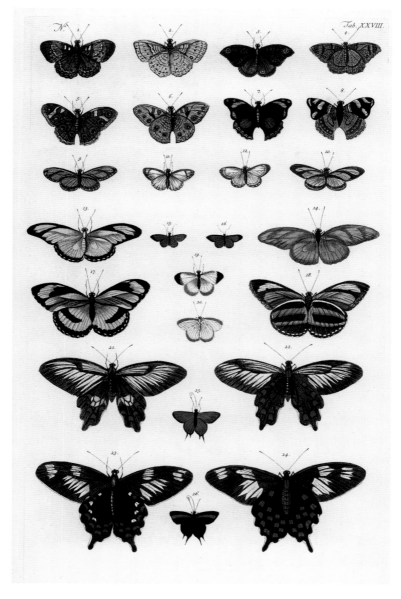

**13-14** *Dryas iulia* **17-18** *Dryadula phaetusa* **21-22** *Atrophaneura polydorus*
**23-24** *Atrophaneura hector* **25-26** Theclinae
Tropical butterflies distributed worldwide · Tropische Tagfalter mit weltweiter Verbreitung ·
Papillons diurnes tropicaux répandus dans le monde entier

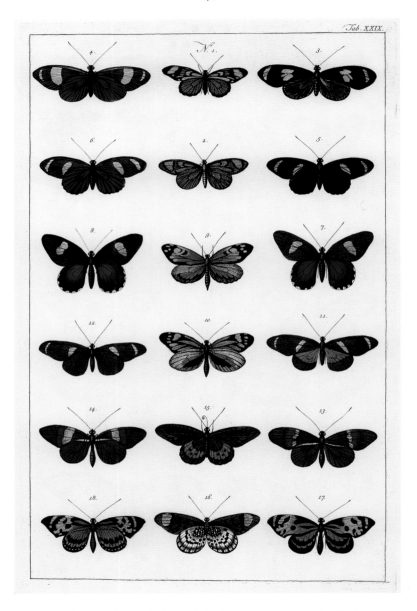

*Tab. XXIX.*

**1-2** *Actinote parapheles* **3-4** *Heliconius doris* **5-6** *Heliconius wallacei* **7-8** Papilioninae
**9-10** *Dismorphia amphiona* **13-14** *Heliconius heurippa* **15-16** *Acraea egina* **17-18** *Tithorea harmonia*
Butterflies from Africa and tropical Central and South America · Tagfalter aus Afrika und dem tropischen
Mittel- und Südamerika · Papillons diurnes d'Afrique et des zones tropicales d'Amérique Centrale et du Su

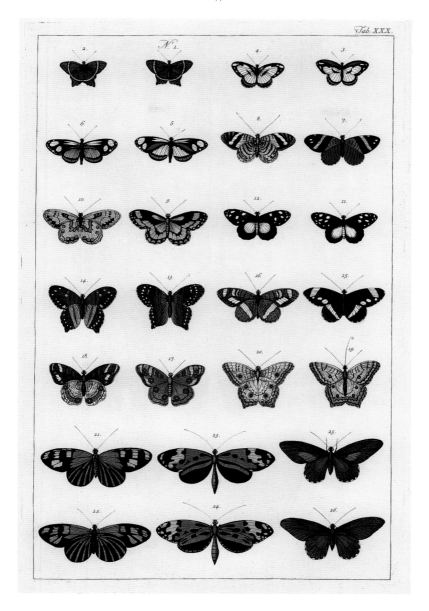

*Tab. XXX.*

1-2 *Riodina lysippus* 5-6 Ithomiinae 7-8 *Tigridia acesta* 11-12 *Hyalothyrus neleus*
15-18 Nymphalinae 19-20 *Anartia jatrophae* 23-24 *Mechanitis polymnia*
Butterflies from tropical America and the region encompassing Africa to Arabia · Tagfalter aus dem tropischen
Amerika, von Afrika bis nach Arabien · Papillons diurnes d'Amérique tropicale et de la zone d'Afrique – Arabie

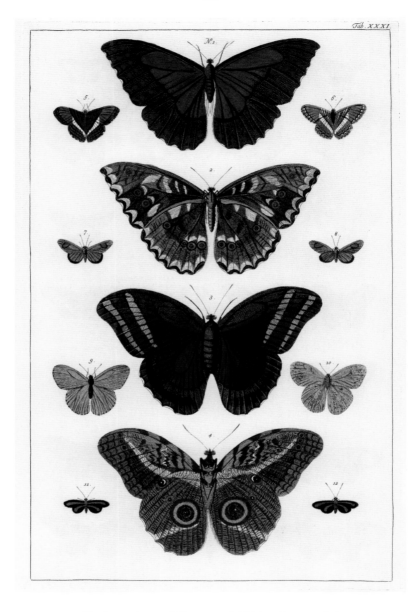

Tab. XXXI

**1-2** *Morpho menelaus* **3-4** *Caligo teucer* **5-6** *Adelpha cytherea* **11-12** *Josia sp.*
Butterflies from tropical Central and South America ·
Tagfalter aus dem tropischen Mittel- und Südamerika ·
Papillons diurnes des zones tropicales d'Amérique Centrale et du Sud

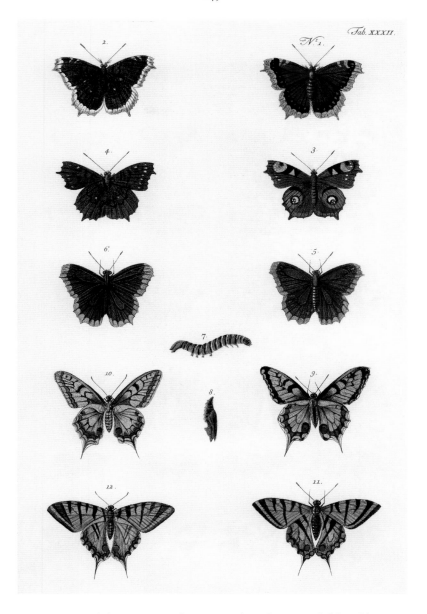

*1-2, 5-6* Nymphalis antiopa *3-4* Inachis io *7-10* Papilio machaon *11-12* Iphiclides podalirius
**1-2, 5-6** Camberwell beauties · Trauermäntel · Morios **3-4** Peacock · Tagpfauenauge · Paon-de-jour
**7-10** (Common yellow) swallowtail/Old World swallowtail · Schwalbenschwanz · Grand porte-queue
**11-12** Scarce swallowtail · Segelfalter · Flambé

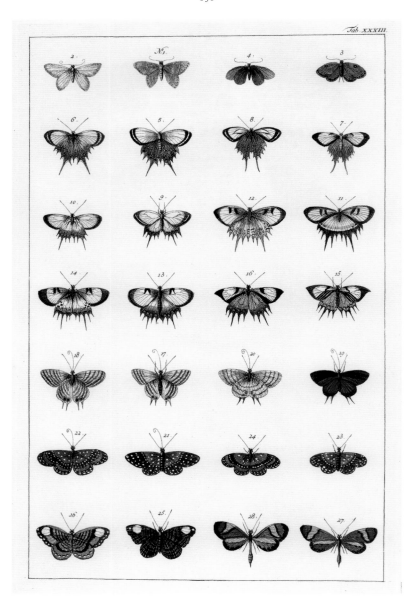

*Tab. XXXIII.*

**5-8, 11-16** *Helicopis cupido* **9-10** *Helicopis endymion* **21-24** *Stalachtis phlegia* **25-26** *Emesis lucinda* **27-28** Ithomiinae
Butterflies from tropical Central and South America ·
Tagfalter aus dem tropischen Mittel- und Südamerika ·
Papillons diurnes des zones tropicales d'Amérique Centrale et du Sud

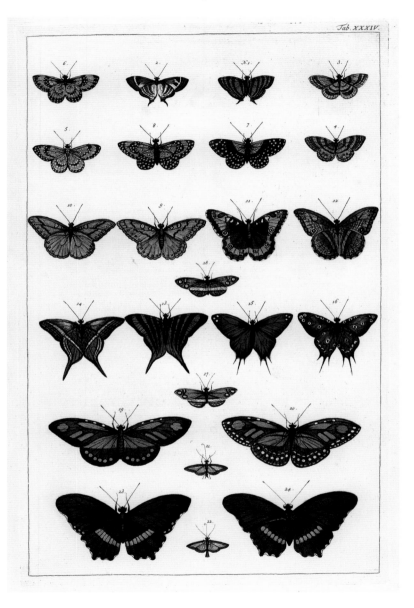

**5-8** *Stalachtis phlegia* **13-14** *Marpesia chiron* **15-16** *Pseudolycaena marsyas* **23-24** *Papilio polytes*
Butterflies from America and South-East Asia ·
Tagfalter aus Amerika und Südostasien ·
Papillons diurnes d'Amérique et d'Asie du Sud-Est

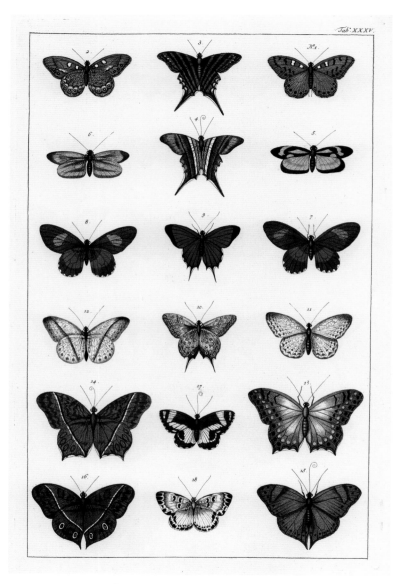

*Tab: XXXV.*

**3-4** *Marpesia chiron* **5-6** Arctiinae **7-8** *Parides sp.* **13-14** *Charaxes varanes*
**15-16** *Doleschallia bisaltide* **17-18** *Salamis anacardi*
Butterflies from Africa and tropical America, the region encompassing South-East Asia to Australia, as well
as one South American moth · Tagfalter aus Afrika und dem tropischen Amerika, von Südostasien bis nach
Australien sowie ein südamerikanischer Nachtfalter · Papillons diurnes d'Afrique et d'Amérique tropicale
de la zone d'Asie du Sud-Est – Australie, ainsi qu'un papillon nocturne d'Amérique du Sud

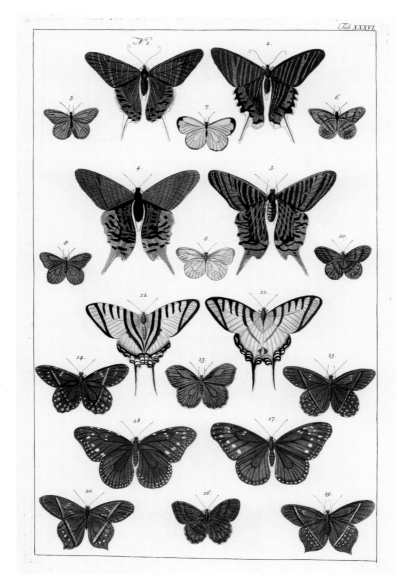

*Tab.* **XXXVI**

**1-4** *Eurytides* **7-8** *Eurema sp.* **11-12** *Eurytides protesilaus* **13-14** *Pierella lena* **17-18** *Danaus eresimus*
Butterflies distributed variously in tropical and subtropical America and worldwide ·
Tagfalter aus dem tropischen und subtropischen Amerika und mit weltweiter Verbreitung ·
Papillons originaires d'Amérique tropicale et subtropicale, et répandus dans le monde entier

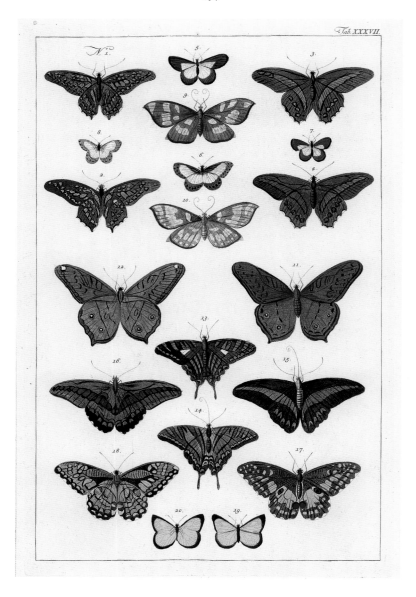

*Tab.XXXVII.*

1-2 *Graphium agamemnon* **3-4, 15-16** *Graphium sarpedon* **5-8** *Danis* **9-10** *Draconia peripheta*
**11-12** *Vindula arsinoe* **17-18** *Papilio demoleus* **19-20** *Eurema sp.*
Butterflies distributed variously from South-East Asia to Australia, and worldwide · Tagfalter von
Südostasien bis nach Australien und mit weltweiter Verbreitung · Papillons diurnes originaires de la
zone d'Asie du Sud-Est – Australie, et répandus dans le monde entier

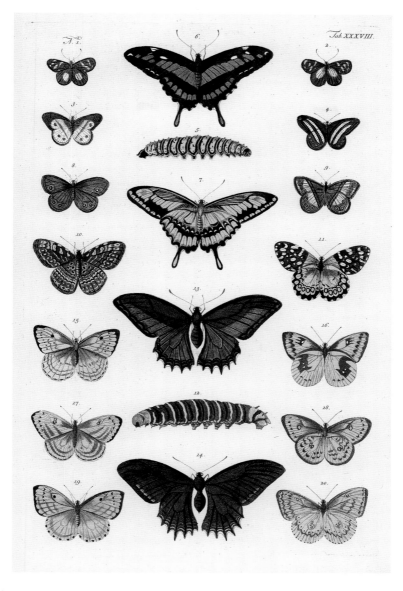

3-4 *Cissia hesione* 6-7 *Papilio thoas* 10-11 *Hamadryas feronia* 13-14 *Papilio androgeus* 15-20 *Phoebis sennae*
Butterflies from tropical and subtropical America ·
Tagfalter aus dem tropischen und subtropischen Amerika ·
Papillons diurnes d'Amérique tropicale et subtropicale

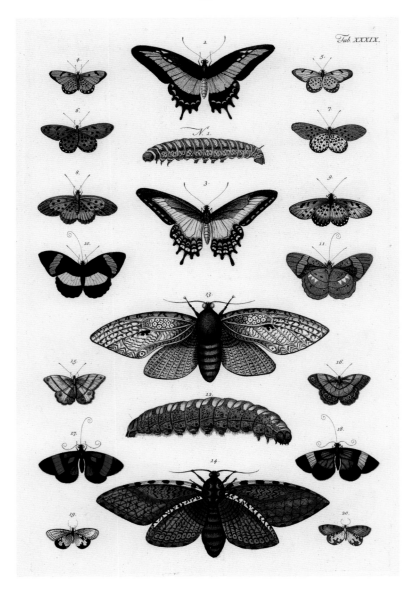

*Tab. XXXIX.*

2-3 *Papilio sp.* **4-7** Nymphalidae **8-9** *Acraea horta* **13-14** *Xyleutes strix* **19-20** *Utetheisa ornatrix*
Butterflies from South America and Africa and moths from Malay Archipelago, New Guinea and America
Tagfalter aus Südamerika und Afrika sowie Nachtfalter aus dem Malaiischen Archipel, Neuguinea und
Amerika · Papillons diurnes d'Amérique du Sud et d'Afrique, et papillons nocturnes de l'Archipel indomalai
de Nouvelle-Guinée ainsi que d'Amérique

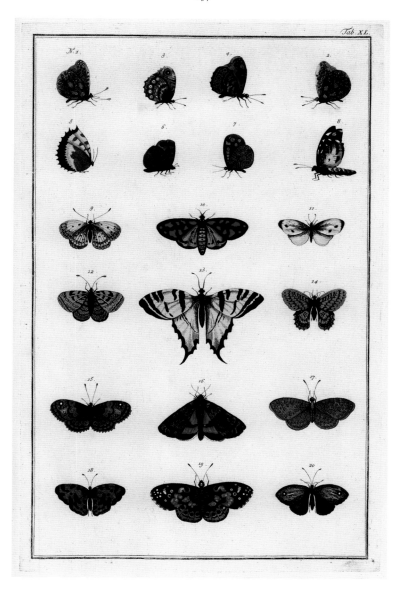

*Tab. XL.*

1-12 Lepidoptera **13** *Iphiclides podalirius* **16** *Catocala* **19** *Hamadryas feronia*
Butterflies and moths from Eurasia and America ·
Schmetterlinge aus Eurasien und Amerika ·
Papillons et teignes d'Eurasie et d'Amérique

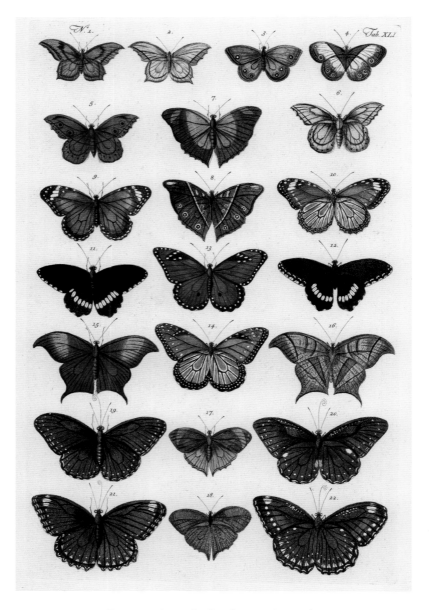

**9-10** *Danaus genutia* **11-12** *Papilio polytes* **13-14** *Danaus plexippus*
**15-16** *Caerois chorineus* **17-18** *Bia actorion* **19-20** *Hypolimnas bolina*
Tropical butterflies distributed worldwide · Tropische Tagfalter mit weltweiter Verbreitung ·
Papillons diurnes tropicaux répandus dans le monde entier

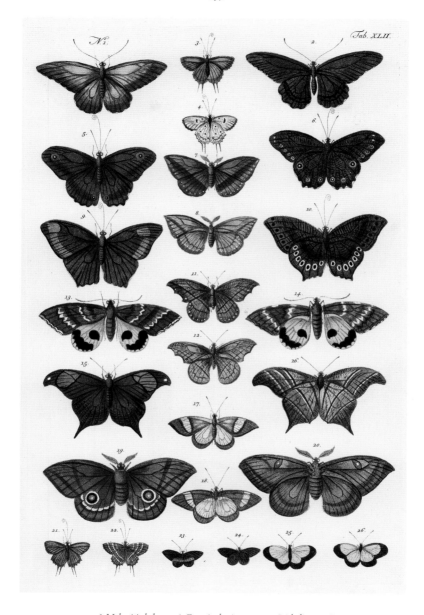

**5-6** *Melanitis leda* **15-16** *Caerois chorineus* **23-24** *Stichelia sagaris*

Butterflies and moths from Central and South America and the region encompassing tropical Africa to Australia · Tag- und Nachtfalter aus Mittel- und Südamerika und vom tropischen Afrika bis nach Australien · Papillons diurnes et nocturnes d'Amérique Centrale et du Sud et de la zone d'Afrique tropicale – Australie

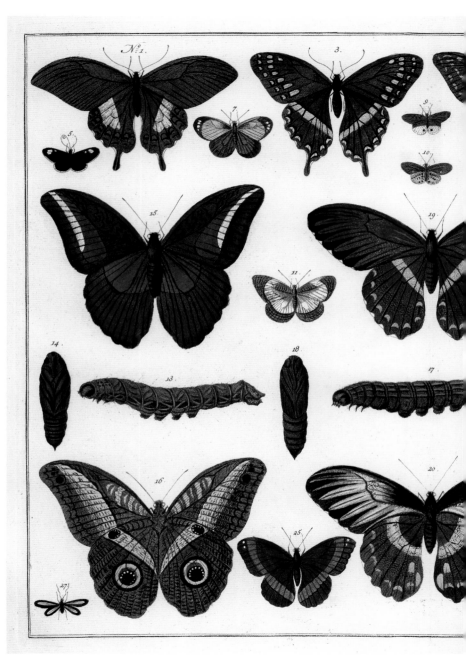

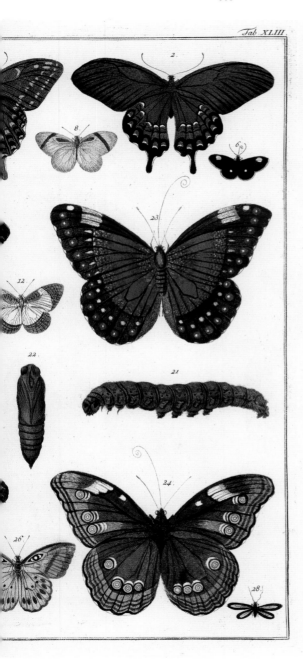

Tab. XLIII

**1-4** *Papilio sp.* **15-16** *Caligo idomeneus* **23-24** *Morpho peleides* **27-28** *Josia sp.*
Tropical butterflies and moths from America ·
Tropische Tag- und Nachtfalter aus Amerika ·
Papillons diurnes et nocturnes tropicaux d'Amérique

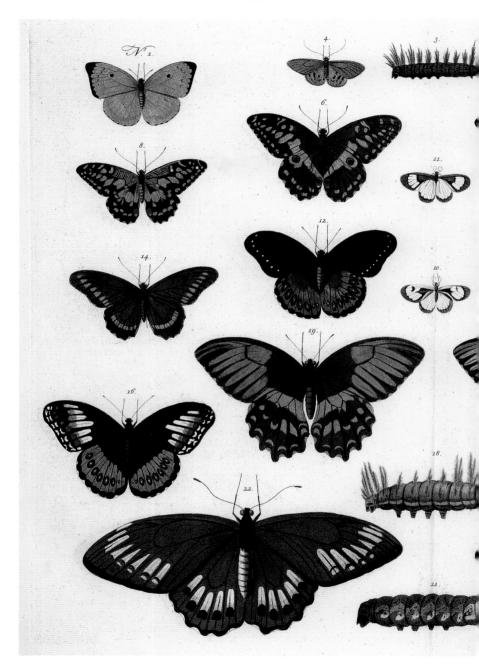

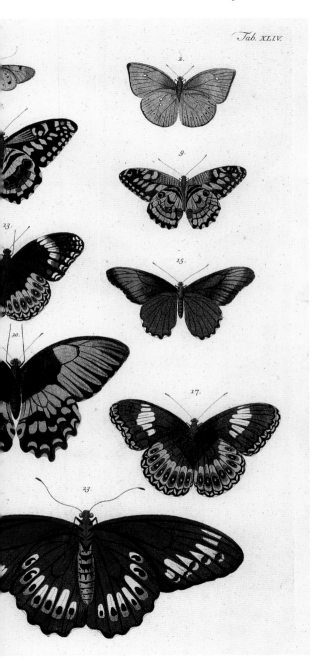

Tab. XLIV.

**6-9** *Papilio demolens*
**12-13, 16-17** *Hypolimnas*
*pandarus* **14-15** *Battus*
*polydamas* **19-20** *Troides*
*helena* **22-23** *Troides hypolitus*
Butterflies from tropical
America and the region
encompassing South-East
Asia to Australia · Tagfalter aus
dem tropischen Amerika und
von Südostasien bis nach
Australien · Papillons diurnes
d'Amérique tropicale et
de la zone Asie du Sud-Est –
Australie

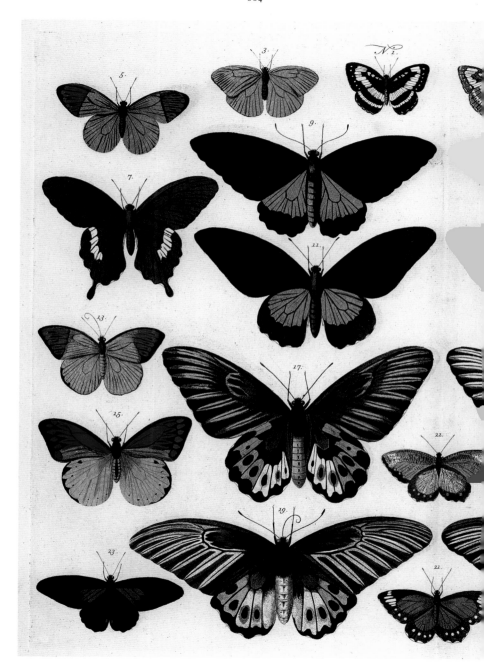

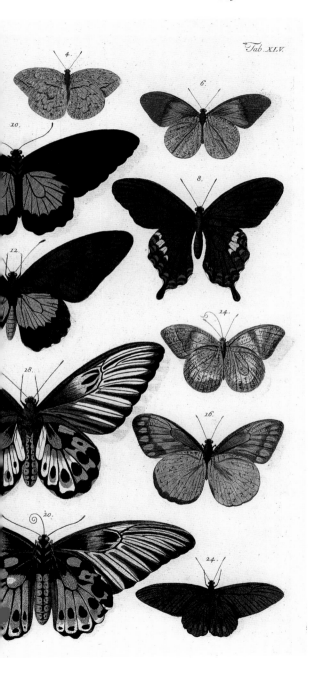

*Tab. XLV.*

1-2 *Athyma perius*
5-6, 13-14 *Hebomoia glaucippe*
7-8 *Papilio fuscus* 9-12 *Troides
helena* 15-16 *Hebomoia
leucippe* 17-20 *Troides
hypolitus* 23-24 *Parides sesostris*
Butterflies from South-East
Asia, North Australia and
Central and South America ·
Tagfalter aus Südostasien,
Nordaustralien und Mittel- und
Südamerika · Papillons diurnes
d'Asie du Sud-Est, d'Australie
du Nord et d'Amérique
Centrale et du Sud

7-8 *Delias pasithoe* **9-10** *Papilio ulysses* **11-12, 19-20** *Troides hypolitus* **13-14** *Hypolimnas pandarus* **15-16** *Papilio polytes* **17-18** *Papilio helenus* **21-22** *Charaxes jasius* Butterflies from South-East Asia and North Africa · Tagfalter aus Südostasien und Nordafrika · Papillons diurnes d'Asie du Sud-Est et d'Afrique du Nord

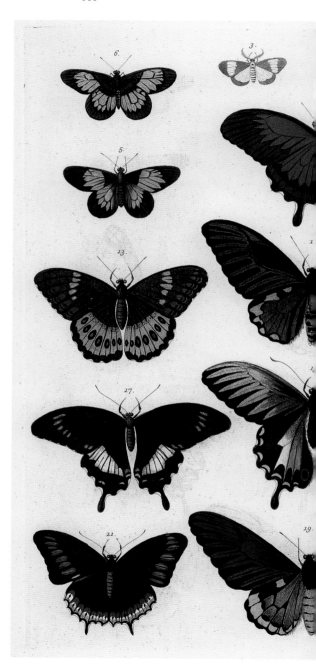

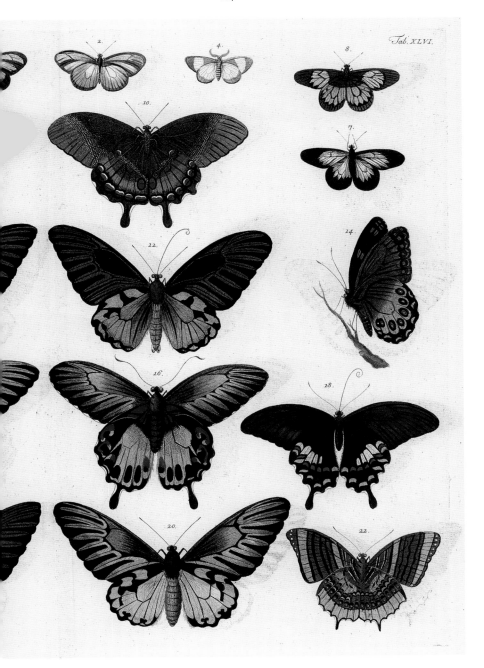

Tab. XLVI.

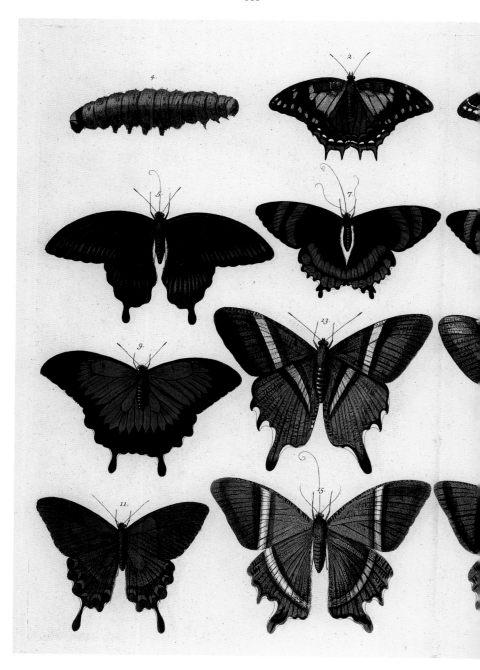

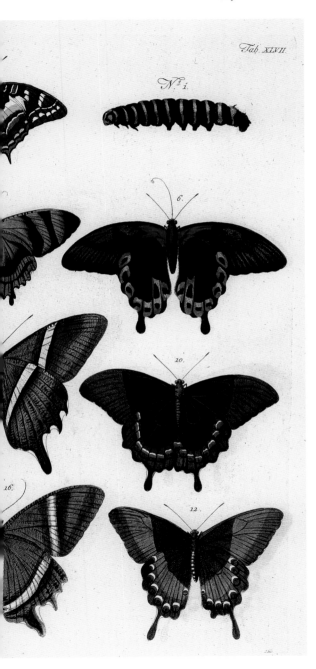

Tab. XLVII.

N.º 1.

2-3 *Polyura pyrrhus* 5-6 *Papilio deiphobus* 7-8 *Papilio sp.*
9-12 *Papilio ulysses* 13-14 *Papilio oenomaus* 15-16 *Papilio hipponous*
Butterflies from the Malay Archipelago, New Guinea and Australia · Tagfalter aus dem Malaiischen Archipel, Neuguinea und Australien · Papillons diurnes de l'Archipel indomalais, de Nouvelle-Guinée et d'Australie

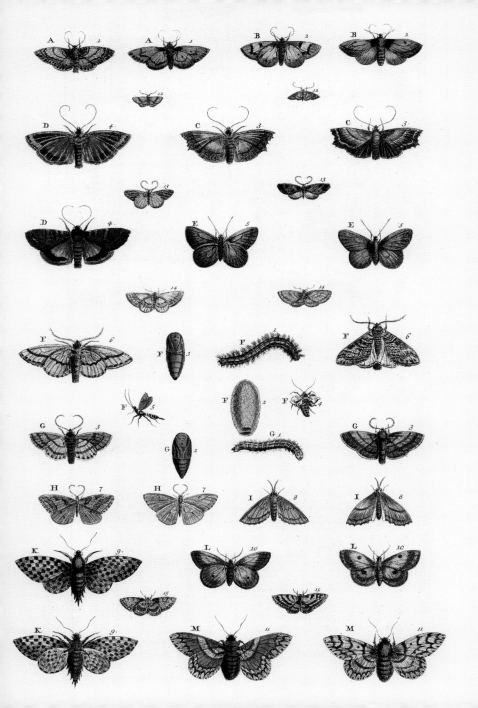

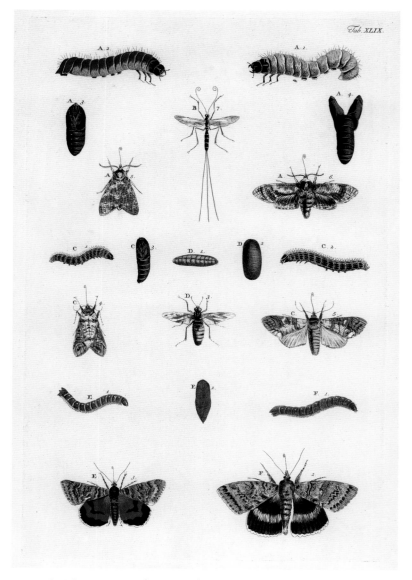

**A1-6** *Cossus cossus* **B7** Ichneumonoidea **C1-5** *Phalera bucephala* **D1-2** Diptera
**D3** Cimbicidae **E1-3** *Catocala sp.* **F1-2** *Catocala fraxini*
**A1-6** Goat moth · Weidenbohrer · Cossus gâte-bois **B7** Ichneumon wasp · Schlupf- und Brackwespe ·
Ichneumon **C1-5** Buff-tip · Mondvogel/Ochsenkopf · Lunule **D1-2** Diptera · Zweiflügler · Diptère
**D3** Cimbicid · Knopfhorn-Blattwespe · Cimbicidé **E1-3** Underwing · Ordensband · Likenée
**F1-2** Clifden nonpareil · Blaues Ordensband · Likenée bleue

TAB. L.

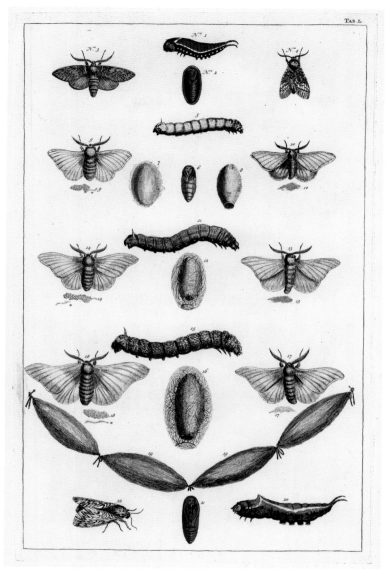

**1-4, 20-22** *Cerura vinula* **5-18** *Bombyx mori*
**1-4, 20-22** Puss moths · Große Gabelschwänze · Queues fourchues
**5-18** Silkworm-moths · Maulbeer-Seidenspinner · Bombyx du mûrier

TAB. LI.

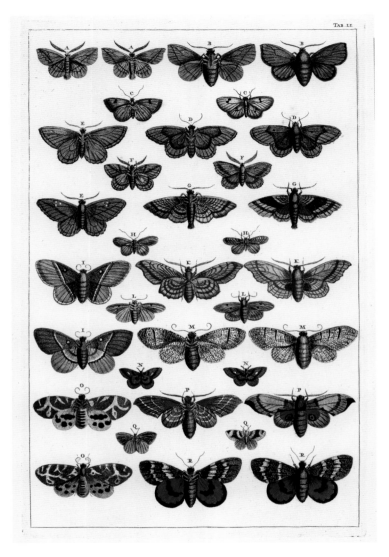

**B** *Macrothylacia rubi* **C** *Diacrisia sannio* **D** *Lasiocampa quercus* **E-F, I** *Euthrix potatoria* **K** *Marumba quercus*
**L** *Lithosia quadra* **M** *Cossus cossus* **N** *Orgyia antiqua* **O** *Arctia caja* **P** *Smerinthus ocellatus*
**B** Fox moth · Brombeerspinner · Anneau du diable **C** Clouded buff · Rotrandbär · Bordure ensanglantée
**D** Oak eggar · Großer Eichenspinner · Minime à bandes jaunes **E-F, I** Drinkers · Grasglucken · Buveuses ·
**K** Oak hawkmoth · Eichenschwärmer · Sphinx du chêne **L** Four-spotted footman · *Lithosia quadra* ·
Lithosie quadrillé **M** Goat moth · Weidenbohrer · Cossus gâte-bois **N** Vapourer moth ·
Kleiner Bürstenspinner · Etoilée **O** Garden tiger/Woolly bear · Brauner Bär · Ecaille martre
**P** Eyed hawkmoth · Abendpfauenauge · Sphinx demi-paon

TAB. LII.

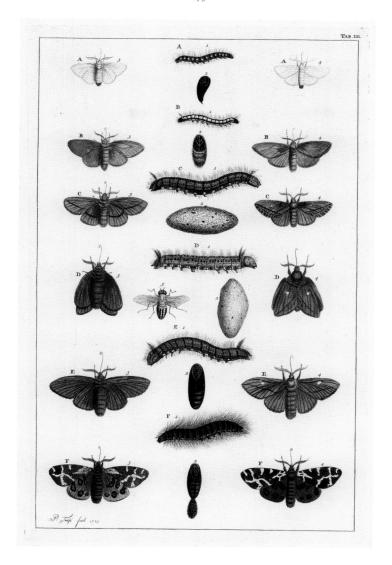

**A** *Euproctis similis* **B** *Leucoma salicis* **C** *Euthrix potatoria* **D1-4** *Lasiocampa quercus* **D5** Diptera **F** *Arctia caja*
**A** Yellow-tail · Schwan · Cul-doré **B** White satin moth · Pappelspinner · Papillon satiné
**C** Drinker · Grasglucke · Buveuse **D1-4** Oak eggar · Großer Eichenspinner · Minime à bandes jaunes
**D5** Fly · Fliege · Mouche **F** Garden tiger/Woolly bear · Brauner Bär · Ecaille martre

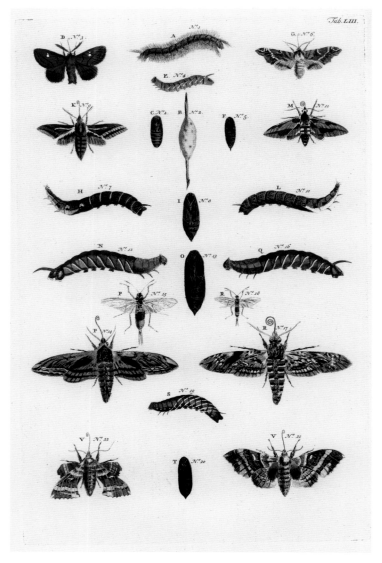

*Tab. LIII.*

**A1-D3** *Euthrix potatoria* **E4-G6** *Mimas tiliae* **H7-K9** *Deilephila elpenor* **L10-M11** *Hyles euphorbiae*
**N12-P14** *Sphinx ligustri* **P15** *Urocerus gigas* **Q16, R17** *Agrius convolvuli* **R 18** *Urocerus flavicornis*
**A1-D3** Drinker · Grasglucke · Buveuse **E4-G6** Lime hawkmoth · Lindenschwärmer · Sphinx du tilleul
**H7-K9** Elephant hawkmoth · Mittlerer Weinschwärmer · Moyen sphinx de la vigne **L10, M11** Spurge
hawkmoth · Wolfsmilchschwärmer · Sphinx de l'euphorbe **N12-P14** Privet hawkmoth · Liguster-
schwärmer · Sphinx du troène **P15** Giant wood wasp · Riesenholzwespe · Sirex géant **Q16-R17** Morning
glory sphinx moth · Windenschwärmer · Sphinx du liseron **R18** Wood wasp · Holzwespe · Sirex

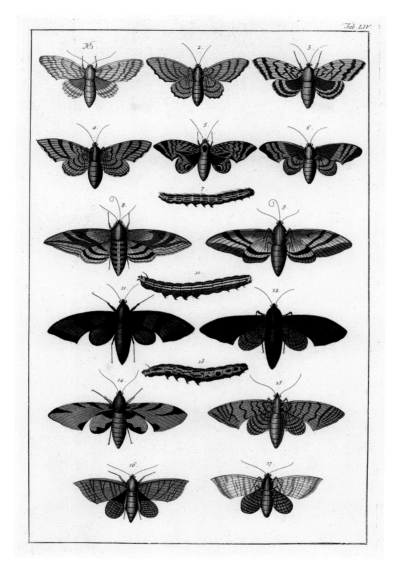

*Tab. LIV*

1-2 *Poecilocampa populi* 3-4 Lasiocampinae 5-6 *Smerinthus ocellatus* 7 *Phalera bucephala*
8-9 *Sphinx ligustri* 10-12, 16-17 *Sphinginae* 13-15 *Hyles nicaea*
1-2 December eggar · Kleine Pappelglucke · Bombyx du peuplier 3-4 Lappet moth · Glucke ·
Lasiocampiné 5-6 Eyed hawkmoth · Abendpfauenauge · Sphinx demi-paon 7 Buff-tip caterpillar ·
Ochsenkopf-Raupe · Bucéphale/Lunule (chenille) 8-9 Privet hawkmoth · Ligusterschwärmer ·
Sphinx du troène 10-12, 16-17 Hawkmoths · Schwärmer · Sphinx 13-15 Mediterranean hawkmoth ·
Großer Wolfsmilchschwärmer · Sphinx nicéa

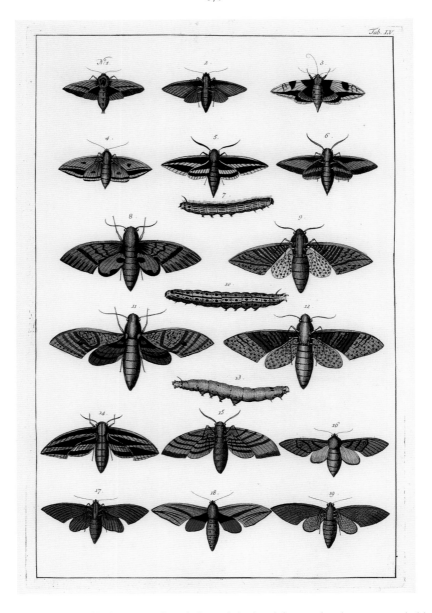

*Tab. LV.*

1-19 Sphingidae 1-2 *Deilephila elpenor* 3-4 *Hyles euphorbiae* 7 *Phalera bucephala* 8-10 *Sphingidae* 11-12 *Eumorpha labrusca*
1-19 Hawkmoths · Schwärmer · Sphinx 1-2 Elephant hawkmoths · Mittlere Weinschwärmer ·
Moyen Sphinx de la vigne  3-4 Spurge hawkmoths · Wolfsmilchschwärmer · Sphinx de l'euphorbe
7 Buff-tip moth · Mondvogel · Phalère bucéphale/Lunule 11-12 Gaudy sphinx moths · Schwärmer · Sphingidé

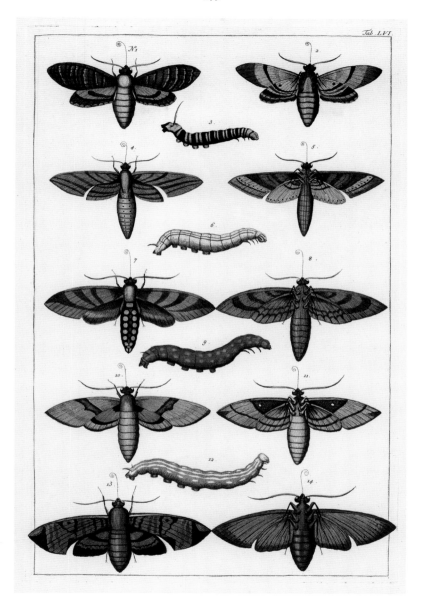

*Tab. LVI*

**1-14** Sphingidae **1-2** *Acherontia atropos* **7-8** *Manduca occulta* **10-11** *Eumorpha labruscae* **13-14** *Pachylia ficus*
**1-14** Hawkmoths · Schwärmer · Sphinx **1-2** Death's head hawkmoth · Totenkopfschwärmer ·
Sphinx tête-de-mort **7-8** Occult sphinx · Schwärmer · Sphinx **10-11** Gaudy sphinx moth · Schwärmer ·
Sphingidé **13-14** Fig sphinx · Schwärmer · Sphingidé

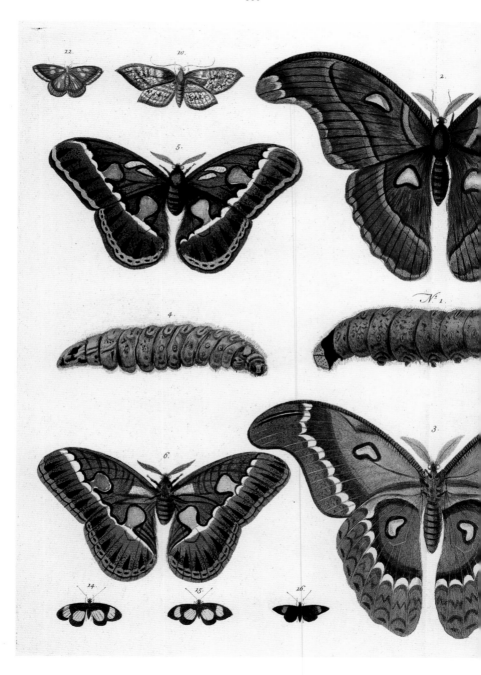

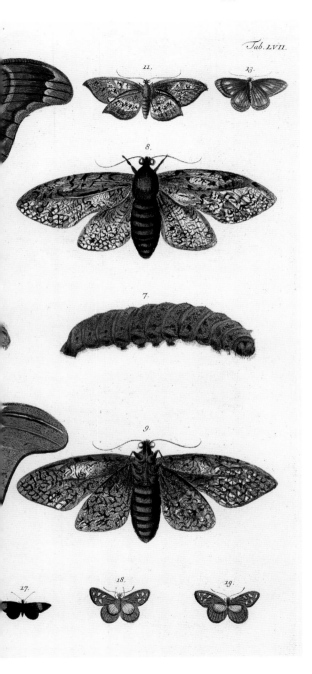

Tab. LVII.

1-3 *Attacus atlas* 4-6 *Rothschildia hesperus* 8-9 *Xyleutes strix*
10-11 *Draconia peripheta*
18-19 *Entheus priassus*
Very large tropical moths from South-East Asia and tropical America ·
Sehr große tropische Nachtfalter aus Südostasien und dem tropischen Amerika ·
Très grands papillons nocturnes d'Asie du Sud-Est et d'Amérique tropicale

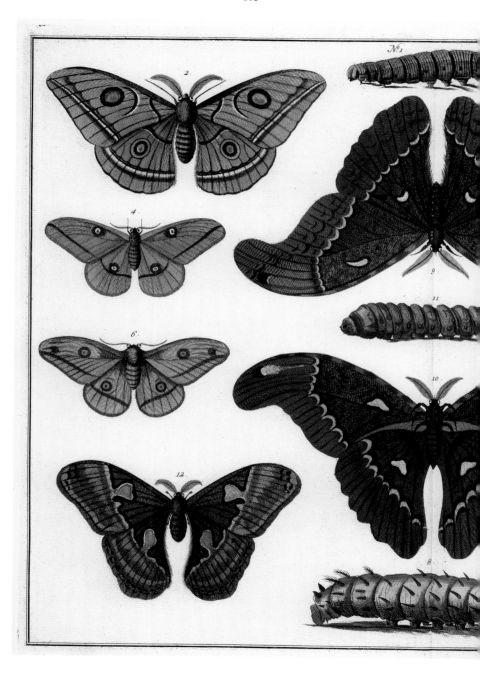

*Tab. LVIII.*

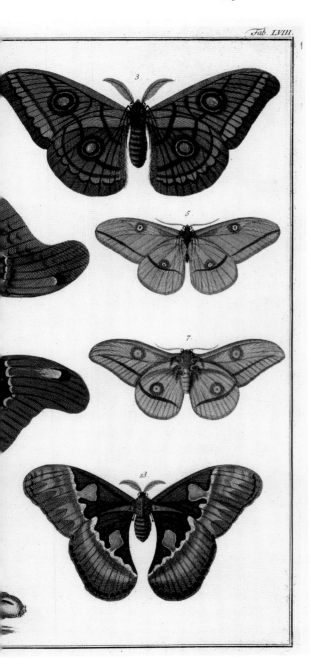

1-7 Saturniidae 8-10 *Attacus atlas* 11-13 *Rothschildia hesperus*
Very large tropical moths ·
Sehr große tropische
Nachtfalter ·
Très grands papillons nocturnes
tropicaux

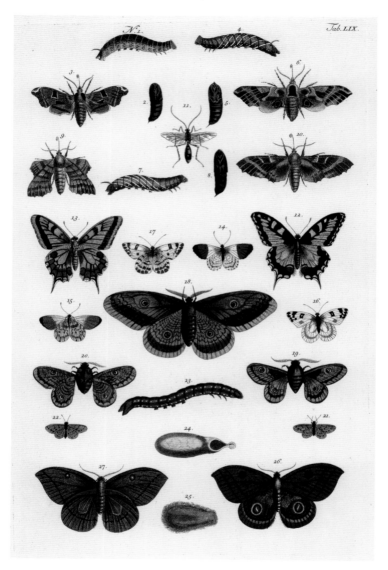

1-3 *Mimas tiliae* 4-6 *Smerinthus ocellatus* 7-10 *Limenitis populi* 11 Apocrita 12-13 *Papilio machaon*
14-15 *Anthocharis cardamines* 16-17 *Pontia daplidice* 18 *Saturnia pyri* 26-27 *Automeris*
1-3 Lime hawkmoths · Lindenschwärmer · Sphinx du tilleul 4-6 Eyed hawkmoths · Abendpfauenaugen ·
Sphinx demi-paon 7-10 Poplar admirals · Große Eisvögel · Grands sylvains 11 Wasp · Wespe · Guêpe
12-13 Swallowtails · Schwalbenschwänze · Grands porte-queues 14-15 Orange tips · Aurorafalter ·
Aurores 16-17 Bath whites · Resedaweißlinge · Marbrés de vert 18 Large emperor ·
Großes Nachtpfauenauge · Grand paon-de-nuit 26-27 Peacocks · Tagpfauenaugen · Automéris

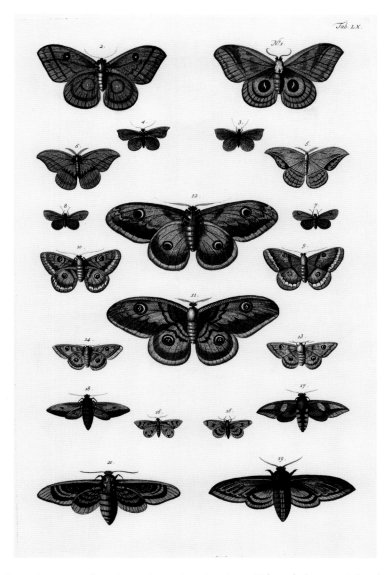

1-2 *Automeris* **9-10, 13-14** *Saturnia pavonia* **11-12** *Saturnia pyri* **17-18** *Hyles euphorbiae* **20-21** *Sphinx ligustri*
**1-2** Peacock · Tagpfauenauge · Automéris **9-10, 13-14** Emperor moths · Kleine Nachtpfauenaugen ·
Petits paons-de-nuit **11-12** Large emperor · Großes Nachtpfauenauge · Grand paon-de-nuit
**17-18** Spurge hawkmoth · Wolfsmilchschwärmer · Sphinx de l'euphorbe **20-21** Privet hawkmoth ·
Ligusterschwärmer · Sphinx du troène

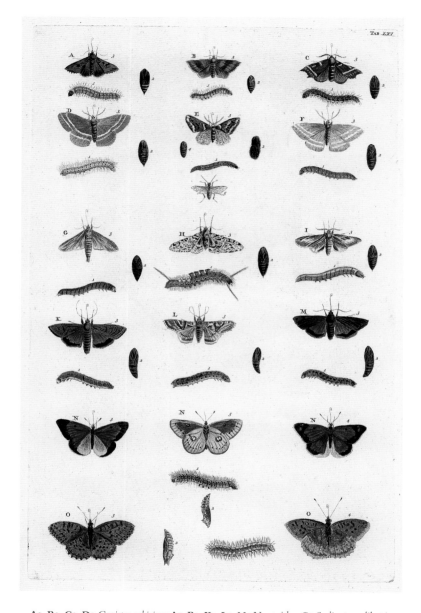

Tab. LXVI

**A2, B2, C2, D2** *Conistra rubiginea* **A3, B3, K3, L3, M3** Noctuidae **C3** *Scoliopteryx libatrix*
**D3, E3, F3, H3** Geometridae **E5** Tenthredinidae **H1** *Calliteara pudibunda* **N3-5** *Colias croceus* **O3-4** Argynnina
Butterflies and moths from Central Europe with caterpillars and pupae · Tag- und Nachtfalter aus Mitteleurop
mit Puppen und Raupen · Papillons diurnes et nocturnes d'Europe centrale ainsi que chrysalides et chenilles

Tab. LXII

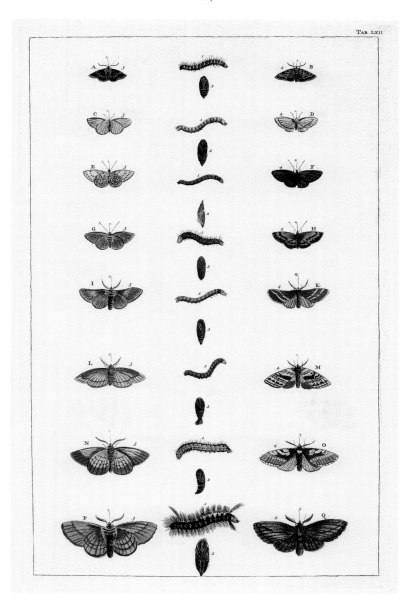

E-F Polyommatinae **P-Q1-4** *Dicallomera fascelina*
**E-F** Blues butterflies · Bläulinge · Azurés
**P-Q1-4** Dark tussocks · Graue Kleespinner · Pattes étendues agathes

TAB.LXIII

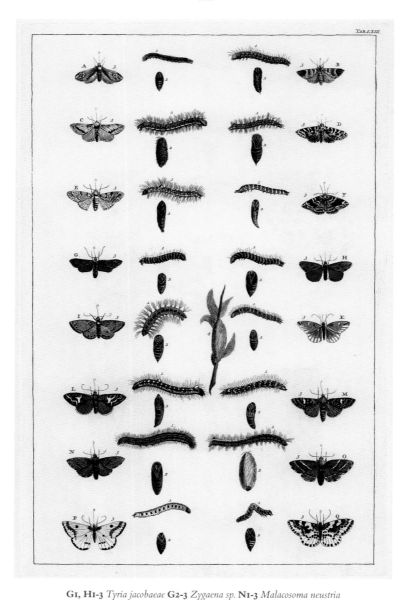

**G1, H1-3** *Tyria jacobaeae* **G2-3** *Zygaena sp.* **N1-3** *Malacosoma neustria*
**O1-3** *Eriogaster lanestris* **P3, Q1-3** *Abraxas grossulariatus*
**G1, H1-3** Cinnabar · Blutbär · Goutte-de-sang **G2-3** Burnet · Widderchen/Blutströpfchen · Zygène
**N1-3** Lackey · Ringelspinner · Livrée des arbres **O1-3** Small eggar · Wollafter/Glucke · Bombyx laineux
**P3, Q1-3** Currant moth · Stachelbeerspanner · Zérène du groseillier

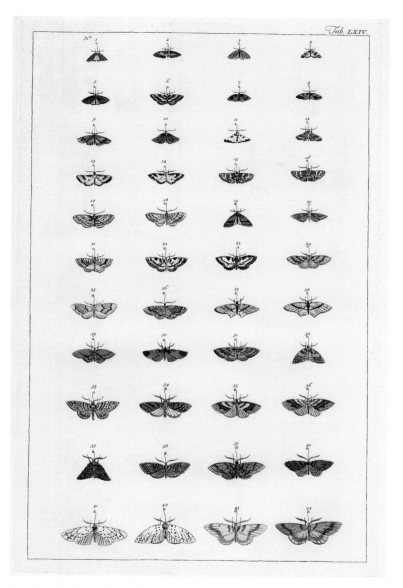

Tab. LXIV.

**1-5, 7-12** Pyralidae oder Tortricidae  **6** *Epirrhoe tristata* **22-23** *Eurrhypara hortulata* **41-42** *Spilosoma lubricipedum*
Moths from Central Europe and North Africa, including pyralids (Pyralidae), tortricids (Tortricidae),
geometers (Geometridae) and noctuids (Noctuidae) · Nachtfalter aus Mitteleuropa und Nordafrika,
darunter Zünsler (Pyralidae), Wickler (Tortricidae), Spanner (Geometridae) und Eulenfalter (Noctuidae) ·
Papillons de nuit d'Europe Centrale et d'Afrique du Nord incluant des pyrales (pyralidés), des tordeuses
(tortricidés), des géomètres (géométridés) et des noctuelles (noctuidés)

1-2 Tipulidae 3-4, 9-11 *Odonata* 5, 7-8 Trichoptera 6 Apocrita 12 Dytiscidae 13 Ephemeroptera 14-24 Orthoptera
Various insects and insect larvae, chiefly grasshoppers ·
Verschiedene Insekten und Insektenlarven, vorwiegend Heuschrecken ·
Divers insectes et larves d'insectes, principalement des sauterelles

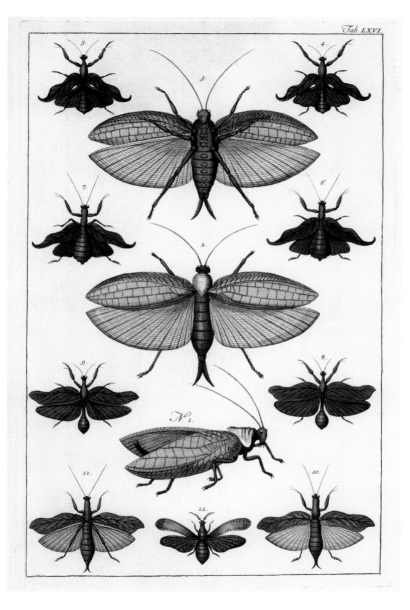

*Tab. LXVI.*

**1-3** Ensifera **4-11** Mantodea **12** Hemiptera
**1-3** Katydids · Langfühlerschrecken · Ensifères
**4-11** Praying mantids · Gottesanbeterinnen · Mantes
**12** Cicada · Zikade · Hémiptère

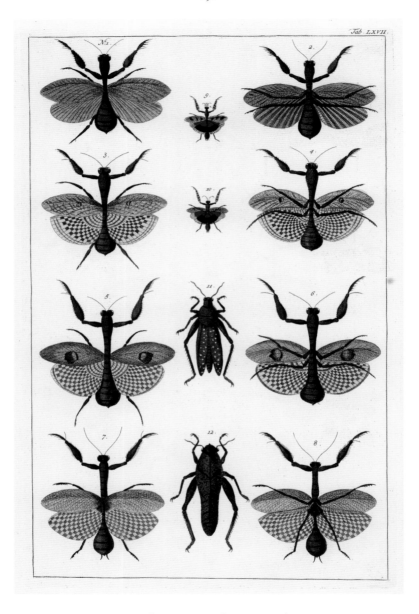

*Tab. LXVII.*

1-10 Mantodea **9-10** *Mantis religiosa* **11-12** Orthoptera
**1-10** Praying mantids · Gottesanbeterinnen · Mantes
**9-10** European praying mantids · Gottesanbeterinnen · Mantes religieuses
**11-12** Grasshoppers · Heuschrecken · Criquets

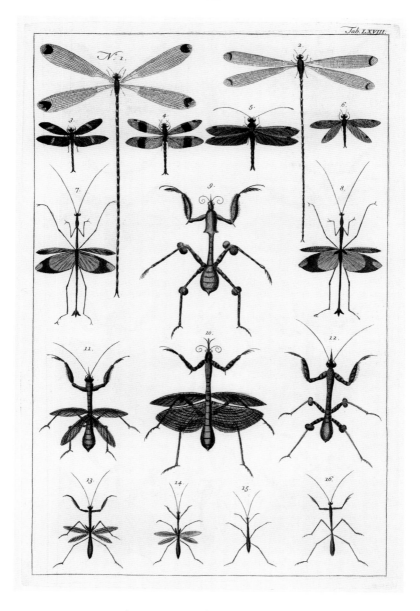

Tab. LXVIII.

1-6 Odonata **7-16** Mantodea **9-12** *Gongylus gongylodes*
**1-6** Dragonflies · Libellen · Libellules **7-12** Praying mantids · Gottesanbeterinnen · Mantes
**9-12** Gargoyle mantids/Walking violins · Wandelnde Geigen · Violons ambulants

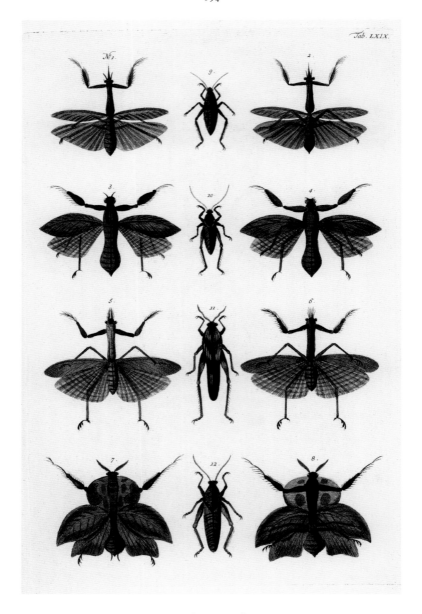

Tab. LXIX.

1-8 Mantodea 9-12 Orthoptera
1-8 Praying mantids · Gottesanbeterinnen · Mantes
9-12 Grasshoppers · Heuschrecken · Orthoptères

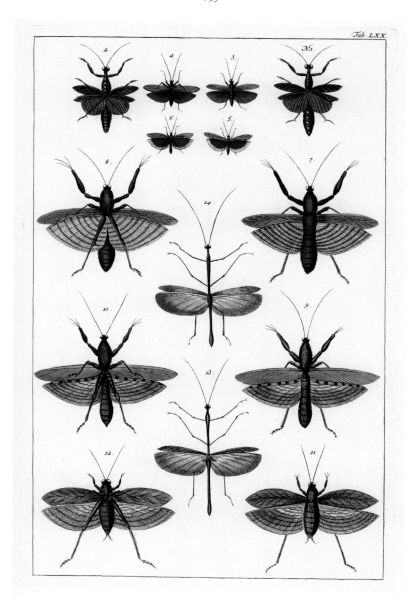

**1-2, 7-10, 14-15** Mantodea **3-6, 11-12** Orthoptera **13-14** Phasmatodea
**1-2, 7-10, 14-15** Praying mantids · Gottesanbeterinnen · Mantes
**3-6, 11-12** Katydids and grasshoppers · Heuschrecken · Sauterelles et criquets
**13-14** Stick insects · Stabheuschrecke · Phasmes

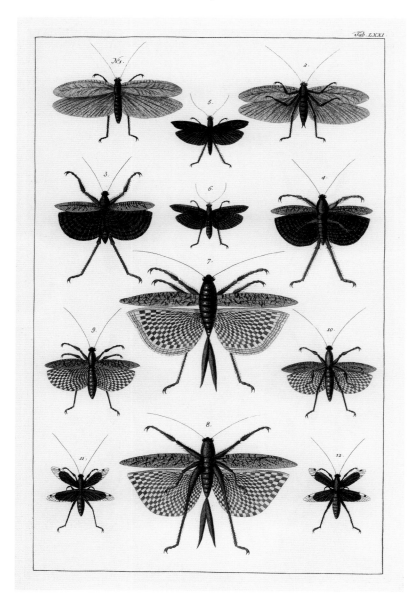

Ensifera
Katydids · Langfühlerschrecken · Sauterelles

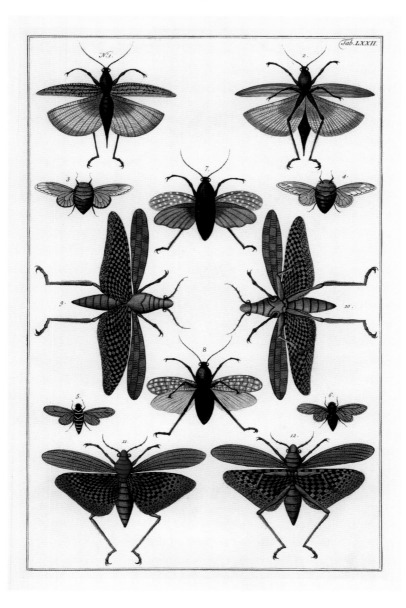

1-2, 9-12 Orthoptera 3-8 Hemiptera 11-12 *Tropidacris cristata*
1-2, 9-12 Grasshoppers · Feldheuschrecken · Orthoptères
3-8 Hemipterans · Wanzen · Hémiptères
11-12 Grasshoppers · Feldheuschrecken · Criquets géants à ailes rouges

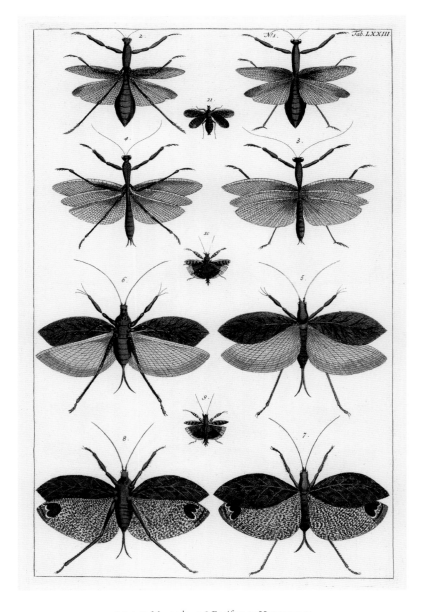

1-4, 9-10 Mantodea 5-8 Ensifera 11 Heteroptera
1-4, 9-10 Praying mantids · Gottesanbeterinnen · Mantes
5-8 Katydids · Langfühlerschrecken · Sauterelles 11 Bug · Wanze · Punaise

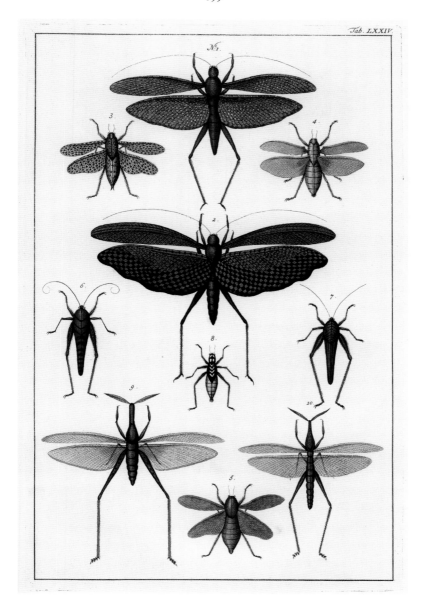

Orthoptera
Grasshoppers, crickets and katydids · Lang- und Kurzfühlerschrecken ·
Criquets et sauterelles

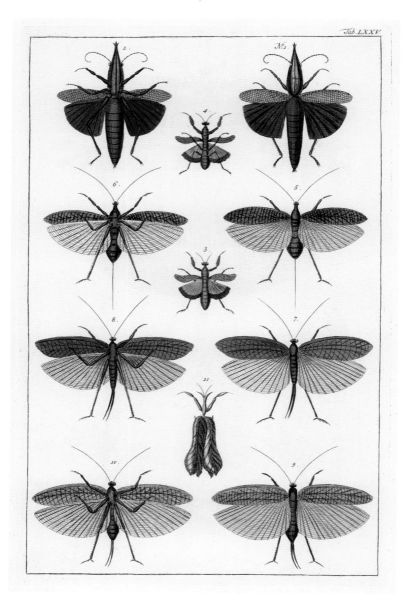

Tab. LXXV

1-2 Caelifera 3-4, 11 Mantodea 5-10 Ensifera
1-2 Grasshoppers · Kurzfühlerschrecken · Criquets
3-4, 11 Praying mantids · Gottesanbeterinnen · Mantes
5-10 Katydids · Langfühlerschrecken · Sauterelles

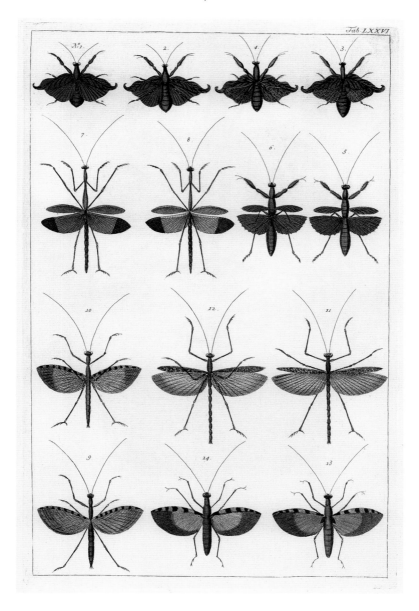

Mantodea
Praying mantids · Gottesanbeterinnen · Mantes

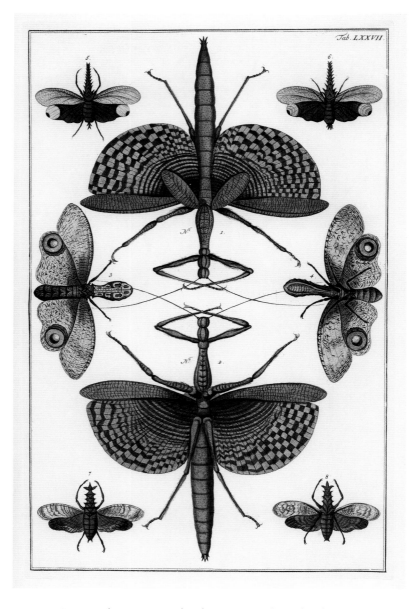

*Tab. LXXVII.*

1-2 *Phasma gigas* 3-4 *Fulgora laternaria* 5-8 Auchenorrhyncha
1-2 Walking stick · Stabheuschrecke · Grand phasme ailé
3-4 Greater lanternfly · Großer Laternenträger · Fulgore porte-lanterne
5-8 Cicadas · Zikaden · Homoptères

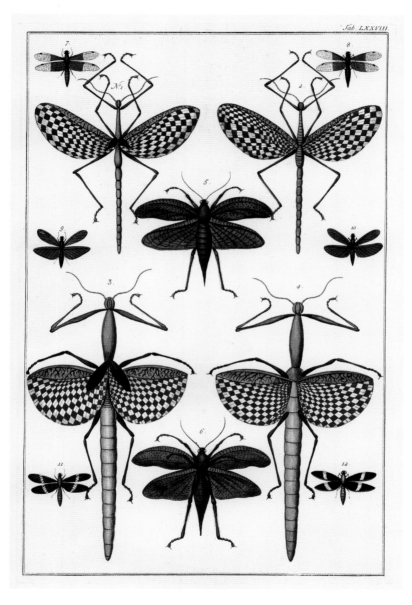

Tab. LXXVIII.

1-4 Phasmatodea 5-6 Ensifera 7-12 Odonata
1-4 Walking stick · Stabheuschrecken · Phasmes
5-6 Katydids · Langfühlerschrecken · Sauterelles
7-12 Dragonflies · Libellen · Libellules

Orthoptera
**7-8** *Phymateus morbillosus*
Grasshoppers and katydids ·
Feld- und Laubheuschrecken ·
Criquets et sauterelles
**7-8** Bush locusts ·
Wanderheuschrecken ·
Sauterelles

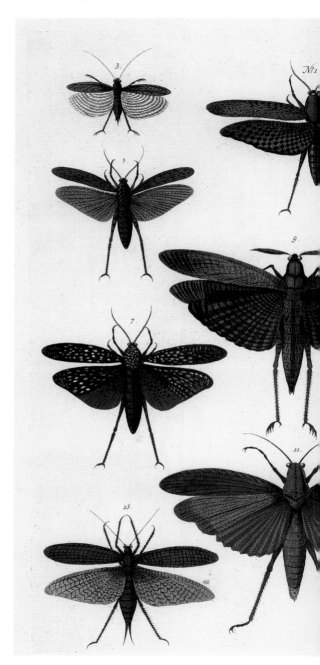

Tab. LXXIX.

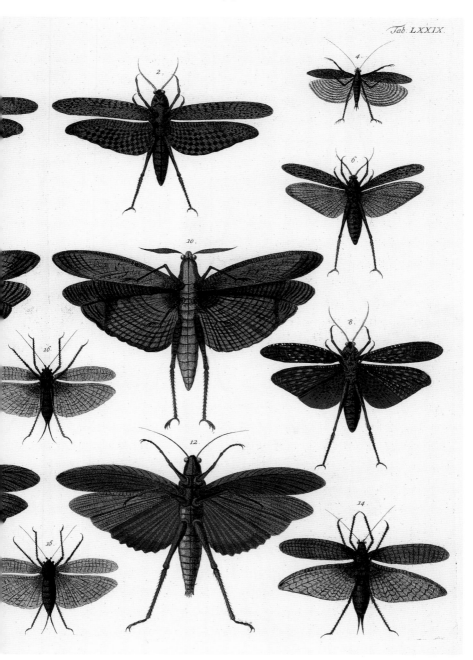

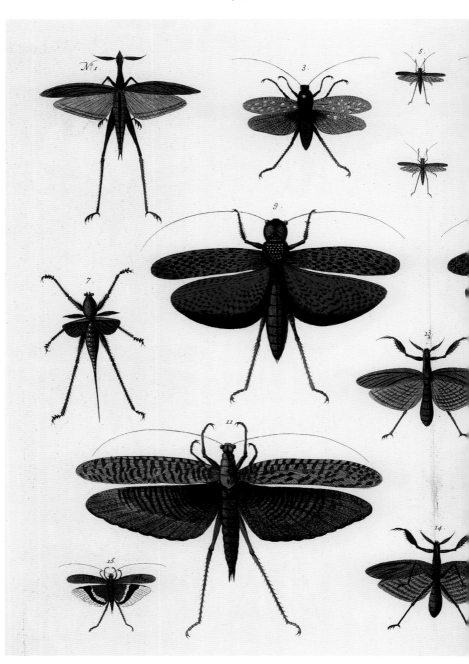

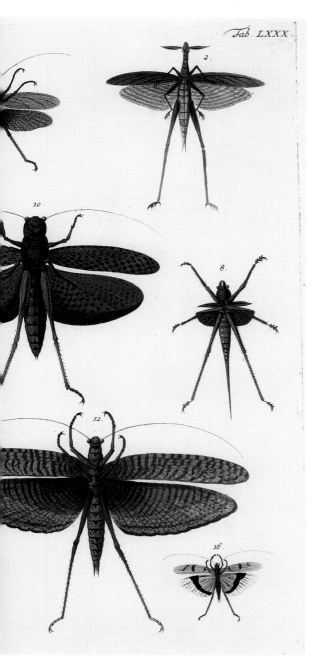

*Tab. LXXX.*

**1-12, 15-16** Orthoptera **1-2** *Acrida turrita* **13-14** Mantodea **1-12, 15-16** Grasshoppers and katydids · Feld- und Laubheuschrecken · Criquets et sauterelles **1-2** Mediterranean grasshoppers · Heuschrecken · Criquets **13-14** Praying mantids · Gottesanbeterinnen · Mantes

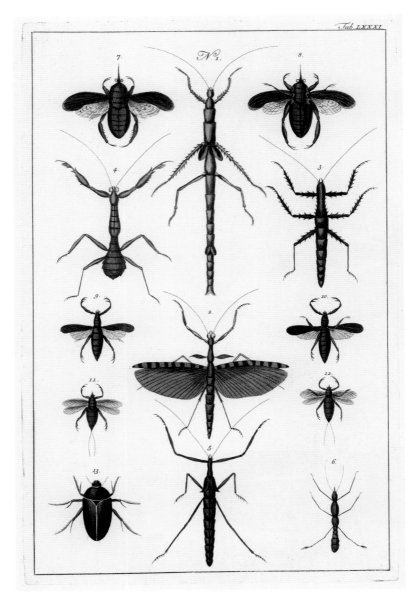

*Tab. LXXXI*

1, 3, 5-6 Phasmatodea 2, 4 Mantodea 7-12 Nepidae 13 Dytiscidae
1, 3, 5-6 Walking sticks · Stabheuschrecken · Phasmes 2, 4 Praying mantids ·
Gottesanbeterinnen · Mantes 7-12 Water bugs · Wasserwanzen · Punaises aquatiques (Nèpes)
13 Water beetle · Wasserkäfer · Coléoptère aquatique (Dytique)

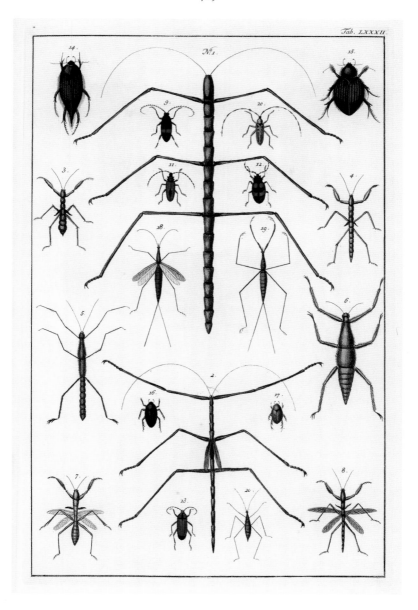

Tab. LXXXII.

**1, 2, 5-6** Phasmatodea **3-4, 7-8** Mantodea **9-17** Coleoptera **18-20** Heteroptera
**1, 2, 5-6** Walking sticks · Stabheuschrecken · Phasmes
**3-4, 7-8** Praying mantids · Gottesanbeterinnen · Mantes **9-17** Beetles · Käfer · Coléoptères
**18-20** Bugs · Wanzen · Punaises

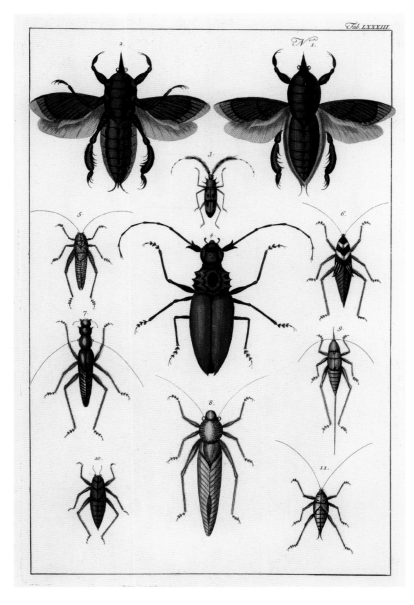

1-2 Nepidae 3-4 Cerambycidae 5-11 Orthoptera
1-2 Water bug · Wasserwanze · Punaise aquatique (Nèpe)
3-4 Longhorn beetle · Bockkäfer · Longicorne
5-11 Grasshoppers and katydids · Heuschrecken · Criquets et sauterelles

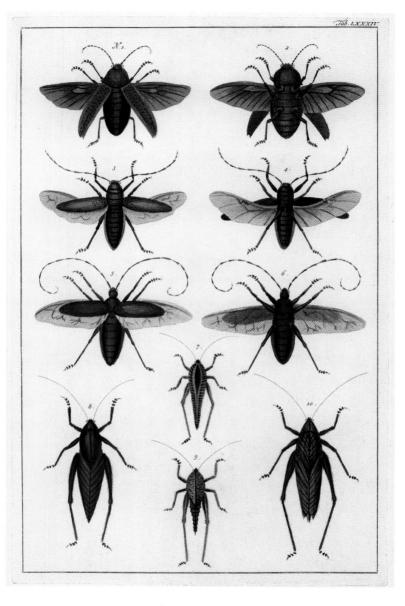

Tab. LXXXIV.

**1-6** Coleoptera **7-10** Orthoptera
**1-6** Beetles · Käfer · Coléoptères
**7-10** Grasshoppers and katydids · Heuschrecken · Orthoptères

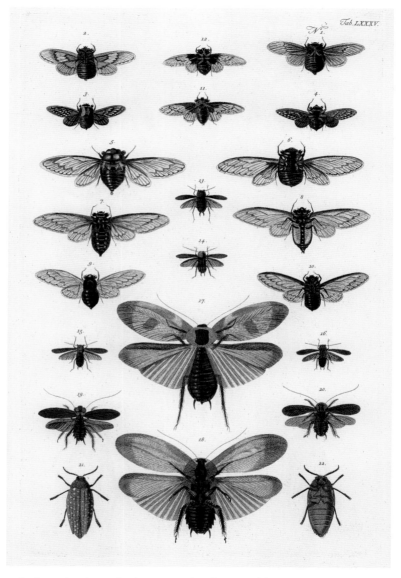

Tab. LXXXV.

1-12 Auchenorrhyncha 5-6 *Cicada orni* 13-20 Blattodea 17-18 *Blaberus giganteus* 21-22 Buprestidae
1-12 Cicadas · Zikaden · Cigales 5-6 Manniferous cicadas · Mannazikaden/Eschenzikaden ·
Cigales de l'orne 13-20 Cockroaches · Schaben · Blattes 17-18 Brazilian cockroaches ·
Brasilianische Schaben · Blattes brésiliennes 21-22 Jewel beetles · Prachtkäfer · Buprestes

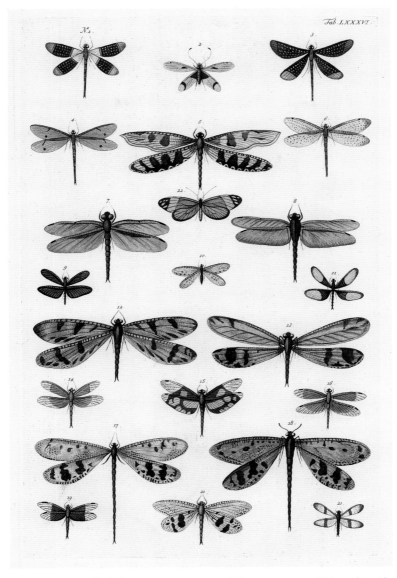

Tab. LXXXVI.

**1, 3** Zygoptera **2** Ascalaphidae **4, 6, 9, 11, 14-16, 19, 21** Odonata **5, 12-13, 17-18** Myrmeleontidae
**7-8** Anisoptera **10** Planipennia **22** Lepidoptera
**1, 3** Damselflies · Wasserjungfern · Demoiselles **2** Lacewing · Netzflügler · Ascalaphe
**4, 6, 9, 11, 14-16, 19, 21** Dragonflies · Libellen · Libellules **5, 12-13, 17-18** Ant lions ·
Ameisenlöwen · Fourmislions **7-8** Dragonflies · Großlibellen · Libellules **10** Neuropterans ·
Netzflügler · Planipenne **22** Butterfly · Schmetterling · Papillon

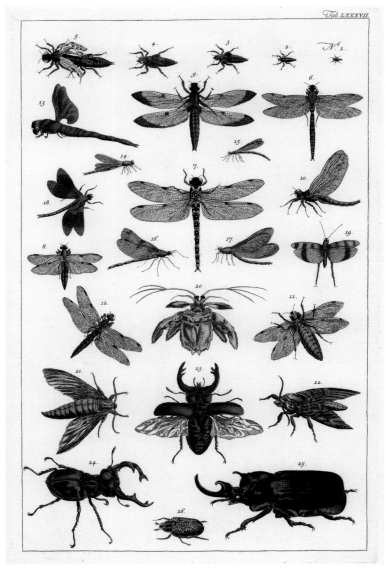

Tab. LXXXVII.

1-18 Odonata 19 Caelifera 20 Crustacea 21, 22 Lepidoptera 23-24 Lucanidae 25 Dynastinae 26 Melolonthinae
1-18 Dragonflies · Libellen · Libellules 19 Grasshopper · Feldheuschrecke · Criquet 20 Crustacean · Krebs ·
Crustacé 21, 22 Hawkmoths · Schwärmer · Sphinx 23-24 Stag beetles · Hirschkäfer · Lucanes cerfs-volants
25 Hercules beetle · Herculeskäfer · Dynaste hercule 26 May beetle · Maikäfer · Hanneton

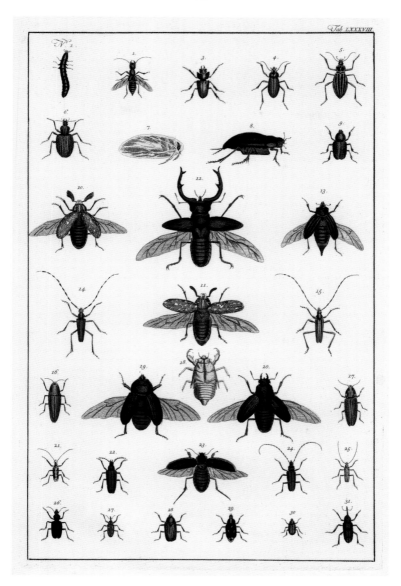

1, 3-4, 8, 21, 25-26, 29-30 Coleoptera 2 Staphylinidae 5-6 Carabidae 9-11, 13, 18-20, 23, 28 Scarabaeidae
12 Lucanidae 14-15, 22 Cerambycidae 16-17 Elateridae 27, 31 Curculionidae
1, 3-4, 8, 21, 25-26, 29-30  Beetles · Käfer · Coléoptères 2 Rove beetle · Kurzflügelkäfer · Staphylin
5-6 Carabids/Ground beetles · Laufkäfer · Carabidés 9-11, 13, 18-20, 23, 28 Cockchafers · Blatthornkäfer ·
Scarabées 12 Stag beetle · Hirschkäfer · Lucane cerf-volant 14-15, 22 Longhorn beetles · Bockkäfer ·
Longicornes 16-17 Click beetles · Schnellkäfer · Taupins 27, 31 Weevils · Rüsselkäfer · Charançons

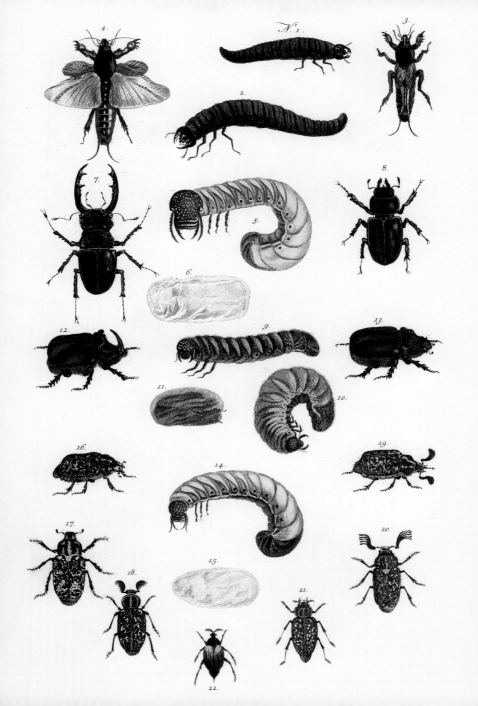

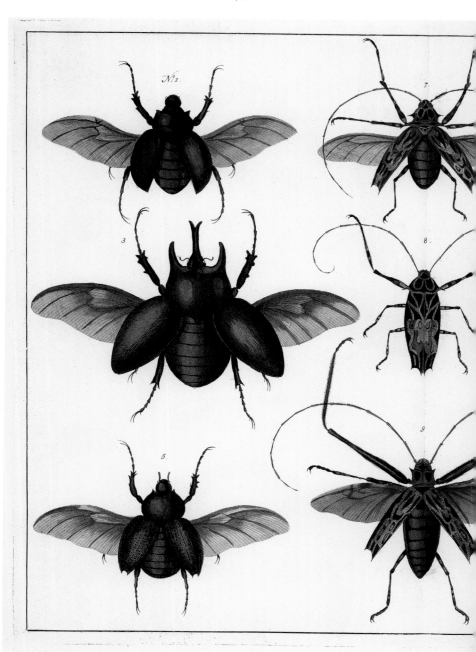

Tab. XC.

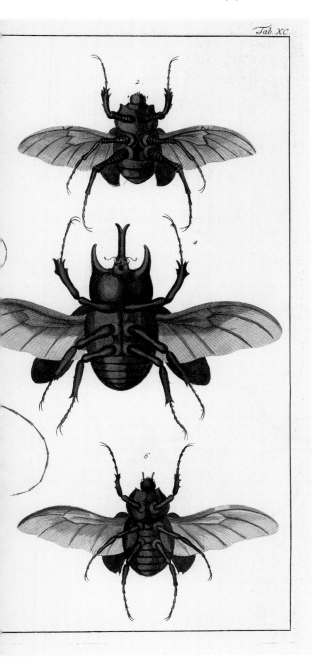

1-6 Scarabaeidae
7-9 Cerambycidae
1-6 Cockchafers · Blatthorn-
käfer · Scarabées
7-9 Longhorn beetles ·
Bockkäfer · Longicornes

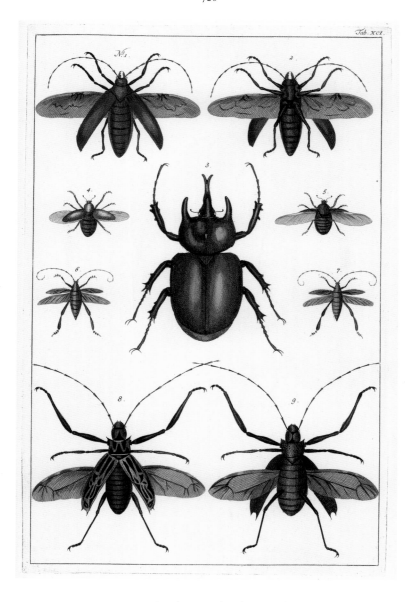

Tab. XCI.

1-2, 8-9 Cerambycidae 3 Scarabaeidae 4-5 Coleoptera
1-2, 8-9 Longhorn beetles · Bockkäfer · Longicornes
3 Cockchafer · Blatthornkäfer · Scarabée 4-5 Beetles · Käfer · Coléoptères

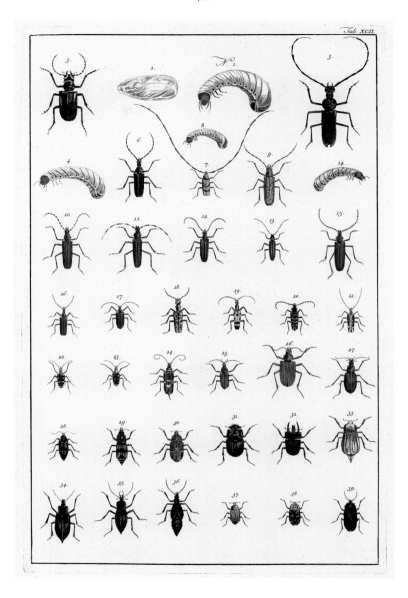

*Tab. XCII.*

1-2, 4, 8, 14, 31 Scarabaeidae 3, 6-7, 9-13, 15-24 Cerambycidae 25-27 Carabidae
28-30, 33-35, 37-39 Silphidae 32 Geotrupidae 36 Meloidae
1-2, 4, 8, 14, 31 Cockchafers · Blatthornkäfer · Scarabées 3, 6-7, 9-13, 15-24 Longhorn beetles · Bockkäfer ·
Longicornes 25-27 Carabids/Ground beetles · Laufkäfer · Carabidés 28-30, 33-35, 37-39 Carrion beetles ·
Aaskäfer · Silphidés 32 Dor beetle · Mistkäfer · Géotrupidé 36 Blister beetle · Ölkäfer · Méloé

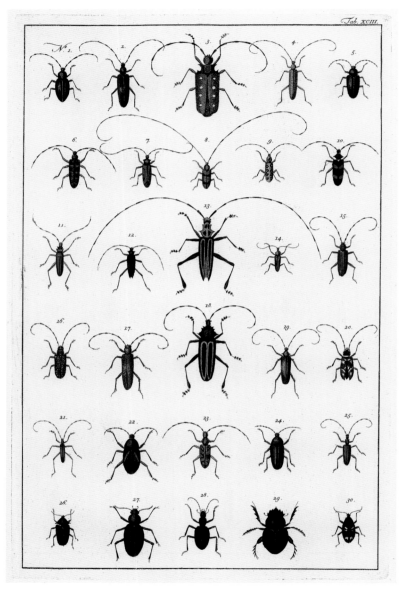

Tab. XCIII.

1-25 Cerambycidae 26 Carabidae 27-28 Tenebrionidae 29 Scarabaeidae 30 Silphidae
1-25 Longhorn beetles · Bockkäfer · Longicornes 26 Carabid/Ground beetle · Laufkäfer · Carabidé
27-28 Black beetles · Schwarzkäfer · Ténébrionidés 29 Cockchafer · Blatthornkäfer · Scarabée
30 Carrion beetle · Aaskäfer · Silphidé

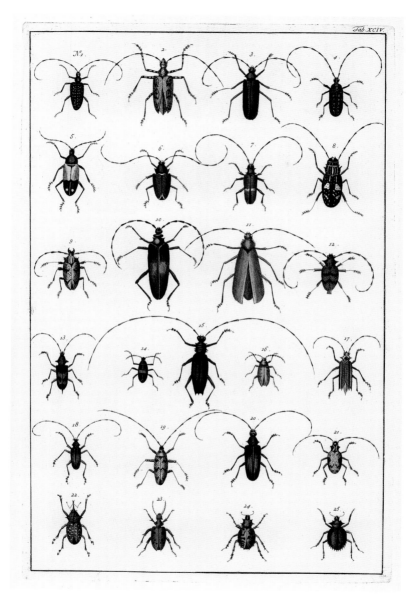

*Tab XCIV*

1-13, 15, 17-21 Cerambycidae 14-16 Coleoptera 22 Curculionidae 23 Donacinae
**1-13, 15, 17-21** Longhorn beetles · Bockkäfer · Longicornes **14-16** Beetles · Käfer · Coléoptères
**22** Weevil · Rüsselkäfer · Charançon **23** Leaf beetle · Schilfkäfer · Chrysomèle (Donacie)

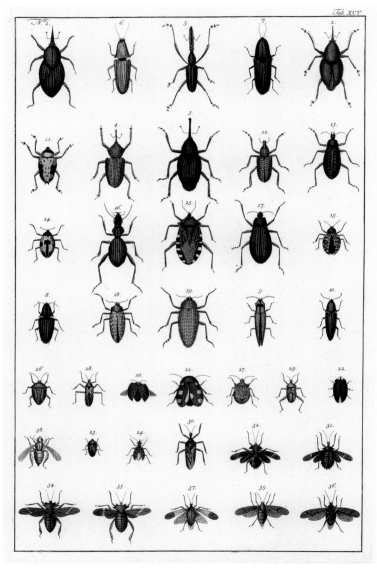

1-5, 12 Curculionidae 6-10 Elateridae 11, 22 Coleoptera 13, 16-17 Carabidae
14-15, 20-21 Chrysomelidae 18-19 Buprestidae 24 Cicindaelinae 38 Aculeata
1-5, 12 Weevils · Rüsselkäfer · Charançons 6-10 Click beetles · Schnellkäfer · Taupins 11, 22 Beetles ·
Käfer · Coléoptères 13, 16-17 Carabids/Ground beetles · Laufkäfer · Carabidés 14-15, 20-21 Leaf beetles ·
Blattkäfer · Chrysomèles 18-19 Jewel beetles · Prachtkäfer · Buprestes 24 Tiger beetle · Sandlaufkäfer ·
Cicindèle 38 Aculeate hymenopterans · Stechimme · Aculéates (Guêpes)

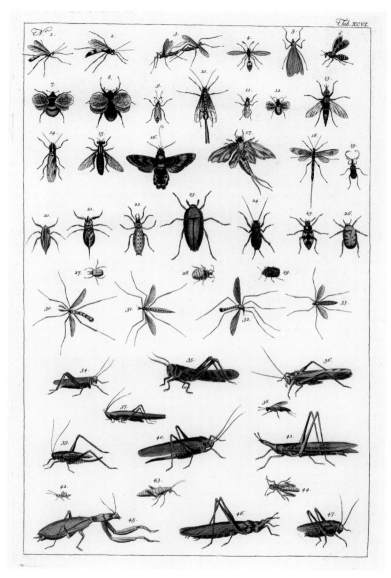

1-2, 4, 6-10, 12, 18, 38 Hymenoptera 3, 11, 13, 15, 30-33 Diptera 14 Plecoptera 17 Ephemeroptera
19, 22-23, 25-27 Coleoptera 28, 29 Heteroptera 34-37, 39-44, 46, 47 Orthoptera 45 Mantodea
1-2, 4, 6-10, 12, 18, 38 Hymenopterans · Hautflügler · Hyménoptères 3, 11, 13, 15, 30-33 Flies · Fliegen · Diptères
14 Stonefly · Steinfliege · Plécoptère 17 Mayfly · Eintagsfliege · Éphémère 19, 22-23, 25-27 Beetles · Käfer ·
Coléoptères 28, 29 Bugs · Wanzen · Punaises 34-37, 39-44, 46, 47 Grasshoppers and katydids · Heuschrecken ·
Criquets et sauterelles 45 Praying mantid · Gottesanbeterin · Mante

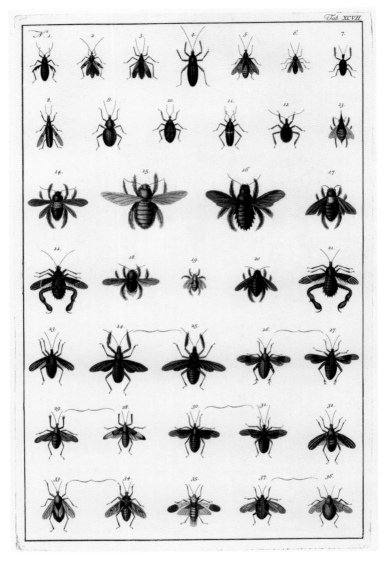

1-2, 12-13, 21-35 Heteroptera 4, 7-11, 36, 37 Coleoptera 5-6 Hymenoptera 14-20 Apoidea
1-2, 12-13, 21-35 Bugs · Wanzen · Punaises 4, 7-11, 36, 37 Beetles · Käfer · Coléoptères
5-6 Hymenopterans · Hautflügler · Hyménoptères 14-20 Bees · Bienen · Apoïdés

*Opposite page*
Apoidea
Bee hives · Bienennester · Ruches d'abeilles

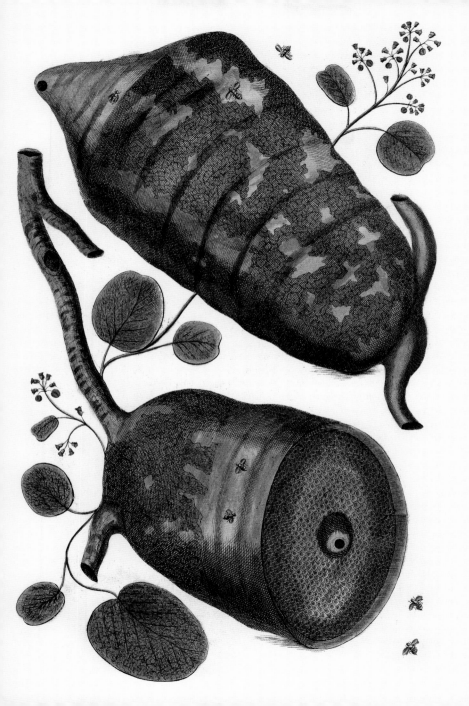

1-2 Pompilidae 3 Diptera 4 Hymenoptera 5-7 Formicidae 8 Mutillidae
9-14 Chelicerata 9-11 Araneae 13 Amblypygi 14 Solifugae
1-2 Spider wasps · Wegwespen · Pompilidés 3 Fly · Fliege · Mouche 4 Hymenopterans · Hautflügler ·
Hyménoptère 5-7 Ants · Ameisen · Fourmis 8 Velvet-ant · Bienenameise · Mutillidé 9-14 Chelicerates ·
Spinnentiere · Chélicérates 9-11 Web spiders · Webspinnen · Araignées 13 Tailless whipscorpion ·
Geißelspinne · Amblipyge 14 Wind scorpion · Walzenspinne · Solifuge

Tab. C.

Mineræ Auri, Argenti cet.
Ores of gold, silver and the
like · Gold-, Silber- und
ähnliche Erze · Or, argent et
minéraux du même type

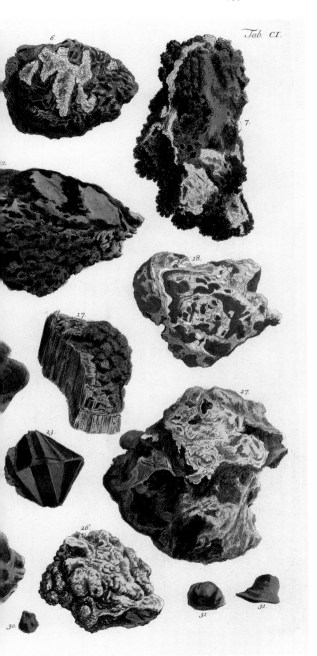

Tab. CI.

Mineræ variæ cet.
Various minerals · Verschiedene
Minerale · Divers minéraux

734

Mineræ variæ cet.
Various minerals · Verschiedene
Minerale · Divers minéraux

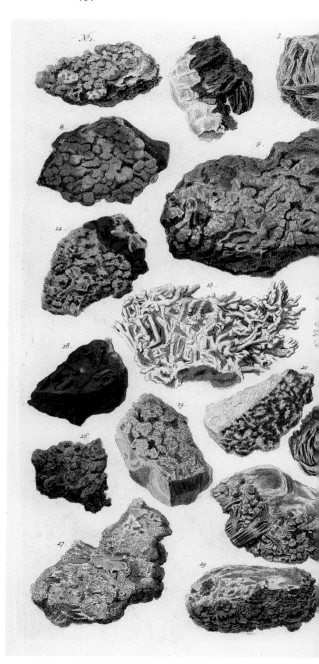

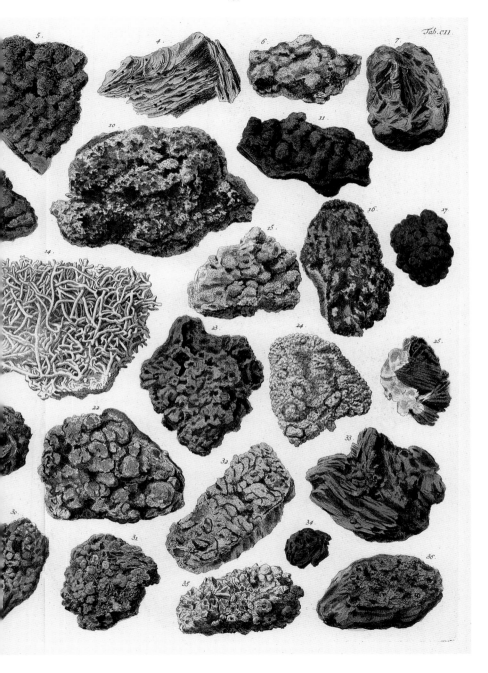

Tab. CII.

Silices causis fortuitis diversimode figurati
Stones shaped by chance · Steine in zufälligen Formen ·
Pierres aux formes diverses dues au hasard

Tab. CV.

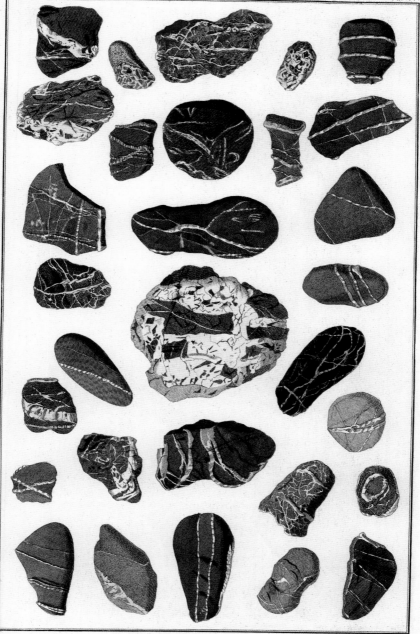

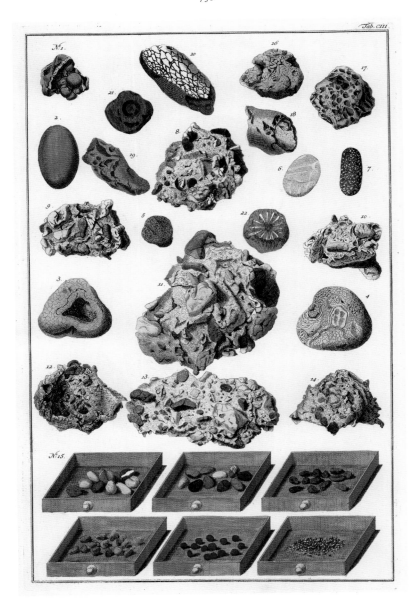

Fossilia varia
Various fossils · Verschiedene Fossilien · Divers fossiles

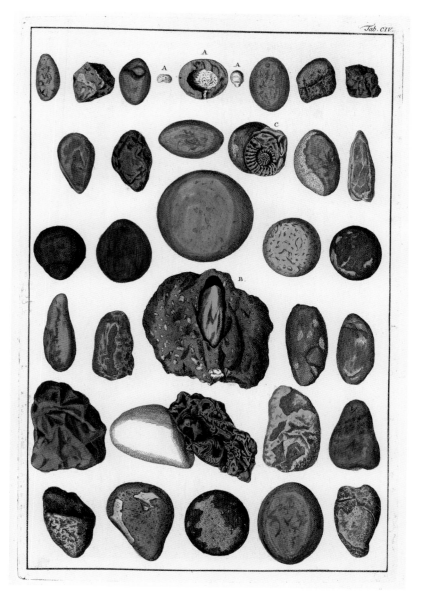

*Tab. CIV.*

Ætitarum variae Species (geodes)
Various species of Ætites or eagle stones (geodes) ·
Verschiedene Arten des Adlersteins (Geoden) ·
Ætites ou pierres d'aigle de différentes espèces (géodes)

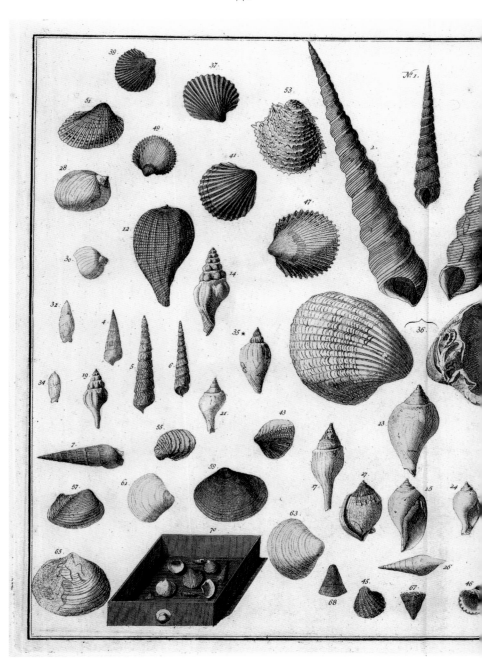

TAB. CVI.

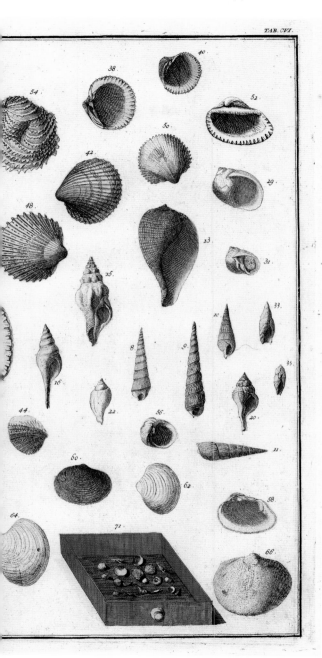

Conchylia marina ex
montibus Avenionensibus
effossa
Marine shells from the
mountains of Avignon ·
Meeresmuscheln aus den
Bergen um Avignon ·
Coquillages de mer, tirés des
montagnes d'Avignon

Conchylia marina & petrifacta, maximam partem in Germania de terra eruta
Petrified marine shells and other fossils, largely excavated in Germany · Versteinerte Meeresmuscheln und andere Fossilien, zum größten Teil in deutschen Landen zu Tage gefördert · Coquillages de mer pétrifiés et extraits en majorité d'Allemagne

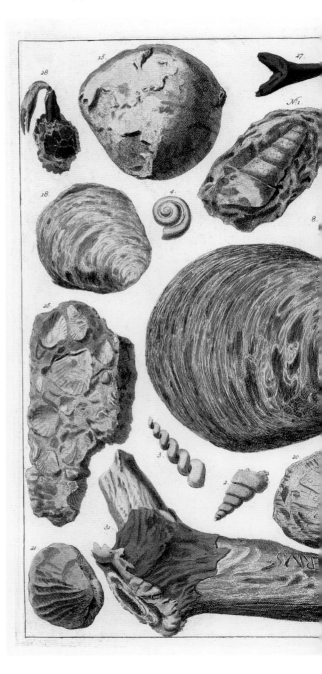

Encyclopaedia
Anatomica

Bourgery. Atlas of
Anatomy & Surgery

Alchemy & Mysticism

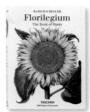

Basilius Besler's
Florilegium

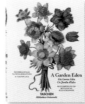

A Garden Eden

Martius.
The Book of Palms

Piranesi.
Complete Etchings

Seba. Cabinet of
Natural Curiosities

Bodoni. Manual of
Typography

Byrne. Six Books
of Euclid

The World
of Ornament

Racinet.
The Costume History

Karl Blossfeldt

Eugène Atget. Paris

Curtis. The North
American Indian

Eadweard Muybridge

Stieglitz.
Camera Work

20th Century
Photography

New Deal
Photography

A History of
Photography

Photographers A–Z

Film Posters of the
Russian Avant-Garde

The Circus.
1870s–1950s

Architectural Theory

Modern
Architecture A-Z

# Monuments and marvels

## A defining record of Islamic art and architecture

Through Syria, Arabia, Persia, and Palestine, Émile Prisse d'Avennes voyaged with a rapturous love for the Orient and a keen eye for the symmetry, opulence, and complexity of visual culture. This TASCHEN edition revives Prisse d'Avennes' 1869–1877 survey *L'Art arabe d'après les monuments du Kaire* in all its attention to detail, as well as to historical, social, and religious contexts. The result is a precious record of Arabic, Persian, and Ottoman heritage as well as of the history of thought and imagination between Europe and the Middle East.

"This publication of Prisse d'Avennes' magisterial chromolithographs is truly a fabulous thing."

— *World of Interiors*, London

*Émile Prisse d'Avennes. Oriental Art*
Sheila S. Blair, Jonathan M. Bloom
520 pages
TRILINGUAL EDITION IN:
ENGLISH / DEUTSCH / FRANÇAIS

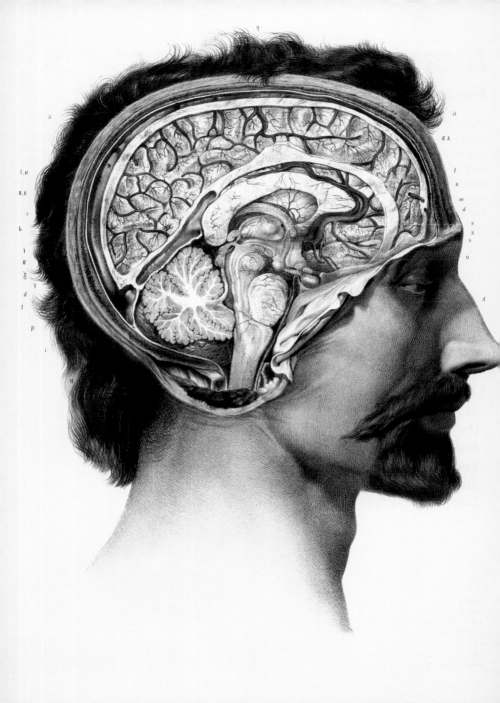

# Anatomically correct

## An unsurpassed treatise of the human body

Discover one of the most comprehensive and beautifully illustrated anatomical treatises ever published. The product of more than two decades of dedication, and spanning descriptive, surgical, microscopic, and general anatomy, as well as embryology, the *Atlas of Human Anatomy* marks what remains to this day a major achievement in medical history, and a breathtaking insight into the workings and wonder of the human body.

"A gorgeous compendium of anatomical drawings from the mid-19th century ... one senses the awe the body once commanded when it was a new, uncharted world begging for exploration."

—*i-D Magazine*, London

J.M. Bourgery & N.H. Jacob

**ATLAS** OF **HUMAN ANATOMY** AND **SURGERY**

THE COMPLETE PLATES

*Atlas d'anatomie humaine et de chirurgie*

*Atlas der menschlichen Anatomie und der Chirurgie*

**TASCHEN**
*Bibliotheca Universalis*

*Bourgery. The Complete Atlas of Human Anatomy and Surgery*
Jean-Marie Le Minor, Henri Sick
832 pages

TRILINGUAL EDITIONS IN:
ENGLISH / DEUTSCH / FRANÇAIS &
ESPAÑOL / ITALIANO / PORTUGUÊS